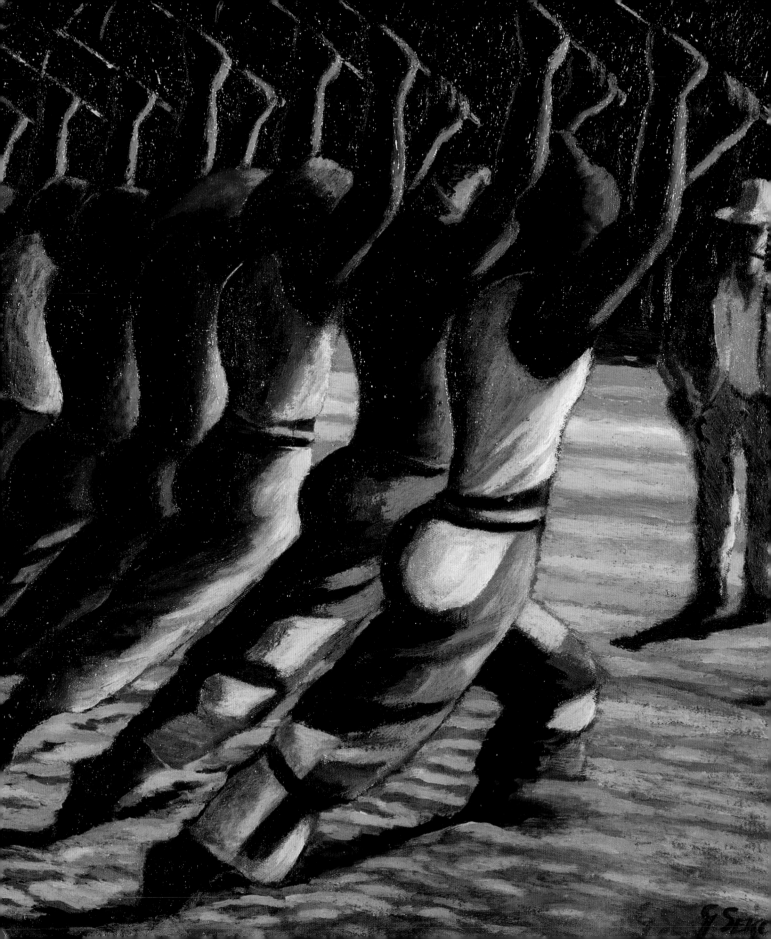

South Africa
the art of
a nation

John Giblin
Chris Spring

Thames & Hudson The British Museum

Frontispiece: *Song of the Pick* (detail), Gerard Sekoto, 1946.
Oil on canvas, 50.5 × 60.5 cm. See page 189.

Page 6: *Transition* (detail), Willie Bester, 1994.
Mixed media, 92 × 152 cm. See page 210.

This publication accompanies the exhibition
South Africa: the art of a nation at the British Museum
from 27 October 2016 – 26 February 2017.

Sponsored by
Betsy and Jack Ryan

Logistics Partner

IAG Cargo

The exhibition at the British Museum has been made
possible by the provision of insurance through the
Government Indemnity Scheme. The British Museum
would like to thank the Department for Culture, Media
and Sport and Arts Council England for providing and
arranging this indemnity.

First published in the United Kingdom in 2016
by Thames & Hudson Ltd, in collaboration with
the British Museum

A catalogue record for this book is available from
the British Library

ISBN 978-0-500-29283-9

Designed by Lisa Ifsits

Printed and bound in Slovenia by DZS-Grafik d.o.o.

To find out about all our publications, please visit
www.thamesandhudson.com. There you can subscribe
to our e-newsletter, browse or download our current
catalogue, and buy any titles that are in print.

For more information about the Museum and its collection,
please visit britishmuseum.org.

Contents

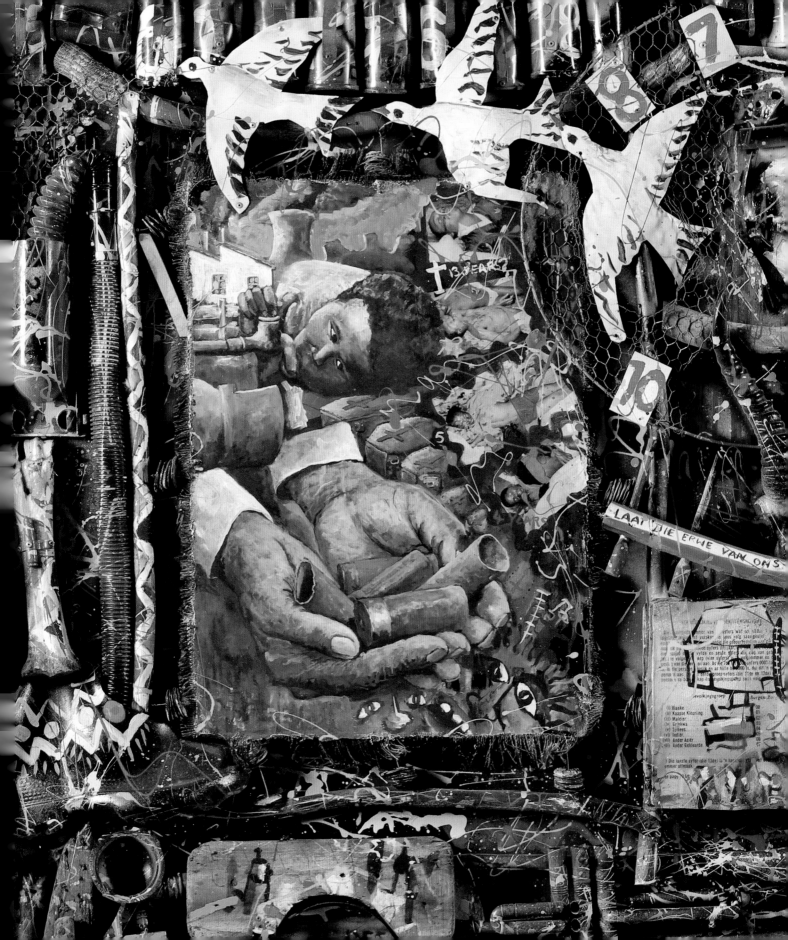

Director's foreword

South Africa: the art of a nation at the British Museum is the first exhibition that attempts to tell the long story of South Africa through contemporary and historic artworks placed in dialogue with one another. South Africa's artistic heritage is unique in its time span. Today, it has one of the most important contemporary art scenes in Africa, increasingly celebrated internationally.

But this exhibition is much more than just an art show: the artworks in this book, and in the exhibition it accompanies, tell a rich and complex story about South Africa and its past, a story that recognizes and respects the country's difficult colonial and apartheid histories but presents them in new ways.

Many aspects of the story will be familiar to a South African audience, but perhaps less so to an international one that may be schooled in the history of apartheid but not necessarily in the events before and since. This is particularly important in the United Kingdom, which has a strong affinity with South Africa as a fellow member of the Commonwealth, but which also shares a difficult history that stretches back to the turn of the eighteenth century and the British colonization of South Africa following Dutch settlement of the Cape.

Over centuries of colonization, the various peoples of South Africa endured an often oppressive relationship with the British Empire. Many of the racial segregation policies that came to define much of South Africa's twentieth-century history had roots in the colonial era. While later, the United Kingdom became a platform for protest against racial segregation in the mid-twentieth century through the Boycott Movement, which later became the Anti-Apartheid Movement.

By using artworks to explore many aspects of South African history, both the book and the exhibition recognize South Africa as one of the cradles of civilization where the human artistic story began, and as a place of great history and complexity, both before and after settlement by European and Asian communities from the mid-seventeenth century onwards.

This exhibition has been made possible through the extraordinary generosity of our sponsors, Betsy and Jack Ryan, and our logistics partner, IAG Cargo. It has also benefited from loans from institutions and individuals within the United Kingdom, including an anonymous private collection, Ron Roche, Jane Samuels, Tate Modern, and the Museum of Archaeology and Anthropology in Cambridge, and from around the world, including the BMW Museum and Studio Breitz in Germany, and a host of institutions and individuals from South Africa, including Iziko, Ditsong, the McGregor Museum, the University of the Witwatersrand, the University of Pretoria, the University of Cape Town, Museum Africa, the Goodman Gallery, Gallery MOMO, MAKER, Karel Nel and South32. Thanks are due also to the South African High Commission, which has contributed towards the public programme.

This is a story that could not have been told without the extraordinary works of South Africa's artists, past and present. To them we owe the deepest debt of gratitude.

Hartwig Fischer
Director, British Museum

Introduction **South African art**

At first the sun was a sleeping man. In his house on earth, he shone for himself only. The earth was cold and dark, and there was no way the people could dry the ant larvae to eat, so the old woman called the children to her: 'Creep up to that old man the sun while he is sleeping, and throw him into the sky while he feels hot. Instruct him to take his place in the sky, so he can shine for the whole world, so we can dry our rice, so we can feel warm, so the earth is bright.'

'Creation of the Sun', as narrated by //Kabbo, a /Xam man, in 1871

South Africa has what is arguably the most remarkable artistic heritage of any nation on earth. In recent decades, archaeologists in South Africa have unearthed some of the world's oldest artworks – wonderful examples of the earliest artistic thought and production – while South African artists today continue to contribute to a powerful contemporary art scene, one that is often political in nature, using the recent and more distant past to comment on the present.

Starting some 3 million years ago with objects that were the precursors to the first true artistic traditions – which began 100,000 years ago – and running right up to the art of today, this book explores the history of South Africa through its artistic legacies, practices and traditions. By creating a dialogue between past and present, it presents a novel perspective on the history of South Africa, a story that begins many millennia before the establishment of the country's contemporary political boundaries. Although South Africa's heritage is rich in many forms of artistic expression, it is tangible artworks, and the intangible meanings attached to them, that are the focus here.

The book is divided into seven, broadly chronological chapters, which together narrate a story of curiosity, creativity and artistic accomplishment in South Africa from the Early Stone Age to the modern day. The story

itself is organized around a series of 'transformational' periods, in which key developments in artistic production coincided with other major shifts in the history of South Africa. Beginning with the precursors to humankind's earliest artistic endeavours, from 3 million to 2,000 years ago (Chapter 1), the story moves forward to encompass the appearance of three-dimensional figurative art and its relationship to the emergence of the first centralized societies and kingdom in the early second millennium AD (Chapter 2); the arrival of non-African artistic influences in the shape of European and Asian settlers from the mid-fifteenth century onwards (Chapter 3); artistic practices related to colonial conflicts, including the Xhosa Frontier Wars, the Anglo-Zulu War and the South African Wars (Chapter 4); the concurrent creation of artworks, especially those focused on the body, by San|Bushmen|Khoekhoen and black South African artists in the nineteenth century (Chapter 5); artistic responses to segregation and apartheid from the early to late twentieth century, which laid the foundations for contemporary South African art (Chapter 6); and, finally, artistic practice since the end of apartheid up to the present day (Chapter 7).

Addressing the major chapters in South Africa's history, this book links the artistic deep past with the present by showcasing contemporary artworks that speak of these formative episodes. Its aim is to highlight the importance of the historical events and artworks to South Africa today.

Using the past as a resource for the present

All art is influenced in one way or another by what has been made before. However, because South Africa's contemporary art scene emerged as a direct response to segregation and apartheid in the twentieth century, and less directly to the preceding centuries of white rule, the practice of exploring the past in order to comment on the present is particularly pronounced in South African art. Indeed, the past serves as a resource for a large number

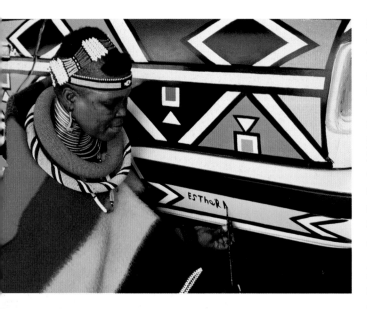

Calder duly turned Poulain's BMW 3.0 CSL into a vivid work of art for the famous 24-hour sports-car race at Le Mans. Poulain's car subsequently became the first in a series of BMW Art Cars created by such world-famous artists as Andy Warhol, Roy Lichtenstein and Frank Stella.[1]

In 1991, as apartheid legislation was being repealed, the project took an unexpected yet much-admired political turn. With the release of political prisoners, including Nelson Mandela in 1990, and the beginning of negotiations that would eventually lead to the first democratic elections in 1994, the process of dismantling apartheid was well underway. To mark this historic moment, BMW commissioned Mahlangu to create an Art Car from its new 525i model.

Mahlangu's Art Car draws on her South African Ndebele heritage and her established practice of transposing Ndebele house-painting designs on to new canvases. As will be discussed further in Chapter 6, these designs not only express cultural identity through their complex iconography, but also represent a form of protest against racial segregation and marginalization as experienced in the early twentieth century.

Ndebele oral tradition records that, during the sixteenth century, under the leadership of a ruler named Musi, the Ndebele broke away from the main Nguni-speaking population concentrated in the eastern part of southern Africa, establishing territory to the north of present-day Pretoria. Over time, the Ndzundza clan gained ascendancy over other groups, and by the mid-nineteenth century had developed into a significant political and military force. However, wars with white settlers deprived the Ndebele of their lands, and they were eventually forced to live in a government-designated area known as KwaNdebele.[2]

Following the loss of their ancestral lands, the Ndebele were forced to work on white farms or to travel long distances – both day and night – to seek work in Pretoria, a process graphically illustrated by David Goldblatt in his photographic essay *The Transported of KwaNdebele* (see page 196). In response, Ndebele women began to make

of contemporary South African artists, with many drawing on historic techniques and materials, episodes and events, in order to highlight the issues that are relevant to modern-day South Africa.

Before embarking on the chronological narrative that makes up the majority of this book, it is instructive to consider five artworks that, as a group, help to illustrate the different ways in which artists have used South Africa's visual heritage as a resource for artistic production and re-presentation in the present. The chosen artworks highlight important issues related to the interpretation of historical works of art, including cultural and individual identities, meaning, secondary sources, and the very nature of art.

The first of these artworks is Esther Mahlangu's *BMW Art Car 525i Number 12* (figs 1 and 2). In 1975 the French racing driver and art auctioneer Hervé Poulain approached BMW with the idea of inviting eminent artists to transform its cars into works of art. Using jagged stripes of red, blue and yellow, the American sculptor Alexander

1 Esther Mahlangu signing *BMW Art Car 525i Number 12*, 1991

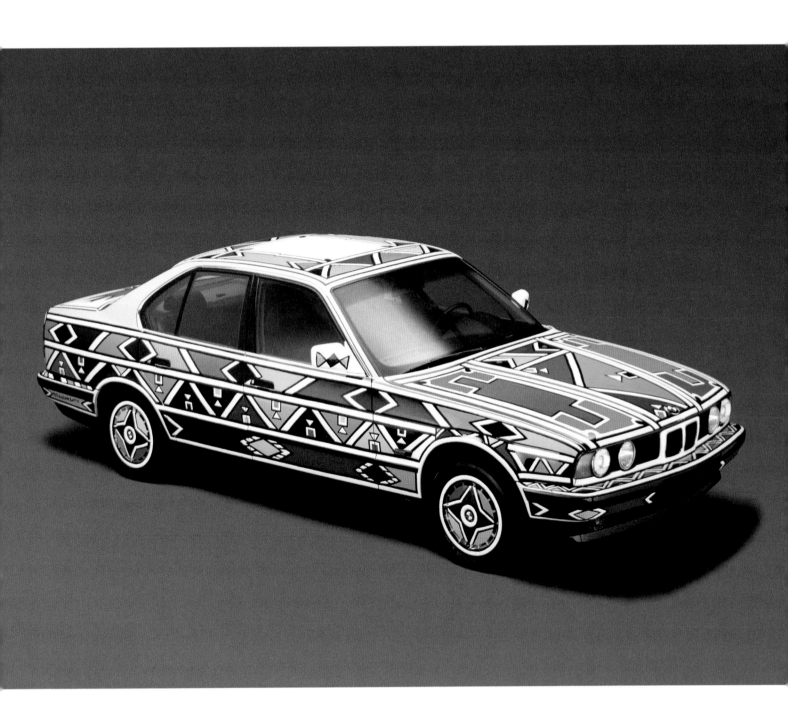

2 *BMW Art Car 525i Number 12*
Esther Mahlangu, 1991
Metal, paint and plastic
H. 141 cm | L. 472 cm
The BMW Museum, Munich 869759

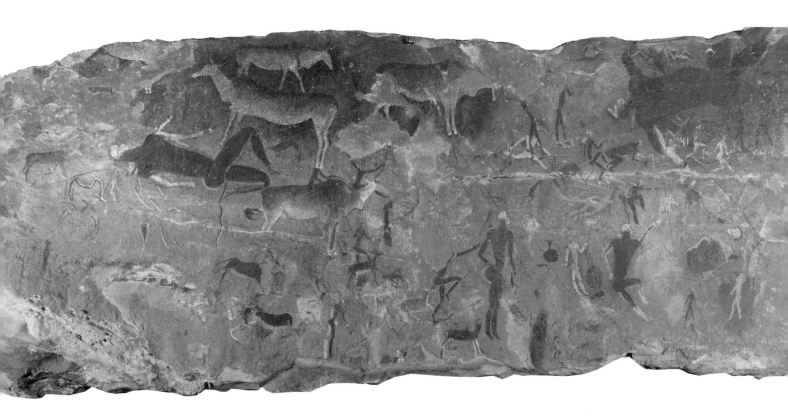

distinctive beadwork for significant events, artworks that identified the Ndebele as a separate cultural identity. In the 1940s, the Ndebele adapted these designs and painted them on their homesteads.[3]

Mahlangu's *BMW Art Car 525i Number 12* can therefore be seen as building on an Ndebele artistic tradition that emerged to define and communicate a cultural identity, first in beadwork, then in house painting, and subsequently on canvas. Her work eloquently illustrates how local artistic traditions can be used to engage with contemporary political situations and events in ways that communicate cultural and political identities to global audiences.

Despite being a radical artwork in many respects, Mahlangu's Art Car is also a more straightforward, 'traditional' work of art, in the sense that it was produced within an established, Western-derived art industry. It was commissioned for a specific historical event and was made

by a known artist whose intentions in producing it have been widely documented. By contrast, the vast majority of South Africa's artistic heritage was produced outside the Western art canon, created by artists whose names were not recorded, and thus are now unknown, and who were inspired by events that were also not recorded. Although this has not hindered the use of the past by contemporary South African artists, it does make the creation of an artistic narrative based around artworks from the distant past more complicated. This problem is well illustrated in the case of the Linton and Zaamenkomst panels, and the South African coat of arms.

Now in the collection of the South African Museum in Cape Town, the Linton Panel (fig. 3) is a 1 × 2-metre section of rock art that was removed from Linton Farm, Eastern Cape, in 1917. Although the removal of rock art from its original location is considered unacceptable today, the curatorial care that has since been given to the panel,

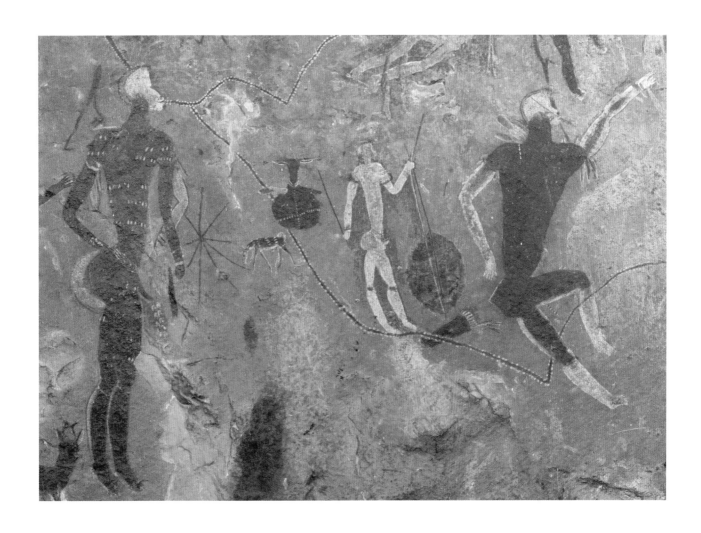

**3 Linton Panel
(opposite; detail above)**
Name(s) of artist(s) unrecorded,
pre-1900
Recorded as San | Bushman
Stone, ochre
H. 85 cm | W. 205 cm
Iziko Museums of South Africa,
Cape Town SAM-AA3186

**4 Republic of South
Africa Coat of Arms**
Iaan Bekker, 2000
Government of Republic
of South Africa

including its protection from weathering and vandalism, has made it one of the best-preserved examples of rock art in South Africa.

The relationship between the Linton Panel and South Africa's post-apartheid coat of arms is perhaps the most famous example in South Africa of a historical artwork being employed in the creation of a contemporary one. The link between the two objects is provided by a human figure from the panel that has been reproduced in the centre of the coat of arms (fig. 4). In common with Esther Mahlangu's Art Car, a prominent artistic tradition in South Africa – in this case rock art – has been used as the inspiration for a contemporary work of art. Indeed, rock art is one of South Africa's oldest artistic traditions, having been practised by the country's First Peoples, the San | Bushmen and Khoekhoen, for thousands of years.

What distinguishes the South African coat of arms from Mahlangu's Art Car, however, is the use of a specific image rather than a more general tradition – an act of reproduction that raises questions about the intention of the original artists and the appropriateness of the image in its new location. These are not easy questions to answer: the artists who made the Linton Panel are long since dead, were not recorded at the time, and their descendants have not practised rock art for at least a century.

The reproduction of a figure from the Linton Panel on the post-apartheid South African coat of arms has given the panel additional political importance. The coat of arms – introduced in 2000 on Freedom Day (27 April) – was designed by Iaan Bekker in response to a government competition to replace the coat of arms that Britain's King George v had granted in 1910 shortly after the creation of the Union of South Africa (see chapters 4 and 5). At the centre of Bekker's design are two figures facing each other, both of whom are based on the central figure in the Linton Panel, albeit without the original's genitalia. According to a government statement about the design, 'The figures are derived from images on the Linton Stone, a world-famous example of South African rock art. The Khoisan,

oldest known inhabitants of our land, testify to our common humanity and heritage as South Africans. The figures are depicted in an attitude of greeting, symbolizing unity. It also represents the beginning of the individual's transformation into the greater sense of belonging to the nation and humanity.'[4] As this statement demonstrates, the contemporary political meaning of the figure in the coat of arms is readily accessible. The original meaning of the rock art, as understood by the artists who produced it and their audience, is much harder to reach.

Cultural identity

One of the reasons for this difficulty is the issue of cultural identity, that is, how we name the peoples who created such artworks as the Linton Panel. The cultural identities of the producers of the most recent examples of rock art are generally known because their activities were recorded in the eighteenth and nineteenth centuries. Moreover, based on cultural continuity evident not only in the artworks but also in supporting historical and archaeological evidence, it is presumed that earlier examples of rock art were made by the ancestors of these peoples. However, the name by which they should be called is subject to debate.

In the official statement quoted above, the creators of the Linton Panel are called Khoisan. This is a collective term for South Africa's First Peoples, who might otherwise be divided into pastoral Khoi, or Khoekhoen, and hunter-gatherer San groups that lived in the region that is now South Africa before the arrival of Bantu-speaking peoples in the first millennium AD (see Chapter 3). However, this collective term is problematic for two main reasons. First, it was San hunter-gatherers, and not Khoekhoen herders – who may have arrived in the region separately approximately two thousand years ago – who produced the vast majority of rock art in southern Africa. Although Khoekhoen herders did produce early rock art, it is believed to have been largely confined to geometric

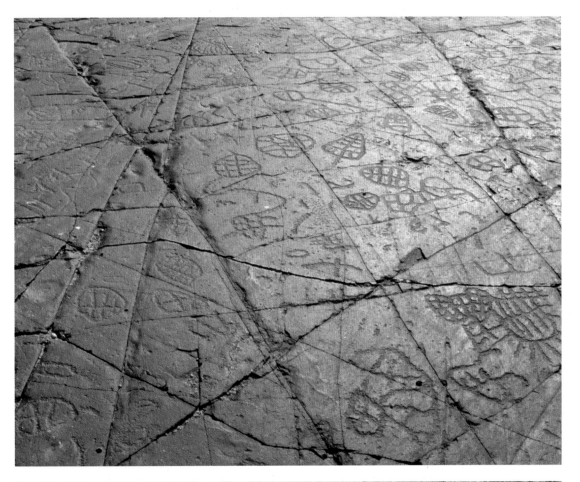

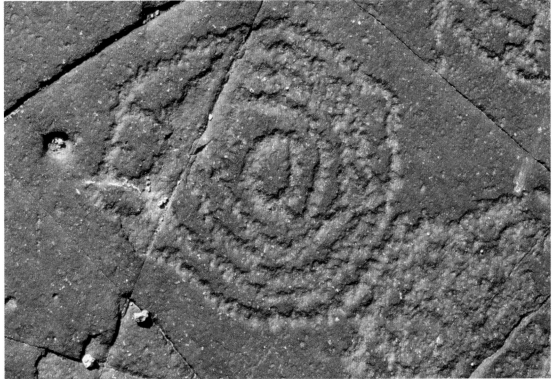

5 Geometric rock art patterns
Name(s) of artist(s) unrecorded,
c. 500 BC – AD 800
Recorded as Khoekhoen
Approx. H. 400 cm | W. 200 cm
Digital image, David Coulson
British Museum 2013,2034.18616
Donated by Trust for African
Rock Art (TARA)

6 Geometric rock art detail
Name(s) of artist(s) unrecorded,
c. 500 BC – AD 800
Recorded as Khoekhoen
Diam. 19 cm
Digital image, David Coulson
British Museum 2013,2034.18664
Donated by Trust for African
Rock Art (TARA)

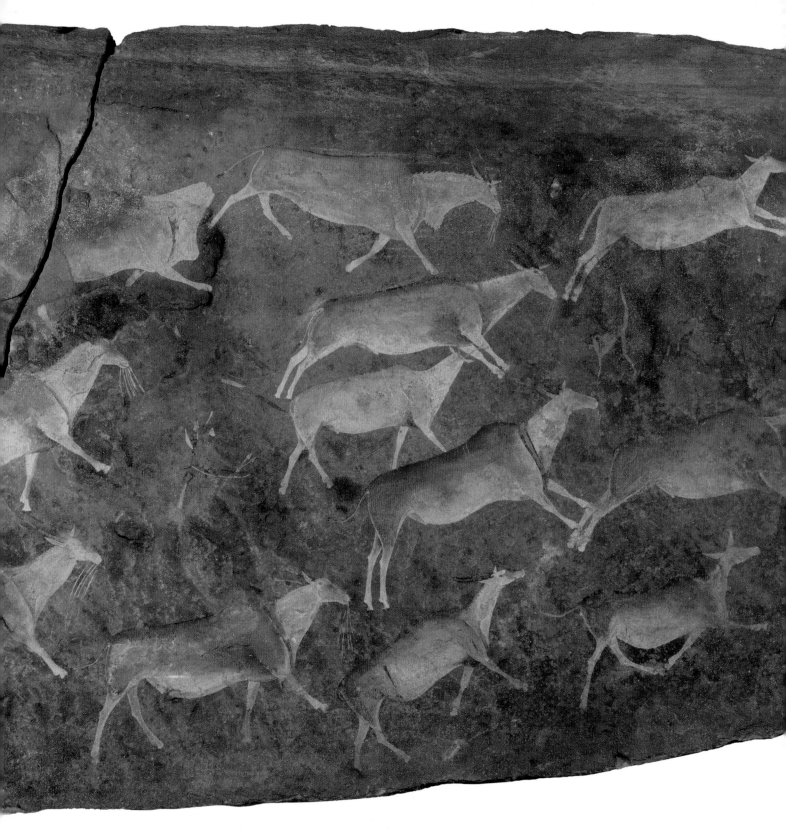

patterns (figs 5 and 6), and is quite distinct from the figurative art of hunter-gatherers (fig. 7).

Secondly, the term 'San' is derived from a Khoekhoen word for 'gatherer', or 'forager', which was used by the pastoral Khoekhoen to differentiate themselves from hunter-gatherers.[5] As such, the term 'San' is now considered by some to be derogatory. An alternative, currently being revived, is 'Bushmen'. However, this term is also problematic owing to its Dutch colonial origins and the way in which it implies that hunter-gatherers are less human than, or at least different from, other 'men'. Because there is no self-referential collective term for hunter-gatherers, there is no term that is entirely unproblematic. Today, southern African hunter-gatherers typically prefer to be identified by the name of their individual language group. But because it is rarely possible to attribute rock art to an individual language group, collective terms are required.[6] To reflect some of the complexities of these terms, we have chosen to use 'San|Bushmen' for hunter-gatherer rock art, 'Khoekhoen' for herder rock art, and 'San|Bushmen|Khoekhoen' for rock art that is more recent, by which time the distinction between San|Bushmen and Khoekhoen communities had been severely undermined by the impact of colonialism.

The difficulty of ascribing cultural identity to South African rock art applies equally to most historic artworks produced in South Africa. While many artworks that were collected in the nineteenth and twentieth centuries had some information recorded at the time of their collection, this information often comes from the collector, rather than the maker or original owner of the artwork. The attribution of cultural identity is often based on the place where the artwork was found, the language presumed to have been spoken by its original maker or owner, or its resemblance to artworks whose authorship is known, all of which may be unreliable as indicators of a lived, self-referential identity. Until recently, it was rare for an artist's personal details to be recorded, and so instead of an artwork being credited to an individual or even a community of artists, it was more typically labelled by culture. As a result, the individuality of the artist and owner was lost to that collective identity. In this publication (as is increasingly common in South Africa itself), if the specific context of an artwork was not recorded at the time of its discovery, it is labelled as 'Name(s) of artist(s) unrecorded, made [date], recorded as [cultural affiliation]'.

Meaning and secondary sources

In the absence of any documentation about the artist who produced a particular work, the interpretation of that work must rely on secondary sources. In the case of rock art, this limitation is compounded because it has not been practised in southern Africa for a century or more. We cannot therefore ask people directly about their reasons

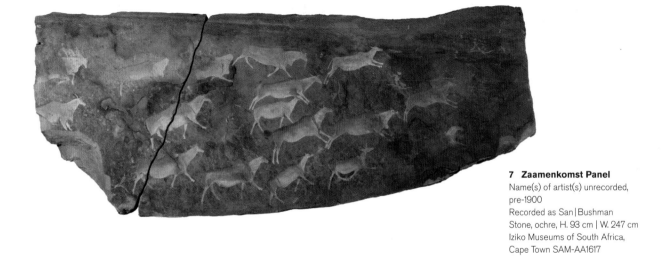

7 Zaamenkomst Panel
Name(s) of artist(s) unrecorded,
pre-1900
Recorded as San|Bushman
Stone, ochre, H. 93 cm | W. 247 cm
Iziko Museums of South Africa,
Cape Town SAM-AA1617

for making rock art, or the meaning behind an individual work. Instead, those studying rock art today must rely on three main secondary sources: a historical explanation of three rock-art sites by a San | Bushman called Qing, from a time when rock art was still being produced; the nineteenth-century archive of two linguistic researchers, Wilhelm Bleek and Lucy Lloyd (Bleek's sister-in-law), who recorded the customs and beliefs of speakers of /Xam (a San | Bushman language group); and a late twentieth-century ethnographic study of living San | Bushmen in neighbouring countries who no longer make rock art but undertake related cultural practices.

The first source, a direct account of rock art, was published in 1874 by Joseph Orpen, a South African magistrate who in late 1873 jointly commanded a British military expedition into the mountains of present-day Lesotho, employing the services of a San | Bushman guide named Qing. In addition to recording legends and myths, Orpen made sketches of rock art that Qing was able to interpret directly. Qing and Orpen's account is now the only surviving explanation of specific paintings made by a member of a community that was still creating rock art.[7]

The second source comes from a study conducted in the 1870s and 1880s by Bleek and Lloyd, who had realized the importance of studying the /Xam San | Bushman language of the Northern Cape before it disappeared – as it did within a generation. To conduct their study, Bleek and Lloyd persuaded the colonial authorities to transfer into their custody /Xam speakers who had been imprisoned in Cape Town for petty crimes. From these 'informants', Bleek and Lloyd took down more than 12,000 pages of verbatim text about /Xam culture. Their main source was //Kabbo (Dream), a shaman who, recognizing that the /Xam language was becoming extinct, wished to preserve his stories. The manuscripts were lost for much of the twentieth century, but are today preserved in the Jagger Library of the University of Cape Town.[8]

The third source consists of anthropological research, first begun in the 1950s, conducted among San | Bushmen living in the Kalahari Desert in Botswana and Namibia. Although these San | Bushmen groups do not practise rock art, they are culturally related to groups who did. Consequently, their belief systems and cultural practices are similar enough to provide a resource for interpreting rock art.[9]

Using these secondary sources, researchers now believe that hunter-gatherer rock paintings are related to a ritual termed the 'great healing', 'curing' or 'trance dance', which is still practised in the Kalahari today. After many hours of dancing, clapping and singing, the healers or shamans may eventually enter an altered state of consciousness, during which they are thought to be able to move between the worlds of the living and the dead. In particular, they are said to be able to heal sick people by sending their sickness back into the world of the dead from whence it was believed to have come. Anthropological accounts of this dance, combined with Qing's reading of rock art as recorded by Orpen, and the traditions recorded by Bleek and Lloyd, strongly support the argument that rock art, including that found on the Linton Panel, is an expression of and guide to the entrance of a healer or shaman into the spirit world.

Among the supporters of this argument is David Lewis-Williams, one of the world's leading experts on San | Bushman rock art. Lewis-Williams has theorized that the Linton Panel depicts the /Xam harnessing a special power called !gi – expressed as a painted line – that enabled the /Xam to heal the sick and resolve social problems. The figure used in the South African coat of arms, for example, stands on the line of !gi and thus has special powers. Lewis-Williams was instrumental in the choice of the Linton Panel figure for the coat of arms, as well as in the creation of the new national motto, written in /Xam, that appears at the bottom of the design: '!KE E: /XARRA //KE' ('Unity in Diversity', or 'Diverse People Unite').[10]

The development of the secondary sources discussed above has radically changed how San | Bushman rock art

is understood. Nineteenth- and early twentieth-century interpretations of hunter-gatherer-fisher rock art drew on European ideas of the definition of art, and suggested that paintings and engravings were merely an attempt to beautify one's surroundings – art for art's sake. Others focused on the presence of wild animals and hunters, suggesting that such rock art was a spiritual offering to ensure the preservation of large herds, while others still argued that it had non-African origins. However, although regional variations exist, analyses from the 1960s have found that humans generally appear far more frequently than animals, and that the animals depicted are not representative of the range and quantities of those that were hunted for food. Commonly hunted animals, such as wildebeest and zebra, are hardly ever shown, for example, whereas eland (a large, spiral-horned antelope) appear quite often. Furthermore, unlike other animals, eland are painted in great detail, using differently coloured paints, while humans may be depicted with eland features, such as hooves and heads. This observation has also been related to the great healing, curing or trance dance – during which shamans reportedly take on eland-like qualities as they enter the spirit world – and further supports the claim that rock art is a metaphorical depiction of the relationship between San|Bushmen and the worlds of the living and the dead.[11]

The Zaamenkomst Panel (fig. 7), a 2.5-metre-long piece of rock art that sits alongside the Linton Panel in the South African Museum, is a good example of the changing face of interpretation. The panel was discovered in 1912 in a rock shelter on Zaamenkomst Farm, near the town of Maclear in the Eastern Cape. It was found lying face down on the ground, in two pieces, suggesting that it had fallen from the wall of the shelter, where it would originally have been part of a much larger rock painting. By the time of its discovery, however, all traces of the rest of the painting had disappeared. It was, it seems, only the fortuitous event of the panel landing face-down in an ash deposit that had preserved the incredible artwork on its surface.

A description of the panel from 1927 illustrates how much has changed in the interpretation of rock art:

> The scene depicted is that of a herd of eland surrounded by hunters armed with bows and arrows and also with battle-axes. The hunters are running rapidly, this impression being conveyed by a conventional drawing of the outstretched legs. The animals are depicted as foaming at the mouth, and, in one instance, approaching death is indicated by the presence of bloody foam. The details of the animal figurines are far more realistic than those of the men.[12]

This, of course, is a very literal account of the content and execution of the panel. More recent interpretations would suggest that this is not merely the depiction of a hunt with animals dying from exhaustion, but an expression of the relationship between San|Bushmen and the spirit world. Just as an eland may froth at the mouth and bleed from the nose when it is dying, for instance, so do shamans bleed from the nose when they are metaphorically dying and entering the world of the dead during the great healing, curing or trance dance. Moreover, the level of detail applied to the eland may reflect the purpose of the painting as an account of the spirit world.

Although a combination of ethnography, history, linguistics and archaeology now offers an increasingly rich interpretation of San|Bushmen rock art, our understanding will always be incomplete. We will never receive first-hand explanations from the artists who produced the art, or from their descendants who were able to 'read' the full language of these historic paintings.

Limitations

The interpretation of other artworks from South Africa's artistic heritage carries similar difficulties. Before the mid-twentieth century, collectors rarely kept detailed records

of African artists, their intentions in producing their art, or the underlying meanings of the artworks themselves (see Chapter 6). Although some artistic traditions from South Africa's history are still practised today – in contrast to San|Bushman rock art – all traditions are dynamic, such that their meanings change over time and cannot be simplistically transposed on to the past. As we move further back in time, such resources as written historical records typically become scarcer, presenting even greater interpretative challenges. The historical artworks featured in this book do not, therefore, project a single voice, but are multivocal. They incorporate traces of the voices of the original artists alongside those of contemporary cultural and scientific specialists. As a consequence, the interpretations offered are subjective and open to reinterpretation.

Although ethnographic, historic and archaeological sources suggest that the Linton and Zaamenkomst panels were painted by male specialist healers, this is only one interpretation. Historical accounts and early ethnographies certainly suggest that the role of healer was confined to men, yet we do not know if this was always the case. In addition, although specialization is indicated by the limited number of mistakes in rock art and the habitual use over thousands of years of specific materials, such as particular paint ingredients, the degree of specialization and how it was maintained remains unknown. Finally, the suggestion that San|Bushman artists were also healers is based on the probability that only those who had experience of moving between the worlds of the living and the dead during the great healing, curing or trance dance would be qualified to represent that experience. Again, however, this is largely conjecture.

What is art?

The recognition that, in the history of South African art, most artists' cultural and individual identities remain elusive presents a related problem, namely, whether such artworks as the Linton Panel and Esther Mahlangu's Art Car can be considered art in the same way. This in turn leads to a more general question: what is art?

Obviously, there is no single answer to such a question. Arguments typically move between two extremes: the 'inclusive', which states that art is any form of symbolic expression; and the 'exclusive', which foregrounds the Western artistic tradition and the emergence of the concept of art that directs the global art market today. Without denying the Western understanding of the term 'art', from the postcolonial perspective adopted here, an inclusive understanding of art is most appropriate because it allows for the existence of artistic creativity before the appearance of the word 'art'. By contrast, to adopt the exclusive position would be to suggest that Africans did not produce art before the arrival of Europeans and the influence of the Western artistic tradition, a historically particular approach that is clearly untenable. To return to the artefacts discussed above, although the Linton and Zaamenkomst panels and BMW's twelfth Art Car were created by artists with different intentions, they are conceptually linked because they are all forms of symbolic expression. Thus, according to the inclusive definition adopted here, they are all works of art.

In the chapters that follow, an object is considered an artwork where an aesthetic response or symbolic expression on behalf of its creator(s) can be identified. In the absence of written historical records, which might have indicated the desire to express symbolic meaning through an object, we have classified something as art where the production of that item is clearly separate from or in addition to its utilitarian function; for example, where an object has been decorated or shaped beyond what is required for it to fulfil that function. It is this inclusive attitude towards what constitutes art and where it may be found that underlies this book and the exhibition it accompanies.

Returning to the past

Esther Mahlangu's Art Car and the Linton Panel, together with the artistic re-presentation of a figure from the latter in the post-apartheid South African coat of arms, demonstrate how the past is an artistic and often political resource for contemporary South African artists. Along with many other artworks featured in this book, they illustrate the way in which cultural traditions may be both resilient and dynamic as the past informs the present. This tension between persistence and change with regards to contemporary artists' use of the past is exemplified by the final artwork under discussion.

As we have seen, rock art is no longer produced in southern Africa. However, descendants of the San|Bushmen and Khoekhoen continue to create artworks that draw on their cultural heritage. In this context, the secondary sources described above provide a resource for the revitalization of San|Bushmen|Khoekhoen art and its recycling into new contemporary artistic practices.

Working at the First People Centre, Bethesda Arts Centre, in the Karoo village of Nieu Bethesda, Eastern Cape, artists of San|Bushmen|Khoekhoen descent have returned to the stories recorded by Bleek and Lloyd to produce a series of narrative 'art quilts' (fig. 8). The artists have taken what some might consider a problematic archive, produced as it was by interviewing captive informants, and have recycled it to produce objects of contemporary cultural value. The narratives depicted in the quilts are based on modern interpretations of the archived stories by the South African poet Jeni Couzyn, the founder of the centre.

The following story, 'Creation of the Sun', is Couzyn's retelling of the version narrated by //Kabbo (Dream) to Bleek and Lloyd in 1871, and is depicted in the art quilt of the same name:

This is the story I tell you.
At first the Sun was a sleeping man.

In his house on earth he gave forth brightness only in the space around him.

The children were those who gently approached to lift up the Sun-armpit while he lay sleeping. The Old Woman was the one who inspired them. Her head was white. The children listened, while their mamma explained what the old woman said
and how to think about it.

They went to sit down, talked it over. Younger brothers, older brothers, companions spoke together.

They waited for him, that old man Sun. They crept closer, stealthily approached him. He lay eyes closed, meaning to stay asleep.

The old woman said to the children, 'O children going yonder!
You must speak to him when you throw him up, instruct him. He must altogether become the Sun that he may go forward, passing along in the sky.'

Stealthily they approached, looked at him, stood perfectly still. Crept forward, stealthily reached him grabbed him all together and lifted him up. He was hot! They raised him, threw him up while he felt hot,
spoke to him, while he felt hot.

The children whispered, 'O Sun! You must altogether stand fast,
you must go along, you must stand fast while you are hot.'
Then the children threw up that old man the Sun while they felt that the old woman was the one speaking.

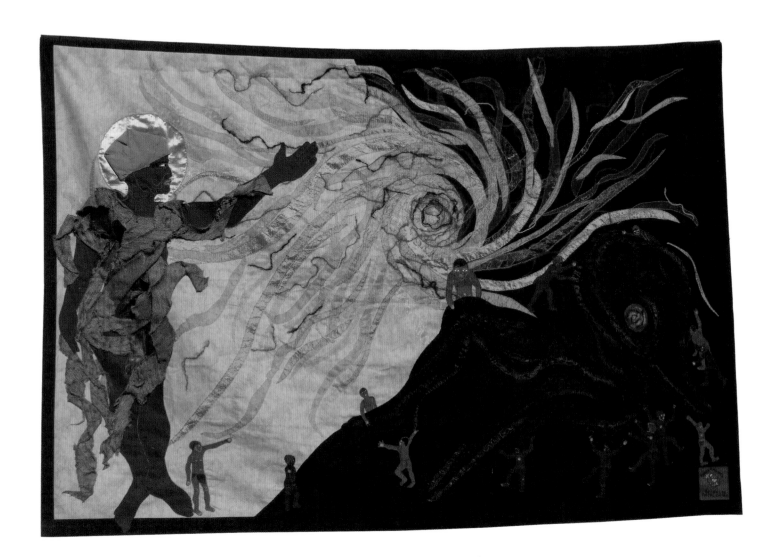

8 *Creation of the Sun*
First People Artists,
Bethesda Arts Centre, 2015
Textile, H. 146 cm | W. 211 cm
British Museum 2016,2023.1

The old woman saw what they'd done.
The mothers saw, the husband saw.
He said, 'They've done it! Old Sun-armpit meant
 to stay asleep
but he's standing fast up yonder!'

The children came racing home. 'I took hold of him!
So did I!' The children felt themselves grow, felt like
 young men.
The youth called to his grandmother,
'O my grandmother we threw him up! I shouted like
 this:
Throw him up! Grasp the old man firmly! Throw
 up the old man!

We told him that he should altogether
become the Sun which is hot for we are cold.
We said: 'O my grandfather, Sun-armpit!
Remain at that place, become the Sun which is hot
that the Bushman rice may dry for us, that you may
 make
the whole earth light,
that the whole earth may become warm in summer
that you may altogether make heat.

Therefore you must altogether shine,
taking away the darkness.
You must come. The darkness go away.'[13]

The combination of the story communicated
by //Kabbo, the recording by Bleek and Lloyd,
Couzyn's interpretation and the resulting art quilt
represents the coming together of various aspects of
San | Bushmen | Khoekhoen artistic pasts and presents.
These diverse forms of expression illustrate the resilience
of cultural knowledge as it passes through different
mediums, as well as the dynamic nature of traditions
and people's abilities to recycle ancient pasts to create
new artistic realities to inform their present.

In 2015, as part of the exhibition *Shared Sky*, the
First People artists from the Bethesda Arts Centre
exhibited their art quilts in the South African Gallery,
Cape Town, alongside collaborative paintings made by
Indigenous Australian artists. The exhibition brought
together two communities that live very far apart, but
which, because they inhabit the same latitude, effectively
live under the same sky. It was this connection that
prompted the involvement of the exhibition's sponsor,
the Square Kilometre Array (SKA) radio-telescope
project, which aims to map the southern skies using
arrays of radio-telescopes in both South Africa and
Australia. Through their involvement in *Shared Sky*,
which later toured the United Kingdom and Australia,
the Bethesda artists not only linked their past and present
with those of Indigenous Australian artists, but also took
the archive created by Bleek and Lloyd in a direction that
the researchers themselves could never have imagined.

As the Bethesda art quilt demonstrates, the way
in which contemporary South African artists use the
past as a resource both revitalizes and redirects tradition.
By looking at and drawing on the past, the artists are
able to make comments about the present that will shape
the future.

Chapter 1 Origins and early art

Art requires the ability to think symbolically, that is, to find meaning in an object beyond the merely utilitarian. Art, therefore, begins in the mind, with the capacity for symbolic thought having developed over the millennia through biological evolution.[1] But there is also a cultural element to art, given that symbolic meaning is established socially, between people.[2] Our ability to think and act symbolically allows us to associate complex information with objects in our environment, and to communicate through language and other abstract systems of meaning. Indeed, it is the ability to think and act symbolically that sets us apart from other species, and which has been identified as a key indicator of modern human behaviour.

'Anatomical modernity' and 'behavioural modernity' are terms used to describe the points in our evolutionary history at which we developed the capabilities that make us distinctly human, such as walking upright, thinking and acting symbolically, and using language. The identification of anatomical modernity can be achieved relatively easily, through the analysis of human remains. Behavioural modernity, however, is much more difficult to establish, because it is based on actions. Changes in brain structure, for example, including the development of areas for symbolic thought, cannot tell us when people actually started demonstrating behavioural modernity. Instead, evidence of symbolic thought, such as early artworks, have become the key identifiers of modern human behaviour.

Because archaeologists have found some of the world's oldest artworks in southern Africa, and in particular in South Africa, they now believe that this is one of the places where modern human behaviour may have begun. The story of South Africa's early artworks is consequently also part of the story of the development of the modern human.

It is important to recognize, however, that while a contemporary audience might find symbolic meaning in early archaeological objects, the same objects may not have had symbolic significance for their original makers and users. The identification of symbolic thought and action in the archaeological record therefore rests on the identification of entirely non-utilitarian objects, or objects that have significant non-utilitarian qualities.

Modern humans in Africa

Prior to the 1920s, it was widely believed that anatomically modern humans developed outside Africa and repopulated the continent at a later date. But a series of new links in the evolutionary chain, found in southern and eastern Africa, began to challenge the prevailing theory, starting with such discoveries as that of the Taung Child, a young *Australopithecus africanus*, in 1924. Today, Africa is firmly identified as the place where anatomically modern humans evolved.

Likewise, the development of behavioural modernity was once believed to have occurred in Europe. This theory was based on French cave paintings dated to 32,000 years ago, coupled with a lack of comparable evidence from elsewhere. This Eurocentric model persisted relatively unchallenged by African evidence, partly because negative stereotypes of the African past as a cultural backwater presented an obstacle to the proper investigation of southern Africa as a location for the origin of modern human behaviour. It was not until the late 1990s that opinions began to change.

It is a matter of national pride in South Africa that, in recent decades, archaeological research at such sites as Blombos Cave, Sibudu Cave, Diepkloof Rock Shelter and Pinnacle Point has found evidence of a symbolic culture – including numerous decorated personal ornaments – active between 100,000 and 70,000 years ago.[3] (Although earlier evidence of the collection and/or production of aesthetically pleasing objects exists in South Africa, archaeologists accept only personal ornaments as 'unqualified evidence of symbolic material culture'.)[4] These findings thus strengthen the case, already built up from fossil and genetic evidence, that fully modern humans evolved in Africa before they populated the rest of the

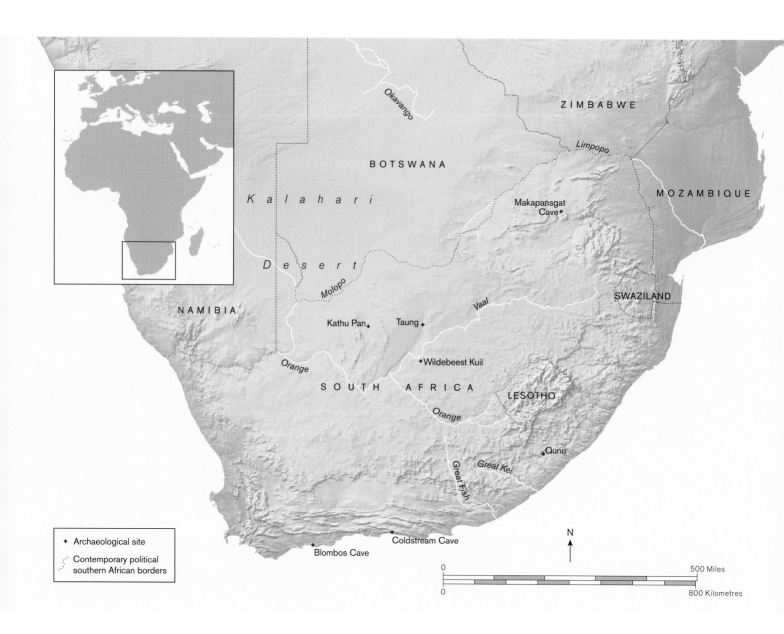

**Map of a selection of key
early archaeological sites
in South Africa**

This map shows the location of
key early archaeological sites
mentioned in the text that display
the development and progression
of artistic thought from *c.* 3,000,000
to *c.* 2,000 years ago.

world. Archaeological research in Africa has now widened its scope to consider how modern artistic behaviour first developed, and how, in turn, it evolved into later, more recognizable artistic practices, such as rock engraving and painting.

Here we explore four key stages in the early development of modern human behaviour, as witnessed by South African archaeology: first, starting 3 million years ago, the appearance of an object that was collected, but not otherwise altered, for its non-utilitarian qualities; secondly, the appearance 1,000,000 to 500,000 years ago of utilitarian objects whose form was deliberately altered to enhance their symbolic value; thirdly, the appearance of decorated objects and bodily ornamentation 100,000 to 50,000 years ago; and, finally, the appearance of two-dimensional figurative rock engravings and paintings at least as early as 27,000 years ago. Turning to the importance of this early period in human evolution to today's South Africa, we end the chapter by considering the work of one of the nation's artists, Karel Nel.

Curiosity and collecting: the Makapansgat Pebble

Objects interpreted by archaeologists as having symbolic qualities include non-utilitarian objects, such as rock paintings, or utilitarian objects that display significant non-utilitarian features, such as pots that have been decorated with distinctive patterns. In both instances, the object has symbolic meaning in addition to its primary function, and over and above the raw materials from which it is made. Contemporary artists, of course, work in a similar way, producing and communicating symbolic meaning by bringing together different materials to create composite objects, such as paintings and sculptures, with new, often multiple meanings. It is the perception of symbolic meaning that makes these objects into art. If the capacity to perceive symbolic meaning did not exist, then such objects would be regarded merely as arrangements of raw

materials, no matter how much technical skill had been invested in their creation.

The same is also true for objects that are made from a single piece of raw material, such as a wooden sculpture carved from a single branch or trunk. The capacity to think symbolically enables a carving to be understood as a sculpture possessed of a range of meanings; without symbolic thought, it could only be understood as a carved piece of wood, useful as a tool, as fuel for fire, or for some other practical activity. In the history of the development of the modern (artistic) mind, however, it is likely that before people began to invest objects with symbolic meaning by modifying or shaping them, they must first have begun to perceive non-utilitarian values in naturally occurring objects and to have collected them.

Archaeologists use the term 'manuport' to describe an object that someone has collected, but which they have not otherwise altered or used. An early-human manuport might include a stone that appears to have no practical purpose, and which, given the availability of geological sources for that kind of stone, and the way it occurs in the landscape, could only have been brought to the place where it was found deliberately and from a long distance away. Examples of early manuports in South Africa include haematite stones found at Kathu Pan that date to 0.8 to 1.3 million years ago,[5] and small water-worn pebbles and quartz crystals from Wonderwerk Cave that are between 276,000 and 500,000 years old, the closest geological sources for which are 20 and 45 km away respectively.[6]

When manuports such as these are found at early-human sites, it is often very difficult to determine what the objects meant to their collectors. Manuports with distinctive colouring, form or other unusual properties may have been collected for those properties, but it is hard to know for certain why those features were important to the collector. It is for this reason that the Makapansgat Pebble is so significant.

The Makapansgat Pebble (fig. 1) was found by Wilfred Eitzman in 1925 during archaeological excavations in

Makapansgat Cave, a site located in Makapan Valley in the province of Limpopo (formerly Transvaal), South Africa.[7] The pebble was discovered alongside the remains of a number of australopithecines, ancestors of modern humans who lived between 2 and 3 million years ago. The remains of the Makapansgat individuals, however, are believed to be closer to 3 million years old.[8]

Capable of being carried in the palm of one hand, the pebble is a small piece of reddish-brown jasperite with veins of greyish-green quartzite running through it.[9] When found, it was notable for its face-like qualities – complete with eyes and a mouth – preserved on two of its sides. In 1926 Eitzman showed the pebble and its markings to the eminent archaeologist and anthropologist Raymond Dart. The significance of the pebble was not recognized by Dart, however, until many decades later, when he realized that the geology of the pebble was foreign to the dolomite cave in which it had been found, and that therefore it may have been brought there deliberately because of its face-like markings. Since Dart's early speculations in the 1950s and 1970s, the Makapansgat Pebble has been described by some as the world's oldest art object, although this remains a highly controversial and contested interpretation.[10]

Today, it is generally accepted that the pebble could not have reached the cave where it was discovered without having been carried there, most probably by one of the australopithecines close to which it was found. This conclusion is based on the distance of the nearest possible geological source for the pebble, which has been given variously as 4.8, 11 or even 32 km away; the size of the pebble, which is too large to have been carried in the gut of an animal or by a bird; and the absence of any evidence to suggest that it may have been deposited in the cave by water.[11]

Microscopic analysis has ruled out a practical use for the pebble – there is no use-wear on its surface, for example – and no other geologically comparable stones were found in the cave, suggesting that the pebble was collected for a specific reason and was not part of normal activity at that location. Explanations for its transport to the cave have thus returned to the pebble's distinctive red colour and the face-like markings on its sides, which scientific analysis has shown to be the result of water action.[12] What we are left with, therefore, is the intriguing possibility that the gaze of an individual was drawn to the pebble because of its colour, and that he or she collected this particular red stone because of its face-like features.

The ability to recognize an individual by their face, and not merely by their smell and/or sound, is central to the way in which human beings interact with one another. It is a capability shared with primates and with few other species. As early humans began to recognize individuals by their faces, they also began to notice things that had face-like features. The ability to recognize such features in objects, it has been suggested, presupposes the ability to relate newly perceived qualities in the physical world to past experiences – in this case, the perception and appreciation of the pattern of a face – which, in turn, suggests a degree of self-awareness.[13]

The pebble's collection by an early hominid has been explained neurologically, with archaeologists drawing on contemporary research into the existence of a universal positive emotional response to the viewing of faces.[14] Of particular interest is the way in which twentieth- and twenty-first-century humans readily identify a face in the pebble that more closely resembles that of a modern human, while it has been argued by some that an alternative face can be discerned on the opposite side, one that more closely resembles the face of one of our ancestors. It is, they argue, this second face, and not the more commonly depicted one, that most likely led to the pebble's collection. In either case, the collector must have had a degree of awareness – either of their own appearance or of that of one of their contemporaries – in order to appreciate this product of nature.[15]

The collection and subsequent care of the pebble can be seen as an early example of curiosity that was a precursor to later, more true artistic activities. Although the pebble's form and fabric were not altered, it was changed

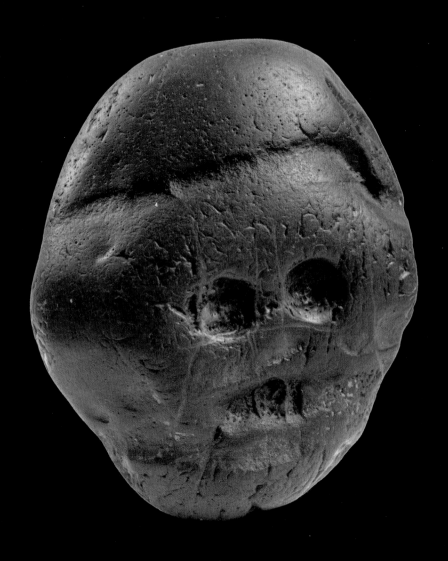

**1 Makapansgat Pebble
of Many Faces**
Originally collected c. 3,000,000 BP
Recorded as australopithecine
Jasperite stone
H. 8.3 cm | W. 6.9 cm
Evolutionary Studies Institute,
University of the Witwatersrand,
Johannesburg

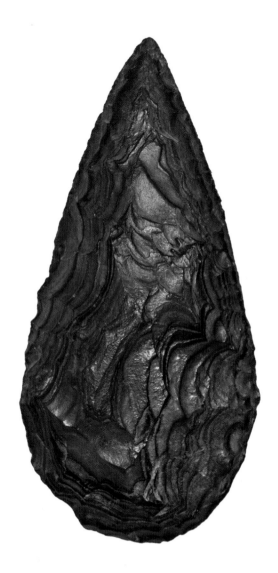

2 Kathu Pan hand-axe
Made *c.* 1,000,000 BP
Recorded as *Homo ergaster*
Banded ironstone
H. 23.2 cm | W. 11.4 cm
McGregor Museum, Kimberley
MMK6538

from a natural to a cultural object in the moment of its collection. At the same time, the unknown individual who picked up the pebble some 3 million years ago might be considered one of the world's first creators of 'found art',[16] a practice that is well established among contemporary artists. Today, this term refers to works that have been created out of natural or cultural objects found in the surrounding environment. These objects are then transformed into artworks, partly through their collection and relocation to new settings – just as the pebble was.

Despite the Makapansgat Pebble being recognized as an early precursor art object by some, there will be many who continue to regard it as nothing more than a pebble whose origins in the cave – natural or otherwise – have yet to be explained. Whatever one's point of view, the pebble and other such manuports present us with an opportunity to consider how and why early humans first began to value natural objects and to collect and curate them.

Making aesthetically pleasing objects: Kathu Pan hand-axe

Early precursors of later, true artistic practice in South Africa leap from the collection and curation – but not alteration – of exotic objects to the manipulation of an object's shape in order to add to or enhance its aesthetic value. Although the Makapansgat Pebble was irrevocably changed from a natural cobble into a personal item when it was collected and cared for by an early human, the form of the object, including its shape and surface markings, remained unchanged. The appearance in the archaeological record of objects deliberately altered for aesthetic pleasure thus marks a huge leap forward in the story of how modern human behaviour developed.

The earliest evidence of objects manipulated by people for aesthetic purposes can be found in hand-axes that have been thinned and symmetrically shaped beyond what is useful for their intended purpose. Hand-axes were made

Origins and early art **31**

at least as early as 1.6 million years ago, and variations were still being produced in Europe some 40,000 years ago, making them the major tool of human history. The production of these multipurpose stone tools required considerable amounts of both time and skill. Yet, despite being evidence of complex thinking, most hand-axes do not necessarily indicate aesthetic behaviour. This is because, in general, the energy invested in their production – the finding and shaping of a stone suitable for breaking, scraping, cutting and so on – can be explained as having contributed towards their utilitarian value.

Around 1.4 million years ago the shape of hand-axes began to change, from bulbous and asymmetrical to something more harmonious, as evidenced by the hand-axes found at Olduvai Gorge in Tanzania. However, although the symmetry of these early hand-axes has been explained in non-utilitarian terms, it is not until 1,000,000 years ago, when exquisitely symmetrical and thinned hand-axes began to appear, that we can safely infer the demonstration of aesthetic production. Experimental archaeological studies have shown that bulbous and asymmetrical hand-axes are more useful tools than those that have been thinned and made highly symmetrical. The additional effort required for the creation of the latter is therefore unlikely to have added any utilitarian benefit; indeed, it might even have been detrimental to the hand-axe's usefulness.[17]

The additional work expended on these highly shaped hand-axes has thus been explained in terms of a desire to lend them an aesthetic value. Although the specific purpose of this work remains unknown, it has been suggested that it reflects the role of such hand-axes – as both 'reliability indicators' and 'aesthetic displays' – in the selection of a sexual partner. As an indicator of reliability, a symmetrical hand-axe may have demonstrated to a prospective mate such abilities as the means to plan ahead, source suitable raw materials and work skilfully with stone. In addition, it may also have been a reliable indicator of good health, including sharp eyesight.

As for aesthetic display, symmetrical hand-axes may have made their maker and user more attractive to the opposite sex, since humans are visually attracted to high levels of vertical symmetry, said to be perceived as an indicator of 'good genes'. The producer of hand-axes may simply have been exploiting this perceptual bias, 'making artefacts that caught the attention of, and were most probably attractive to, members of the opposite sex'.[18]

The Kathu Pan hand-axe (fig. 2) is a famous example of a non-utilitarian stone tool from the Early Stone Age. It has been shaped out of banded ironstone, a material that, today at least, has enormous visual appeal. The hand-axe was found with a few hundred-thousand other stone tools at Kathu Pan on the edge of the Kalahari Desert. It displays all of the non-utilitarian features described above, including careful thinning and detailed working around the edge to create a symmetrical outline. Since its deposit at Kathu Pan, however, it has taken on another feature appreciated by contemporary audiences: a sheen created by a film of silica, formed naturally by groundwater after the tool had been discarded.[19]

Decoration and modern human behaviour: Blombos Cave

The Makapansgat Pebble and the Kathu Pan hand-axe are both precursor art objects from the Early Stone Age (around 3.4 million to 300,000 years ago), albeit from either end of that archaeological period. The next development in artistic behaviour in southern Africa presented here is the use of perforated shell beads as bodily ornamentation in the Middle Stone Age (a period that lasted from around 300,000 to 25,000 years ago). The shell beads and other finds discovered at Blombos Cave, discussed below, represent the earliest firm evidence for the existence of modern human behaviour and a symbolic artistic culture.

Anatomically modern humans are known to have evolved in Africa between 200,000 and 100,000 years ago,

with 160,000-year-old remains having been identified at Herto, and 195,000-year-old remains at Omo-Kibish I, both of which are archaeological sites in Ethiopia.[20] However, as previously discussed, anatomical modernity is not an indicator of behavioural modernity, which is seen instead as first appearing archaeologically in the use of personal ornaments as part of a symbolic culture. By this definition, the Makapansgat Pebble and the Kathu Pan hand-axe are evidence not of modern human behaviour, but of the ongoing development of such behaviour as a precursor to true artistic traditions. While the Makapansgat Pebble is likely to have been a personal object, it was not decorated and was not necessarily used for decorative purposes; nor is it known to be part of a larger culture, being rather a unique object found in isolation. Likewise, although the Kathu Pan hand-axe's thinning and symmetry are not unique, they have not been shown to be part of a defined symbolic culture; instead, they are features seen on hand-axes across the Early and Middle Stone Ages in Europe and Africa.

Before the Blombos Cave finds were reported, modern human behaviour was thought to have appeared in Europe after either 50,000 or 40,000 years ago, a first step on the path to modern humans replacing Neanderthals. In the apparent absence of evidence of symbolic cultures in Africa before this time, this theory was allowed to prevail.[21] Since the late 1990s, however, it has gradually been replaced by the growing evidence of a symbolic culture at Blombos, Sibudu, Diepkloof and several other sites in South Africa dating from 100,000 to 60,000 years ago.

Blombos Cave is located on the coast of the Western Cape, 300 km to the east of Cape Town. Excavations at the site began in 1991, but it would be nearly another decade before the first evidence of symbolic artistic behaviour was discovered. The evidence centred on two pieces of red ochre that had been deliberately decorated with incisions (fig. 3).[22] Ochre is earth or rock with a high concentration of iron, typically created by erosive water action. While it occurs naturally at some sites, at others it may have been brought there by humans. Historically, ochre was used in the preparation of animal hides and as the main ingredient in paint. It has also been demonstrated that ochre was used to improve the quality of hafting resins (used to secure handles to cutting or hunting implements) by people of the Middle Stone Age.[23] At Blombos, archaeologists were able to show that in contrast to the many thousands of other pieces of ochre that had been found in the cave, the marked pieces could not have been incised incidentally, such as through repeated use, but must have been given their patterns on purpose.

Since these initial finds, microscopic studies of other pieces of marked ochre from Blombos Cave have shown that thirteen more may also have been decorated. This collection of engraved ochre suggests that the practice of applying distinct patterns to objects was taking place as early as 100,000 years ago, thus demonstrating a nearly 30,000-year-long decorative tradition.[24] In 2008 two 100,000-year-old ochre processing kits were also discovered at Blombos – including the remains of a liquefied ochre mixture stored in two abalone shells – alongside bone, charcoal, grindstones and hammerstones.

The exact nature of the symbolic importance of ochre at Blombos Cave remains unknown, but its overall importance to the residents of the cave is clear from the finds themselves. It is possible that the ochre was initially valued for its use in animal-hide processing before it took

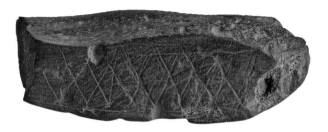

**3 Blombos Cave
engraved ochre**
Name(s) of artist(s) unrecorded,
c. 75,000 BP
Recorded as *Homo sapiens*
Ochre, H. 7.5 cm | W. 4.1 cm
Iziko Museums of South Africa,
Cape Town SAM-AA 8938

on a symbolic value that led to its decoration. In any case, it is exciting to speculate that the processing kits were also used to make paint for skin protection and bodily decoration, and that, as an object used for the latter, ochre itself began to be decorated.[25] Indeed, there is a growing body of evidence from other sites in South Africa and the wider region for the non-utilitarian processing of ochre in the Middle Stone Age.[26]

The excavations at Blombos Cave also unearthed a bone point with an engraved pattern, in this case a series of almost parallel lines made with a single stone tool (fig. 4). Ethnographic and archaeological comparisons of butchery remains from other sites, together with scientific analysis of the incisions, have shown that these markings also seem to be a form of decoration.[27] The appearance of similar patterning on two different types of object adds weight to the argument that a symbolic culture existed at Blombos Cave in the Middle Stone Age.[28] According to the archaeologist Jill Cook,

> The appearance of carvings, engravings and the use of pigments as paint and crayon have no practical explanation. They suggest the invention of self-conscious activities that help people to come to terms with themselves, with nature and, perhaps, with the forces that they perceive as governing the natural world. They are evidence of the development of the modern brain in Africa. In Europe, such evidence is more recent.[29]

Evidence of engraved decoration at other Middle Stone Age sites has since been found, including engraved pieces of bone, and fragments of vessels made from ostrich eggshell engraved with geometric designs dating from 63,000 years ago. Discovered at Diepkloof Rock Shelter in the Western Cape, the eggshell fragments are decorated with five different motifs – a clear indication of the existence of a symbolic culture at the site.

Some of the most convincing evidence for the existence of a symbolic culture at Blombos Cave is the forty-nine *Nassarius kraussianus* shell beads that were found in two separate layers dating to 78,000 and 75,000 years ago respectively.[30] Each of the shells was found with a single perforation, and some bore traces of red ochre. Scientific analysis of the shells has shown that they could not have found their way to the cave by natural or accidental means: the shells' closest natural source to the cave would have been 3 km away; animals do not move shells that far; and their contents would not have been a source of food for humans. Comparative analysis with modern shells has shown that the perforations do not occur naturally and were not caused by damage, while experimental archaeology has suggested that the perforations were most likely made deliberately with a bone point. Analysis of the use-wear on the inside of the perforations clearly shows a smoothed edge, indicating that the shells were strung together as beads. Moreover, the shells were found in small concentrations, in groups of five to twelve, while the individual shells in each group shared a distinct form of smoothing at the point of perforation, suggesting that each collection of shells had been used for a separate necklace, anklet or bangle (fig. 5).[31]

The shell beads discovered at Blombos Cave represent the earliest firm evidence for symbolic bodily

4 Blombos Cave incised bone
Name(s) of artist(s) unrecorded,
c. 70,000 BP
Recorded as *Homo sapiens*
Bone, H. 32 cm | W. 17 cm
Courtesy of Christopher Henshilwood
and Francesco d'Errico

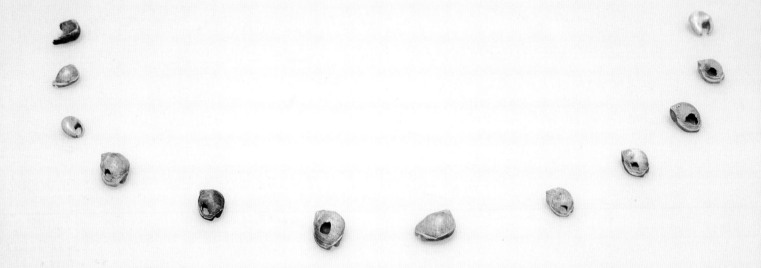

5 Blombos Cave beads
Name(s) of artist(s) unrecorded,
c. 78,000–75,000 BP
Recorded as *Homo sapiens*
Nassarius kraussianus shells
Average H. 0.8 cm | W. 0.6 cm
Iziko Museums of South Africa,
Cape Town SAM-AA 8987/001-012

ornamentation anywhere in the world. Indeed, setting to one side a group of naturally perforated 90,000-year-old shells from Israel that some have claimed to be beads – a claim that is disputed – the next earliest evidence for beads comes after 40,000 years ago in Europe, Asia and Africa.[32] Although thirteen deliberately perforated *Nassarius gibbosulus* shells with traces of use-wear and ochre dating to 80,000 years ago were found at Grotte des Pigeons in eastern Morocco, their identification as beads has also been contested.[33] It is nevertheless of interest that shells from the same genus were being collected and used at the same time, approximately 8,000 km apart.

The evidence from Blombos Cave and Diepkloof Rock Shelter, together with that from other sites in southern Africa, demonstrates that symbolic cultures existed in Africa much earlier than in Europe. Although little is known about the exact purpose of such cultures, we can at least speculate that certain aspects were either for private or for public display. The engraved ochre pieces from Blombos Cave, for example, would likely have been too small for public consumption, and were therefore probably for more private, personal use; by contrast, the shell beads – at least when worn – would likely have been for public display, as would the highly visible engraved decoration on the large ostrich eggshell vessels.

Decorated and/or highly worked objects intended for public display may have operated as a sign that the maker was a reliable mate for sexual selection (as in the case of the symmetrical hand-axes discussed above). Alternatively, they may have been used to communicate individual and/or group identity, as has been argued for the ostrich eggshell containers found at Diepkloof.[34] It is more difficult, however, to discern the function of objects intended for private use. One hypothesis is that the incised, cross-hatched decoration on the ochre, bone and ostrich eggshell was not an abstract geometric design, but was instead representative of important patterns that their makers had 'observed and experienced in their cultural and natural environments'.[35] In other words, the makers

of these cross-hatched patterns may have been influenced by, say, the designs of their nets, traps, weaving and basketry. If such objects did exist at this time, they would have significantly altered not only their makers' means of sourcing food, but also possibly their symbolic worlds.

Two-dimensional figurative art: rock painting and engraving

Although artistic representation of a non-abstract kind may have emerged in the Middle Stone Age – as part of the establishment of symbolic cultures – the earliest indisputable two-dimensional figurative art found so far dates to the end of the Middle Stone Age and start of the Later Stone Age (approximately 25,000 years ago) in southern Africa, and to a comparable time in Africa, Europe, Australia and, slightly later, the Americas.[36]

The oldest known examples of rock art in Africa are seven small slabs of painted rock excavated from Apollo 11 Cave in Namibia. The paintings' creation was originally dated to 27,000 years ago,[37] but recent research has dated it more reliably to 30,000 years ago.[38] Although it is impossible to identify individual species with any confidence, the paintings clearly depict a number of animals, including at least one possibly mythological creature with what appear to be human hind legs.

The leap from abstract geometric decoration and representational patterning, at the end of the Middle Stone Age, to the figurative representation of living or mythological beings, at the start of the Later Stone Age, appears to be a radical, sudden development in modern human behaviour. It took hominids nearly 3 million years to go from collecting exotic objects to the creation of decoration and personal ornamentation; only a few tens of thousands of years later, however, humans apparently suddenly developed the desire and ability to represent complex beings figuratively. It is important to note that this rapid development may not reflect a radical cognitive

event, but rather a lack of reliable scientific dating. It may also reflect a lack of preserved rock art that can be dated: in contrast to early French rock art, which is preserved deep inside caves, rock art in southern Africa is typically found on exposed rock surfaces, where it can erode more rapidly. As typological and scientific dating is generated by the current archaeological research in southern Africa, it may become possible to offer a more gentle curve for the development of figurative rock art in the region.

Here, in contrast to the rock art found on the walls of rock shelters, we focus on two examples of 'mobile' rock art: a painting and an engraving created on individual pieces of rock. The first example is the Coldstream Stone (fig. 6), famous for the elegant and remarkably well-preserved painting of three humans on its surface that may be up to 9,000 years old. In 1911, during excavations in a rock shelter near the Lottering River in the southern part of the Western Cape, the stone was found on the site of a human burial, carefully placed above where the head would have lain. The burial is believed to date to 7,000 BC, and the specific placement of the stone indicates that rock art had ritual uses at this time. The painting

is so well preserved that many have alleged that it was 'enhanced' by the original excavators, but analysis of the paint and the historical circumstances of the stone's recovery strongly refute these suggestions.[39]

The painting depicts three figures with distinctly different red-and-white hairstyles, red bodies, white faces, black joints and a black outline. The central figure is clearly carrying a number of items: a stick of some kind in his right hand, an unidentified object in his left hand, and what appears to be a sheath of arrows over his left shoulder. Streaks of red across the figures' faces represent the smearing of blood from nasal haemorrhages, a practice that occurred in the great healing, curing or trance dance performed by San|Bushmen as they moved between the worlds of the living and the dead in order to heal the sick (see page 18).[40] If the Coldstream Stone does date to the Later Stone Age, it therefore serves as a witness to the great antiquity of the San|Bushmen trance dance.

The second example of mobile rock art is a petroglyph, or rock carving, of an *Equus quagga*, a subspecies of zebra that became extinct in the nineteenth century (figs 7 and 8). Although the petroglyph is officially classified as mobile rock art, in practice it is unlikely that anyone would have been able to carry this 94-kilogramme rock very far, very often. The petroglyph was donated to the British Museum in 1886, and was described as having come from the Wildebeest Kuil site near Kimberley, Northern Cape. Subsequent analysis suggests that the engraving is up to 2,000 years old. Given the possible emissions coming out of the animal's front legs and the raised hairs on the back of its neck, the petroglyph is of particular interest in the context of the trance dance mentioned above. Raised hair on the back of animals' and humans' necks is a common feature in rock-art depictions of the trance dance, reflecting the way in which hairs stand up on an animal's neck as it is dying from injuries sustained during a hunt, and the comparable feeling that a shaman experiences as they enter a state of trance.

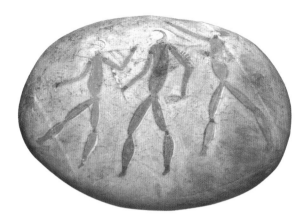

6 Coldstream Stone
Name(s) of artist(s) unrecorded,
c. 9,000 BP
Recorded as San|Bushman
Stone, ochre, H. 8 cm | W. 30 cm
Iziko Museums of South Africa,
Cape Town SAM-AA6008

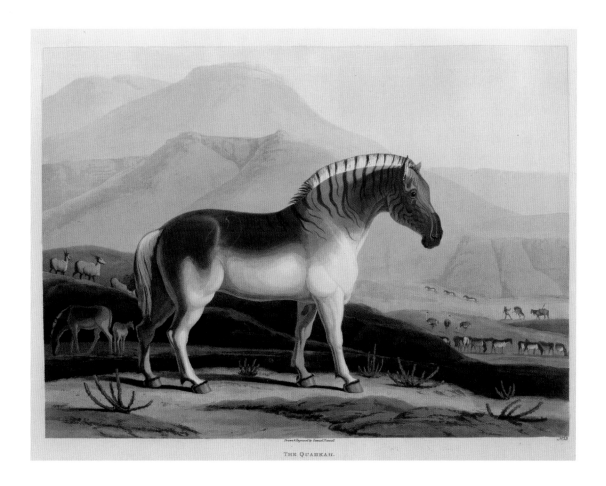

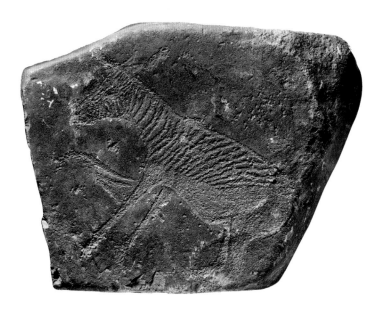

7 *The Quahkah*
Samuel Daniell, 1804–5
Aquatint, paper
H. 45.5 cm | W. 59.6 cm
British Museum 1913,0129.1.16

8 Quagga petroglyph
Name(s) of artist(s) unrecorded,
c. 1,000–2,000 BP
Recorded as San | Bushman
Andesite rock, H. 38 cm | W. 48 cm
British Museum Af1886,1123.1
Donated by F. Schute

9 *Taung*
Karel Nel, 1985
Digital image
H. 148 cm | W. 112 cm
Collection of the artist,
Johannesburg

Early artists and contemporary South Africa

The importance of the deep artistic past to South Africa can be demonstrated by the manner in which the archaeological remains discussed above are preserved and displayed. One of the ochre processing kits, for example, currently occupies a dedicated, central exhibition space in the South African Museum in Cape Town, while the decorated red ochre is considered so precious that only a cast is on display in the same museum, with the real objects kept in a safe. However, equal to their importance as precious archaeological artefacts is their significance as symbols of a new South Africa built on the heritage of many millennia of modern human behaviour.

The recent shift in our understanding of the development of modern humans is important not only in terms of our understanding of human evolution, but also in terms of southern African – and especially South African – politics. Indeed, the celebration of southern Africa as one of the places where modern human behaviour evolved is not simply a case of continental, regional or national one-upmanship; rather, it is an important redressing of Eurocentric interpretations of world history. In a postcolonial and post-apartheid context, the establishment of southern Africa as one of the landscapes in which modern human behaviour began presents a valuable challenge to previously prevalent racist notions of human development.

In order to illustrate some of the ways in which contemporary art in South Africa has engaged with the nation's deep human past, we conclude this chapter with an examination of three works by a single artist, Karel Nel. Born in Pietermaritzburg in 1955, Nel often refers in his work to the importance to contemporary South Africa of its geological and archaeological past, using such themes to comment on recent and contemporary politics in South Africa more generally.

In late 1984, the palaeontologist Philip Tobias invited Nel to create a poster to advertise the Taung Diamond Jubilee International Symposium, which Tobias was planning to hold at the University of the Witwatersrand the following January. The purpose of the symposium was to mark the sixtieth anniversary of the publication in 1925 of Raymond Dart's sensational and, at the time, hotly disputed claim that the first hominid species to be found in Africa, which he named *Australopithecus africanus*, represented an evolutionary link between primates and humans – a claim that has since been accepted. In response to Tobias's invitation, Nel produced a computer-generated image of the skull of a young hominid who had lived some 2.5 million years ago (fig. 9). Known as the Taung Child, the hominid had been unearthed by lime-quarry workers in 1924, in the area of the modern-day town of Taung in South Africa's North West province.

Given his abiding interest in the interface between art and science, Nel proved to be the ideal person to carry out the commission. In order to create the image of the skull, Nel worked with a company called Ideadata, drawing on the most advanced computer technology of the time. Although computer graphics have developed enormously over the intervening decades, the image remains as fresh as when it was first conceived, subtly linking the skills of the palaeontologist, the artist and the computer-software designer. It also suggests, even in the mind of this 2.5 million-year-old child, the complexities of the 'inner space' of the human brain and its ongoing exploration of the universe.

With *Taung/Piltdown* (fig. 10), Nel took his examination of the significance of the Taung Child a step further. Created for *Life of Bone*, an exhibition held at the Origins Centre of the University of the Witwatersrand to celebrate the eighty-fifth anniversary of the hominid's discovery, the work consists of two quantities of dust: one collected from the Buxton Limeworks at Taung, the other made of 'Fuller's earth', a material that, among other things, is used as 'pretend' dust in the theatre. By juxtaposing the two types of dust – one real, one fake – the work highlights the controversy surrounding the 'discovery' of Piltdown

10 *Taung/Piltdown*
Karel Nel, 2011
Dust panels
Each H. 35 cm | W. 150 cm
Collection of the artist, Johannesburg

11 *Potent Fields*
Karel Nel, 2002
Ochre, linen
H. 122 cm | W. 242 cm
British Museum 2016,2005.1

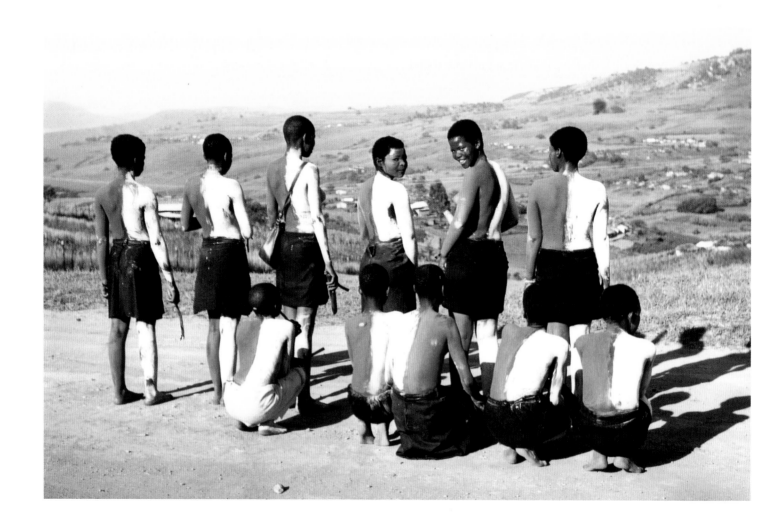

12 *Umemulo* **ceremony girls**
Katesa Schlosser, 1983
Photographic print
H. 31 cm | W. 20.5 cm
British Museum Pictorial Archive

Man and the subsequent claims by Eurocentric scientists that his existence was proof that the origins of humankind lay in Europe, and in particular in England. Found in 1912 in Piltdown Village, Sussex, Piltdown Man was claimed to be 500,000 years old and the missing link between apes and humans. In 1949, however, new scientific techniques showed that some of the remains were only 50,000 years old, while it was later found that the specimen was made up of bones from different species, some of which had been manipulated to make them look older. It was, in short, an elaborate hoax. As Nel explains:

> As humans, we are indeed so mesmerized by our own suppositions and projections that at times we are unable to see an alternative view. Although the Piltdown Man eventually turned out to be a palaeoarchaeological hoax, its history is a fascinating example of the struggle between that which one does – and doesn't – want to know.[41]

The juxtaposition of geological and 'stage' dust in *Taung/Piltdown* is part of a theme that runs throughout Nel's art. In *Potent Fields* (fig. 11), an earlier work by Nel, the artist presents two planes of ochre: one white and one red, not quite square in shape, and abutting each other in a simple, rectangular frame. It is a complex image, not least because of the opposition and adjacency set up between the two planes, which are alike in texture but different in colour. The work was composed in the same year in which archaeologist Christopher Henshilwood and his team announced that two pieces of cross-hatched ochre had been found at Blombos Cave.

As well as referring to the debate over the location of the development of modern human behaviour, *Potent Fields* alludes to the suppression of the facts behind this debate during the apartheid regime, especially in the perceived segregation between the white and the 'coloured' plane. A further reference to this period of recent South African history comes from the source of the ochre used in the

work. Nel gathered the ochre from Transkei (now part of the Eastern Cape), the place where Nelson Mandela was born, and the place where he would have taken part in ceremonies involving ochre – as many of the peoples of South Africa and elsewhere still do. These ceremonies include rites associated with the threshold of birth, the coming of age, and death. Nel is also acutely aware that his home and studio are located in the Rivonia district of Johannesburg, where in 1963–4 the infamous Rivonia Trial took place, at which Mandela and other members of the African National Congress were accused of high treason. Although there is a tension between the white and the coloured plane of ochre in *Potent Fields*, there is also a balance, echoing the famous statement made by Mandela at his trial:

> During my lifetime, I have dedicated myself to the struggle of the African people. I have fought against white domination, and I have fought against black domination. I have cherished the ideal of a democratic and free society in which persons live together in harmony and with equal opportunities. It is an ideal which I hope to live for and achieve. But if needs be, it is an ideal for which I am prepared to die.[42]

Today, Zulu girls celebrate their twenty-first birthday with a coming-of-age ceremony known as *umemulo*, which proclaims their marriageable status. Organized by the girls' parents, the ceremony enables them to show their appreciation for the way in which their daughters have lived their lives up to that point. A photograph taken in April 1983 shows eleven girls on their way to invite all their relatives to an *umemulo* ceremony. Their bodies have been painted with ochre, one half in white, the other in red (fig. 12).[43] It is hard to imagine a better way of suggesting the transition in their lives than this use of ochre as a modern manifestation of the ancient tradition of body painting – one that chimes in several ways with Nel's aims in creating *Potent Fields*.

Chapter 2 Sculpture and initiation

New groups began to arrive in southern Africa approximately 1,500 years ago. These people, who spoke Bantu languages and were descended from communities living in central and eastern Africa, migrated south, bringing with them new ways of living. The descendants of these Bantu-speaking peoples now make up the vast majority of South Africa's population, and between them speak nine of the eleven official national languages: isiZulu (spoken by the Zulu), isiXhosa (Xhosa), siSwati (Swazi), Sesotho (South Sotho), Sepedi (Northern Sotho), isiNdebele (Ndebele), Xitsonga (Tsonga), Setswana (Tswana) and Tshivenda (Venda), with English and Afrikaans being the remaining two official languages.

Archaeological evidence suggests that before the appearance of these peoples, the inhabitants of southern Africa had a largely mobile lifestyle, based on hunting, gathering and fishing, and on the recent introduction of small-scale sheep and cattle herding.[1] By contrast, the new arrivals brought with them a more sedentary way of life, supported by cattle, sheep and goat herding, agriculture, and such technologies as metallurgy. Alongside these lifestyles came new social practices aimed at maintaining the health of society, and new opportunities for international trade, which placed power in the hands of an emergent elite. One way in which these practices and social structures were communicated, negotiated and maintained was by means of wood, ceramic or metal figurative sculptures. These sculptures, it is believed, were used in age-related initiation ceremonies and as indicators of status.

The previous chapter concluded with the ancestors of San|Bushmen practising two-dimensional figurative rock art. Here, we continue the story at the start of the period referred to by archaeologists as the Iron Age – although the societies involved may more appropriately be termed Early Farming Communities – when figurative sculpture first appears in southern Africa. In contrast to Chapter 1, in which the story of early artistic production was intertwined with the story of the emergence of modern human behaviour, this chapter focuses on the social histories to which figurative sculptures bore witness, ending with the settlement of European populations from the mid-seventeenth century onwards. Through the work of two contemporary artists, Penny Siopis and Owen Ndou, it reflects on the role of these precolonial sculptures as important evidence of the Bantu language-speaking societies living in southern Africa before the arrival of Europeans. This evidence remains politically potent today, challenging colonial and apartheid myths of South Africa as an empty land ripe for European settlement.

The Lydenburg Heads: masks and initiation

The Lydenburg Heads (fig. 1) are seven hollow sculptures made of terracotta, six in the shape of human heads, and one with animal-like features. The heads are the earliest known examples of three-dimensional figurative art in southern Africa. Charcoal found with the heads has been radiocarbon-dated to around AD 500, while the decoration on pottery found with the heads, and the decoration on the heads themselves, suggest a date closer to the ninth or tenth centuries AD.[2]

A young schoolboy, Ludwig von Bezing, discovered the heads in a fragmentary state in the 1950s as they eroded out of a gully near the town of Lydenburg in the province of Mpumalanga, South Africa. In the 1960s, when Von Bezing became a student at the University of Cape Town (UCT), he donated the heads to the university's collection. In the 1970s one of the large heads was sent to the British Museum for restoration, and in 1979 all seven were permanently loaned to the South African Museum, where they are now on display.

Of the seven heads, two are large enough to be worn over a human head as a mask, and both of these have eyeholes, suggesting that they may have been used in ceremonial performances. The other five heads are

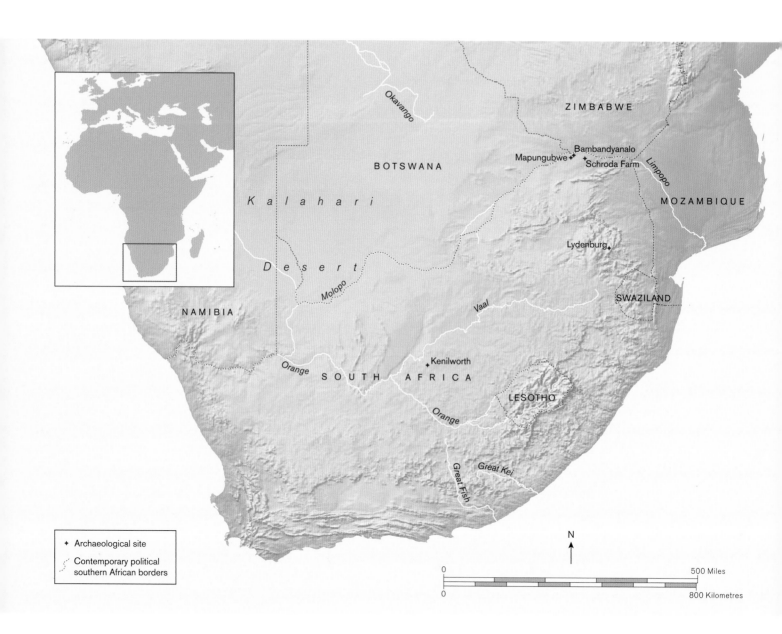

**Map of early sculptural
archaeology sites in South Africa**
This map shows the location
of important archaeological
sites that demonstrate three-
dimensional sculptural practices
from c. AD 500 until c. 1650.

too small to be worn as masks, even by children, and
may instead have been worn as a form of decoration,
or placed on wooden poles during the performances.[3]
Compared to the smaller examples, the two large heads
are decorated in a different style, with clay studs applied
behind the hairline bar, and an animal figurine on top.[4]
They were finished with white paint and specularite
(specular hematite, a silvery mineral), both of which
provide a contrast with the red terracotta, and may have
shimmered under moonlight or acted as reflectors of
sunlight or firelight. At one time, it has been suggested,
the masks may have been decorated with other white
features, made out of ivory or bone.[5] The association
of the heads with performances suggests that they
were meant for group display; however, whether these
performances were for large or small groups, and
whether the masks were worn by a privileged and ritually
empowered few or passed around a larger number of
individuals, remains unknown.

In the decades since Von Bezing's discovery and
donation to UCT, excavations at the Lydenburg Heads
Site have revealed additional information about the makers
and users of the sculptures. The decoration on the heads,
as well as similar decoration on domestic pottery from
the site, is comparable to pottery decoration typically
found at early farming sites, thus identifying the makers
of the heads as farmers.[6] The results of the excavations
also suggest that the heads were deliberately placed in
a pit, where they were either stored or ritually discarded,
possibly having been burnt first.[7] The care taken to hide
the heads when they were not in use further supports
the interpretation that they were powerful artworks whose
visibility needed to be carefully managed.[8]

The decorative features on the heads also provide
a fascinating insight into the lives of these early farmers.
In particular, the similarities between the decoration
on the heads and the decoration on the domestic pottery
indicate that these two aspects of the farmers' world were
conceptually linked.[9] This connection may have signalled

1 Lydenburg Head
Name(s) of artist(s) unrecorded,
AD 500–900
Recorded as Bantu language speaker
Terracotta, white pigment and
specularite, H. 38 cm | W. 26 cm
University of Cape Town Collection
at the Iziko Museums of South Africa,
Cape Town UCT701/1

the importance of ceramics to the storage and cooking of food, and thus to the maintenance of the community's well-being. Moreover, some of the decorative features on the heads suggest that their makers and users may have practised bodily decoration. Notched-ridge decoration, for example, may represent scarification, while the mouths speak of dental alteration, a practice – as found in human remains from this period – involving the filing or removal of upper and lower teeth.[10] Finally, the heads' cowrie shell-like eyes may indicate that their makers had a relationship with the eastern African coastline some 300 km away in what is today Mozambique.[11]

The Lydenburg Heads help to illuminate the lives and practices of their users and makers in the mid- to late first millennium AD, including the staging of complex initiation performances involving the wearing of masks. More importantly, perhaps, they 'testify to a complex aesthetic sensibility among early agricultural communities [in southern Africa] a millennium before the advent of colonialism'.[12] In the absence of written records or relevant oral histories, however, interpretations rely on comparisons with contemporary, recent or historical practices in the region for which we do have detailed written, oral or photographic records. Such ethnographic comparisons highlight, for example, how Venda and north-east Sotho groups use masks in their male and female coming-of-age ceremonies.[13] However, although ethnographic comparison can provide possible explanations of the function and meaning of the heads by drawing on the cultural experiences of the peoples of southern Africa, it must be remembered that the experiences being compared may be separated by as much as a thousand years, over which time many social changes have taken place. Although ethnographic evidence provides a range of possibilities for the use and significance of the sculptures, there exist many differences between the archaeology of early farmers and the later ethnography of more recent peoples. The exact usage of the heads thus remains elusive.[14]

The Schroda Figurines: initiation and fertility

Ethnographic analogies are also useful in the study of another important group of sculptures: the Schroda Figurines (figs 2–4). Composed of more than a hundred clay sculptures, the figurines were found in a fragmentary state during excavations in the 1970s and early 1980s at Schroda Farm, 7 km to the east of the junction of the Limpopo and Shashe rivers in the far north of South Africa. Reconstruction of the figurines has revealed them to be depictions of people, animals, mythological beings, phalli and other, yet-to-be-identified subjects. The most widely accepted theory on the purpose of the figurines suggests that they were used by a community of three to five hundred people that lived at Schroda from AD 900 to its abandonment around AD 1020. It is believed that while one type of figurine was used to ensure household fertility, most of the others were used in a coming-of-age ceremony.

The figurines were discovered in 1977 by the archaeologist Edwin Oscar Hanisch, who noticed that a large number of fragments had been brought to the surface by burrowing springhares. Hanisch continued excavating regularly at Schroda until 1982, by which time a sizeable quantity of figurines had been amassed, together with a wealth of other archaeological remains.[15]

The ceramics found at Schroda link its residents to the Zhizo people, who arrived in the region around AD 900 as the climate improved for farming and hunting.[16] In common with other Zhizo groups at this time, the occupants of Schroda herded cattle, farmed sorghum grain, hunted and gathered wild food, used iron tools and weapons, possessed bone ornaments, and wore decorative beads – in some cases on iron bead strings – made from ostrich eggshell, glass, copper and the shells of giant land snails.[17] Schroda was distinct from other communities in the area, however, because its people controlled trade with the eastern African coast. Hundreds of cowrie shells and foreign glass beads found at the site are evidence of this trade, while the remains of ivory bangles and certain wild

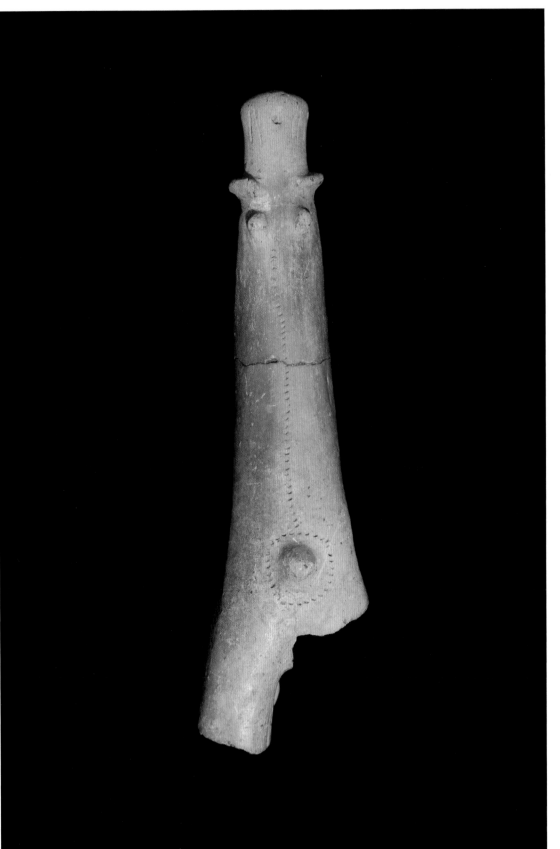

2 **Schroda female fertility figurine**
Name(s) of artist(s) unrecorded,
AD 900–1020
Recorded as Zhizo
Clay, H. 22 cm | W. 5.8 cm
Ditsong National Cultural History
Museum, Pretoria

3 Schroda human figurines
Name(s) of artist(s) unrecorded,
AD 900–1020
Recorded as Zhizo
Clay
Male H. 21.2 cm | W. 9.6 cm
Female H. 18.4 cm | W. 8.8 cm
Ditsong National Cultural History
Museum, Pretoria

**4 Schroda Figurines
(opposite)**
Name(s) of artist(s) unrecorded,
AD 900–1020
Recorded as Zhizo
Clay
From top left:
Bird figurine
H. 19.8 cm | W. 5.5 cm

Goat figurine
H. 8.8 cm | W. 11.3 cm
Mouse figurine
H. 5.5 cm | W. 3.8 cm
Mythological Beast figurine
H. 8.2 cm | W. 17 cm
Expressive Human
figurine
H. 6.7 cm | W. 4 cm

Hippopotamus figurine
H. 15.5 cm | W. 22.6 cm
Elephant figurine
H. 13.5 cm | W. 15 cm
Ditsong National Cultural History
Museum, Pretoria

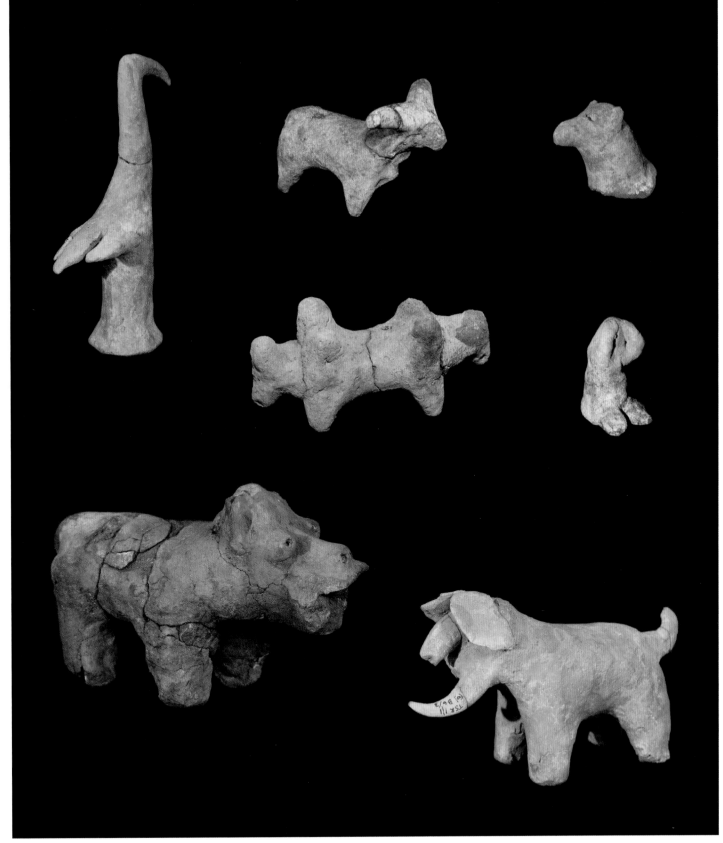

animals suggest that ivory and skins were traded in return.[18] The ivory objects and glass beads found at Schroda are the earliest such finds in the region, and it has been suggested that Schroda's residents settled there in order to exploit the large elephant herds in the surrounding Limpopo Valley and provide ivory for the Indian Ocean trade network, receiving glass beads in return. In addition, the relatively large number of carnivore remains at Schroda may indicate that animal skins were also being exported to the coast.[19]

Hanisch's excavations at Schroda ceased around the time of increased militarization along the border with Zimbabwe, as the apartheid government attempted to prevent African National Congress (ANC) guerrillas from crossing into South Africa. Sadly, in the years that followed, the site was damaged by military vehicles and the continued burrowing of springhares.[20] Despite the need for more work on the surviving remains, the Schroda Figurines represent a remarkable collection of sculptures, illuminating the lives of people at the end of the first millennium AD in what is today northern South Africa.

Two different types of figurine were found at Schroda. The first, the stylized figure of a female (fig. 2), was found dispersed regularly and individually across the 300 × 500-metre site. It has stylized facial features, slightly raised areas to indicate shoulders, arms and breasts, and what appears to be steatopygia (large accumulations of fat around the buttocks).[21] Hands are absent, but it does have feet and decorative incisions that may indicate scarification. By contrast, examples of the second type of figurine (figs 3 and 4) were found deliberately broken, discarded and spread across a 30 × 30-metre area at the edge of a cattle enclosure.[22] This concentration of figurines was divided into two distinct groups by the remains of a 23-metre-long fence with a 1-metre-wide gateway at its centre.[23] The figurines on the north-eastern side of the fence were made out of coarse clay and were extremely friable, having been badly fired or sun-dried; those on the south-western side of the fence, however, were made out of fine clay that had been fired more thoroughly.[24] Some of the coarse-clay

figurines were painted with red or white ochre, or had been made with differently coloured clays, and were decorated with incisions and small puncture marks – decorative features that, in general, were not displayed by the fine-clay figurines. The coarse-clay figurines were mostly of stylized or realistic humans, wild animals (hippopotami, elephants, crocodiles), birds, phalli and objects that could not be identified, while the fine-clay figurines were mainly of domestic animals (sheep, goats, cattle, dogs), non-zoomorphic objects with decorative lines, and small phalli.[25]

The Schroda Figurines, in common with the Lydenburg Heads, provide a range of information about the lives of their makers and users. The scarification marks, for example, provide evidence of body modification; the crests on some of the figurines hint at hairstyles; and the addition of paint on others may suggest body painting. Moreover, the figurines reveal the symbolic importance of different species of animals – wild and domestic – while the pronounced genitalia on some of the human figurines, as well as the separate phalli, clearly indicate a concern with fertility. Of particular note is the presence of at least one phallus with a foreskin alongside others with none, indicating perhaps that circumcision was practised at this time.[26] Indeed, the emphasis on fertility across the collection, including conspicuous genitalia, buttocks and breasts, suggests that the figurines were not toys to be played with by children, but were instead important in the communication and maintenance of sexual information and gender-specific roles.[27]

As in the case of the Lydenburg Heads, explanations of the meaning and function of the Schroda Figurines rely on ethnographic comparisons. The stylized female figurine, for example, has been compared to Venda, Zulu and Sotho figurines associated with household fertility.[28] In these examples of similar practice, figurines are placed in each house to preserve the fertility of that household. The comparable fertility features of the stylized female figurine and its regular distribution at Schroda raise the

possibility that it too was intended to preserve the fertility of each household, with one figurine per home.[29]

By contrast, the figurines concentrated on the edge of the cattle enclosure may have been used by the younger members of the community in rites of passage to adulthood.[30] Until relatively recently, similar figurines were made by Shona, Venda and north-east Sotho groups for male and female initiation ceremonies, which were normally carried out near cattle enclosures belonging to community leaders.[31] These age-related initiations would rarely take place more than once at a chief's or a king's cattle enclosure, so that subsequent initiations could take place at other homes. The figurines found at Schroda may therefore have been made for a single initiation event. This suggestion is also supported by the figurines' fragility, which may have prevented them from being used more than once.[32]

Other comparisons between the Schroda Figurines and more recent examples of gender- and age-related cultural practices in southern Africa also broadly support a role in initiation ceremonies. The division between the wild and the domestic animals may, for example, reflect gender divisions, whereby males are typically associated with the management of domestic animals.[33] By contrast, the wild animals may have had a totemic purpose as emblems for family groups, explaining and reinforcing group identities, or they may have been used to communicate certain taboos associated with particular animals.[34] The way the bases of some of the figurines have been moulded allows them to be fitted together in a single scene, while some have piercings from which they may have been hung; ethnographic research has shown that both these practices have formed part of initiation ceremonies in which the initiates are exposed to narratives involving multiple characters and metaphors.[35] The deep punctures in the back of some of the figurines may have been filled with feathers, while the use of white and red ochre may have reflected beliefs around the symbolic meaning of colours.[36] In some southern African societies, white was traditionally associated with such 'fertilising agents' as semen, and was

seen as cooling; red, by contrast, was associated with fire and menstrual blood, and was seen as hot. Both colours had to be balanced for successful reproduction (for a related discussion of colour symbolism, see pages 42–3).[37]

Whatever their original purpose and meaning, the Schroda Figurines today offer a rare window on the artistic world of people living in southern Africa at the end of the first millennium AD. The hippo and elephant figurines, for example, animated with open mouths and flared ears, testify to the artists' abilities to capture motion (fig. 4, top row), while the small and simple human figurine crouched with its hands over its face, as if it were hiding its eyes, expresses a complex sensitivity (fig. 4, centre right). In their range and expressive beauty, the Schroda Figurines are remarkable works of art.

Mapungubwe gold sculptures: state and status

After Schroda was abandoned in the early eleventh century AD, a new group of people settled a short distance away at Bambandyanalo (also known as K2), close to the junction of the Shashe and Limpopo rivers. This site became the centre of activity in the region from approximately AD 1030 to 1220, at which time the focus shifted to the nearby site of Mapungubwe Hill – a flat, 300-metre-long sandstone outcrop with sheer, 30-metre-high sides above a separate, larger southern terrace – which was occupied from 1220 to 1290.[38] As at Schroda, clay figurines, ivory and glass beads were discovered at both Bambandyanalo and Mapungubwe, while at the latter, three burials were found to contain a number of grave goods made of gold. These finds included animal figurines (a rhinoceros, an ox or cow, a wild cat, a possible crocodile, as well as the fragments of unidentified animals), a sceptre, a bowl (considered by some to be a crown), bracelets, bangles, beads, nails and discs (figs 5–9).[39] The burials were part of a cemetery containing twenty-seven elite graves on Mapungubwe Hill, overlooking the rest of the settlement

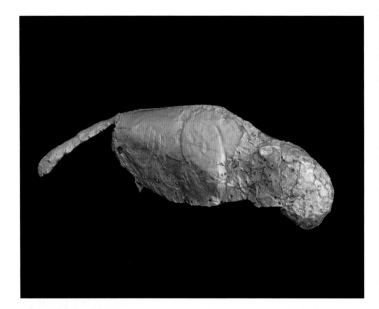

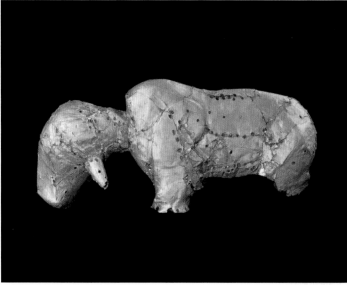

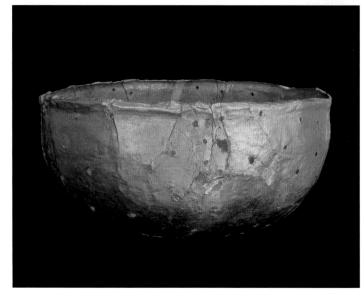

5 Mapungubwe feline
Name(s) of artist(s) unrecorded,
AD 1250–90
Recorded as Zhizo
Gold, H. 5.1 cm | L. 17 cm
University of Pretoria
MAP/G/2015/003

6 Mapungubwe bovine
Name(s) of artist(s) unrecorded,
AD 1250–90
Recorded as Zhizo
Gold, H. 5.6 cm | L. 12.2 cm
University of Pretoria
MAP/G/2015/002

7 Mapungubwe sceptre
Name(s) of artist(s) unrecorded,
AD 1250–90
Recorded as Zhizo
Gold, L. 20.6 cm | Diam. 5.7 cm
University of Pretoria
MAP/G/2015/004

8 Mapungubwe bowl
Name(s) of artist(s) unrecorded,
AD 1250–90
Recorded as Zhizo
Gold, H. 6.1 cm | Diam. 14 cm
University of Pretoria
MAP/G/2015/005

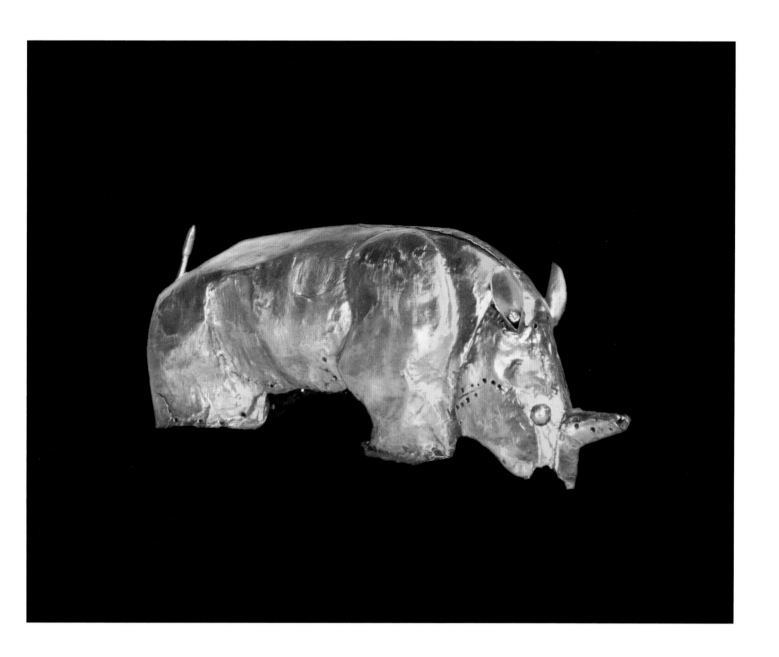

9 Mapungubwe rhinoceros
Name(s) of artist(s) unrecorded,
AD 1250–90
Recorded as Zhizo
Gold, H. 6.2 cm | L. 14.5 cm
University of Pretoria
MAP/G/2015/001

below. The sculptures found in the graves testify not only
to the appearance in South Africa's artistic heritage of
a new sculptural medium, gold, but also to a new purpose
for figurative sculpture, as an indicator of royal status.

Mapungubwe was a significant settlement with a well-
defined social structure. Elite members of the community
lived and were buried on the hill plateau, which could be
accessed only through a single entrance, while the other
members of the community lived on the southern terrace
below, where they were also buried. It has been suggested
that the shift in focus away from Bambandyanalo occurred
as a new elite emerged and sought out a settlement site that
would allow them to be physically separate from the rest
of society – requirements that were met by the geological
features of Mapungubwe Hill. Based on this hierarchy
at Mapungubwe, the site has been identified as the capital
of the first southern African kingdom, whose royalty ruled
this region and controlled trade with the eastern African
coast in the thirteenth century AD.

Although Mapungubwe was eventually abandoned,
the oral histories of local residents recorded in the early
twentieth century continued to refer to the site as a
powerful and sacred place. It was first 'discovered' by
outsiders in the 1890s, by the explorer François Lotrie, and
then again more famously in 1932, when a farmer, Mr van
Graan, his son and two friends persuaded a local informant
to show them the site and the secret route to the top of the
hill. At this time, amateur archaeological interest in the
area was being driven by the identification of gold at sites
in neighbouring Zimbabwe, and in this respect Van Graan
and his fellow amateur explorers were not disappointed.[40]
Following a chance discovery of gold on one of the slopes,
they scratched around on top of the hill and eventually
found gold beads, bangles and bracelets, some of which
they associated with a human burial. News of the gold
objects reached the University of Pretoria via Van Graan's
son, who was a student there, and a team of experienced
archaeologists was sent to excavate in 1933, followed
by a second, less-experienced team from 1934 to 1935.

Unfortunately, the royal cemetery was discovered at a time
when an inexperienced member of the second team had
been left alone at the site. As a consequence, much valuable
archaeological information about the finds, including their
exact location in the graves and their associations, was lost.[41]

Nevertheless, a rich picture of life at Mapungubwe
has been generated through subsequent excavations on
both the hilltop and the terrace, as well as in the wider
landscape, and through further analysis of the early
finds. What emerges is a picture of a highly successful
farming community that practised a mixture of agriculture
and cattle-herding, but which also engaged in hunting
and gathering. Key to the community's wealth and the
establishment of a royal class on the hill was its control
of trade with the eastern African coast. Finds of Chinese
porcelain reveal that Mapungubwe was connected to
the Indian Ocean trade network. This connection, it is
believed, was a continuation of the earlier trade in animal
skins and (to a lesser degree) ivory in return for glass
beads, but with the addition of a new and important trade
in gold, supplying the eastern African coast through the
Swahili port of Kilwa Kisiwani in modern-day Tanzania.
As the royal burials affirm, gold became so important
to Mapungubwe's residents that it began to replace glass
beads as a symbol of wealth and status.[42]

The gold objects found at Mapungubwe can be divided
into three groups: beads, wire bracelets and the foil-
covered sculptures. To produce the sculptures, a quantity
of gold was first of all hammered out on a stone anvil.
The resulting foil was then pressed and creased over a
wooden carving and held in place by gold pins, with some
features, such as ears and tails, being made out of thicker
foil added separately. Some of the sculptures were then
punched or impressed to give them features, such as the
teeth on what may be a crocodile. Analysis of the gold has
revealed the considerable care and skill that was invested
in the production of the sculptures, resulting in many
cases in highly lifelike forms, such as that of the rhinoceros.
Moreover, analysis indicates that this gold-working practice

was developed locally, as attested to by its similarity to copper- and iron-working practices in the region.[43]

Exactly why such skills, time and valuable materials were invested in the production of the sculptures remains elusive; so too, therefore, does their original purpose. In the absence of detailed evidence from other sites, and given the possibility that gold and other objects went missing during the original excavations in the 1930s, we are left with an incomplete picture. This situation is worsened by a lack of ethnographic parallels that might aid interpretation. While the sculptures may demonstrate the symbolic importance of particular animals, including cats, rhinoceroses, crocodiles and cattle, and the role of certain objects as signifiers of power, such as the sceptre and what might be a crown, little more can currently be said about their original meanings.

The contemporary significance of the Mapungubwe gold sculptures is, by contrast, much easier to state. Although all the precolonial artworks in this chapter have political relevance as evidence of the existence of sedentary Bantu-speaking societies before the arrival of European settlers, the Mapungubwe gold sculptures are the most prominent forms of such evidence in contemporary South Africa. In 1999 the sculptures were designated National Treasures by South Africa's post-apartheid government, and in 2002 it created the Order of Mapungubwe, the highest honour in South Africa – the first recipient of which was Nelson Mandela. At the centre of the award itself is a depiction of the most famous of all Mapungubwe's sculptures, the gold rhinoceros. As the regalia of the first southern African kingdom, and as one of the symbols of the new South Africa, the Mapungubwe gold sculptures have been described as 'South Africa's crown jewels'.[44]

The Kenilworth Head

Continuing our discussion of precolonial sculpture, we turn now to the Kenilworth Head (fig. 10), a small stone carving of a head with a naturalistic face.[45] The head was found

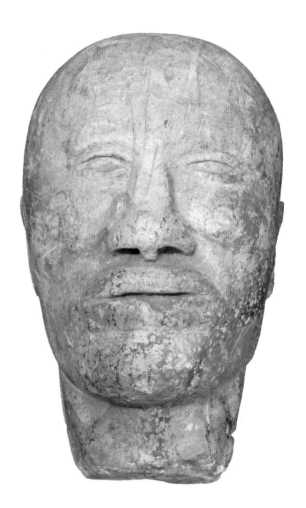

10 Kenilworth Head
Name(s) of artist(s) unrecorded,
c. 1650
Recorded as San | Bushman
or Khoekhoen
Schist stone, H. 15 cm | W. 9 cm
McGregor Museum, Kimberley
MMK 85

buried 2.5 metres below the surface in Kimberley in 1901, by road-builders constructing Siege Avenue during the Second South African War (1899–1902). As the head's discovery was not part of a formal archaeological dig, evidence that might have explained the story behind its burial was not recorded, meaning that very little is known about it. Nevertheless, the Kenilworth Head has been compared to a similar stone head found with iron bangles in a grave at the Transvaal Road site close to Kimberley, which has been dated to around AD 1650, shortly before the Dutch began to settle in the Cape. To add further intrigue, Maria Wilhelm, former director of the McGregor Museum in Kimberley, was told by an elderly Afrikaner Boer visitor to the museum that, in his youth, 'the Bushmen on his father's farm [...] had a similar head, which they were in the habit of bringing out on festive occasions and dancing round.'[46]

The Kenilworth and Transvaal Road heads are mysterious examples of artistic production that may date to the period immediately before the arrival of European settlers. While the more famous examples of precolonial sculpture – the Lydenburg Heads, the Schroda Figurines, the gold sculptures discovered at Mapungubwe – are associated with Bantu-speaking peoples, the Kenilworth and Transvaal heads may be evidence for the existence of figurative stone sculptures made and used by San | Bushmen and/or Khoekhoen. They also serve to highlight the many gaps in our understanding of precolonial figurative sculpture.

Precolonial art and the myth of an empty land

In 1980 the eminent historian Shula Marks published a paper in the journal *History Today* titled 'The Myth of the Empty Land'. In it, Marks explained how the apartheid government had attempted to justify the forced displacement of Bantu-speaking black South Africans into supposed ethnic 'homelands' by arguing that these were the lands that their ancestors had occupied when European settlers first encountered them. Conveniently for the white apartheid state, this meant that the vast majority of South Africa's population (80 per cent at the time) would be confined to what amounted to only 13 per cent of the nation's land, leaving the white minority to enjoy the rest. The 'myth' of the title of Marks's paper states that Bantu-speaking groups arrived in southern Africa only at the same time as Europeans, diminishing their land rights even further.[47] However, as Marks and many others have argued since, the archaeological evidence, exemplified by the precolonial sculptures discussed above, demonstrates that settled Bantu-speaking peoples were present in the region for more than a thousand years before the arrival of Europeans.

Although by the 1980s the Lydenburg, Schroda and Mapungubwe artworks were well known by archaeologists, had been widely reported in newspaper articles and were in some cases displayed in museums, the picture they painted of precolonial life was not part of official accounts of South African history. Indeed, the myth of an empty land persisted in South African textbooks and in the propaganda of the South African Department of Information. The story was so pervasive that it reportedly even appeared in British textbooks and television programmes.[48] Archaeology was well-placed to refute constructions of history that underpinned apartheid ideology, but the inability of archaeologists to articulate this evidence to a popular audience, and the state's deliberate refusal to engage with it, meant that such refutations rarely occurred. Instead, the precolonial sculptures discussed in this chapter and the archaeology around them remained politically marginalized until after the end of apartheid.

The denial and marginalization of black South African histories and knowledge at the expense of those of white settlers has been addressed by a number of contemporary artists. Here, we focus on Penny Siopis, who works in a range of media, and Owen Ndou, a sculptor.

Born in 1953 in the town of Vryburg, Northern Cape, Siopis studied art in both South Africa and the United Kingdom. Commenting on her painting in Sue Williamson's

book *Resistance Art in South Africa* (1989), Siopis remembers how South African history was taught in local schools: 'We were brought up on those stereotyped images of colonized and colonizers. Our textbook stories were illustrated by them and we copied them for our history projects.'[49]

To create *Patience on a Monument: 'A History Painting'* (1988; fig. 11), Siopis tore up a collection of old secondary-school history textbooks, extracted the pictorial representations of colonial history (mainly battle scenes from the Anglo-Zulu war, or the 'heroic' achievements of the Boer Voortrekkers), and built up a collage landscape of stereotypical imagery, such as might have existed in the colonizers' imaginations. Siopis also made photocopies of some of the textbook representations so that these could be reduced in scale and repeated within the work to expose the constructed-ness of history while also giving the illusion of spatial recession in the landscape.

Among other things, Siopis's work subverts the genre of history painting, in which artists were commissioned to paint the official, usually heroic version of a nation's history. *Patience on a Monument* directly references Eugène Delacroix's *Liberty Leading the People* (1830), a prime example of history painting in which a bare-breasted Liberty, clutching a musket in one hand and the tricolour of the French revolution in the other, leads the people of France to victory and the overthrow of the monarchy. By contrast, Siopis's Patience is perched on a midden, a rubbish dump of discarded objects, some of which are symbolic of Western culture in general and of white South African social status in particular, including a bronze bust of a black man as 'noble savage' produced by the South African sculptor Anton van Wouw in 1907. Patience, with one breast bared, has turned her back on this version of South Africa's history and, in contrast to the warlike, male-dominated racist patriarchy battling behind her, is performing the simple domestic task of peeling a lemon.

In 1989 Siopis created *Cape of Good Hope: 'A History Painting'* (fig. 12), in many ways a sister work to *Patience on a Monument*. In an interview with Polly Savage in 2010,

which was later published in Savage's *Making Art in Africa: 1960–2010* (2014), Siopis provided a description of the work, in which a young, naked black woman reaches up to clasp a heavy blue drape, appearing to pull it down:

> The tattoos [on her back] are [details of] reproductions of abolitionist engravings of slaves, so while the title and these little labels [attached to the drapes] reference South African history, these markings on her body reference colonial history much more broadly, particularly slavery. On her face are small fragments of texts, which are taken from Saartjie Baartman's baptismal certificate and death certificate [sourced from the Musée de l'Homme], and the labels pinned to the cloth are [the same] image repeated of [a South African history painting] showing the arrival of [the so-called founding father] Van Riebeeck at the Cape and his encounter with indigenous people. So it's also meant to be a [critical] history painting.[50]

It is important to note that each of the labels attached to the drapes features the same image, Charles Bell's *The Landing of Jan Van Riebeeck (1619–1677) 6th of April 1652* (1850), which depicts the arrival of Van Riebeeck at the Cape. Repetition here, as in *Patience on a Monument*, speaks to how constructions of history are created and ingrained as much through visual convention as content. Moreover, there is a strong sense that the woman is about to enact change. As Siopis notes, 'I like to think she's pulling the cloth of official apartheid history down, a bit like in official contexts, when monuments are revealed by the pulling away of a curtain. The idea that she's a young woman is important because I wanted defiance in [the painting].'[51]

When it comes to depicting history, Siopis is keenly aware of the significance of the figure not just as iconography but as bodily material presence, her painstaking layering of colour over the 'empty' spaces between the engraved lines that shape the image fragments emphasizing this significance: 'History is not just about

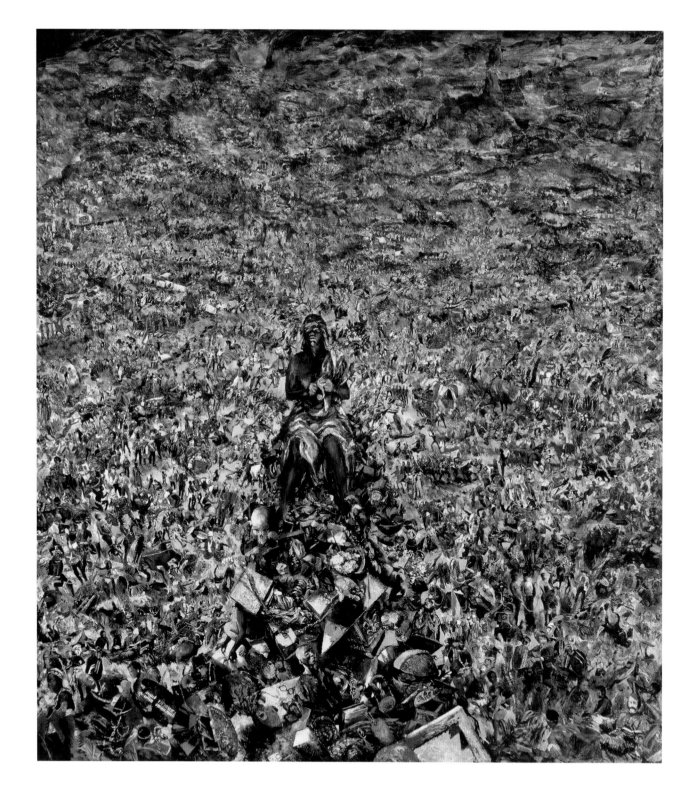

11 *Patience on a Monument:*
'A History Painting'
Penny Siopis, 1988
Collage, oil on canvas
H. 198 cm | W. 176 cm
William Humphreys Gallery,
Johannesburg

12 *Cape of Good Hope:*
'A History Painting'
Penny Siopis, 1989
Collage, oil on canvas
H. 155 cm | W. 141 cm
Private collection, London

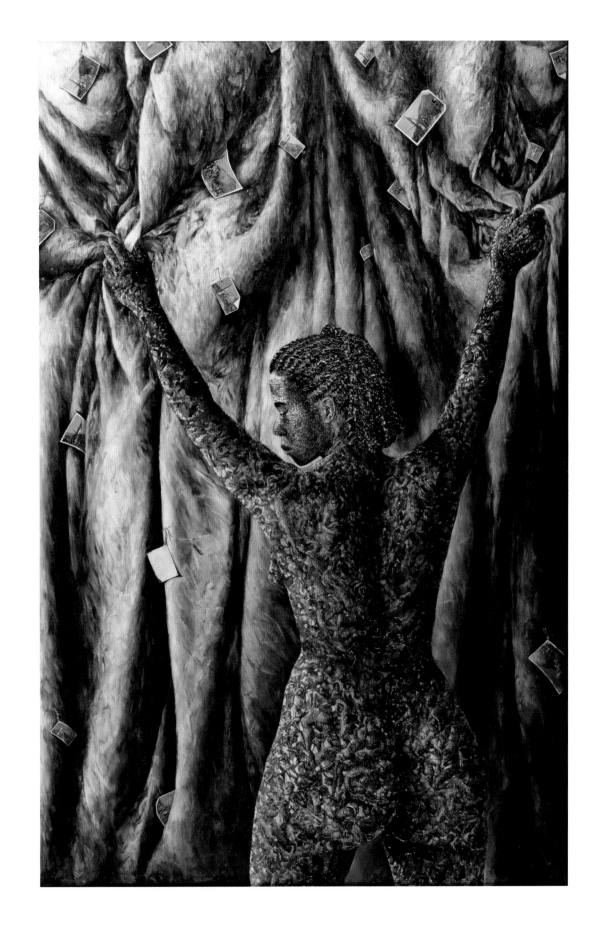

13 Oxford Man
Owen Ndou, 1992
Wood, paint, H. 135 cm
Private collection, London

images, it's about bodies, so the materiality [of the painting] is a kind of stand-in for the bodies, both absent and present, that make up this history. It's also a way of marking my own subjectivity on, in and of the surface. That's still very important for me and all the work I do.'[52]

One of the references for the figure in *Patience on a Monument* is the allegorical sculpture of Nubia that used to stand in front of the Musée de l'Homme in Paris.[53] For many years, this museum displayed the remains of Saartjie Baartman, a Khoekhoe woman from the Eastern Cape who, owing to her steatopygia, was paraded around Europe in the nineteenth century as the 'Hottentot Venus'. Museums have always fascinated Siopis, and her installations have often incorporated museum collections:

'As a child one of my most vivid memories was of a museum. I loved the kind of extreme looking sanctioned there … It felt a bit like the cinema, being an experience of going into, and coming out of, a temporal and spatial bracketing off from everyday life, as if some kind of moratorium from life was possible.'[54]

In her autobiographical film *My Lovely Day* (1997), produced almost a decade after the creation of *Patience on a Monument* and *Cape of Good Hope*, Siopis draws on fragments of South African oral history, as narrated by her grandmother. This dialogue ('But you play as if nothing is happening around you', for example) appears as subtitles to home-movie footage shot by Siopis's mother during the artist's childhood in the 1950s and 1960s. Through this combining of visual and oral histories, Siopis achieves a kind of settlement, both with her own history and with the world she was taught about in her childhood.

That history is something that Siopis's late husband, the artist and writer Colin Richards (1954–2012), dedicated himself to redressing: 'Our task is to uncover our history and recover our traditions, to straighten distortions, to make the negative positive; to do this with those who have been absent for so long – exiled, jailed and marginalized. To do this in memory of those who cannot return.'[55]

Owen Ndou was born in Venda, now part of the Limpopo province, in 1964, and began to sculpt full-time shortly after completing his education.[56] *Oxford Man* (1992; fig. 13) was created at a time when South Africa was still in turmoil – after the end of the apartheid system, but before the country's first democratic elections, which returned Nelson Mandela as president in 1994. Commenting on the work, Ndou has said:

The title of this sculpture comes from Oxford, the name of a dictionary [...] Oxford Man is also trying to symbolize the spirit of Mandela. Before [his release in 1990] we made little sculptures for the men who were in prison; these are revolution sculptures. We tried to show people that this man is intelligent and that he will

14 **Owen and Goldwin Ndou with** *Cutting the Ropes of Apatheid*
Steve Hilton-Barber, *c.* 1992
Photographic print

definitely reach the goal because he has everything inside his brain, he is everything. The whole world is looking to him. In his briefcase, he collects everything that the people need and want. As with the [Oxford] dictionary, you can find everything inside of this briefcase.[57]

Ndou's sculpture highlights the importance of education and knowledge – of both the past and the present – to the fight against oppression. Many scholars, including Mandela, who studied and practised law, focused on this importance during the struggle against apartheid. Ndou's work also causes us to think about the affective power of art, in this case the 'little sculptures' and the pleasure they gave to the imprisoned revolutionaries.

Having embarked on his career as an artist, Ndou persuaded his older brother, Goldwin, that he should become a sculptor too. (The brothers' father and grandfather were also woodcarvers.) The Ndou brothers worked on a number of pieces together, including a sculpture of Nelson Mandela and F. W. de Klerk, *Cutting the Ropes of Apartheid* (1992; fig. 14). Such artists as the Ndous, hailing as they do from a rural area of Limpopo, have a very close association not only with their ancestral lands but also with the raw materials they use to create their work. As Owen Ndou recalls:

When I looked at wood I immediately saw something. When I looked at rock or stone I could see something. Even when I looked at the wall I could make a picture out from the lines there. So I had art in my head long ago when I was still young […] Art is not just carving, it is a kind of language […] Art is in everything and everything is in art, just like in the dictionary you can find the definition of any words you want. Everything is inside.[58]

Chapter 3

European and Asian arrivals

The desire to find a sea route to Asia in order to exploit trade opportunities – and to circumvent those countries that controlled more direct routes overland – drove Europeans to South Africa's coastline. European explorers ventured ever further south along the west and south-western coasts of Africa until, in 1488, Bartolomeu Dias, a Portuguese nobleman, became the first European to round the Cape of Good Hope, sailing as far as the Great Fish River in the Eastern Cape. The sea route was finally established ten years later, with the Portuguese explorer Vasco da Gama reaching India in 1498. From that point onwards, European ships became an increasingly familiar part of South Africa's maritime landscape, as they travelled to and from Asia. Occasionally, their crews would drop anchor and go on shore, erecting territorial and navigational markers and buying cattle from Khoekhoen herders to replenish their supplies. It would be another 154 years, however, before Europeans began to settle permanently in South Africa. In 1652 Jan van Riebeeck, a Dutch colonial administrator for the Dutch East India Company, established the first European settlement at what would eventually become Cape Town, an act that set in motion the European colonization of South Africa.

In the centuries that followed, a range of new arrivals landed in South Africa, including Dutch, French, German and British settlers. With these new arrivals came enslaved people from Africa and Asia, and political prisoners, indentured servants and free economic migrants from Asia. Although it had been the Dutch who had first colonized South Africa, it was the British who, from the turn of the nineteenth century, came to dominate the colonial political sphere. In theory, the colonial period came to an end in 1931 with the passing of the Statute of Westminster, an Act of Parliament that established the equality of the Dominions (the self-governing territories of the British Commonwealth, South Africa included) in international law. In practice, however, South Africa ceased to be a colony – in the same sense as others in Africa – after the creation of the Union of South Africa in 1910.

European arrivals: Portuguese, Dutch and British

Some of the first European objects to be installed in South Africa were *padrões*. These large stone crosses inscribed with the Portuguese coat of arms acted as territorial and navigational markers. For such explorers as Bartolomeu Dias, *padrões* served as political and religious testaments to the new reaches of Portuguese and Christian influence. It seems unlikely, however, that these monolithic carved crosses, and the ships and men that brought them to South Africa, were understood by the Khoekhoen in the same terms. As the inhabitants of the region at the time, the Khoekhoen were probably the first South Africans to encounter these new arrivals.

Today, little is left of the original *padrões*. One exception is the Dias Cross (fig. 1), erected by Bartolomeu Dias in 1488 at the most easterly point of his journey along the South African coast. The remains of the cross were found at the bottom of a cliff in the 1930s; since then, the cross has been reconstructed and installed in the William Cullen Library at the University of the Witwatersrand, while a memorial has been placed at the cross's original location. Exactly why the cross ended up at the bottom of a cliff remains unclear: it may have been the victim of coastal erosion, but it may also have been pushed – evidence, perhaps, of the nature of its reception by Khoekhoen.[1]

Although the Portuguese continued to make landings on the South African coast, they did not establish there either a settlement or a base for resupplying their ships. Instead, they chose to use Delagoa Bay in what is now Mozambique.

Voyages by both Dias and Vasco da Gama opened up the lucrative sea route to Asia for other European countries to exploit. Many Dutch ships, known as Indiamen, undertook the journey to the East Indies, and in 1602 the Dutch government established the Dutch East India Company (Vereenigde Oost-Indische Compagnie, VOC), granting it a monopoly over the spice trade. The VOC went on to dominate the Europe–East Indies trade

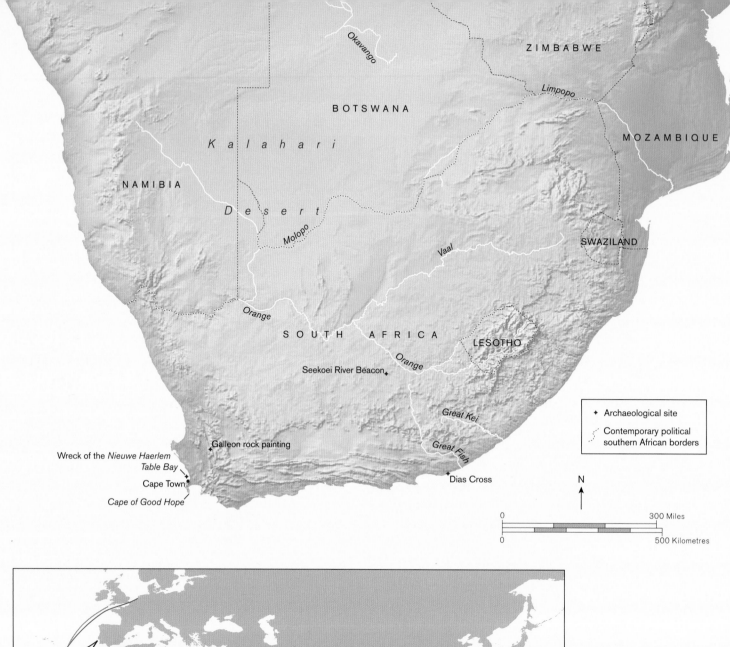

ZIMBABWE

Okavango

BOTSWANA

MOZAMBIQUE

K a l a h a r i

NAMIBIA

D e s e r t

Limpopo

SWAZILAND

Molopo

Vaal

Orange

SOUTH AFRICA

Orange

LESOTHO

Seekoei River Beacon ✦

Great Kei

Great Fish

Galleon rock painting ✦

Wreck of the *Nieuwe Haerlem*
Table Bay

Cape Town

Dias Cross ✦

Cape of Good Hope

✦ Archaeological site

⋯⋯ Contemporary political
southern African borders

N ↑

0			300 Miles
0			500 Kilometres

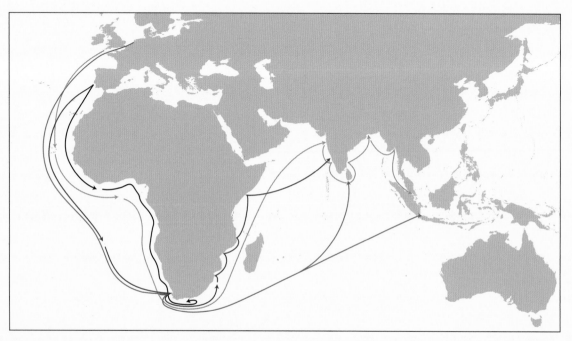

↗ Bartolomeu Dias route

↗ Vasco da Gama route

↗ Dutch trade route

↗ British trade route

route until the end of the eighteenth century. Dutch Indiamen, however, were often ill-equipped for the journey, and many ran aground off the coast of South Africa, ending up as wrecks as their crews sought to barter for supplies with Khoekhoen. Together with their cargoes, these wrecks – many of which are still on the seabed – are some of the earliest traces of the Dutch in South Africa.

Among this early evidence of the Dutch colonization of South Africa is a collection of twenty-two miniature porcelain bottles painted in underglaze blue (fig. 2). Made in Jingdezhen in China, the bottles were being transported to the Dutch Republic on board the *Nieuwe Haerlem* when it was wrecked in a storm in Table Bay in 1647. In the mid-nineteenth century, during the period of British colonial rule in South Africa, the bottles were recovered during a dredging operation and donated to the British Museum.

The *Nieuwe Haerlem* and its cargo are important players in the story of the colonial settlement of South Africa. In the aftermath of the storm, most of the ship's cargo was salvaged and taken on to the Netherlands by the rest of the fleet. Not everything could be carried, however, and some of the crew were left behind to protect the remaining cargo until more ships could arrive. It was a year before these crew members were returned to the Netherlands. There, they were asked to compile a report for the VOC about the feasibility of establishing an outpost at the Cape. The report was approved in 1650, and in 1651 Jan van Riebeeck was sent to establish a refreshment station there. Completed in 1652, the station gradually grew into the settlement that would eventually become Cape Town.

Khoekhoen herders who encountered these new arrivals negotiated their presence by means of rock art, as evidenced by a painting found in Porterville, Western Cape, of what is believed to be a Dutch galleon (fig. 3). Having assessed a photograph of the painting, experts at the National Maritime Museum in London identified a shoreline with a cross and, to its right, a ship with a short bowsprit crossed with a spritsail yard, and three masts bearing Dutch flags. Although we cannot be certain,

Map of key contact points and trade routes in and around South Africa from 1488 onwards
This map shows the early exploration and trade routes that drove the colonization of South Africa.

1 Dias Cross
Name(s) of artist(s) unrecorded, 1488
Recorded as Portuguese
Stone, H. 228 cm | W. 40.6 cm
William Cullen Library, University of the Witwatersrand, Johannesburg

2 Twenty miniature bottles
Name(s) of artist(s) unrecorded,
c. 1648
Recorded as Chinese
Glazed porcelain
Average H. 4.8 cm | W. 2.4 cm
British Museum 1853,1220.30-50
Donated by Henry Adams

3 Dutch galleon rock art photo
Name(s) of artist(s) unrecorded, c. 1650
Recorded as Khoekhoen
Digital image, David Coulson
H. 29 cm | W. 38 cm (galleon)
British Museum 2013,2034.19495
Donated by Trust for African
Rock Art (TARA)

these and other features identified on the ship suggest that the paining was created in the mid-seventeenth century – around the time, therefore, of the sinking of the *Nieuwe Haerlem* and the establishment of Cape Town.

This type of rock painting, one that depicts European objects and people, is termed 'contact art'. As in the case of other Khoekhoe or San | Bushman rock art, the ship painting – far from being a mere representation of something seen in the landscape or on the horizon – suggests that the local populations were using art to reconcile with their belief systems the appearance of new peoples in the South African landscape. Quite what they thought of these new arrivals, however, remains difficult to know.

Dutch settlers and explorers did not confine their activities to the coast. Following the settlement of Cape Town, the Dutch began to colonize the interior of South Africa, largely through the migration of the poorer sections of the white community, called Trekboere. As they went, a series of territorial markers were installed to mark the new limits of the colonial territory. One such marker was the Seekoei River Beacon (fig. 4), erected close to the modern-day town of Colesberg on 4 October 1778 by the then governor of the Cape Colony, Joachim van Plettenberg, to mark the colony's north-easternmost point.[2] Engraved on the face of the beacon are the Van Plettenberg family coat of arms and the year 1778. Two farmers found the beacon in 1905, in a broken and burnt state, and donated it to the South African Museum. Why it was in such a state is unknown: it may have been used as a cooking plate by local herders, or deliberately thrown into a fire. Either way, the condition of the beacon suggests a disregard for, if not also an explicit protest against, colonial ownership and marking of the land.[3]

The Dutch governed the Cape Colony until 1795, when it was seized by Britain in response to the French capture of the Netherlands and the risk this action posed to British use of the lucrative Europe–East Indies trade route. The British returned the colony to the Dutch in 1803, but, following the continued threat from France, retook it in 1806. Sovereignty over the Cape Colony was formally ceded to Britain in 1814. Like that of the Portuguese and Dutch, early British involvement in South Africa was largely based on maritime concerns, but as they became more established in the region they too ventured inland. During these expeditions, colonial artists would record the peoples, landscapes, animals and art that they encountered.

One such artist was Samuel Daniell, an English painter with an interest in natural history. In 1801, having arrived in Cape Town two years earlier, Daniell was appointed official artist and secretary to a military expedition despatched by General Dundas, the then governor of Cape Colony, to buy cattle from Khoekhoen herders. The mission travelled further north than any previous European expedition, reaching a town it named Leetakoo (more correctly known as Dithakong; fig. 5).

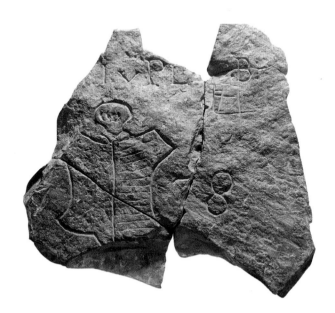

4 Seekoei River Beacon
Name(s) of artist(s) unrecorded,
c. 1788
Recorded as Dutch
Stone, H. 45 cm | W. 43 cm
Iziko Museums of South Africa,
Cape Town ACC.225

THE TOWN OF LEETAKOO.

Drawn, Engraved & Published by Samuel Daniell, N.9, Cleveland Street, Fitzroy Square, London, Sept.r 16, 1805.

5 *The Town of Leetakoo*
Samuel Daniell, 1804–5
Aquatint, paper
H. 45.5 cm | W. 59.6 cm
British Museum 1913,0129.1.24
Transferred from the British Library

6 *Trekboer Making a Camp*
Samuel Daniell, 1804–5
Aquatint, paper
H. 45.5 cm | W. 59.6 cm
British Museum 1913,0129.1.19
Transferred from the British Library

Daniell produced a variety of sketches during the expedition, which he later published as watercolours in *African Scenery and Animals* (1804–5).[4] As well as capturing the towns that he encountered, including Leetakoo, Daniell depicted the animals and people that he met along the way (see, for example, figs 6 and 7). As might be expected from a European artist of the period wishing to appeal to a European audience of the time, Daniell's sketches are highly romanticized, with many figures rendered in an idealized, classical style. Daniell also employed terminology that would have been derogatory and racial in tone even at the time. 'Hottentot', for example, said to derive from the German for 'stutter', *hotteren-totteren*, was used to refer to Khoekhoe speakers because of the

clicking sounds that form part of their language. The term 'Kaffre', meanwhile, used by white South Africans of the period to refer to all people of Bantu descent, is derived from the Arabic for 'disbeliever', or one without religion.[5] While he was undoubtedly a product of his time, creating paintings that now represent a challenging part of South Africa's colonial artistic heritage, Daniell's work clearly demonstrates a respect and admiration for the people he met and depicted, Khoekhoen and Trekboere alike.

While Daniell was a painter who joined a military mission, Allen Francis Gardiner left his career as a British naval officer and travelled to South Africa to undertake Christian missionary work. Gardiner published an account of his endeavours in *Narrative of a Journey to the Zoolu Country*

A HOTTENTOT. A HOTTENTOT WOMAN

A KAFFRE. Drawn & Engraved by Samuel Daniell. A KAFFRE WOMAN.

London Published December 10 1804 by Samuel Daniell N.9 Cleveland Street Fitzroy Square

7 *A Hottentot, A Hottentot*
Woman, a Kaffre, a Kaffre
Woman
Samuel Daniell, 1804–5
Aquatint, paper
H. 45.5 cm | W. 59.6 cm
British Museum 1913,0129.1.15
Transferred from the British Library

in South Africa, undertaken in 1835 (1836). Having arrived in Cape Town in 1834, Gardiner made his way to Port Natal, where he established his first mission. From 1834 to 1836 he travelled throughout Zululand with the aim of establishing Christianity among the Zulu, but found little success.[6] In contrast to Daniell, Gardiner was not a natural artist, with most of the faces he painted being remarkably similar and clearly stylized. He did, however, produce one work of note: a drawing of the Zulu king Dingane kaSenzangakhona (fig. 8), who had recently killed and succeeded his brother, Shaka kaSenzangakhona – remembered as one of the founders of the Zulu nation. Gardiner's drawing provides a wonderfully rich example of the exotic way in which Dingane's dress and manner must have appeared to the missionary. For his part, Dingane found Gardiner and his Christian teachings to be equally exotic, as recounted in a biography of Gardiner published in 1866:

When Gardiner reached the district round Port Natal, he found that the Zulus in its neighbourhood had recently, after the frequent manner of African tribes, passed under the dominion of a new chief, Dingarm [Dingane], who had lately acquired his dignity by the murder of his brother. Gardiner found himself unable to make any progress in religious teaching, he, however, acquired some personal influence over the chief, and obtained from him a grant of territory near Natal. The advantage derivable from this position induced him to return to England to seek assistance from the Church at home. The result of his efforts was that, in 1836, he returned to Natal in company with the Rev. Francis Owen and his family, and mission stations were planted at Hambanati and elsewhere in the territories of Dingarm. The Bible was read and interpreted, schools established, and instruction given in reading, sewing, planting, building, and fencing. Many were the questions asked by Dingarm when the doctrine of the resurrection was expounded. 'How can the dead get

up again?' 'Will they have the same body?' 'Will it be on a Sunday when they get up?' But the savage heart of the Zulu chief was not touched. War quickly ensued between his followers and an invading army of Dutch Boers, and the missionaries were forced to leave the country. Yet the first ground had been broken, and the first and greatest difficulties in the way of the preaching of the gospel had been in a great measure overcome.[7]

By the mid-nineteenth century a new class of explorer-artist had appeared in South Africa: private individuals who were not attached to either military or missionary expeditions. One such artist was the painter George French Angas. Following a successful painting trip to Australia, Angas travelled to South Africa to explore the natural and cultural worlds of another British colony. Angas documented his explorations in *The Kafirs Illustrated* (1849), which includes thirty plates of hand-coloured lithographs and eleven wood engravings.[8] Like those of Daniell before him, Angas's paintings and language are very much of the period, with picturesque and romantic scenes and poses often annotated with racial colonial language.[9] However, the respect that Angas afforded his subjects – greater, perhaps, than that shown by Daniell – is obvious, with detailed accounts appearing alongside his paintings. The result is in an invaluable ethnographic record of the people and places he encountered.

One of Angas's most famous subjects was the Zulu king Mpande kaSenzangakhona (fig. 9), who in 1840 had killed and succeeded his brother Dingane, the subject of Gardiner's sketches. Although Mpande ruled from 1840 to 1872, he was effectively succeeded in 1856 by his son Cetshwayo kaMpande, the eventual leader of the Zulu against the British in the Anglo-Zulu War of 1879 (see page 100). Angas's watercolour provides us with a detailed depiction of a proud, long-reigning Zulu king and his accoutrements, including his headrest, shown next to his feet; a white shield, a symbol of his royal ancestry, here being used to protect him from the sun; brass armbands,

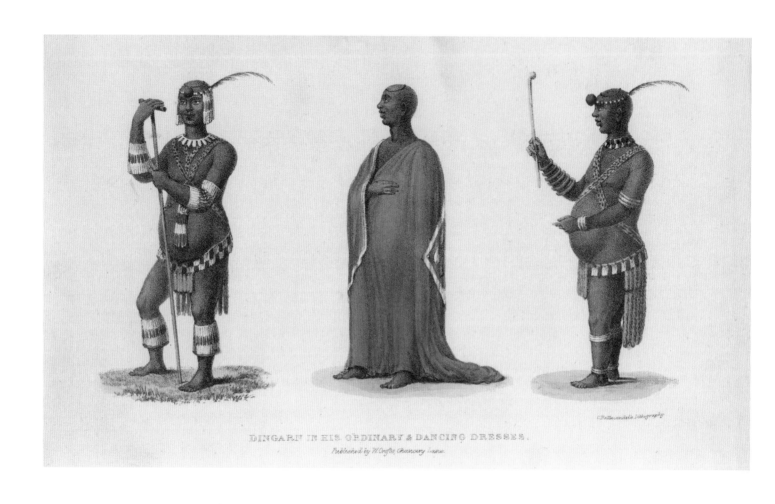

DINGARI IN HIS ORDINARY & DANCING DRESSES.

Published by W. Onglis Chancery Lane.

8 Illustration from *Narrative of a Journey to the Zoolu Country in South Africa*
Allen Francis Gardiner, 1836
Ink on paper (leather-bound book)
H. 23.5 cm | W. 15 cm
British Museum, Anthropology
Library & Research Centre

9 Umpanda, King of the Amazulu, from *The Kafirs Illustrated*
George French Angas, 1849
Ink on paper (leather-bound book)
H. 52.5 cm | W. 32.5 cm
British Museum, Anthropology
Library & Research Centre

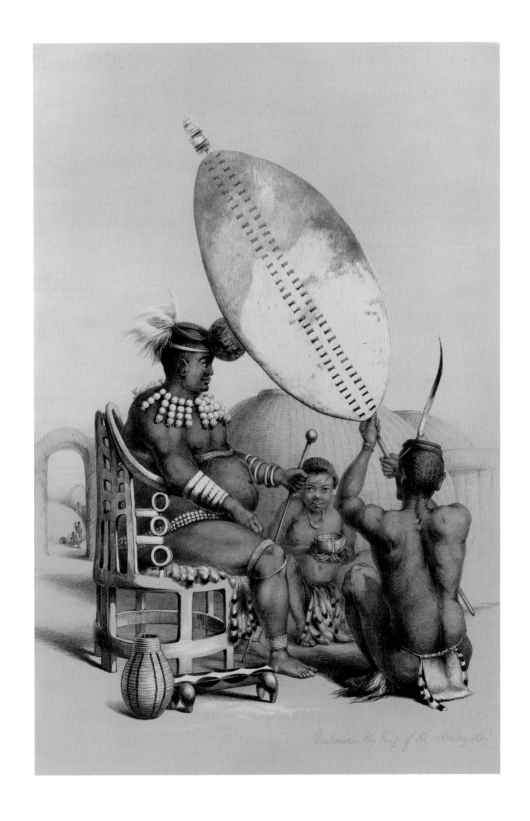

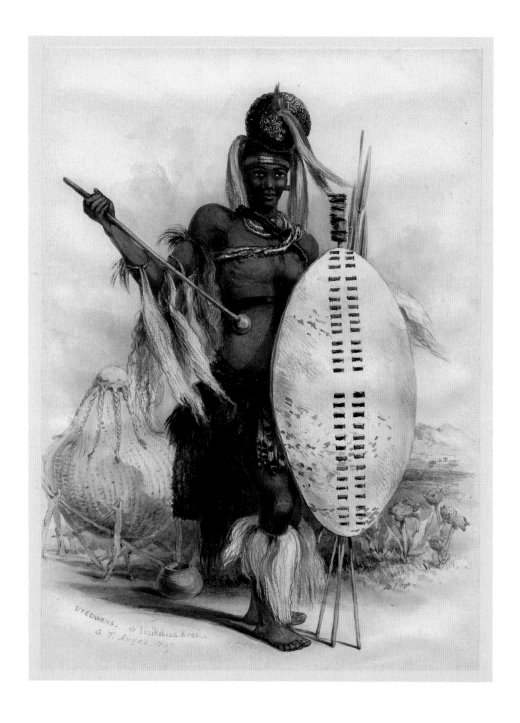

10 *Portrait of Uyedwana,*
a Zulu, in Visiting Dress
George French Angas, 1847
Watercolour and bodycolour on paper
H. 32.7 cm | W. 23.7 cm
British Museum 1876,0510.502

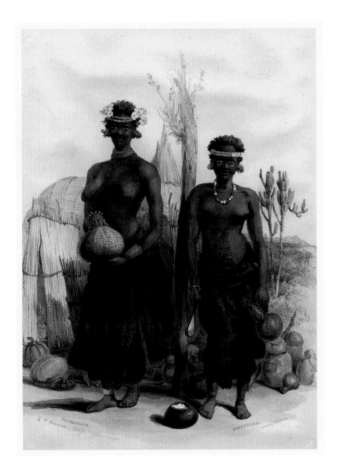

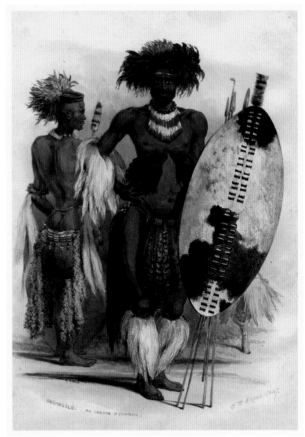

**11 *Portraits of Unomnyenya
and Unobasoko, two Zulu girls***
George French Angas, 1847
Watercolour and bodycolour on paper
H. 34 cm | W. 24.5 cm
British Museum 1876,0510.501

**12 *Portrait of Umzimgulu,
a Zulu chief***
George French Angas, 1847
Watercolour and bodycolour on paper
H. 34.6 cm | W. 24.6 cm
British Museum 1876,0510.503

Drawings on the rock walls of a Bushmans cave
in the mountains on the frontier of Natal
South of Bushmans river South Africa
Carefully drawn, & coloured on a reduced scale on the
spot. in June 1863 by. A. Moncrieff

Tracing of the original drawing
A Moncrieff

13 Drawing of
San|Bushman rock art
Alexander Moncrieff, 1863
Ink, colour wash, paper
H. 26.7 cm | W. 19 cm
British Museum Af1979,01.2732
Donated by Sir John Henry Lefroy

signifying his military strength; and, in his left hand, his knobkerrie, a form of club. In contrast to other artists of the time, Angas named not only the royal figures he painted, but also some of his other subjects, such as Uyedwana (fig. 10), Unomnyenya and Unobasoko (fig. 11), and Umzimgulu (fig. 12). Angas's pictures also provide a rare record of early Islamic life in South Africa (discussed in more detail below).

Following a distinguished military career, Colonel Alexander Moncrieff, 'a man of many interests, genial and sociable', visited South Africa and Canada 'in search of sport'.[10] Moncrieff was also an amateur artist, and he is remembered here for what is currently the earliest known sketch of San|Bushman rock art made by a European (fig. 13).[11] Produced by Moncrieff in Natal in 1863, the sketch survives on a single piece of paper. The caption reads:

> Drawings on the rock walls of a Bushman's cave in the mountains on the frontier of Natal south of Bushman's river South Africa carefully drawn and coloured on a reduced scale on the spot in June 1863 by A. Moncrieff.

Compared to Joseph Orpen's sketches and Qing's accounts discussed in the introduction (see page 18), Moncrieff's sketch does little to further our knowledge of San|Bushman rock art. It does, however, represent an early example of European interest in such art. It also demonstrates, despite some two hundred years of colonial settlement in South Africa, how poorly Europeans understood San|Bushman art and beliefs. In creating his sketch, Moncrieff took a range of images from the walls of the Natal cave and placed them in a single scene, imposing his own sense of order by reproducing them as caricatures in neat, evenly sized rows.[12] In so doing, he decontextualized the original images beyond anything meaningful to the artists that produced them, and beyond anything useful to contemporary archaeologists, who are unable to identify the original paintings. Instead, the composite sketch reflects the belief – prevalent until the mid-twentieth century – that rock paintings were merely literal depictions of individual elements of the world as experienced by San|Bushmen. This interpretation is in stark contrast to the rich and complex metaphorical scenes that we now believe them to represent.

Colonialism and contemporary art

Many recent and contemporary South African artists have been influenced by colonial history, including Johannes Phokela. Several of the Johannesburg-based artist's large oil paintings have reworked European Old Masters from the colonial era as commentaries on colonial, Western legacies in contemporary South Africa. As Phokela himself explains:

> Most of my work is a contemporary take on Old Dutch and Flemish Masters, where I take on what is perceived to be Europe's grandiose history of art as a medium to convey values and ideals represented within a global context of cultural elitism.[13]

Pantomime Act Trilogy (1999; fig. 15) is one of a number of pastiches by Phokela that take as their starting point a pen-and-wash drawing by the Dutch artist Jacques de Gheyn II, *Allegory on Transience and Equality in Death* (1599; fig. 14), prints of which were widely owned in the South Africa of Phokela's youth. De Gheyn's drawing features two men of very different social standing – a wealthy nobleman and an impoverished peasant – who are united by death, which lies at the bottom of the work in the form of two cadavers. The moral of the piece, that death is a great leveller, would have come as scant consolation to those who had suffered years of oppressive colonialism and apartheid in South Africa.

Born in Soweto, South Africa, in 1966, Phokela was fascinated by the fact that many people in the town owned prints of Dutch Old Masters: why, he wondered, were they

so popular? Given that most of the original paintings were created at a time when the Dutch were beginning to colonize South Africa, Phokela decided to use the images as historical sounding boards, testing and commenting on the collision between Africa and Europe and the ongoing consequences. Here, Phokela explains in more detail the story behind *Pantomime Act Trilogy* and the use of de Gheyn's drawing:

> Christmas pantomime is meant to be allegorical. It's meant to tell family jokes while hinting at the truth [...] You could make the link between the colonial history

of South Africa and Dutch genre painting, which has so many traits of South African culture, but that wasn't really the main aim. I wanted to make political work, but without being really specific and I found allegory to be the most subtle medium. This piece is allegorical of the difference between rich and poor, between the aristocrats on the right and the peasants on the left. It talks about how death equalizes everything; in the end we all die, rich or poor [...] It's a sort of pastiche, and in the centre you have a child soldier with a comic red nose. It's symbolic of rapid change and the enforced dependency of developing nations. We are forced to buy arms, to give rights for mining, and it's escalated now into corporate greed [...] Obviously it's done with a bit of humour; I don't intend to offend anyone.[14]

The plastic red nose worn by the naked child soldier, who also sports an AK-47 assault rifle, was made famous by the UK-based charity Comic Relief, an organization that has been criticized for investing the public donations it receives in tobacco, arms and drinks companies.[15] 'Once I bought a red nose', recalls Phokela, 'and it fell off when I tried to fit it on to my nose. That's when I found out that the noses were not designed to be worn by someone with a flat nose like mine.'[16]

Commenting more generally on his subject matter and decision to work in oil – his handling of which is both naturalistic and surreal – Phokela observes:

> I adopted a way of working that I felt would defy stereotyped expectations of an African artist [...] If you were black it was as if your art had to be black art or about black consciousness [...] so I guess I decided from an intellectual point of view that I wanted to surpass gender and race, rather than quenching some sort of liberal zest or missionary ideals.[17]

As in *Pantomime Act Trilogy*, Phokela often superimposes on his paintings a series of rectangles, references in part

14 *Allegory on Transience and Equality in Death* (study for a print)
Jacques de Gheyn II, 1599
Pen, ink, paper
H. 45.7 cm | W. 34.8 cm
British Museum 1895,0915.1031

15 *Pantomime Act Trilogy*
Johannes Phokela, 1999
Oil on canvas
H. 183 cm | W. 168 cm
Private collection, London

to the 'golden section' (also known as the 'golden mean' or 'divine proportion') in Western art: the most aesthetically pleasing division of a line or rectangle into two unequal parts. Phokela's rectangles are also a humorous reference to his partial namesake, the seventeenth-century Dutch Old Master Johannes Vermeer, the compositional balance of whose work is said to exemplify the use of the golden section. Phokela subverts this Western artistic tradition by using the rectangles to create an imbalance. In the context of recent South African history, the rectangles also reference the deep divisions in the country, as well as drawing the viewer's attention to those parts of the painting that Phokela wishes to emphasize.

Asian arrivals: Cape Malays, Indians and Chinese

The VOC began to exile political opponents to South Africa shortly after the establishment of Cape Town, and to bring in free labourers from its Asian colonies and enslaved people from Africa and Asia to provide cheap labour for the growing settlement. The first enslaved people to arrive in South Africa were a few hundred Africans from Angola and Ghana who had been captured from the transatlantic slave trade in 1658. They were followed by many more from Madagascar and Mozambique. The majority of enslaved people who arrived in South Africa, however, were Asians brought by the VOC from places along the Europe–East Indies trade route, including Ceylon (now Sri Lanka), India and Malaya (now part of Malaysia). In total, approximately 60,000 enslaved people were brought to South Africa, but, because of their relatively low life expectancy, at the time of the abolition of slavery in 1834 only 38,000 were recorded as living in South Africa.[18]

Together with their descendants, the Asian arrivals – the majority of whom were Muslim – came to be known as Cape Malay. Although this term has been used interchangeably in South Africa with 'Muslim', it more

16 Conical *toedang* hat
Name(s) of artist(s) unrecorded,
1700–1900
Recorded as Cape Malay
Vegetable fibre, textile, H. 27 cm | W. 51 cm
British Museum Af1960,20.113
Donated by Royal Botanical
Gardens at Kew

correctly refers to the descendants of those Muslims who arrived and lived in Cape Town. The presence in South Africa of the early Malays can be represented by means of a conical *toedang* hat (fig. 16).[19] The example illustrated here was made in the nineteenth century, or before, out of *Prionium palmita*, a palm or rush that grows extensively in South Africa, especially in the Western Cape. Conical palm hats of various styles are worn throughout Asia, where they have traditionally provided farmers with shelter from the sun and rain. By wearing these carefully made hats, the Cape Malays not only protected themselves from the elements, but also made a highly visible statement about their identity as people of Asian origin.

Enslaved Indians were first brought to South Africa in 1684, a process that continued until the abolition of slavery 150 years later. Indians migrated to South Africa by other means too: as indentured servants from the 1860s, and as voluntary economic migrants in the late nineteenth century. The most famous Indian economic migrant was Mohandas Karamchand Gandhi, who travelled to South Africa as a commercial lawyer to work on a particular case.

By the time of his arrival in Durban in 1893, however, there was growing opposition to Indian immigration among white South Africans, and in June 1893, despite holding a first-class ticket, he was ejected from a train in Pietermaritzburg after refusing to move to a third-class compartment because he was Indian.[20]

Gandhi won his employer's legal case and was determined to return to India. However, he was persuaded to stay in South Africa and fight a bill that intended to deny the vote to Indians. As he later wrote: 'The farewell party was turned into a working committee [...] thus God laid the foundations of my life in South Africa and sowed the seed of the fight for national self-respect.'[21]

In 1900 Gandhi served in the Indian Ambulance Corps during the Second South African War, receiving a medal for attending to the wounded at the Battle of Spion Kop. After the war he practised as an attorney in the Johannesburg law courts, a period of his life that, in 2003, inspired the sculptor Tinka Christopher to depict Gandhi in his legal attire for a statue in Gandhi Square, Johannesburg.

The racism that Gandhi and his family experienced while living in Johannesburg hardened his resolve to resist laws that discriminated against the Asian population of South Africa. The 1906 Transvaal Asiatic Law Amendment Ordinance, for example, consisted of three elements: first, all Asians over eight years old must carry a pass; secondly, Asians must be segregated; and thirdly, Asians are forbidden from migrating to the Transvaal. In response, Gandhi chaired a meeting attended by 3,000 people of Asian descent at which a resolution was passed to peacefully protest against the ordinance. This resolve formally began the period of Indian non-violent resistance, or *satyagraha*, in South Africa, for which Gandhi served two terms of imprisonment:

> Up to the year 1906 I simply relied on appeal to reason. I was a very industrious reformer [...] But I found that reason failed to produce an impression when the

17 Maquette for the Gandhi Memorial Statue
Anton Momberg, 1990
Fibre cast resin, H. 63.9 cm
Iziko South African National Gallery,
Cape Town SANG93/21

critical moment arrived in South Africa. My people were excited – even a worm can and does turn – and there was talk of wreaking vengeance. I had then to choose between allying myself to violence or finding out some other method of meeting the crisis and stopping the rot, and it came to me that we should refuse to obey legislation that was degrading and let them put us in jail if they liked. Thus came into being the moral equivalent of war.[22]

Following the brutal beating of Gandhi and a group of miners who were protesting against the treatment of Indians in South Africa, the government was forced to enter into negotiations. Led by General Jan Smuts on one side and Gandhi on the other, the negotiations resulted in the passing of the Indian Relief Act of 1914. This act removed some of the oppressive laws that affected Indians, and convinced Gandhi of the power of peaceful protest and the need to implement similar tactics against British colonial rule in India. Before leaving South Africa in 1915, Gandhi presented Smuts with a pair of sandals made as a gesture of peace and respect (fig. 18). In 1939, on the occasion of Gandhi's seventieth birthday, and shortly after being elected prime minister of South Africa for a second

time, Smuts stated: 'I have worn these sandals for many a summer, even though I may feel that I am not worthy to stand in the shoes of so great a man.'[23]

In many ways the red-leather sandals, with their simple brass buckle and yellow stitching, are utilitarian objects. However, the sandals were not made and given to Smuts merely for him to wear, but were crafted to symbolize the struggle of South Africa's Indian population, a hoped-for peaceful resolution to that struggle, and the need to uphold Indian human rights in the country. In this sense, the humble sandals encapsulate all the hopes that their maker had for their intended audience, Smuts – who throughout his second term in office campaigned against total racial segregation, and for black South Africans to be able to settle in urban areas.

Gandhi's policy of peaceful protest inspired the opponents of apartheid. The ANC, for example, employed the philosophy of *satyagraha* in the anti-pass campaigns of the 1950s, in which black South Africans were encouraged to leave at home the government-issued pass books that limited their movement. Gandhi's contribution to the struggle against apartheid was celebrated in 1993 when Archbishop Desmond Tutu unveiled a statue of him in Pietermaritzburg (figs 17 and 19), the place where he had been thrown off the train for sitting in the 'wrong' carriage. Created by Anton Momberg, the statue depicts Gandhi in a *dhoti*, the traditional Hindu garment that Gandhi later adopted in his struggle against the British Raj in India.

Despite his reputation as a champion of human rights and freedom from oppression, there are some who have accused Gandhi of only supporting the human rights of South Africans of Indian descent, and of conspiring with the British colonial government to promote racial segregation in South Africa. In April 2015 Tinka Christopher's statue of Gandhi was vandalized during a wave of attacks on figures from the colonial period, which also resulted in the removal of a statue of Cecil John Rhodes from the University of Cape Town.[24]

18 Gandhi's sandals
Mohandas Karamchand Gandhi,
pre-1915
Leather, brass, wool
L. 27.6 cm | W. 10.5 cm
Ditsong National Cultural History
Museum, Pretoria HG. 51388/1–2

STATUE OF HOPE

MOHANDAS KARAMCHAND
GANDHI

BORN 2 OCTOBER 1869

DIED 30 JANUARY 1948

"MY LIFE IS MY MESSAGE."

**19 Statue of Mohandas
Karamchand Gandhi,
Pietermaritzberg**
Anton Momberg, 1993

In addition to arrivals from various points along the Europe–East Indies trade route, discussed above, Cape Town also saw the appearance of migrants from China. Although there is evidence of Chinese people living in Cape Town in the late seventeenth century, they were few in number. From the 1870s, however, in parallel with similar levels of Indian migration, thousands of Chinese indentured servants and free economic migrants arrived as a source of cheap labour – with 63,000 arriving between 1904 and 1910 alone. Upon arrival, many were greeted with anti-Chinese racism, driven by the fear that they would take jobs away from white South Africans. As a result, most Chinese immigrants did not settle in South Africa, but chose instead to return to China.[25] Today, traces of these newcomers from China can be found in two postcards, the first depicting the arrival of Chinese migrants at the East Rand (fig. 20), the second showing a group of free entrepreneurs who were touring as performers of Chinese opera (fig. 21).

New religions: Christianity and Islam

As Europeans began to settle in South Africa, the religions of the San|Bushmen, Khoekhoen and Bantu-speaking communities were joined by Christianity brought by the Dutch and British, Islam brought by Cape Malays, Hinduism and Buddhism brought by Indian and Chinese migrants, and finally Judaism, which arrived in the nineteenth century. Here, we focus on the two religions that not only arrived first but also had the greatest impact: Christianity and Islam.

Dutch and British missionaries, such as David Livingstone from the London Missionary Society, campaigned to spread Christianity in South Africa in the eighteenth and nineteenth centuries. The early impact of this missionary work was slight, as illustrated by the story of Allen Francis Gardiner recounted earlier in this chapter. Although 80 per cent of the South African

population identified themselves as Christian in the 2001 national census, this is probably as much a result of the development of new, distinctly African-Christian institutions and the recent spread of Pentecostalism, as it is of the work performed by European missionaries.[26]

As a means of exploring the positive and negative legacies of Christianity in South Africa, we examine here the work of two artists, the late Jackson Hlungwani and Willem Boshoff. Although they come from very different backgrounds, both men found salvation in Christianity. In Hlungwani's case, this was a physical and spiritual salvation: preparing to take his own life, he was stopped by a vision of Christ and God, which guided him towards his vocation as a preacher and visionary artist. As for Boshoff, his strict Calvinist upbringing taught him that South Africa was his promised land, 'that it was bought with blood and given to us by God'.[27] He later came to believe, however, that he had been misled by both the doctrine of apartheid and the Church, and instead found salvation in a new understanding of religion in general and Christianity in particular.

Jackson Mbhazima Hlungwani was born in 1923 on the banks of the Klein Letaba River in the province of Limpopo, where many generations of his family had lived and died, and where his paternal grandmother raised him to understand the history and customs of the Hlungwani clan. As a young boy he herded the family livestock and learned to understand and appreciate the natural world around him. It was his father who taught him the art of woodcarving: 'What you see me doing with wood he taught me [...] My father taught me to make bed stands, chairs, tables, boxes, doors, mortars, pestles, spoons, porridge stirrers, scoops, sticks and headrests.'[28]

Christianity was part of Hlungwani's life from an early age. As a young man he was ordained in the African Zionist Church, which, in common with many southern African churches at the time, combined Christianity with traditional beliefs and practices. Hlungwani saw no conflict between the use of divining bones, natural remedies and

First Arrival of Chinese Coolies at East-Rand.

Braune, Franssen & Co. B.F.C. No. 132
 J.

How do you like the look of them?
e.j.j

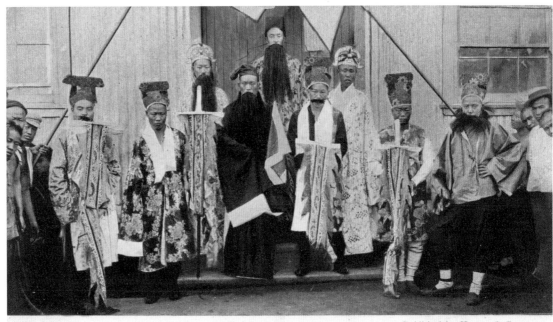

PERFORMERS OF CHINESE OPERA ON THE RAND.

Published by HALLIS & Co.,
Port Elizabeth.

**20 Postcard *First Arrival
of Chinese Coolies on the
East Rand***
Name of artist unrecorded, 1904
Ink, card
Warren Siebrits, Johannesburg

**21 Postcard *Performers of
Chinese Opera on the Rand***
Name of artist unrecorded, c. 1904–10
Ink, card
William Cullen Library, University of
the Witwatersrand, Johannesburg

the teachings and consolations of the Bible. Eventually, he came to associate his ancestors with the prophets and patriarchs he encountered within its pages.

One event in particular had a profound effect on Hlungwani, shaping his life as an artist. In 1978, while he was working on a building site, he developed ulcers in both legs. One of the ulcers, which he attributed to satanic influences, became so badly infected that he was unable to walk. The pain was so great, in fact, that he contemplated taking his own life. But then a vision came to him:

> Jesus stretched out his right arm and grasped my right hand. Then he gave me his message. Number one, he said: 'You see, today you are healed, you will not die.' Then, number two: 'You will serve God for your whole life.' Number three, he said: 'You will see God himself. Look over there.' [...] I did not, in fact, see God's full stature. I only saw his legs, from the knees down not touching the ground but moving slightly above it. I watched the legs passing by, going in the direction of KwaZulu. They finally disappeared below the horizon. Jesus said to me, 'Now you have seen God.'[29]

This experience inspired Hlungwani to found his own church at the site of an ancient hilltop settlement, which he named New Jerusalem. At this site he created a series of monumental wood sculptures of animals, warriors and biblical figures, such as *Christ with Football* (1992; fig. 22). These he used as teaching aids as he preached his particular gospel of hope and salvation, in which all people and creatures would live in peace and harmony. Just as Hlungwani's father had taught him the values and customs of his ancestors through the Venda traditions of woodcarving, so Hlungwani's sculptures enabled him to teach the values of his new world order.

When it was first displayed to the South African public, as part of the groundbreaking exhibition *Tributaries* (Africana Museum, Johannesburg, 1985), Hlungwani's work caused a sensation. This exhibition, which featured

22 *Christ with Football*
Jackson Hlungwani, 1992
Wood
H. 210 cm | W. 57 cm
Private collection, London

the work of both white and black South African artists, also represented the public debut of work that had been produced outside the formal system of art education, which at that time was available only to white students under the apartheid regime. As the British businessman, art collector and philanthropist Robert Loder recalls:

I first saw the work of Jackson Hlungwani at the *Tributaries* show and, faced by his crucifix shown there, realized that this was a major talent that embraced local formal tradition, but was also contemporary and relevant in feeling. No representation of work from South Africa can be without reference to Jackson's work. It is entirely *sui generis* but at the same time an assertion of the common humanity of all the diverse peoples that make up South Africa.[30]

Standing in stark contrast to Hlungwani's positive experience of Christianity, Willem Boshoff's *Bad Faith Chronicles* (1995; fig. 23) is an angry response to the way in which Christian churches colluded with the apartheid regime, and to how the Bible was used to justify apartheid. According to Boshoff himself:

Bad Faith is kind of a philosophical concept, and in my case I think it's very specifically the things that were given to us in good faith: church, school and home upbringing. Everybody thought they were doing the right thing. They were very sincere, but in the end it turned out to be really bad. The ministers of religion didn't even allow black people in the church.[31]

The idea for *Bad Faith Chronicles* came to Boshoff when, while sitting in 'a slightly more progressive' church one day, he picked up a copy of the Bible translated into Zulu, a language he was keen to learn:

I wanted so much to speak to Zulu people, to black people, so I thought I must start with the Bible. It opened at Psalm 111, verse 16, and there was the word *amandla*. That was a word I knew, but I didn't know what it was doing in the Bible. When black people march in the street, they do a black salute, the power salute, and they shout at the top of their voices, in their thousands, 'AMANDLA!' It means 'power'. I looked for the same text in an English Bible and it said, 'God gave his people the power to take the land of other nations.' I thought, what the hell would God do that for? I had thought we were God's people here in South Africa! That upset me very much; it really made me angry, because that's the story of South Africa. We came here and we just took. I began to question God and to question myself as well … It's kind of hideous and it's not my experience of religion. Religion for me was an adventure, a kind of crazy roller coaster, where I had great fun and a wonderful sense of learning about other people. I think if it hadn't been for the Bible, we would probably not have been as possessive and overbearing and conquering, as colonial as we became in South Africa.[32]

After further research, Boshoff discovered that the Bible contains the names of thirty-six peoples of the ancient world whose lands were appropriated in God's name and given to 'his people'. *Bad Faith Chronicles* was his response to this discovery.

Boshoff's work consists of eleven panels, one for each of the official languages spoken in South Africa. At the bottom of each panel is a Bible in one of those languages, held open at the offending verse of Psalm 111. Immediately above each Bible are thirty-six miniature pink plastic dolls, pinned down 'so they look like they've been crucified or like a collection of insects'.[33] Beneath each doll is a label bearing the name of one of the biblical peoples whose land was taken by God, together with the name of one of South Africa's peoples whose land was also appropriated.

Boshoff's artistic interest in faith is not confined to Christianity. After falling critically ill with lead poisoning,

23 *Bad Faith Chronicles*
Willem Boshoff, 1995
Paper, metal, plastic
H. 125 cm | W. 63 cm
Private collection, London

24 *Moonwords*
Willem Boshoff, 2005
Textile, beads
H. 137 cm | W. 190 cm
University of Johannesburg,
Johannesburg

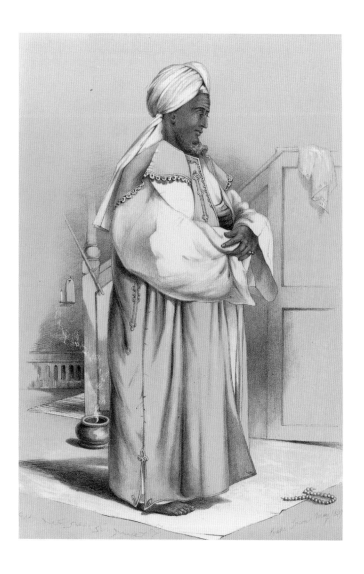 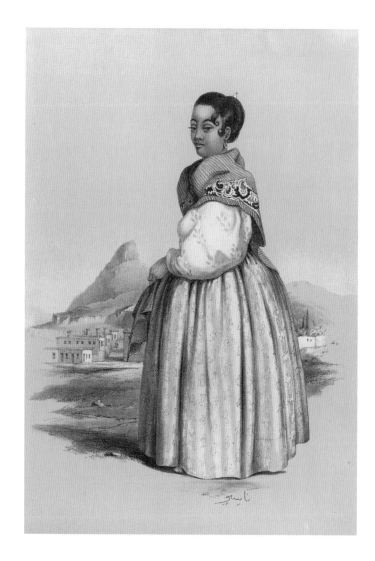

**25 'Cape Malay Priest
and his wife Nazea', from**
The Kafirs Illustrated
George French Angas, 1849
Ink on paper (leather-bound book)
H. 14.5 cm | W. 67.5 cm
British Museum, Anthropology
Library & Research Centre

Boshoff read widely during his long recovery about the beliefs and practices of South Africa's San|Bushmen. One of the titles on his reading list was a 1956 dictionary of San|Bushman languages compiled by Dorothea Bleek. Inspired by the thirty-eight /Xam words for the moon that he found therein, Boshoff produced *Moonwords* (2005; fig. 24). Dorothea Bleek was the daughter of Wilhelm Bleek, the linguist discussed in the introduction who, together with Lucy Lloyd, devised a phonetic /Xam alphabet as part of his and Lloyd's efforts to record San|Bushman beliefs in the late nineteenth century (see page 18). As Boshoff has observed, 'Today, the Bleek and Lloyd texts are the only surviving documentation of the /Xam language, offering us a thread of understanding back to the development of our own thinking.'[34] Here, Boshoff poignantly reminds us that the Christian religion, which was meant to supplant supposedly false African beliefs, was itself – albeit in a very distant way – a product of those same beliefs.

After Christianity, Islam was the next major religion to become newly established in South Africa. Its growth there can be traced to an irony of the Dutch Christian colonial project, namely, its enslavement of Muslims from Asia and East Africa, and its importation of both free Muslims to help with defence and labour, and political opponents from the Dutch East Indies. Today, Islam remains a minority religion in South Africa.

George French Angas's *The Kafirs Illustrated* provides an account and portrait (fig. 25) of two Muslim residents of nineteenth-century Cape Town: Karel, a Cape Malay imam, and his wife, Nazea:

Karel, the Hadj, is one of the leading priests of the Malays of Cape Town: he boasts the grand distinction of having performed the pilgrimage to Mecca, and styles himself the original and only genuine pilgrim amongst the followers of the Prophet there. Karel is an intelligent and interesting man, and has more liberal views and sentiments of any of his rival priests. He

repeatedly sat to me for his portrait, and encouraged his people to do the same although it is contrary to the law of Mussulmen to represent the human countenance [...] Nazea is the only surviving wife of Karel, – as amongst all Mahommedans, it is customary for the Malays to be allowed a plurality of wives, but it is very seldom that we find them with more than two, whilst a majority have only one. The costume of the Malay women is very neat: they wear a variety of gay colours; but in their dresses they invariably adhere to one rigid pattern, as do the men in the cut of their garments and the fashion of their hats. Nazea is portrayed in her walking dress. The priest, in his robes, officiating at prayers, before a white linen cloth. In the background of Nazea's portrait is a view of the Lion's Head Mountain adjoining Cape Town.[35]

Chapter 4 Colonial conflicts

The European colonization of South Africa led to an increase in the competition for resources and, subsequently, to violent clashes over the right to access and control those resources. While ideological factors certainly contributed to these outbreaks of violence, underlying each of them was a desire to control land and/or people. The first years of the settlement of Cape Town were relatively peaceful: trade relations with local Khoekhoen herders remained amicable, and the European settlers confined themselves to a limited area on the coast around Table Bay. As colonial settlements spread, however, and Khoekhoen resisted the colonization of their land, violent confrontations began to erupt, leading eventually to a series of wars between the Dutch and Khoekhoen in the late seventeenth century.

Although violence existed in South Africa before the arrival of Europeans, the spread of colonial rule changed the nature of this violence irrevocably, accelerating competition over resources and bringing with it new technologies and strategies of war. Not all conflict during the colonial period can, however, be framed as colonial. The first half of the nineteenth century, for example, saw a period of extensive warfare and displacement primarily between black South Africans, often termed the Mfecane (meaning 'the crushing' in Nguni). While colonial activities may have had some influence on these conflicts, they were largely the result of internal politics and environmental change. Violence also broke out between competing groups of Xhosa in the Frontier Wars, including between those opposed to colonial rule and those allied to the British. Similarly, settlers of European descent fought one another over the right to control South Africa's land and mineral wealth, notably in the First and Second South African Wars (1880–81 and 1899–1902).

Today, colonial conflicts live on in South Africa's national memory, and numerous traces of these episodes of violence can be found in its artistic heritage. Here, we use a selection of works by South African artists as a medium for examining three prominent colonial conflicts from the nineteenth and early twentieth centuries: the

Xhosa Frontier Wars, the Anglo-Zulu War and the Second South African War.

New weapons and art

In the previous chapter, a rock painting of a Dutch ship illustrated how European maritime activity was incorporated into the world view of San|Bushmen and Khoekhoen (see page 67). This process of incorporation also occurred with some of the weaponry introduced by the Europeans, as illustrated by three headrest-staffs dating to the late nineteenth century (figs 1–3). The first, more traditional headrest-staff combines a headrest with a knobkerrie (a staff with a bulbous end used as a club), while in the other two examples the knobkerrie has been replaced with a new weapon: a rifle.

In southern Africa, headrests are carved and used mainly by men – except in the case of some double headrests (see Chapter 6). They are extremely personal artworks, combining functional and social elements with deeply spiritual associations. In practical terms, the purpose of a headrest is to preserve its owner's often very elaborate coiffure from being crushed while sleeping, and to keep the head away from any creatures crawling on the ground. Headrests were carried on long journeys, and the kind illustrated here may have had an additional function, providing a means of carrying a bundle of possessions over one's shoulder.[1] The form and design of each headrest reveals its owner's cultural affiliations, as well as symbolizing his power, prestige, and status.

The knobkerrie in the traditional headrest-staff (fig. 1) has been carved in the shape of a man's head, complete with a head-ring to indicate maturity and wisdom.[2] In the other two examples (figs 2 and 3), the knobkerrie has been transformed into a carving of a rifle, indicating the increasing use and ownership of firearms in South Africa and their transformation into symbols of power and prestige. Beginning with the Kimberley diamond rush of

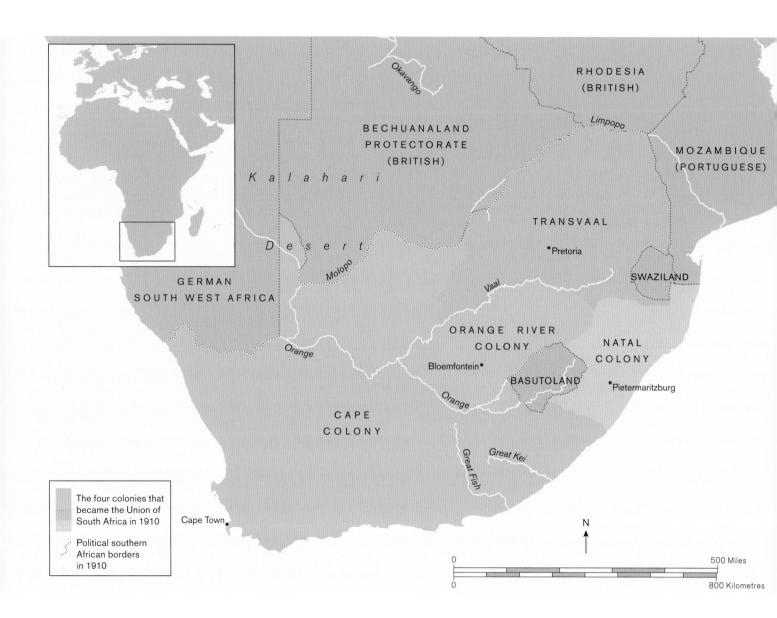

**Map of the South African
colonies prior to 1910**
This map shows the colonial borders
before the unification of South Africa.

the 1860s and 1870s, migrant labourers would occasionally bring home guns from the mines; as a consequence, such weapons became associated not only with status and power, but also with the safe return of workers.[3] One of the rifle headrests (fig. 2) probably depicts a Martini-Henry, as used by the British infantry in the Anglo-Zulu War; indeed, its characteristic cleaning rod can be clearly seen beneath the rifle's barrel. The other rifle headrest (fig. 3) may represent a Lee-Speed rifle, which was widely used by British officers in the late nineteenth century.

On a spiritual level, headrests are closely associated with the dead.[4] The appearance of firearms on headrests signalled not only the owner's prestige among the living, but also their ability to communicate this power and status to their ancestors. Headrests and other important personal artefacts were often buried with their owners; on some occasions, however, they were preserved as heirlooms, imbued with the power to communicate with the deceased. Among the Tsonga, such artefacts were known as *mhamba*,[5] or 'any object or act or even person which is used to establish a bond between the gods and their worshippers'.[6]

Because we do not know exactly when or by whom the three headrest-staffs shown here were made, they should not be viewed as illustrating a simple evolution from traditional to colonially influenced forms. Even if rifle headrests do represent a later development, it is likely that knobkerrie forms persisted in parallel. Nevertheless, these headrest-staffs are an example of the way in which European weapons and symbols of power were incorporated within, and negotiated artistically through, traditional wood carvings associated with power.

Xhosa Frontier Wars

As European settlers spread out from Cape Town, first along the coast and then inland, the new frontiers they created pushed ever further into San|Bushmen, Khoekhoen and black South African lands. The result

was a series of conflicts along the newly created borders. The longest of these conflicts was the sequence of military actions known as the Xhosa Frontier Wars, which lasted from 1779 to 1879. A total of nine such wars took place over this one-hundred-year period, involving Xhosa, British settlers, Afrikaner Boers, Khoekhoen and San|Bushmen.

In the 1700s, owing to a shortage of arable land around Cape Town, the poorer members of the white farming community – the Trekboere – began to settle further inland. As a consequence, the Dutch East India Company (VOC) was forced to expand the borders of the Cape Colony and to follow the Trekboere in order to maintain a sense of control over their activities. The advance by these 'Boer' settlers encroached on the farmlands of the Xhosa, Khoekhoen and San|Bushmen, restricting where they could graze their cattle and leading to retaliatory attacks on settler farms by Xhosa and Khoekhoen. These attacks led in turn to retaliations by the settlers, backed up eventually by the VOC and – following British annexation of the Cape – the British army.[7]

The first (1779–81), second (1789–93) and third (1799–1803) of the frontier wars were essentially conflicts between Afrikaner Boer and Xhosa farmers, with the VOC and, later, the British providing military support to the Boers. By contrast, the fourth war (1811–12) was fought directly between the British and Xhosa armies, with the former attempting to reclaim an area that had been occupied by Xhosa farmers, but which the British had designated no man's land. The war was settled by an agreement between the British and Gaika, the then chief of the Western Xhosa. The agreement between the two parties re-established the neutral zone, with white settlers on one side and Khoekhoen, Xhosa and San|Bushmen on the other.[8]

The fifth frontier war (1818–19) began when Gaika was defeated by a neighbouring Xhosa group and the British intervened on his behalf, while the sixth war (1834–5) was initiated when the neutral zone broke down again and tensions between the once-segregated groups led 12,000 Xhosa to invade the Cape Colony. The seventh war (1846–7)

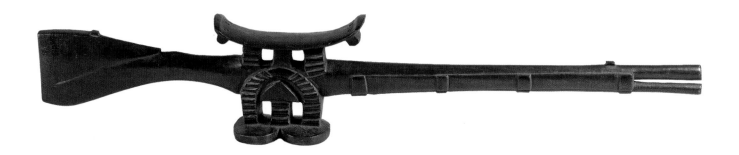

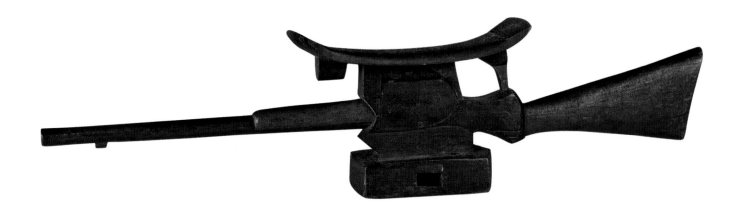

1 Knobkerrie headrest
Name(s) of artist(s) unrecorded,
c. 1850–99
Recorded as Tsonga
Wood, H. 15.2 cm | W. 61.9 cm
British Museum Af1954,+23.1825
Donated by the Wellcome
Historical Medical Museum

**2 Martini-Henry shaped
rifle headrest**
Name(s) of artist(s) unrecorded,
c. 1850–99
Recorded as Tsonga
Wood, H. 13.5 cm | W. 74 cm
British Museum Af1954,+23.1824
Donated by the Wellcome
Historical Medical Museum

**3 Lee-Speed shaped
rifle headrest**
Name(s) of artist(s) unrecorded,
c. 1850–99
Recorded as Tsonga
Wood, H. 16 cm | W. 66 cm
British Museum Af1979,01.4935

4 *Attack of the Kaffirs on the Troops under the Command of Lt Col. Fordyce of the 74th Highlanders, while forcing their way through the Kroomie Forest on the 8th September 1851*
J. Harris, after Thomas Baines, 1852
Coloured aquatint
Brown University Library

is known as the 'War of the Axe', after the alleged theft of an Afrikaner Boer's axe by a Xhosa man resulted in a British retaliatory invasion of Xhosa territory. The eighth and ninth wars (1850–53 and 1877–9) were the result of Xhosa rebellions against the increasingly restrictive territorial boundaries and rules imposed on them by the British.[9]

As early as 1829, Cowper Rose, an officer in the Royal Engineers sent with his regiment to fight the Xhosa, spoke out with remarkable candour concerning the iniquities of the colonial policy on the frontier:

> The policy adopted towards [the Xhosa] has been severe; for, when did Europeans respect the rights of the savage? By the Dutch Border-farmers, over whom their government had little control, they are said to have been slaughtered without mercy […] Some of the old chiefs inhabit tracts a hundred and fifty miles farther back than their former lands […] when one of them was ordered to quit it, he simply and affectingly said, 'that his fathers had eaten the wild honey of those hills, and he saw not why he should leave them' […] I hate the policy that turns the English soldier into the cold-blooded butcher of the unresisting native: I hate it even when, by the calculator, it might be considered expedient; but here it is as stupid as it is cruel.[10]

There are many paintings of the Xhosa Frontier Wars by British artists, including Thomas Baines (fig. 4), but it is conflict artworks made and/or used by the Xhosa that are the focus here. The first is an axe of unusual form for this part of southern Africa, with a broad blade and a long, slim haft made of ivory – the top of which is carved in the shape of a head – making it too fragile to be used as a weapon (fig. 7). When the axe was donated to the British Museum in 1949, a note attached to it stated that it was 'taken in the Gaika war'. This note may link the axe to the ninth of the frontier wars, which was known by the British as the Gaika-Galeka War. The axe was almost certainly not made in the area associated with the war, and neither

does its style appear anywhere in the established literature. But weapons were often traded over long distances, and at least one nineteenth-century account refers to weapons with rhinoceros-horn hafts coming from 'distant hordes' to the north for use among the Cape Nguni.[11] In light of the note that accompanied the axe, it seems reasonable to suggest that a British soldier took it as a trophy.

Other artworks associated with the Xhosa Frontier Wars include two ivory armbands donated to the British Museum in 1936 by Lady Cunynghame (figs 5 and 6), a descendant of Lieutenant General Sir Arthur Thurlow Cunynghame, the commander of British forces in South Africa from 1874 to 1878.[12] Xhosa chiefs wore one or more thick ivory armbands, or *umxhaka*, on the left arm above the elbow as a sign of honour and status;[13] such armbands were also given as a mark of favour to distinguished warriors, councillors and favourites.[14] Based on the inscription on the British Museum armbands, which reads 'the Galeka 1878', it seems likely that they too were 'collected' during the ninth frontier war, in this case by Lieutenant General Cunynghame.

The Anglo-Zulu War

The Anglo-Zulu War was fought between the British and Zulu armies in 1879. The pretext for the war was minor cross-border raids by Zulu soldiers and the subsequent refusal by King Cetshwayo kaMpande to meet an ultimatum laid down by the British, which demanded the king's abdication and the disarmament of his soldiers. Other theories, however, suggest that following the end of the Xhosa Frontier Wars, Sir Henry Bartle Frere, high commissioner for South Africa between 1877 and 1880, set about deliberately destroying the Zulu kingdom as part of a wider plan to unify all the kingdoms and colonies of South Africa under British rule. Three of the most famous battles from the Anglo-Zulu War are the Battle of Isandhlwana, the Battle of Rorke's Drift and the Battle

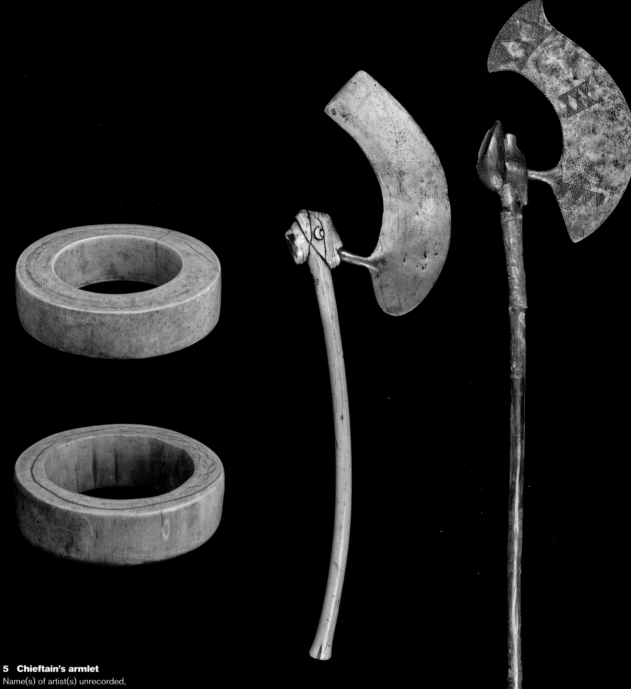

5 Chieftain's armlet
Name(s) of artist(s) unrecorded,
c. 1800–79
Recorded as Xhosa
Ivory, H. 3.5 cm | W. 11.5 cm
British Museum Af1936,1218.20
Donated by Lady Cunninghame

6 Chieftain's armlet
Name(s) of artist(s) unrecorded,
1800–99
Recorded as Xhosa
Ivory, H. 3 cm | W. 12.2 cm
British Museum Af1936,1218.19
Donated by Lady Cunninghame

7 Human figure axe
Name(s) of artist(s) unrecorded,
1800–99
Cultural identity unknown
Iron, ivory, fibre
H. 68.3 cm | W. 20.5 cm
British Museum Af1949,46.612
Purchased with contribution
from the Art Fund

8 Decorated axe
Name(s) of artist(s) unrecorded,
1800–99
Cultural identity unknown
Wood, iron, lead and fibre
H. 84.7 cm | W. 19.5 cm
British Museum Af1878,1101.536

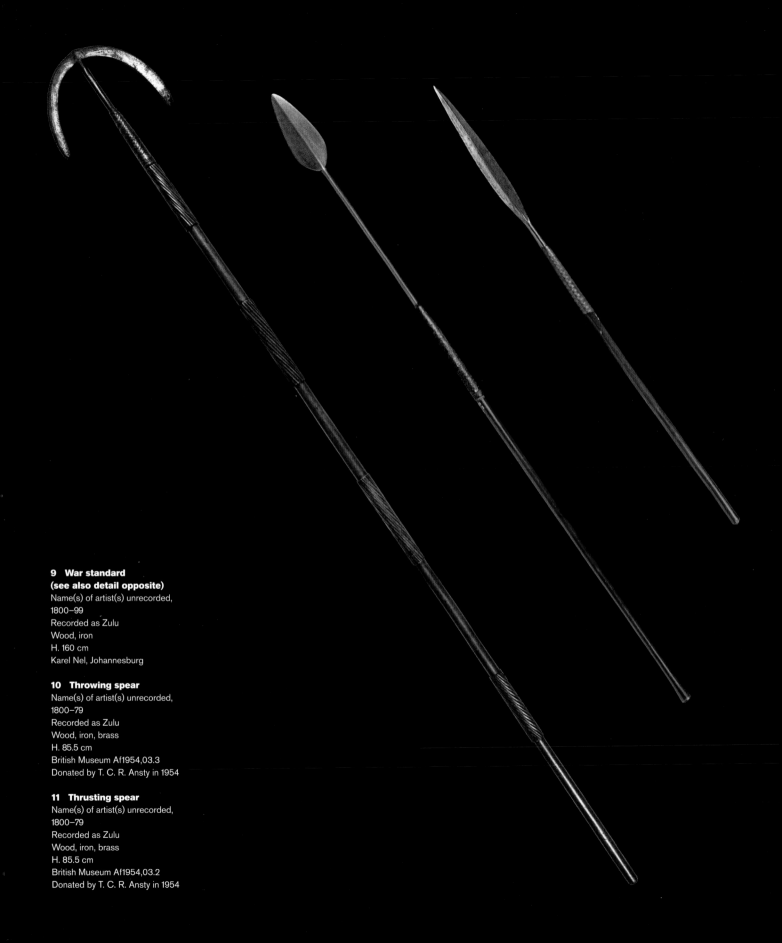

9 War standard
(see also detail opposite)
Name(s) of artist(s) unrecorded,
1800–99
Recorded as Zulu
Wood, iron
H. 160 cm
Karel Nel, Johannesburg

10 Throwing spear
Name(s) of artist(s) unrecorded,
1800–79
Recorded as Zulu
Wood, iron, brass
H. 85.5 cm
British Museum Af1954,03.3
Donated by T. C. R. Ansty in 1954

11 Thrusting spear
Name(s) of artist(s) unrecorded,
1800–79
Recorded as Zulu
Wood, iron, brass
H. 85.5 cm
British Museum Af1954,03.2
Donated by T. C. R. Ansty in 1954

of Ulundi. The last of these resulted in the capture of Ulundi, the Zulu capital, and marked the beginning of the dismantling of the Zulu kingdom.

The Battle of Isandhlwana was the first major encounter of the Anglo-Zulu War. In January 1879, in the hope of defeating the Zulu in one decisive action, the British sent three columns to attack Ulundi from three different directions. The central column was led by Lord Chelmsford, the then commander of British forces. On 20 January, Chelmsford's men set up camp at Isandhlwana Hill, where they mistook some minor local resistance for the main Zulu army. Wrongly assuming that he had seen off the army, Chelmsford split his forces and left half behind at Isandhlwana, unprepared for further attack and dangerously exposed. The following day, a small group of British soldiers left Isandhlwana to follow a Zulu raiding party and discovered 20,000 Zulu soldiers in a neighbouring valley. Having been found, the main Zulu army immediately attacked the remaining British forces at Isandhlwana.

During the attack, the Zulu army employed its traditional battle formation, the 'horns of the bull', to devastating effect. This formation imitated the horns, chest and loins of a bull, with the youngest and swiftest warriors, the black shields, making up the 'horns' in an attempt to surround the enemy and draw him into the 'chest', where the elite white shields would destroy him. Thought to have originated as a means of encircling game during a hunt, the formation is celebrated in the Zulu war standard, or *nhlendla* (fig. 9). Such objects have a crescent-shaped metal blade similar to those made for Zulu battle axes, but set into a wooden shaft so that it faces upwards rather than to the side. Only important chiefs and members of the Zulu royal family could carry the *nhlendla*.[15]

In addition to their disciplined battle formation, the Zulu had at their disposal an arsenal of weaponry and fighting skills that had been developed since the time of Shaka kaSenzangakhona (see page 73). Shaka's main innovation had been to substitute the short stabbing spear,

or *iklwa*, for the throwing spear, or *isijula*, with the short spear proving extremely effective in Zulu campaigns against other southern African peoples. When the Zulu were confronted by mounted European and other African opponents with guns, however, Shaka's successor, Dingane kaSenzangakhona, reintroduced the throwing spear as a weapon to be used alongside the *iklwa*. It was this combination that defeated the British at Isandhlwana.[16]

In 1954 examples of both kinds of spear were donated to the British Museum (figs 10 and 11). The spears' donor, Mr Anstey, reported that his father had retrieved them from the body of his brother, Lieutenant Edgar Oliphant Anstey, who had been killed at the Battle of Isandhlwana itself. Recognizing such objects as artworks when they are also efficient killing tools is of course contentious. However, in common with the other examples of Zulu weaponry discussed in this chapter, the spears were also symbols of Zulu power and identity, carefully crafted to conform to strict aesthetic principles.

Following the defeat of the British at Isandhlwana, most of the remaining troops retreated to Rorke's Drift, a small British garrison on the Buffalo River, the then border between the British colony of Natal and the Zulu kingdom. The next day, however, they were attacked by a group of Zulu reserves. Protected by a makeshift fort, the British were better able to use their rifles and bayonets, and the resulting victory served to distract the British

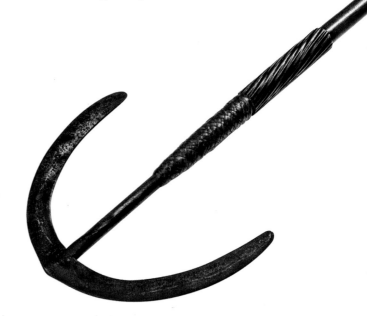

The Battle of Rorke's Drift about 1879 between Z OVanSilisa no Ma... y oualud 1879

and British, Started the Battle of Rorke's Drift.

1981

12 *The Battle of Rorke's Drift*
John Muafangejo, 1981
Linocut print on paper
H. 44.5 | W. 69.5 cm
Wits Art Museum, University of
the Witwatersrand, Johannesburg
Johannesburg 1986.20.19

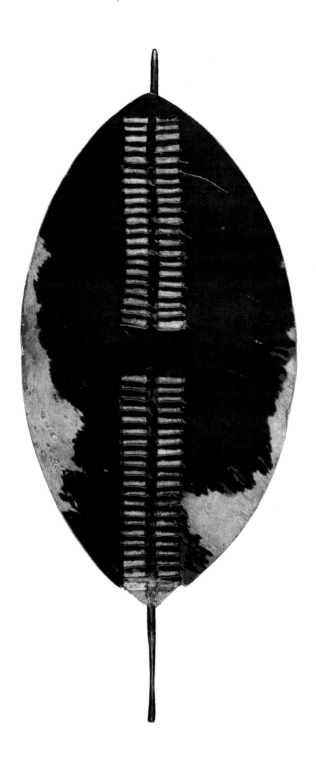

public from the crushing defeat of Isandhlwana. In Britain and internationally, the Battle of Rorke's Drift was made famous by the 1964 film *Zulu*, starring Michael Caine. This much-celebrated film offers a very British perspective on the battle, playing up the heroics of the British against the overwhelming strength-in-numbers of the Zulu.

A different way of thinking about the Battle of Rorke's Drift is provided by the Angolan/Namibian artist John Muafangejo (*c.* 1943–1987). In 1962 a Swedish initiative opened the Evangelical Lutheran Church Art and Craft Centre at Rorke's Drift. The centre became one of the most important institutions for black South African artists during apartheid, with Azaria Mbatha, Lionel Davis, Avhashoni Mainganye, Kagiso Patrick Mautloa and Sam Nhlengethwa all having taught or studied there. One of the centre's most famous alumni was John Muafangejo. In 1969, while studying at the centre, Muafangejo created the first version of his *The Battle of Rorke's Drift* (1981; fig. 12), a work that one of his teachers thought he should destroy because it was too political. The second version, created in 1981, is a much more complex composition, and was one of the pieces exhibited at the Commonwealth Institute in London in 1983 that prompted the art critic Edward Lucie-Smith to describe Muafangejo as 'a printmaker of world class'.[17] In this later version, the British soldiers, crammed into a tiny defensive position, are surrounded by the enormous and powerful figures of their Zulu opponents.

In July 1879, six months after the Battle of Rorke's Drift, the Battle of Ulundi saw Lord Chelmsford, bolstered by the arrival of British reinforcements, attack the Zulu capital and defeat Cetshwayo. The king fled, but was captured by the British and sent into exile in Cape Town. The Zulu shield illustrated here (fig. 13) is an artistic witness to these events. It was reportedly taken from Cetshwayo's enclosure in the wake of the battle by the finder of the Zulu spears, discussed above.

Zulu war shields, or *isihlangu*, are made from the hide of a cow. In addition to protecting a soldier's body, they were used to indicate his status and rank, with white

13 Oxhide shield
Name(s) of artist(s) unrecorded,
1800–79
Recorded as Zulu
Oxhide, H. 149 cm | W. 115 cm
British Museum Af1954,03.1

14 Ceremonial armlets
Name(s) of artist(s) unrecorded,
1800–99
Recorded as Zulu
Brass

Left to right:
H. 18 cm | W. 10 cm
British Museum Af1926,0612.1
Donated by G. R. Clarkson

H. 18.3 cm | W. 7.7 cm
British Museum Af1923,1010.1
Donated by Lady Mary Bruce

H. 16.2 cm | W. 9.2 cm
British Museum Af1934,0712.8
Donated by Major General
Sir Reginald Thynne

shields carried by the elite members of the army, black
by the young, and red by the reserves. This use of colour
was another of the military innovations introduced by
Shaka kaSenzangakhona. Shaka divided his regiments,
or *impi*, into different encampments, each with a herd
of cattle whose hide was of a colour appropriate to the
status of that regiment. It was from these hides that the
soldiers' shields were made. Running up the centre of each
shield are two columns of horizontal slits through which
strips of a differently coloured hide would be threaded
for reinforcement.[18] Shields were for both warfare and
ceremonial use, with their colour indicating a man's social
status in other areas of his life, such as his search for a
marriage partner.

The brass armlet, or *izingxotha*, is another symbol
of Zulu status and military strength (fig. 14). Similar
in function to the Xhosa ivory armbands, *umxhaka*, seen
earlier, the *izingxotha* is a broad gauntlet of brass once
worn on the right wrist by Zulu kings. In common with
umxhaka, it was distributed by the king to royal women,
isigodlo, and to notable warriors and men of status as part
of a system of royal patronage.[19] In Zulu society, as in
other parts of Africa, brass signified royal status, with its

use and production monopolized by the Zulu king. A royal
guild of brass smiths, higher in status than iron workers,
resided at a royal homestead, or *ikhanda*. Brass, in the form
of long bars or coils of wire, was originally obtained from
the Portuguese at Delagoa Bay (see page 65). The armlets,
whether with a ringed pattern or serrated *amasumpa* (warts)
design, were cast in moulds in shallow rock or sand before
being worked into shape. However, with the onset of
warfare in 1879 and the impact of European traders selling
brass implements to his people, it became increasingly
difficult for the Zulu king to maintain his monopoly.[20]
One of the three armlets illustrated here (fig. 14, left) was
donated to the British Museum by Major General Sir
Reginald Thynne, who had served in the Anglo-Zulu War.

After the Battle of Ulundi, the British set about
dismantling and, in the end, destroying the Zulu kingdom
by dividing it up into thirteen chiefdoms ruled by chiefs
allied to the British. Although Cetshwayo was reinstalled
as king in 1883, following a successful trip to Britain
to petition the government for the return of Zululand,
his power was greatly reduced. Zululand was annexed
by Britain in 1887, and then, in 1897, attached to the
British colony of Natal. Fighting between rival Zulu

factions and the British army continued throughout this period. Ultimately, however, Britain succeeded in destroying the Zulu kingdom by radically restructuring its administration.[21]

Remembering the Anglo-Zulu War

The story of the Anglo-Zulu War is recorded in a series of carved cattle horns from the late nineteenth century. They were engraved by artists who spoke isiZulu, but whose names were not recorded. Two pairs of these horns are held at the KwaZulu-Natal Museum, Pietermaritzburg, and two more at the British Museum (fig. 15). The KwaZulu-Natal horns differ from each other in both style and content: while one is more concerned with urban, domestic and religious subjects from the colonial period, the other provides very detailed descriptions of military personnel, including their uniforms, weapons and other equipment.[22] The images on the British Museum horns are closely linked to those on the second of the KwaZulu-Natal horns, suggesting that they may have been produced by the same artist. Although the practice of carving and engraving animal horns was certainly highly developed among Zulu artists of the time,[23] these horns are unique

in being the only known artworks produced by Zulu artists of the late nineteenth century that include engraved figurative images. It is possible that the use of cattle horns was inspired by the famous Zulu 'horns of the bull' battle formation.

For the horns' carvers to have created such a detailed record of events, they must have experienced the British at close quarters over a prolonged period of time. Indeed, as African soldiers made up half of the British army in the Anglo-Zulu War, they may have been members of the Natal Native Contingent, a group of soldiers recruited from the local population who fought for the British, and who therefore would have witnessed the scenes portrayed at first-hand.[24] The events depicted on the horns include the presence of the Naval Brigade, complete with men in rowing boats and artillery pieces supplied by HMS *Active* during the war; bearded soldiers (a concession granted by the army while on campaign);[25] Zulu soldiers and weaponry; and even a British cavalryman displaying his riding skills by standing on his head, a scene typical of the displays that took place at gymkhanas.

Although it seems likely that the horns were produced for a European (presumably British) market and may have been engraved by a Zulu ally of the British – and thus present colonial scenes – they nevertheless provide

15 Carved cattle horns and cranium (see also detail opposite)
Name(s) of artist(s) unrecorded, 1879–99
Recorded as Zulu
Animal bone, horn
H. 38 cm | W. 68 cm
British Museum Af1960,08.1a,b&c

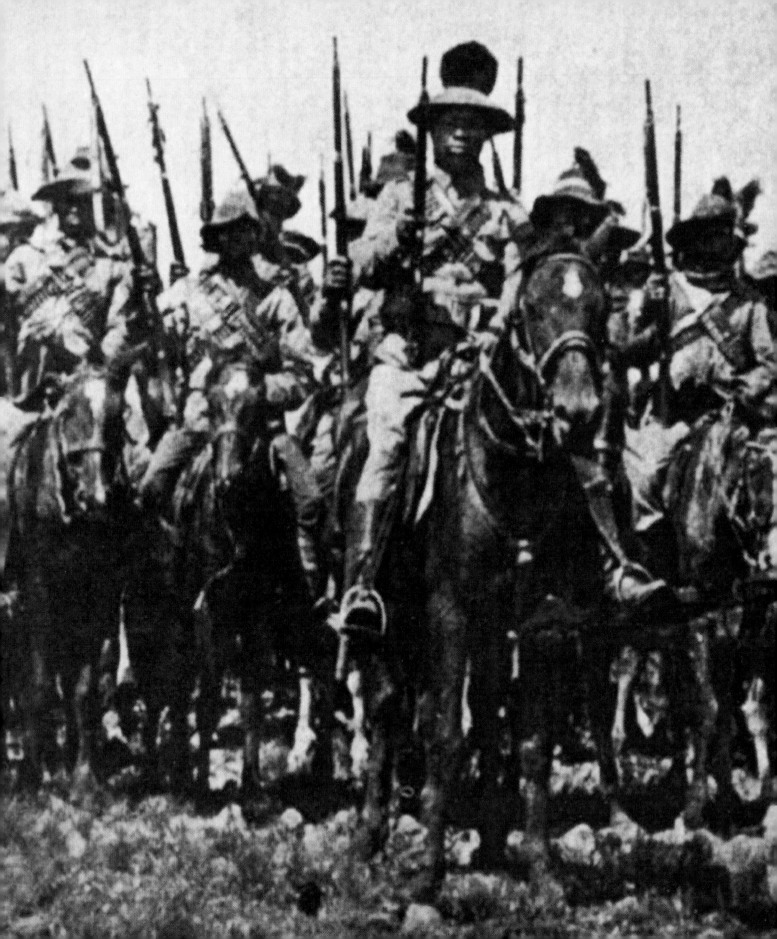

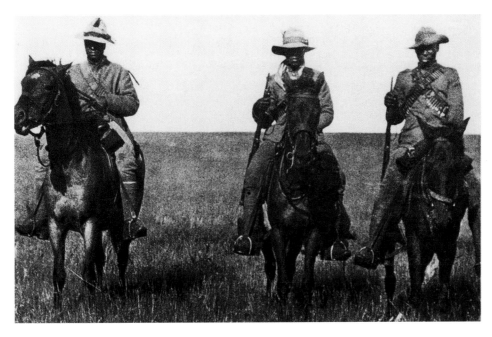

**16 Black commandos
on horseback**
Name(s) of artist(s) unrecorded,
1899–1902
Recorded as South African
Photographic print
The War Museum, Bloemfontein

**17 Three mounted black
commandos**
Name(s) of artist(s) unrecorded,
1899–1902
Recorded as South African
Photographic print
The War Museum, Bloemfontein

a valuable insight into warfare and life in late nineteenth-century South Africa.

The Second South African War

The two wars that took place between Britain and the Afrikaner Boer republics of the Transvaal and the Orange Free State in the final decades of the nineteenth century have been known by different names. While in British contexts they used to be called the First and Second Anglo-Boer Wars, Afrikaners called them the *Eerste Vryheidsoorlog* and *Tweede Vryheidsoorlog* (the First and Second Wars of Freedom). In recent decades, however, they have been renamed the South African Wars to reflect the fact that many different people were affected by and involved in them.

The first war (1880–81) was sparked by an Afrikaner Boer revolt against the British annexation of the Transvaal (formally known as the South African Republic) in 1877. However, it ended after only three months of conflict with a peace treaty that permitted Boer self-governance. By contrast, the second war (1899–1902) was much longer and more brutal. It resulted in the deaths of many thousands of Boer, British and British Empire soldiers, as well as the deaths of tens of thousands of black and white South African civilians, many of whom died in British concentration camps. Moreover, although it was supposed to be 'a white man's war', black South Africans were deployed on both sides. It is estimated that approximately 100,000 black South Africans served in the British forces and 14,000 in the Boer forces (figs 16 and 17).

A powerful commentary on the effects on the local population of the Second South African War is provided

by Helena Hugo's *Verbrande aarde, verbrande mens* (2013; fig. 18), which depicts a black female farmer in Victorian dress with two houses burning in the background. Hugo's painting, the title of which roughly translates as 'scorched earth, burnt man', makes a direct reference to the scorched-earth policy employed by the British army during the war (see below), and to the destruction of the livelihoods of black farmers who worked on white farms or who leased farmland from white farmers. As Hugo observes:

> These black workers and families are often neglected in the history of the Anglo-Boer War […] Too quickly we forget that the war and suffering was a collective experience; too often in history oppression repeats itself. Through this project I realized that we share a long and sensitive history. It is only by studying this history, by learning from it, that we can develop a compassion for each other.[26]

The root cause of both South African wars was the struggle over resources between the British colonies and the Afrikaner Boer republics that escalated in the mid- to late nineteenth century. After slavery was abolished in most of the British Empire in 1834, disgruntled Boer settlers – the Voortrekkers – embarked on what is known as the Great Trek, a migration from the Cape Colony to the interior of southern Africa. Moving along the coast to the east, they settled first in Natal. Following the British annexation of Natal in 1843, however, they continued north and inland, where they established two republics: the Transvaal and the Orange Free State, which were formally recognized by Britain in 1852 and 1854 respectively.

The discovery of diamonds in Kimberley in 1866 changed the political landscape dramatically, refocusing Britain's attention on the areas held by the Afrikaner Boers. In 1877, in an attempt to unite the whole of South Africa and thus reduce colonial expenditure, the British government annexed the Boer republics. Crucially, though,

it underestimated both the resentment this would cause and the capabilities of the Boer militia, which quickly beat the British into submission in the ensuing First South African War. The discovery of gold in the Transvaal in 1886, however, revived British expansionist ambitions.

Thousands of foreign, mostly British, migrants flooded into the Transvaal to work in the gold mines. So many arrived, in fact, that in some areas – notably in and around Johannesburg – they eventually outnumbered the Afrikaner Boers. The British pressed for voting rights for the migrants but were refused by the Boer government, which recognized the threat of a more inclusive democracy. In 1899 the British made a final demand for full voting rights. In response, Paul Kruger, president of the Transvaal from 1883 to 1900 (see page 119), issued an ultimatum for the British to remove their troops from the borders of the Transvaal. The ultimatum was ignored, and the republics declared war on Britain.[27]

At the heart of the Afrikaner Boer militia was the commando (*kommando* in Afrikaans), a group of armed, mounted farmers affiliated to a particular town and led by a *kommandant*. Compared to more traditional fighting units, commandos were better suited to warfare in South Africa's rugged landscape, and could be activated and disbanded when necessary. Boer commandos have a long history in South Africa. They were first formed in the mid-seventeenth century when war broke out between Khoekhoen herders and Dutch farmers. Later, they fought for the Dutch Batavian Army when the British took control of the Cape in 1806, and alongside the British in the Xhosa Frontier Wars. They also formed the main defences of the Boer republics, which were without standing armies.

The farmers who made up the commandos were expert marksmen well practised in the saddle, making them highly effective against the slower, heavier British troops. It was because of the farmers' skills that the First South African War was brought to a swift conclusion in the Afrikaner Boers' favour. The British artist Charles Wellington Furse, who visited South Africa in 1895 for his health, sketched

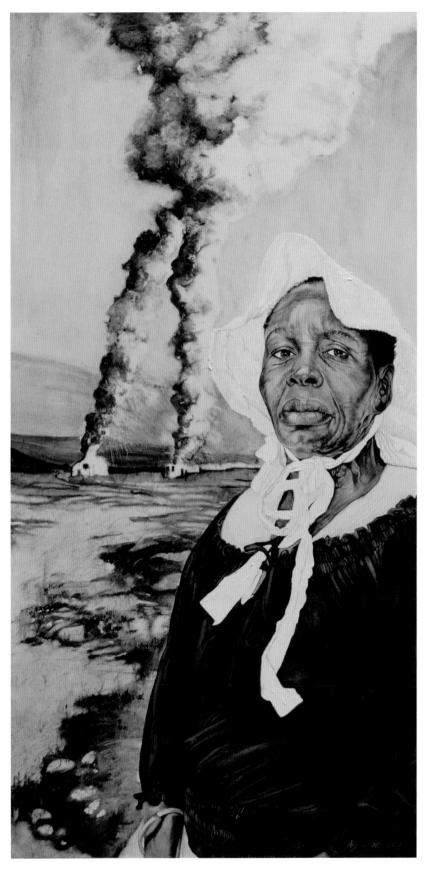

18 *Verbrande aarde,*
verbrande mens
Helena Hugo, 2013
Oil on board
H. 80 cm | W. 41.5 cm
The War Museum, Bloemfontein
07361/00001

19 Boer commandos sketch
Charles Wellington Furse, *c*. 1895
Graphite on paper
H. 22 cm | W. 43.9 cm
British Museum 1907,1018.5

**20 Boer commando
horse sketches**
Charles Wellington Furse, *c*. 1895
Graphite on paper
H. 22 cm | W. 43.9 cm
British Museum 1907,1018.30-31

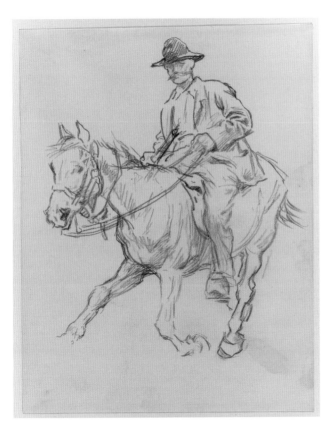

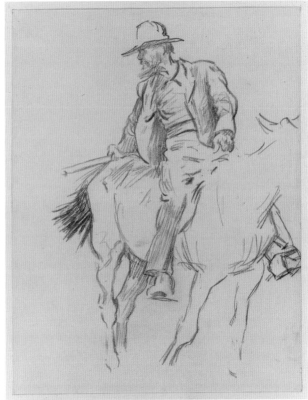

21 Concentration camp plate
Miss Hamelberg, *c.* 1900
Unglazed earthenware,
paper, adhesive
Diam. 36.1 cm
Museum Africa, Johannesburg
MA1972/606

22 British military tunic
Name(s) of artist(s) unrecorded,
c. 1902
Recorded as British
Fabric and ink
H. 75 cm | W. 51 cm
Museum Africa, Johannesburg
MA1967/709

a number of these farmers (figs 19 and 20). Furse's collection of sketches presents the commando member as a man of great horsemanship, wearing his own clothes and carrying his own rifle, stealthily climbing through the rocky landscape to find the right spot from which to fire his weapon.

At the start of the Second South African War, in 1899, Afrikaner Boer commandos were again used to devastating effect in pre-emptive strikes against the British. The following year, the British responded with large-scale reinforcements against the Boers, enabling them to relieve towns under siege and invade the Transvaal. From this point on, the war was effectively won. However, elements of the Boer commandos battled on. Known as *bittereinders* (literally, 'bitter-enders'), these fighters were able to use their greater mobility and knowledge of the landscape to evade the British and prolong the war by two years. In the face of such resistance, lords Kitchener, Milner and Roberts – key figures in the leadership of the British forces – were persuaded to begin the systematic destruction of Boer farms and homesteads in order to weaken the resolve of the Boer fighters. As Boer homes were set on fire, Boer women, children and the remaining men were interred in concentration camps. Black South Africans who worked on Boer farms or leased land from Boer farmers were forced into separate camps. In total, 116,000 Boers were imprisoned in the camps; the total number of imprisoned black South Africans was not recorded. Life in the camps was brutal: by the end of the war, an estimated 27,000 Boer women and children and 20,000 black South African women and children had died. Owing to the failure to keep accurate records, the number of black South African deaths may have been much higher.[28]

Detailed accounts of conditions in the concentration camps were provided by Emily Hobhouse, a British welfare campaigner. Hobhouse's first-hand descriptions of these sites, which were euphemistically described by the British government as 'refugee camps', paint a grim picture of the truth behind the façade:

It can never be wiped out of the memories of the people. It presses hardest on the children. They droop in the terrible heat, and with the insufficient unsuitable food; whatever you do, whatever the authorities do, and they are, I believe, doing their best with very limited means, it is all only a miserable patch on a great ill. Thousands, physically unfit, are placed in conditions of life which they have not strength to endure. In front of them is blank ruin [...] If only the English people would try to exercise a little imagination – picture the whole miserable scene. Entire villages rooted up and dumped in a strange, bare place.[29]

South African art, past and present, has borne witness to both the concentration camps and the scorched-earth policy, with artists responding to these atrocities in many different ways. A plate decorated by a Miss Hamelburg in the Bethlehem concentration camp speaks of one of the few pleasures that internees had in the camps: the artistic embellishment of otherwise domestic, everyday objects (fig. 21). The unglazed earthenware plate decorated with postage stamps stands as a testament to the artistic creativity of the internees in the face of brutal oppression, and to their use of that creativity to inspire a sense of hope amid the spectre of mass mortality.

The creation of art by those directly involved in or affected by the war was not confined to Afrikaner Boer women. A British soldier, whose name was not recorded, painted twelve scenes from the Second South African War in ink on a military tunic (fig. 22). As explained by the curators of the exhibition *Democracy X* (2004):

[the] scenes evoke the rural landscape of the war, with remote farmsteads, koppies, and tented camps. The steamship is a reminder of the wider imperial meaning of the war, underlining the importance of the Cape sea-route to the British Empire. One's gaze is also drawn to a burning farmhouse – a warning about the destructiveness of this war on South African soil.[30]

23 *The Watchers*
Francki Burger, 2014
Photographic print
H. 40 cm | W. 70 cm
British Museum 2016,2011.1

The theme of scorched earth and concentration camps is referred to again in Francki Burger's series *Battlefields* (2014). Burger's artistic practice involves the layering of contemporary and archival photographs to suggest the landscape of South Africa in flux, shaped by politics, race and violence. For *Battlefields*, Burger worked with archival images created by both official and amateur photographers to produce multilayered representations of landscapes affected by conflict. Concerned with issues of land, memory, identity and trauma, the images in *Battlefields* address such conflicts as the Xhosa Frontier Wars, the Anglo-Zulu War and the Second South African War. *The Watchers*, for example, is a combination of a recent photo of the Spion Kop battlefield, showing historic features created during the war, overlain with the photographs of two children waiting at a train station to be taken to a concentration camp (fig. 23). This work captures both a sense of Afrikaner Boer pride in the outcome of the Battle of Spion Kop, in which 8,000 Boer fighters defeated 20,000 British soldiers sent to relieve the besieged town of Ladysmith, and the traumatic memory of the imprisonment and death of children in internment camps. Spion Kop subsequently gave its name to the 'Kop' at Liverpool F. C.'s Anfield ground in memory of the many soldiers of the Lancashire Regiment who died in the battle.

The Second South African War came to an end with the signing of the Treaty of Vereeniging in 1902. Despite the effective defeat of the Afrikaner Boers, it is a testament to their skills and belief that for the three years of the conflict 80,000 Boer fighters were able to resist 450,000 British soldiers. Among some South Africans, the war lives on as an important part of their collective memory, not only in terms of the heroics of the commandos, but also

in terms of the tragic and brutal oppression of their ancestors as their farms were burned and their loved ones interred in concentration camps.

Remembering the Second South African War

The immediate impact of defeat on an Afrikaner Boer leader is captured in *Kruger in Exile* (1907; fig. 24) by Anton van Wouw (1862–1945). In 1890 Van Wouw left his native Netherlands for South Africa, where he lived until his death. Following his arrival, Van Wouw became involved in the Boer struggle, and over the course of his working life he returned numerous times to the subject of Paul Kruger, a Boer hero. Kruger took part in the Great Trek, was witness to the establishment of the Transvaal, and was made commandant-general of the republic in 1863 and president in 1883 – an impressive list of achievements for a once-poor migrant farmer.[31]

During the Second South African War, Kruger and his government fled Pretoria as the tide began to turn against the Afrikaner Boers. With the intention of gaining support for the Boer cause and avoiding capture, Kruger left South Africa for Europe on 11 September 1900. At the end of the war, unwilling to return to his beloved South Africa to live under British rule, he chose to exile himself in Switzerland. He died in the village of Clarens in 1904.

Van Wouw's sculpture depicts Kruger at the end of his life. Here, the work is described by the art historian A. E. Duffey:

> [*Kruger in Exile*] shows a dejected President Kruger as an old man seated in a large easy chair with a blanket over his knees and a great State Bible on his lap. The old President holds the top of the Book with his right hand and rests his left arm on the armrest of the chair. His eyes are not on the Bible, but stare into the uncertain, unfathomable future. He bends pensively over the great Book and in front of him on the Bible lies a crumpled handkerchief. With this small sculpture Van Wouw gives us a glimpse into the lonely old President, far from his homeland, sad and alone.[32]

The loss of the Afrikaner Boer republics was, Van Wouw's sculpture appears to suggest, too much for Kruger to bear.

Although Van Wouw is now revered as one of the fathers of white South African sculpture, an extract from the diary of a collector of his work describes the artist's struggle for recognition among the Boers:

> [Van Wouw] arrives, seems weary and dejected, a disappointed man. I refer to his 'Kruger in Exile', saying that it ought to be in the house of every well-to-do Transvaal farmer, but he smiles sadly and shakes his head. 'I've got 16 of them and had the greatest difficulty in disposing of that number.' More than half the buyers were English – alas![33]

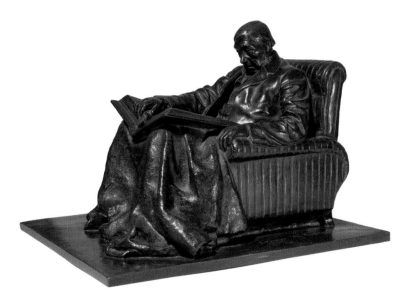

24 *Kruger in Exile*
Anton van Wouw, 1907
Bronze, H. 24.5 cm | W. 34 cm
Private collection, London

Chapter 5 **Rural art in the 1800s**

Although many rural artworks by San | Bushmen, Khoekhoen and black South Africans survive from the 1800s, their stories and the individual voices of the artists who made them were rarely recorded. We know the names of some artists, such as Unobadula, a Zulu master carver who was commissioned to make works for the International Exhibition of 1862 held in London (fig. 1); and sometimes we can also attribute multiple works to a single, unnamed artist, such as the so-called Baboon Master, a Tsonga artist who made elaborately carved staffs for a European market in the late nineteenth century (fig. 2).[1] In most cases, though, personal details and individual intentions either were not recorded or have been lost. As a consequence, we lack information regarding the names and lives of most of the artists whose work is discussed in this chapter.

Much of the art that was produced during this period was collected by Europeans. Their choices, however, were often informed by the racial beliefs of the period, meaning that, from a modern perspective, their collections are problematically biased. But without the undertakings of European collectors, many South African artworks might have been lost for good. Indeed, owing to the absence of earlier colonial collecting, it is not possible to present as wide a variety of artworks from before the nineteenth century, since few have been preserved. Of course, if there had been no colonial presence in South Africa, some artworks might have been maintained in the homes of their original owners and inherited by their descendants. As it is, we are left with a range of superb artworks that demonstrate the skill, creativity and concerns of San | Bushmen, Khoekhoen and black South African artists in the nineteenth century, albeit as part of collections driven by colonial ideologies.

In discussing these issues, we have chosen to concentrate on artworks that relate to the body. This focus on the human form reflects the collecting practices of the period, which were often an attempt to collect and objectify people – including their bodies – through the ownership of their artworks.

1 Carved throne
Unobadula, made before 1862
Wood, H. 93.5 cm | W. 49 cm
British Museum Af1979,01.2800

2 Staff
Artist's moniker: The Baboon Master, 1850–99
Wood, beadwork, fibre
H. 116 cm | W. 5.5 cm
British Museum Af1954,+23.1337
Donated by the Wellcome Historical Medical Museum

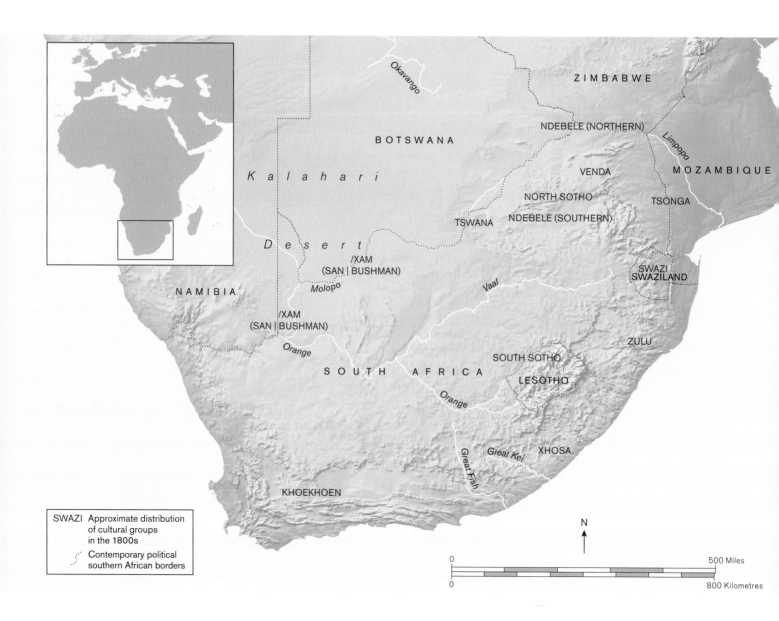

SWAZI Approximate distribution
 of cultural groups
 in the 1800s

‥‥‥ Contemporary political
 southern African borders

**Map of the approximate
location of cultural groups
in the 1800s in South Africa**

Artworks as bodies

Drawing on the metaphorical power of the human body, artists of the nineteenth century often used bodily features to embellish otherwise non-figurative artworks. Such features were used to communicate the functional and symbolic importance of their creations, as well as other social information. Vessels were often treated in this way. Here, in order to illustrate the 'artwork as body' metaphor, we consider two types of carved wooden vessel associated with isiZulu speakers.

The first is the *ithunga* (pl. *amathunga*), a tall, narrow milk pail with distinctive carved female features. These features include raised areas at both the top of the vessel and around its body, representing, respectively, breasts and the scarification often applied to women's bodies. Such features were sometimes accentuated by pyrography, a mark-making technique used to decorate wood by burning. The incorporation of female features into the *amathunga* links them symbolically to breastfeeding, sustenance and the importance of cattle and milk.[2] The three *amathunga* shown here (figs 3–5) were collected by Garnet Joseph Wolseley, 1st Viscount Wolseley, between 1879 and 1880 when he was governor and high commissioner of Natal.

Despite the symbolic connections between *amathunga* and the female body, they were not used by women. Rather, *amathunga* could be commissioned only by the male head of a homestead. They were made and used only by men because they were employed in the milking of cattle – traditionally, a male domain.[3] Milking would be carried out mid-morning by boys, who would kneel beneath the cows with the *amathunga* clasped between their legs and held firmly by the 'breasts' for extra grip.[4] *Amathunga* never left the cattle enclosures. Instead, the fresh milk was immediately decanted into large calabash vessels made by women, who used them to ferment *amasi* (soured milk), a once important part of the Zulu diet. In this way, the milk moved from the male to the female domain.

The design features of the *amathunga* may have developed during the early nineteenth century as a way of identifying objects closely associated with the Zulu royal house and its rapidly expanding sphere of influence. Traditionally, *amathunga* were carried high in the air, partly to avoid the milk becoming contaminated with dust, and partly to honour the cattle. It has been suggested, therefore, that the first *amathunga* to be decorated with female motifs were those belonging to the royal household, to indicate that the milk was from the king's herd.[5]

The second type of carved wooden vessel is far more elaborate than the *amathunga*, but was also associated with Nguni speakers – such as the Zulu – and carved from a single piece of wood. These vessels were not everyday items, and may never have been used as containers. Instead, they are believed to have been made to demonstrate the woodcarving skills of a particular artist or workshop, and were obtained by high-status individuals to decorate their homes and demonstrate their power. A question remains as to whether these were made for a black South African market, a white market, or both.[6]

The example illustrated here (fig. 6) features four vertical handles joined at the top and bottom by two circular ones. The vessel itself sits on four feet, and has been decorated all over with deep parallel grooves accentuated by pyrography. In terms of the vessel-as-body metaphor, two lids at the top represent breasts, while the grooves may represent the comparable grooves in a Zulu women's traditional dress.

Affecting the body

In nineteenth-century South Africa, ceremonies involving the ritual consumption of various substances were powerful ways in which people altered their consciousness and state of being. As we have seen, such transformations were illustrated in rock paintings related to the trance dance (see pages 18 and 36). Other artworks, however, were made to enable these transformative practices, including tobacco consumption.

3 Milk pot
Name(s) of artist(s) unrecorded,
1850–80
Recorded as Zulu
Wood, H. 55.7 cm | W. 17.5 cm
British Museum Af1917,1103.5
Donated by Dowager
Viscountess Louisa Wolseley

4 Milk pot
Name(s) of artist(s) unrecorded,
1800–80
Recorded as Zulu
Wood, H. 46.3 cm | W. 17.5 cm
British Museum Af1917,1103.8
Donated by Dowager
Viscountess Louisa Wolseley

5 Milk pot
Name(s) of artist(s) unrecorded,
1800–80
Recorded as Zulu
Wood, H. 52.6 cm | W. 17.5 cm
British Museum Af1917,1103.7
Donated by Dowager
Viscountess Louisa Wolseley

6 Ornamental vessel
Name(s) of artist(s) unrecorded,
1800–69
Recorded as Zulu
Wood, H. 33 cm | W. 34 cm
British Museum Af.1561.a-c
Donated by Henry Christy

Following its introduction into southern Africa in the sixteenth century by the Portuguese, tobacco soon became an important part of San|Bushmen, Khoekhoen and black South African life. The consumption of tobacco, whether by smoking a pipe or snorting it from a spoon in the form of snuff, became both a social and spiritual act, celebrating on the one hand the status and generosity of individuals within a larger group, and on the other a means of transforming and transporting the body into the realm of the ancestors. By the nineteenth century, for example, Venda, Tsonga and Xhosa people were using tobacco for divination, while among the Zulu it played an important role in feasting, for both men and women:

[It] was a formal part of many major feasts and was enjoyed equally by the living and the spirits of the dead [...] The Zulu placed beer, meat and snuff on the *umsamo* (a small raised platform at the back of the hut which is the place where the ancestors sit).[7]

Although tobacco was consumed by both sexes, its cultivation and the making of accessories were men's work, associated with virility and procreation. This stands in marked contrast to the production of another transformative substance: beer. Linked to fertility and birth, it was brewed in large ceramic vessels by women.

The importance of tobacco in nineteenth-century South Africa is demonstrated by the huge range of paraphernalia that was produced around its consumption. Below we focus on snuffboxes, snuff-spoons and pipes.

Snuffboxes were created in a wide variety of forms using a diverse array of materials. Although highly personal, they were worn or carried in ways that would make them highly conspicuous. Snuff containers, for example, such as the horn snuffbox with one bulbous and one pointed end illustrated here (fig. 7), might be pushed into the hair, tucked into an armband or head -ring, or hung round the neck or waist. They might even be inserted into a pierced earlobe, as depicted by George French Angas in his mid-nineteenth-century print of Zulu blacksmiths (fig. 8).[8] In wearing a snuffbox so conspicuously, the owner communicated a wealth of information, including his or her social rank, wealth, ethnicity and/or marital status.

The British Museum holds a range of snuffboxes in its collection, several of which are illustrated here. However, their makers' names were not recorded; instead, the snuffboxes were attributed variously to Xhosa, Zulu, Tsonga, Sotho and/or Tswana cultural groups. Below, we discuss the snuffboxes according to their design: those that are figurative, those that present more abstract forms and decoration, and those that are combined with other artworks, such as headrests and knobkerries.

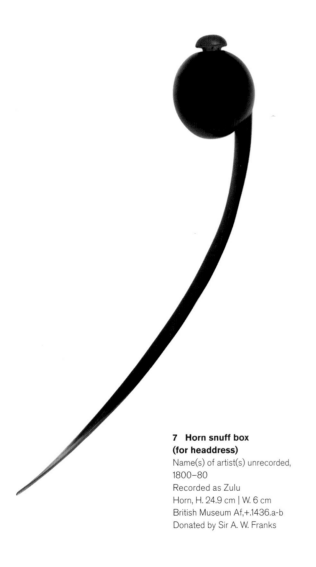

**7 Horn snuff box
(for headdress)**
Name(s) of artist(s) unrecorded,
1800–80
Recorded as Zulu
Horn, H. 24.9 cm | W. 6 cm
British Museum Af,+.1436.a-b
Donated by Sir A. W. Franks

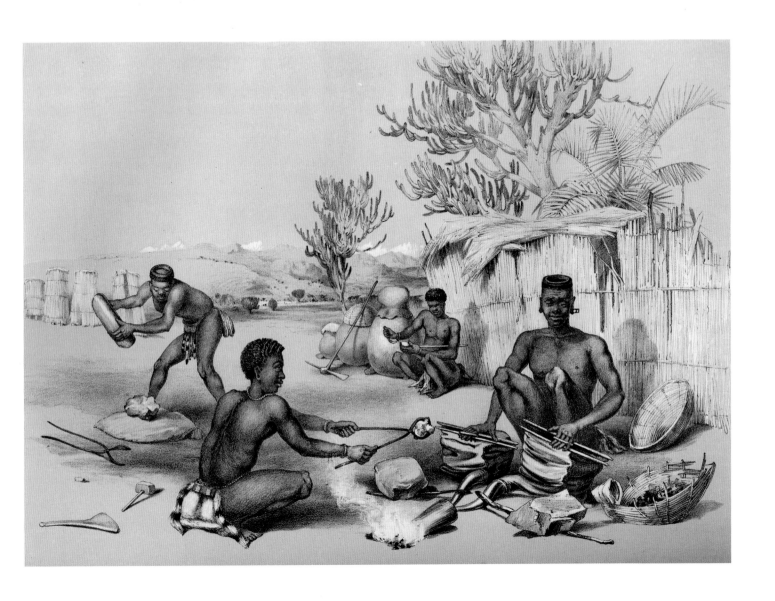

**8 'Zulu Blacksmiths',
from *The Kafirs Illustrated***
George French Angas, 1849
Ink on paper (leather-bound book)
H. 14.5 cm | W. 67.5 cm
British Museum, Anthropology
Library & Research Centre

9 Ox snuff box
Name(s) of artist(s) unrecorded,
1850–99
Recorded as Xhosa
Sinew, blood, hair, H. 9.8 cm | W. 7.5 cm
British Museum Af1910,1005.63
Donated by Sir Bartle Frere

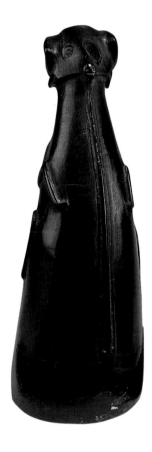

10 Human figurine snuff box
Name(s) of artist(s) unrecorded,
1800–99
Recorded as South Sotho
Horn, wood, H. 12 cm | W. 4.3 cm
British Museum Af1949,46.600
Purchased with contribution
from the Art Fund

11 Cattle figurine snuff box
Name(s) of artist(s) unrecorded,
1800–99
Recorded as South Sotho
Horn, wood, H. 11.2 cm | W. 4.5 cm
British Museum Af1949,46.599
Purchased with contribution
from the Art Fund

The first figurative snuffbox we have chosen to look at is a famous ox-shaped design often attributed to Xhosa artists (fig. 9). Cattle are frequently referred to in both the design and the materials of snuffboxes, linking two traditionally male domains. To create this particular snuffbox, the artist covered a clay core with a paste composed of scrapings of hide mixed with cattle blood and small amounts of clay. While this coating was still malleable, the artist used a sharp implement to raise the 'hide of the ox-snuffbox into numerous spiky protuberances. When the coating was dry, a small aperture was made between the animal's horns so that the clay mould could be removed, ready for the insertion of snuff. It has been suggested that the cattle blood and skin were taken from animals sacrificed to the ancestors, imbuing the snuffbox with additional power.[9]

An equally distinctive type of figurative snuffbox is the kind made from the tip of an animal's horn. Attributed to South Sotho artists, these snuffboxes typically take the form of a carved male, female or cow-like figure, with the curved, gracefully tapering horn tip providing a basic body shape (figs 10 and 11). To turn it into a snuffbox, the carved horn would be plugged at its base and then drilled with a small hole about two-thirds of the way up, allowing it to be filled with snuff. These vessels are distinctly phallic, their Sotho name, *koma*, meaning both 'snuffbox' and 'penis'.[10] Speakers of Sesotho used tobacco to clear their minds so they could better communicate with the ancestors, while

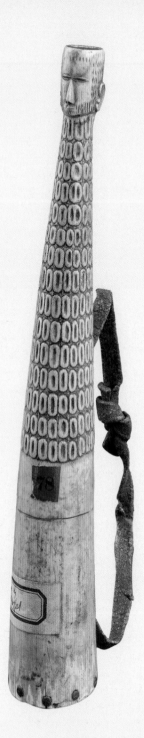

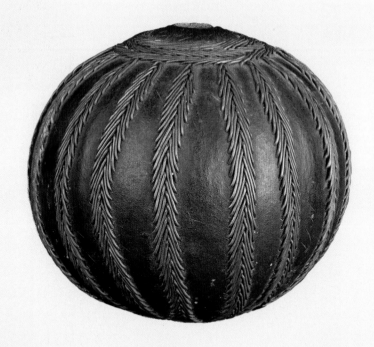

12 Ivory snuff box
Name(s) of artist(s) unrecorded,
1800–99
Recorded as Tswana
Ivory, wood, leather
H. 20 cm | W. 3.5 cm
British Museum Af1910,-.384.a

13 Gourd snuff box
Name(s) of artist(s) unrecorded,
1800–99
Recorded as Zulu
Gourd, brass
H. 6.1 cm | W. 7.5 cm
British Museum Af,Br.133

the snuffboxes themselves were exchanged during marriage ceremonies. In choosing to combine notions of male sexual power with male, female and cattle figures in a snuffbox exchanged at weddings, the creators of these artworks were addressing the symbolic relationship between fertility, cattle and the ancestors.[11] Some of the snuffboxes made by Setswana-speaking artists are similar in form, although they are often made from ivory (fig. 12).

A range of non-figurative snuffboxes was also produced in the nineteenth century. Zulu artists were renowned for their snuffboxes made of hollowed gourds or shell fruit decorated with copper and brass in various geometric designs (fig. 13). These can be contrasted with the beaded-gourd snuffboxes made by Xhosa artists (fig. 16). Zulu artists were also known for their snuffboxes of worked horn. The example illustrated here (fig. 17) has an engraving on its base: 'John Dryden Snuff Box Wills Coffee House. Bow St. 1672'. Tobacco had already arrived in the region by this point, so it is possible that the snuffbox was acquired on the South African coast by a sailor en route to the East Indies in the seventeenth century, and that it then found its way to London. Given, however, that the colonial settlement of South Africa had begun only twenty years earlier, in 1652, and that early encounters in the southern African interior were mostly with Khoekhoen herders in the Cape, the inscription may have been added at a later date, possibly in the nineteenth century, perhaps to increase its value. Whatever the truth of the matter, the association of the snuffbox with Dryden – seventeenth-century playwright, poet, snuff-user and frequenter of Will's Coffee House on Bow Street – says something about its reception in London society and the perception of its historical importance, aesthetic qualities and antiquity.

Snuffboxes were also combined with such objects as headrests and staffs. In the example illustrated here, the double-headrest form typical of Tsonga artists has been embellished with two snuffboxes at either end (fig. 15). Headrests provided a bridge to the spirit world, as did the taking of snuff, and it was common practice among the Tsonga to rub some snuff on their headrest – for the appreciation of the ancestors – before making use of it.[12] (It has been suggested that the chain links seen in the double headrest, as well as in many other examples of Tsonga woodcarving, were developed in response to Portuguese and Arab slave trading along the south-east coast of Africa.)[13] Other artists chose to combine snuffboxes with knobkerries, as demonstrated by an example attributed to Zulu (fig. 14). As in the case of the headrests, the incorporation of a snuffbox into what is a presumably ornamental knobkerrie makes a metaphorical link between the spiritual power of tobacco and the power of the holder of the staff.

In terms of the actual consumption of tobacco, it was typically ingested in one of two ways: by snorting it from a spoon in the form of snuff, or by smoking it in a pipe. The snuff-spoons shown here are part spoon and part comb (figs 18 and 19). Although such objects may have been used for hair preparation, they would also have been worn in the hair, providing their owners with visible bodily decoration and an easily accessible snuff tool.

The practice of smoking tobacco in a pipe was much less widespread in South Africa than the taking of snuff. The earliest tobacco pipes were delicately carved and decorated tubes of either bone or stone – usually steatite – made by San|Bushmen (fig. 20). They had no 'bowl', as such, but were simply wider at one end, tapering towards a narrow mouthpiece.[14] Thereafter, pipes were based on European designs, particularly early Dutch or German examples, although in the hands of South African artists the designs became far more elaborate.

In common with snuffboxes, tobacco pipes can be divided into those that are figurative in appearance and those of a more simple and/or abstract design. A famous example of the former are the horse-shaped pipes commonly attributed to South Sotho speakers (fig. 21). As a foreign introduction to South Africa, the horse was adopted by relatively few San|Bushmen, Khoekhoen and black South Africans. In the nineteenth century, however, San|Bushmen living in the Maloti Mountains of Lesotho,

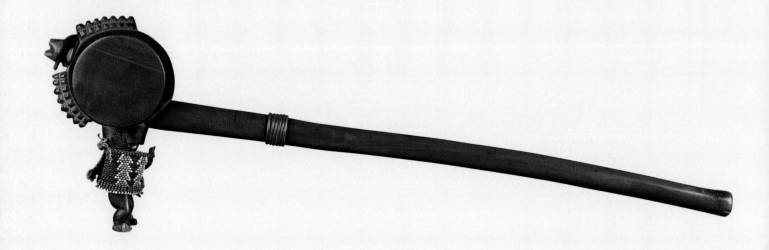

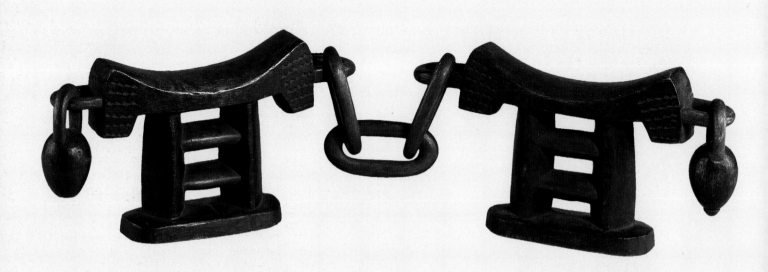

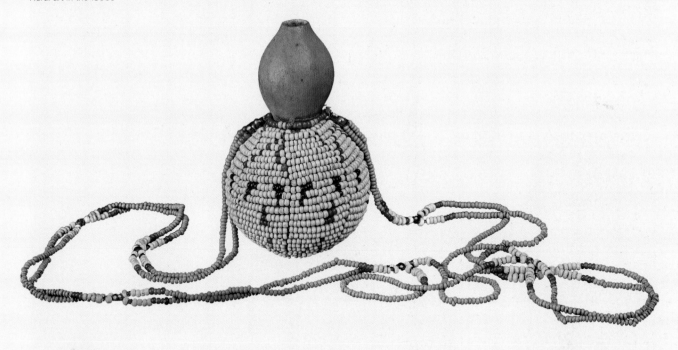

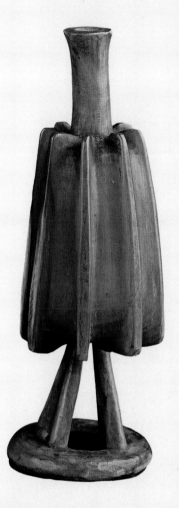

14 Ornamental knobkerrie snuff box
Name(s) of artist(s) unrecorded, 1800–99
Recorded as Zulu
Wood, glass, cotton, resin
H. 16 cm | W. 60 cm
British Museum Af1954,+23.62
Donated by the Wellcome Historical Medical Museum

15 Headrest snuff boxes
Name(s) of artist(s) unrecorded, 1850–99
Recorded as Tsonga
Wood, metal
H. 17.5 cm | W. 85.5 cm
British Museum Af1939,03,01

16 Beaded snuff box
Name(s) of artist(s) unrecorded, 1800–80
Recorded as Xhosa
Gourd, glass, fibre
H. 64.5 cm | W. 7.5 cm (incl. cord)
British Museum Af1883,0608.1
Donated by Thomas Pike

17 Horn snuff box
Name(s) of artist(s) unrecorded, 1800–99
Recorded as Zulu
Horn, metal
H. 14 cm | W. 5 cm
British Museum Af1954,+23.591
Donated by Wellcome Institute for the History of Medicine

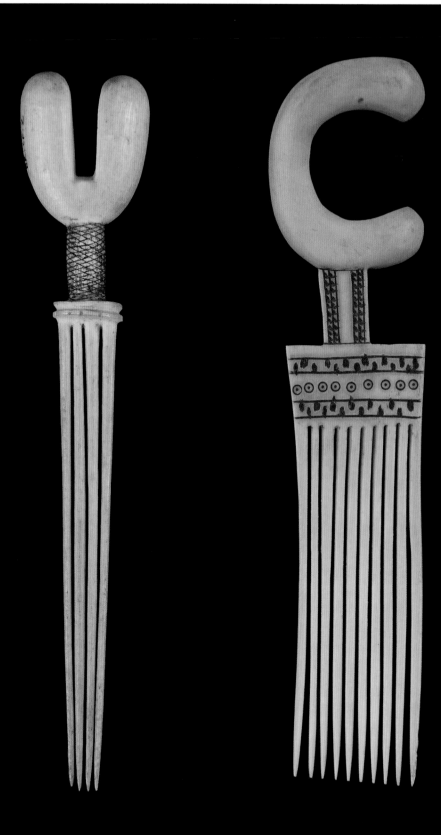

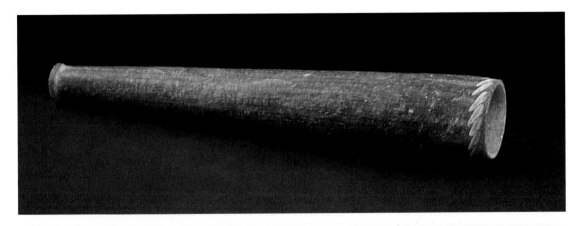

18 Snuff-spoon comb
Name(s) of artist(s) unrecorded,
1800–95
Recorded as Zulu
Bone, H. 22 cm | W. 5 cm
British Museum Af1895,0806.10
Donated by A. Byrne

19 Snuff-spoon comb
Name(s) of artist(s) unrecorded,
1800–82
Recorded as Zulu
Bone, H. 14.6 cm | W. 3 cm
British Museum Af,Cf.2

20 Pipe
Name(s) of artist(s) unrecorded,
1800–99
Recorded as San | Bushman
Steatite, H. 11 cm | Diam. 0.9 cm
British Museum Af.9034
Donated by Dr W. H. I. Bleek

21 Horse-shaped pipe
Name(s) of artist(s) unrecorded,
1860–93
Recorded as Sotho
Wood, H. 7.5 cm | W. 3 cm
British Museum Af1905,-.64
Donated by Jeffrey Whitehead

22 Pipe
Name(s) of artist(s) unrecorded,
1850–79
Recorded as Xhosa
Wood, metal, H. 7.5 cm | W. 3 cm
British Museum Af1936,1218.17
Donated by Lady Cunninghame

23 Pipe
Name(s) of artist(s) unrecorded,
1860–93
Recorded as Xhosa
Wood
H. 13.2 cm | W. 2.8 cm | L. 47.5 cm
British Museum Af1905,-.71
Donated by Jeffrey Whitehead

24 'A Wayside Chat', from
The Bantu Tribes of South Africa
Alfred Martin Duggan-Cronin,
1928–54
Photographic print
H. 30 cm | W. 22 cm
McGregor Museum, Kimberley

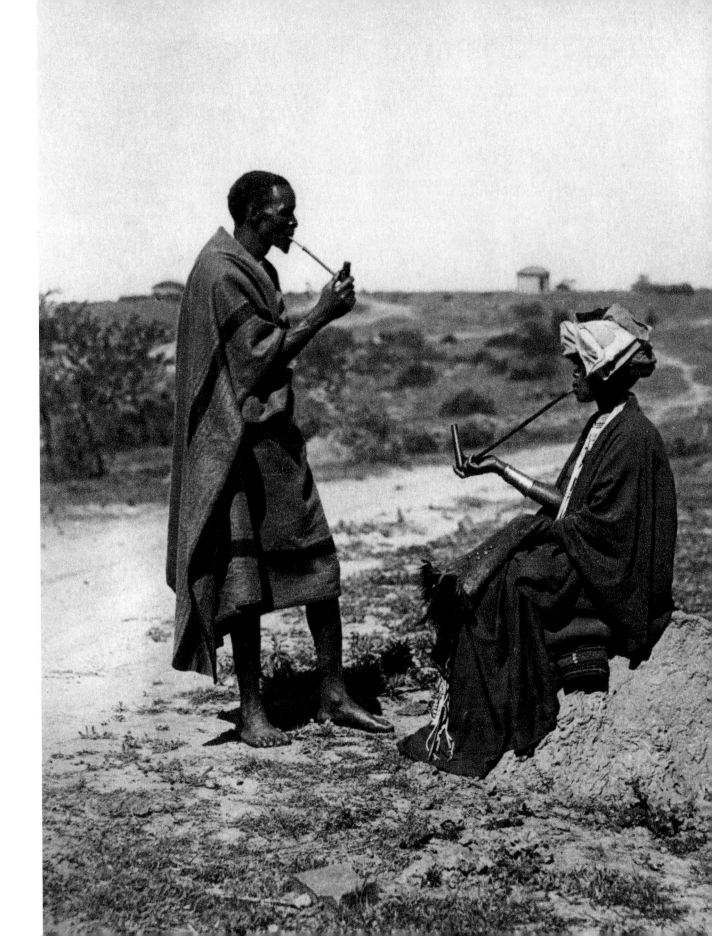

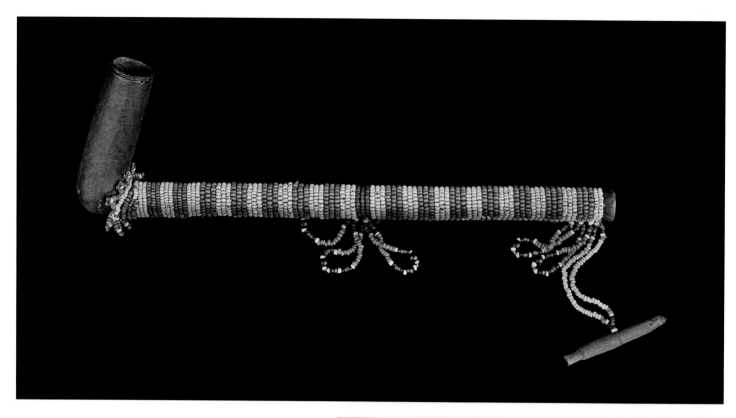

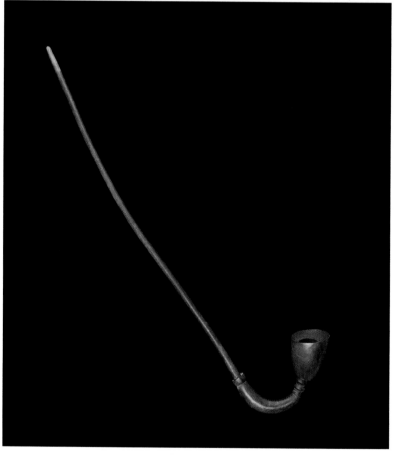

25 Beaded pipe
Name(s) of artist(s) unrecorded,
1800–99
Recorded as Xhosa
Wood, iron, glass, fibre
H. 16 cm | W. 2.4 cm | L. 26.7 cm
British Museum Af1933,0609.34
Donated by Frank Corner
through the Art Fund

26 Pipe
Name(s) of artist(s) unrecorded,
1850–99
Recorded as Tswana
Wood, H. 51 cm | W. 4.9 cm
British Museum Af,Cd.53.a&b

27 Human figure pipe
Name(s) of artist(s) unrecorded,
1860–93
Recorded as Xhosa (Gcaleka)
Wood, beads
H. 10.5 cm | W. 4.2 cm
British Museum Af1905,-.63.a-b
Donated by Jeffrey Whitehead

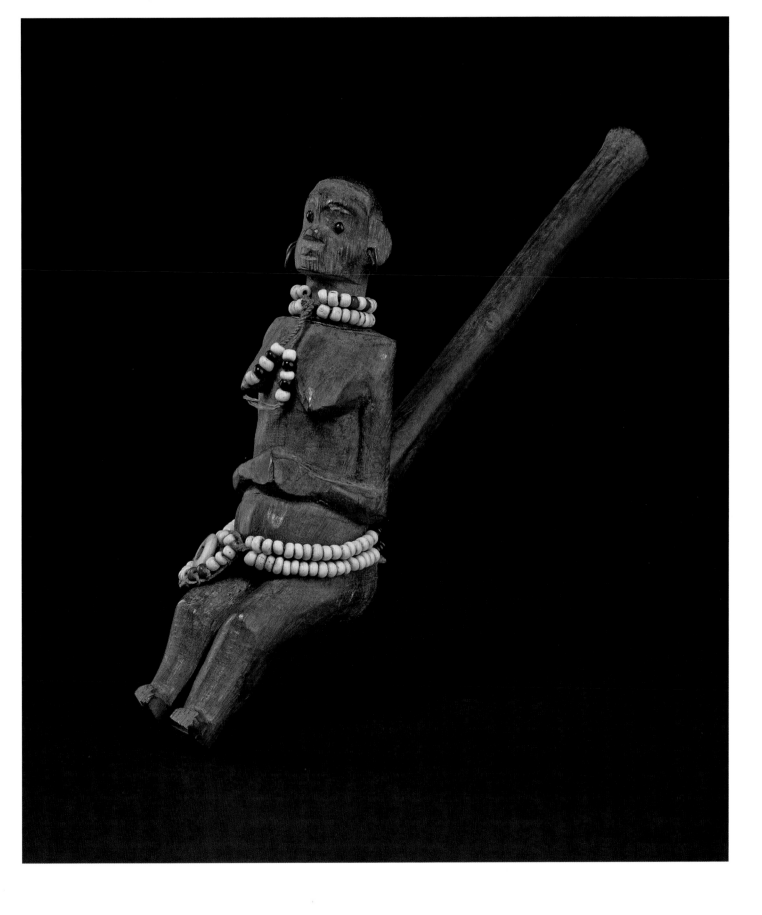

as well as some Khoekhoen and South Sotho, became excellent riders, with the last of these groups incorporating the horse into their art.[15] The second figurative pipe illustrated here has a bowl in the shape of a seated woman, her head acting as a stopper (fig. 27). Although this pipe has been attributed to a Xhosa artist, examples with similar beadwork adornments – in collections in South Africa and America – have been attributed to South Sotho speakers.

Pipes of a more abstract, non-figurative appearance are illustrated here with four examples. The first is a short pipe carved from a single piece of wood decorated with geometric designs (fig. 22). It is reminiscent of a revolver, although this may be purely coincidental. By contrast, the second pipe has a long, elegant stem with an undecorated bowl (fig. 23; see also fig. 24 and, for a discussion of the problems associated with Duggan-Cronin's photographs, page 164), while the third is of a medium size and is decorated with colourful beads (fig. 25). All three of these pipes have been attributed to Xhosa, and were made in the late nineteenth century. Together, they illustrate the variety of artistic pipe production among one cultural group and, as such, the problem of associating a single group with one particular style. The final pipe under consideration here – said to have been made by a Tswana artist – is a long, thin example with a detachable stem and bowl (fig. 26). As smoking was often a communal practice, the use of such a pipe meant that the bowl could be passed around the group, with each member having their own personal stem.[16] And, in general, the longer the stem, the more senior its user.

Representing the body

In this section we concentrate on figurative sculpture. This is an important class of artwork in southern Africa, but one that was often ignored or marginalized in earlier art studies, which tended to focus on the better-known figurative sculptural traditions of West and Central Africa. One of the reasons for this anomaly, it has been suggested, is that by the time the Western art world turned its attention to African art in the mid- and late twentieth century, the political landscape of apartheid in South Africa deterred concerted research in southern Africa.[17]

In fact, South Africa has a long-standing tradition of figurative wood sculpture, the vast majority of the work having been produced in male and female pairs by male artists, either as models for teaching during initiation ceremonies or for sale to visitors. Typically, examples of the former kind of sculpture have pronounced sexual features, while examples of the latter kind do not. Young girls and women also created small figures, which, albeit

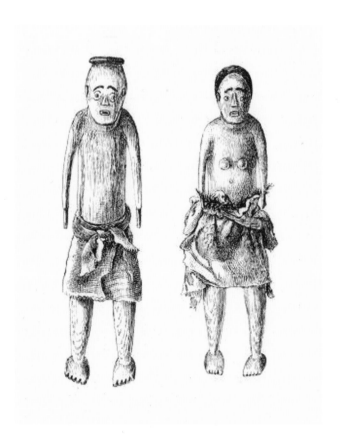

28 'Magwamba [Tsonga] Carvings', from *A Naturalist in the Transvaal*
William Lucas Distant, 1892
R. H. Porter, London

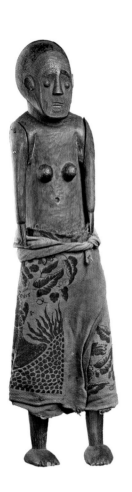
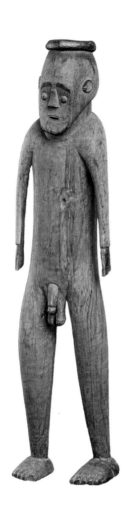
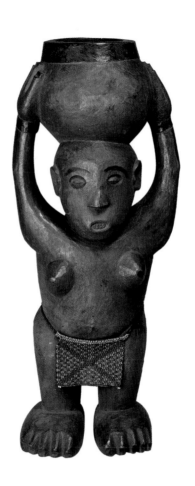
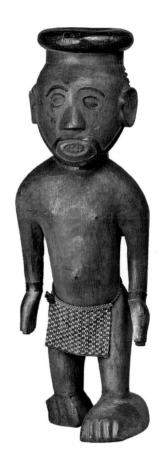

29 Pair of human figurines
Name(s) of artist(s) unrecorded,
1800–92
Recorded as Tsonga
Wood, textile
Female H. 55 cm | W. 16 cm
Male H. 56.5 cm | W. 13.5 cm
British Museum Af,+.6190-1
Donated as part of the
Christy Collection

30 Pair of human figurines
Name(s) of artist(s) unrecorded,
1800–99
Recorded as Tsonga
Wood, beadwork
Female H. 56 cm | W. 23 cm
Male H. 55.5 cm | W. 18.5 cm
British Museum Af 1954,+23.3564-5
Donated by the Wellcome
Historical Medical Museum

somewhat misleadingly, are described collectively as 'fertility dolls'. Although some of these figures may have been for play, others communicated important information about a young woman's status within society.

The pairs of figurative sculptures created for age-related initiation ceremonies can be compared to those used at Schroda more than a thousand years ago (see page 48). Such figurines, typically attributed to Tsonga artists, were produced in two principal styles: short and stocky, with one or both figures usually carrying a pot on their head, and tall and slim (figs 29 and 30). Among the best documented of these figurines are those collected during the late nineteenth century in the Spelonken district of Soutpansberg (now part of Limpopo province) from the Magwamba, a Tsonga group of trading middlemen. In many cases, the figurines were burned after the initiation ceremony; in others, however, they were preserved, kept as the possessions of chiefs and used for the teaching of initiates and at ceremonies where warriors were given their head-rings as a sign of status and bravery.[18] The English entomologist William Distant illustrated the Magwamba figures in the British Museum's collection in his book *A Naturalist in the Transvaal*, published in 1892 (fig. 28).[19]

Virtuoso carving skills are also evident in the naturalistic or stylized woodcarvings most probably produced for visitors. Apart from the absence of genitalia referred to earlier, these sculptures are similar to the figurines discussed above in that they also concentrate on Western-held stereotypes of African male and female attire and accessories, with men holding weapons and shields, and women displaying peaked hairstyles, often wearing skirts and with children on their backs. An example of this kind of woodcarving is the famous Tsonga figure (long thought to be Zulu in origin) with two sets of arms or handles on either side (fig. 31).[20] Some commentators have suggested that this sculpture, in the collection of the British Museum, might have been used as a large pestle. However, the circular base shows no sign of the kind of wear that might have supported this theory.[21]

As mentioned earlier, the anthropomorphic figurines created by girls and young women are often referred to as 'fertility dolls'. However, this tends to obscure an understanding of the differences between the various types of figurine, which range from children's playthings to 'objects used by adults in the performance of specific rituals'[22] and items made for sale to visitors. Among the Xhosa, girls and their mothers made dolls out of maize cobs by dressing them in spare pieces of cloth (fig. 34); sometimes, these dolls were worn on the girls' and women's backs like real babies. At the other end of the spectrum are the large figurines made from a variety of materials, including glass bottles, and covered with bands of beadwork (fig. 35). South Sotho women used these dolls during wedding ceremonies to symbolize their desire to become mothers, while others used them to treat infertility (fig. 33).[23] The term 'doll' has also been used to describe the figurines produced by the many women whose husbands were forced to work as migrant labourers in the farms, cities and mines of South Africa:

> The women, left behind in rural regions that were often extremely barren, had to master that difficult situation and come up with survival strategies. And dolls helped them to do so. In a socially deprived rural society, dolls attained new significance and assumed new qualities. Dolls had until then been used as toys, as aids to education and – to alleviate problems arising in pregnancy or to combat infertility – as ritual objects. Now they became merchandise to sell to city dwellers and tourists. The little figures soon developed into an important, often the sole, source of income for women living in the country.[24]

Dressing the body

In South Africa, as in other parts of the world, information about an individual's power, prestige, religious beliefs,

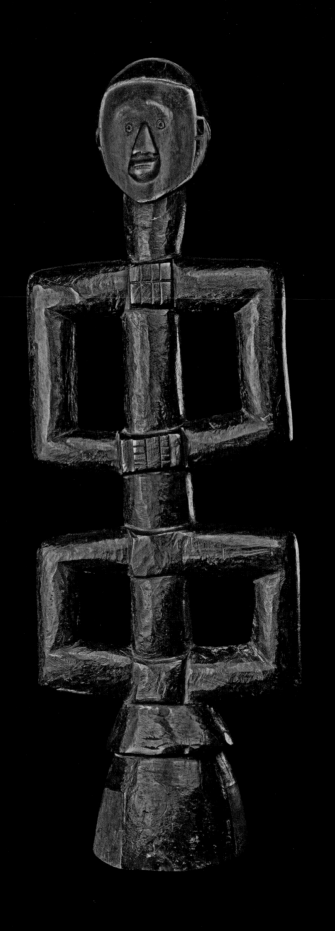

**31 Sculpture of
a human figure**
Name(s) of artist(s) unrecorded,
1850–99
Recorded as Tsonga
Wood, H. 62.5 cm | W. 22 cm
British Museum Af1954,+23.3567
Donated by the Wellcome
Historical Medical Museum

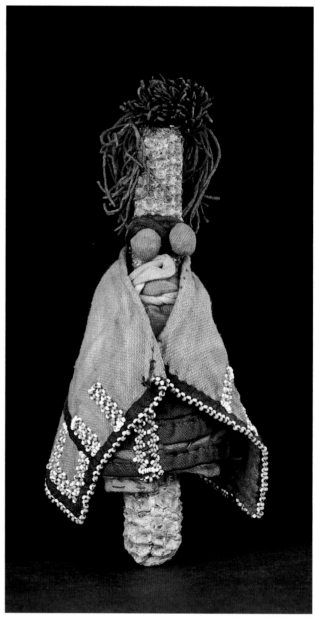

33 'Fertility Dolls', from
The Bantu Tribes of South Africa
Alfred Martin Duggan-Cronin,
1928–54
Photographic print
H. 30 cm | W. 22 cm
McGregor Museum, Kimberley

34 Doll
Name(s) of artist(s) unrecorded,
1900–33
Recorded as Xhosa
Corn, ochre, fibre, glass, cotton
H. 22.5 cm | W. 10 cm
British Museum Af1933,0609.134.a-b
Donated by Frank Corner
through the Art Fund

35 Pair of gun cartridge dolls
Name(s) of artist(s) unrecorded,
1900–33
Recorded as Sotho
Glass, brass, seed, leather, fibre
H. 7.4–7.5 cm | W. 2–4 cm
British Museum Af1933,0609.137.a-b
Donated by Frank Corner
through the Art Fund

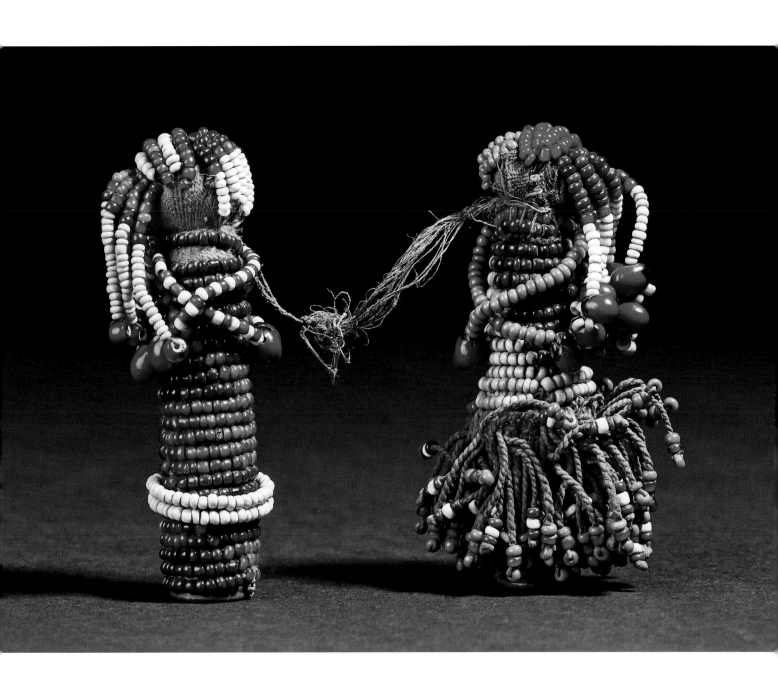

cultural affiliations, and spiritual and material wealth was communicated through their clothing and bodily adornments. Using a variety of colours and materials, such as glass beads, metal studs, organic matter, and animal bones, teeth and skin, a person was able actively to express their identity. Although the main purpose of some clothes was to offer protection against the elements, others were worn primarily to communicate personal information. Some clothes were also designed to affect the wearer's body – to promote fertility, for example, or to enable communication with the ancestors. Here we explore examples of four broad classes of socially communicative and/or affective clothing made in the nineteenth century: headdresses, necklaces, capes and aprons.

One of the most famous examples of communicative headwear from the nineteenth century is the *umnqwazi*, a conical leather headdress decorated with glass beads that was worn by married Xhosa women of high status (fig. 37). The *umnqwazi* is not in use today, but depictions by such European artists as Thomas Baines and Frederick l'Ons reveal how it may have been worn in the nineteenth century (fig. 36). A typical *umnqwazi* consisted of a tall, conical cap of antelope skin, heavily embellished on one side with small black and white glass beads. Although there is disagreement among some as to how the *umnqwazi* was worn, Baines's and l'Ons's paintings depict the narrow end folded back over the head.[25] In the early nineteenth century, when glass beads were hard to obtain, the *umnqwazi* was one of the most important signifiers of status among the Xhosa; as the availability of such beads increased later in the same century, the *umnqwazi* became much more elaborately decorated. The use of white beads for decoration may have been of particular significance to the Xhosa, who considered white to be the primary colour of purity and mediation with the ancestors.[26]

Necklaces featuring lion or leopard teeth or claws are often associated with chiefs and royalty among the Xhosa; indeed, when real ones were unavailable, the Xhosa would fashion imitation teeth and claws out of

bone or brass.[27] Real or imitation animal-tooth necklaces were also worn by Xhosa brides as part of their wedding outfits (fig. 38).[28] In the nineteenth century, the Zulu lion-claw necklace, *umgexo*, was likewise primarily worn by kings and chiefs, although such high-status individuals reserved the right to distribute *umgexo* among councillors and favourites (fig. 39). Over the course of the twentieth century, as overhunting threatened the existence of wild game and wildlife sanctuaries were set up to protect endangered species, artists developed the craft of *amazipho*, the carving of bone in the form of animal claws for use in imitation royal necklaces.[29] In the Zulu kingdom, *iziqu* – necklaces made up of interlocking, vertebrae-like carved wooded beads – were awarded for bravery. In the example shown here, two sets of beads are separated by pieces of carved bone that appear to have been made to look like claws (fig. 40).[30]

Necklaces, it was believed, could affect the wearer's body. Among the isiXhosa-speaking peoples, particularly the Thembu and Mfengu, both men and women wore necklaces made of exquisitely carved pieces of wood from the *umthombothi* tree (*Spirostachys africana*; fig. 41).[31] The sweetly scented wood exudes a milky latex that was thought to promote lactation in women.

Necklaces could also be political and subversive. Mpondomise isiXhosa-speaking artists made beaded-panel necklaces that incorporated snuffboxes adorned with the faces of British monarchs – a form of protest, perhaps, against colonial rule, while at the same time appearing to show allegiance to the crown. Although the beadwork design on each of these necklaces is unique, the necklaces themselves are otherwise quite similar, consisting of single or multiple panels of beadwork with one or two snuffboxes suspended from the longest, central panel, such that the snuffboxes will sit on the wearer's chest (fig. 42). The outward face of each snuffbox typically features the crowned head of a British king or queen – Victoria, Edward VII and George V included – taken from coronation or jubilee medals. As Anitra Nettleton,

36 _Head Wife of a Chief_
Thomas Baines, 1873
Oil on canvas
H. 61.5 cm | W. 45 cm
Iziko South African
National Gallery

37 Headdress
Name(s) of artist(s) unrecorded,
1825–74
Recorded as Xhosa
Glass, fibre, skin, hair
H. 144 cm (incl. straps) | W. 35 cm
British Museum Af.3244
Donated by Henry Christy

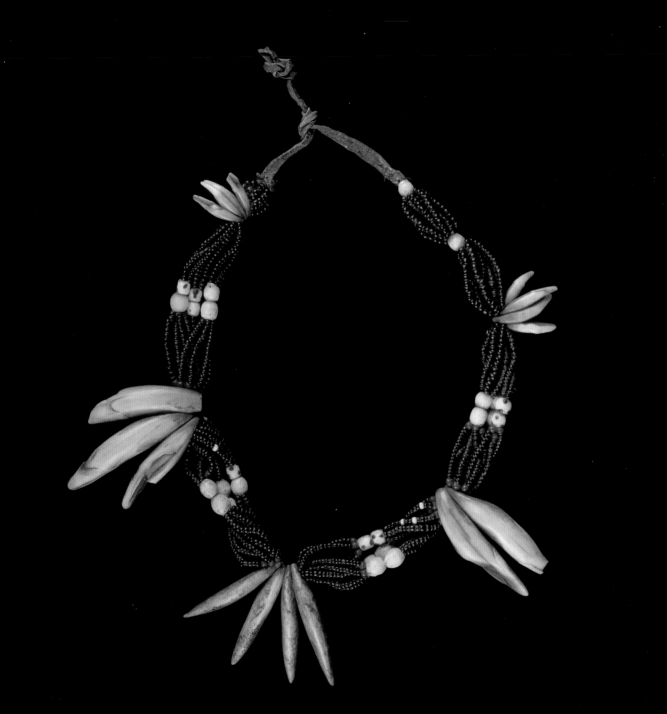

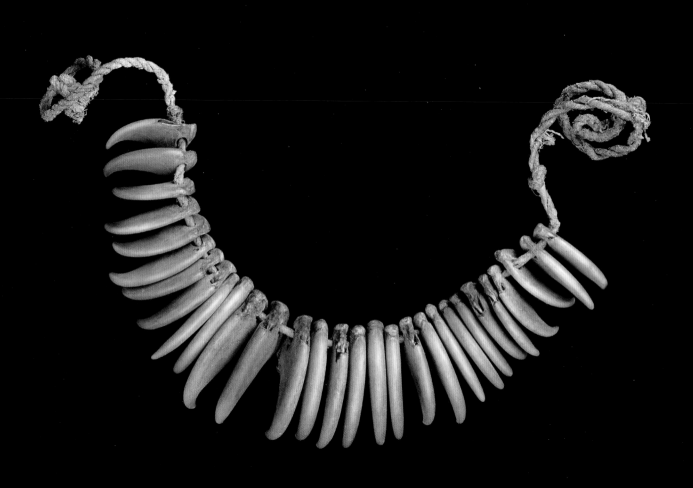

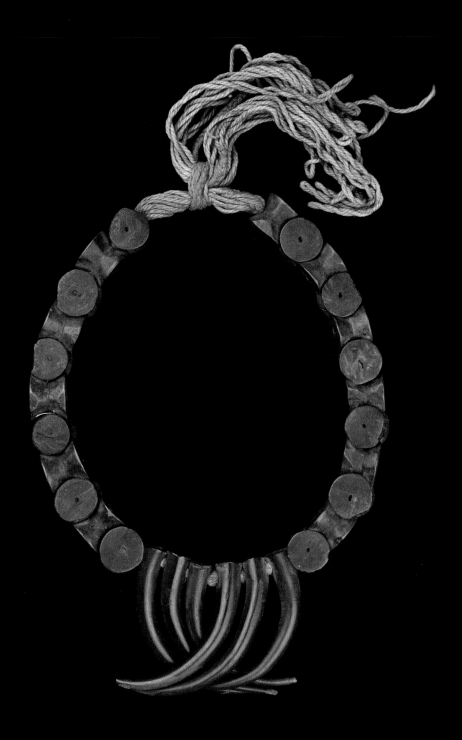

40 *Iziqu* necklace
Name(s) of artist(s) unrecorded,
pre-1945
Recorded as Tsonga
Wood, antelope horn, cotton
H. 25 cm | W. 15 cm
British Museum Af1945,04.24
From Mrs F. J. Newman

41 Wood necklace
Name(s) of artist(s) unrecorded,
pre-1933
Recorded as Xhosa
Wood, glass, sinew
H. 20 cm | W. 20 cm
British Museum Af1933,0609.114
Donated by Frank Corner
through the Art Fund

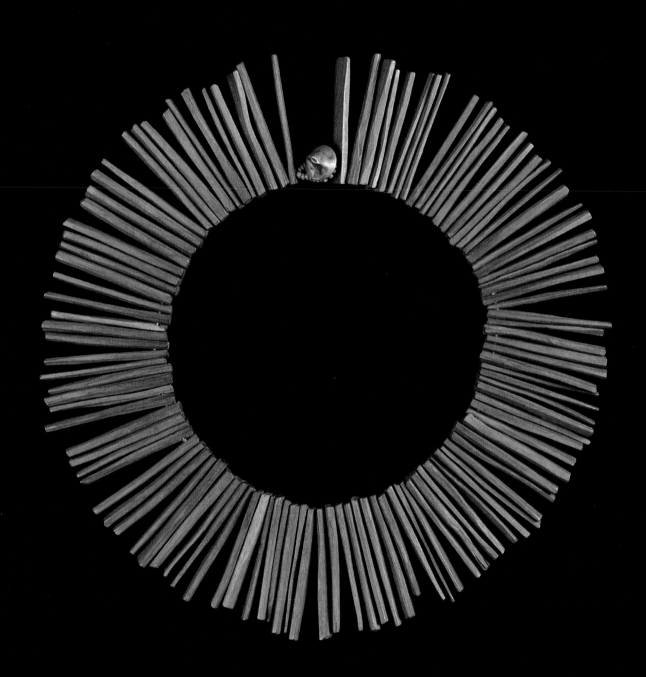

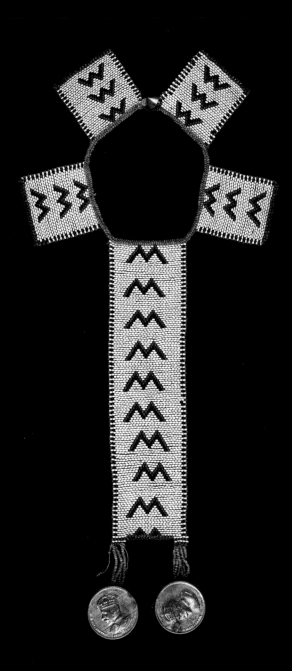

42 Snuff-box necklace
Name(s) of artist(s) unrecorded,
pre-1933
Recorded as Xhosa
Tin, fibre, glass
H. 48 cm | W. 20 cm
British Museum Af1933,0609.28
Donated by Frank Corner
through the Art Fund

**43 Vaseline snuff-box
necklace**
Name(s) of artist(s) unrecorded,
pre-1933
Recorded as Xhosa
Metal, beadwork
H. 48 cm | W. 6.8 cm
British Museum Af1933,0609.3

**44 'A Newly Married
Bride', from *The Bantu
Tribes of South Africa***
Alfred Martin Duggan-Cronin,
1928–54
Photographic print
H. 30 cm | W. 22 cm
McGregor Museum, Kimberley

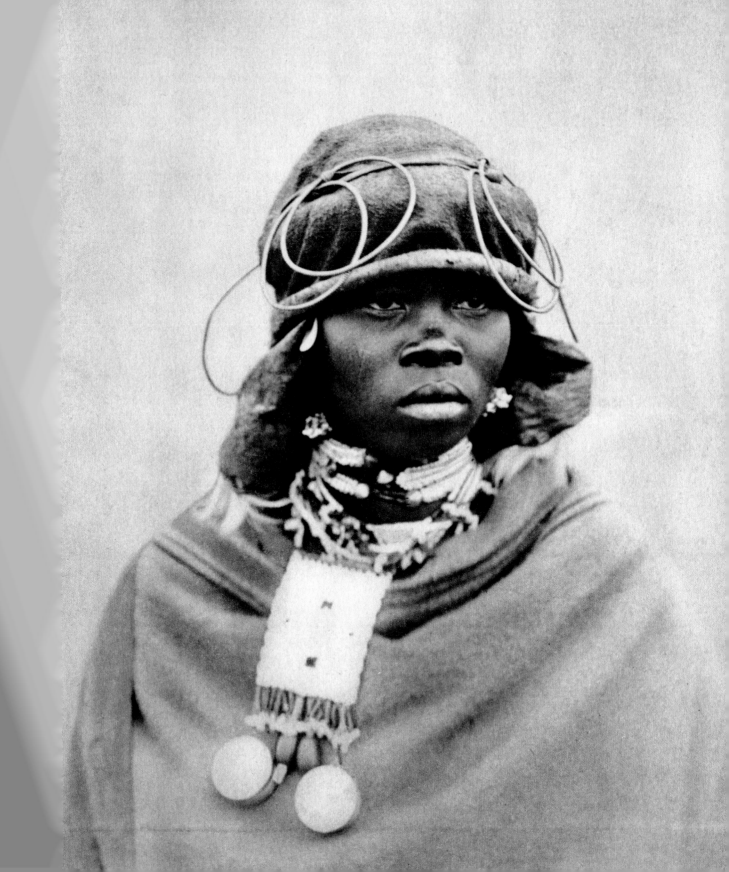

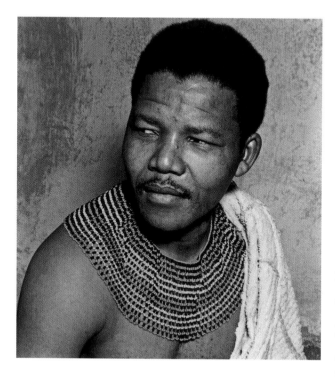

a snuffbox embellished with the head of a monarch. In a variation on the usual design, complete with slightly different beadwork construction, a Vaseline tin has been hung from the end of the necklace (fig. 43). Nettleton has speculated that because Vaseline was a valued and rare commodity in South Africa, introduced by missionaries, it symbolized access to medicine and wealth. Although early photographs suggest that only men wore snuffbox necklaces, later photos demonstrate that, by the mid-twentieth century, young women were wearing them too, often several at once (fig. 44).[33]

Nineteenth-century necklace designs were used in the twentieth century as a form of political and cultural protest against colonialism and apartheid. In 1961, while on the run from the authorities, Nelson Mandela was famously photographed in traditional Xhosa dress, including an *ingqosha* (fig. 45); moreover, at the conclusion of the Rivonia Trial that followed his capture (see page 209), he reportedly arrived for sentencing in an *ingqosha* chosen for him by his then wife Winnie.[34] The *ingqosha* is a deep beaded collar traditionally worn by young Xhosa women and men at such important occasions as weddings and for such ceremonial dances as the *intlombe*, or 'dance of the young adults' (fig. 46).[35] By choosing to wear an *ingqosha* and other traditional clothing, Mandela made a powerful cultural and political statement about his Xhosa ancestry.

To protect themselves against the elements, both women and men wore wide capes or long cloaks, some of which were embellished with adornments designed to assert the social status of the wearer. The *ingubo*, for example, was a large hide cloak worn by Xhosa women of high status (fig. 47). *Isibhaca*, leather panels with lines of brass studs combined with long, small-link iron chains, were attached to the neck of the cloak so that they fell over the wearer's shoulders and hung down their back; the number of studs and chains indicated the wealth of the cloak's owner and their ability to afford expensive materials.[36] Over the *isibhaca* was hung a tortoiseshell, which contained cosmetics and a small cloth for applying

a leading scholar in the historic and contemporary art of southern Africa, has observed:

> What more visible way to make one's survival, and resistance to, British colonial power evident than to combine materials of one's economic engagement with the colonial authority – beads and tobacco – with images of its powerful objects of exchange – the coin-like profiles of the head of the colonial empire?[32]

Nettleton has also suggested that the depiction of British monarchs' heads on the snuffboxes might have been an ironic reference to the severing and taking of heads as trophies at the end of a battle, a ritual practised by both the British and the Xhosa in the nineteenth century. However, not all Mpondomise snuffbox necklaces feature

45 Nelson Mandela
wearing an *ingqosha*
Artist unrecorded, 1961
Photographic print
PVDE/Bridgeman Images,
London

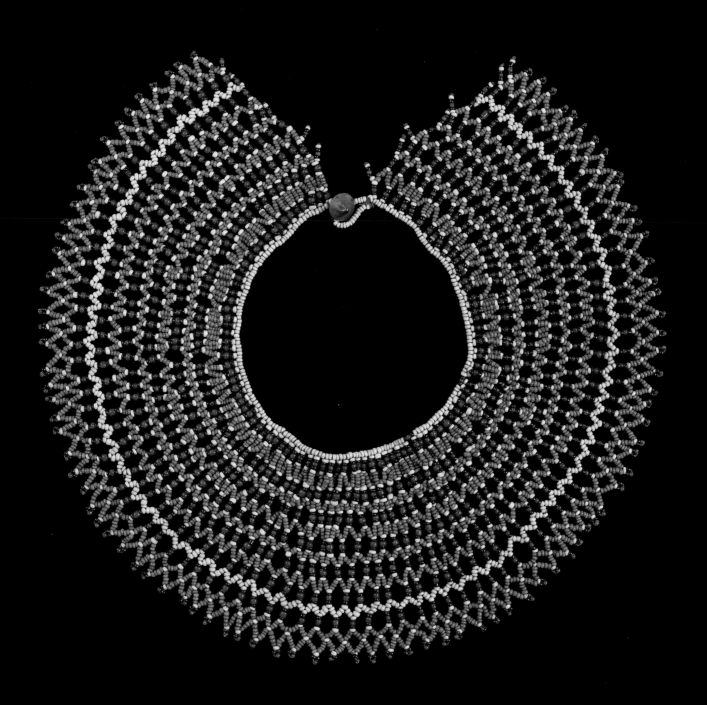

46 *Ingqosha* beaded necklace
Name(s) of artist(s) unrecorded,
1850–99
Recorded as Xhosa
Brass, fibre, glass
H. 9.5 cm | W. 27 cm
British Museum Af1933,0609.44
Donated by Frank Corner
through the Art Fund

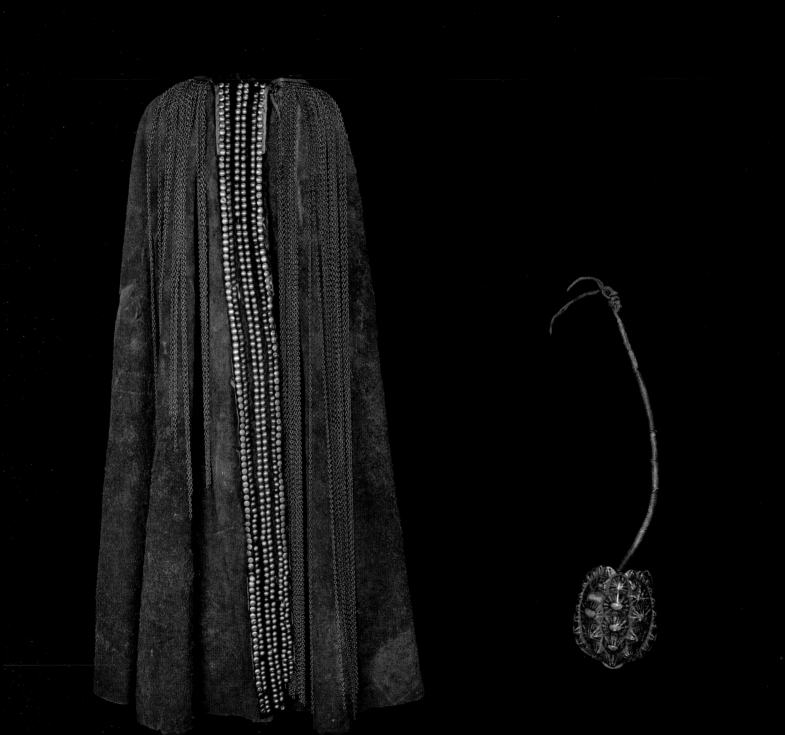

them to the body (fig. 48).[37] The cloak could be worn with an *umnqwazi* (discussed above) and an *inkciyo*, an elaborately beaded apron (also discussed below). The *inkciyo* illustrated here (fig. 50) is a rare type of forked apron, which was donated to the British Museum in 1868, and acquired in association with the Paris Exhibition of 1867.

In his book *The Kafirs Illustrated* (see page 73), George French Angas includes an illustration of a Xhosa woman called Nofelete wearing an *ingubo* (fig. 49). Beginning with a description of Xhosa dress more generally, Angas writes:

> The Amakosa females are many of them women of noble bearing and graceful manners. Their costume differs greatly from that of the Amazulu and Amaponda, consisting of garments much more ample, formed of carefully dressed skins and curiously decorated steel chains and brass-bell buttons. The leather cloak, worn by Amakosa women on all festive occasions has usually a broad belt of leather, about eight inches wide, extending all down the back, and separated from the dress over which it falls; this is thickly studded with brass buttons, and the shell of a small land-tortoise, containing a preparation of herbs, as a supposed charm against witchcraft, is suspended from it by a piece of coiled wire.[38]

While cloaks were worn by both sexes, aprons were worn only by women, on either the front or the back of the body, below the waist. Illustrated here are two contrasting examples. The first is a Xhosa *inkciyo* (fig. 50). The *inkciyo* was designed to cover a woman's pubic area, with some descriptions suggesting that it was worn under an apron or skirt, and others that it was worn on top of such garments. The two 'prongs' of the *inkciyo* depicted here are believed to symbolize the vulva, while the use of white beads is intended to suggest purity – as we saw earlier in the case of the *umnqwazi*.[39]

The second type of apron under consideration here is a piece of Zulu beadwork that would have been worn by a young girl (fig. 51).[40] In the Zulu kingdom, beadwork developed into a formal, courtly form of communication that could be understood by all. However, the destruction of centralized Zulu power in the late nineteenth century (see pages 100–108) led to the development of various regional styles, each with its own patterns and colour conventions.[41] A particular colour of bead could have two different meanings, and accurate interpretation was dependent on the colours of the adjacent beads.

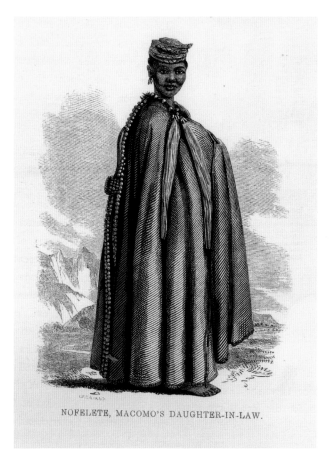

NOFELETE, MACOMO'S DAUGHTER-IN-LAW.

49 **'Nofelete, Macomo's daughter-in-law', from** ***The Kafirs Illustrated***
George French Angas, 1849
Ink on paper (leather-bound book)
H. 52.5 cm | W. 32.5 cm
British Museum, Anthropology
Library & Research Centre

50 *Inkciyo* apron
Name(s) of artist(s) unrecorded,
1800–67
Recorded as Xhosa (Gcaleka)
Leather, glass beads, brass
H. 33.5 cm | W. 16.5 cm
British Museum Af4582
Donated by John Currey

51 Girl's belt and apron
Name(s) of artist(s) unrecorded,
1800–99
Recorded as Zulu
Glass beads, vegetable fibre
H. 31 cm | W. 32 cm
British Museum Af1902,0717.2
Donated by Mr and Mrs R. Samuelson

Defending and attacking the body

As we have indicated throughout this book, many of the objects created by South African artists have a symbolic value beyond their more obvious practical uses. In Chapter 4, for example, we discussed Xhosa and Zulu arms and armour. Here, we focus on the Basotho shield and breastplate, and on axes made by Venda and Tsonga artists.

King Moshoeshoe I (reigned 1822–70) was a shrewd politician and military tactician. Founder of the Basotho nation – now the modern-day country of Lesotho – he managed to resist the British, the Afrikaner Boers and the Ndebele, successfully maintaining the independence of his kingdom. He also gave his name to *shweshwe*, the famous indigo-dyed cloth that continues to be worn by South Africans (fig. 52). In his early encounters with Nguni-speaking warriors, who by that time had adopted the Zulus' 'horns of the bull' battle formation, large oval shields and thrusting spears, Moshoeshoe realized that the strong winds of the highveld made such shields unwieldy. In response, he abandoned the traditional round shield used by the Basotho and re-equipped his men with a light, swallow-shaped shield known as the *thebe* (fig. 54), as depicted on the coat of arms of Lesotho. With its highly distinctive shape, the *thebe* also acted as a declaration of identity, allowing Moshoeshoe to distinguish his people from the various cultural groups that, following the Mfecane (see page 95), were struggling for ascendancy on the highveld.[42] One of these groups was described by the Sotho as Matabele (literally, 'one who hides behind his large shield'). However, it was in fact the northern Ndebele, who, led by Mzilikazi, fought against Moshoeshoe's warriors before eventually travelling further north to settle in modern-day Zimbabwe.

Another of Moshoeshoe's innovations was the *sefoka*, a long wooden stick covered with ostrich feathers that could be attached to the back of the *thebe* (fig. 55). Used in ceremonial contexts as a mark of the owner's status and bravery, *sefoka* would not have been in place when Basotho warriors were engaging the enemy. Moshoeshoe also rewarded his bravest fighters with a *khau*, a V-shaped breastplate fashioned from brass (fig. 53). In addition to being a highly valued commodity in the early nineteenth century, brass would have provided Moshoeshoe's men with additional protection without slowing them down in combat. Manufacture of these breastplates reportedly came to an end with the death of Moshoeshoe in 1870.[43]

The modern nation of Lesotho owes its independence to Moshoeshoe, who, having fought and won a number of wars with the British and then the Afrikaner Boers,

**52 *Shweshwe* dress,
in memory of Ma Sisulu**
Noxolo Dyobiso, 2012
Textile
H. 135 cm | W. 191 cm
British Museum 2012,2044.1

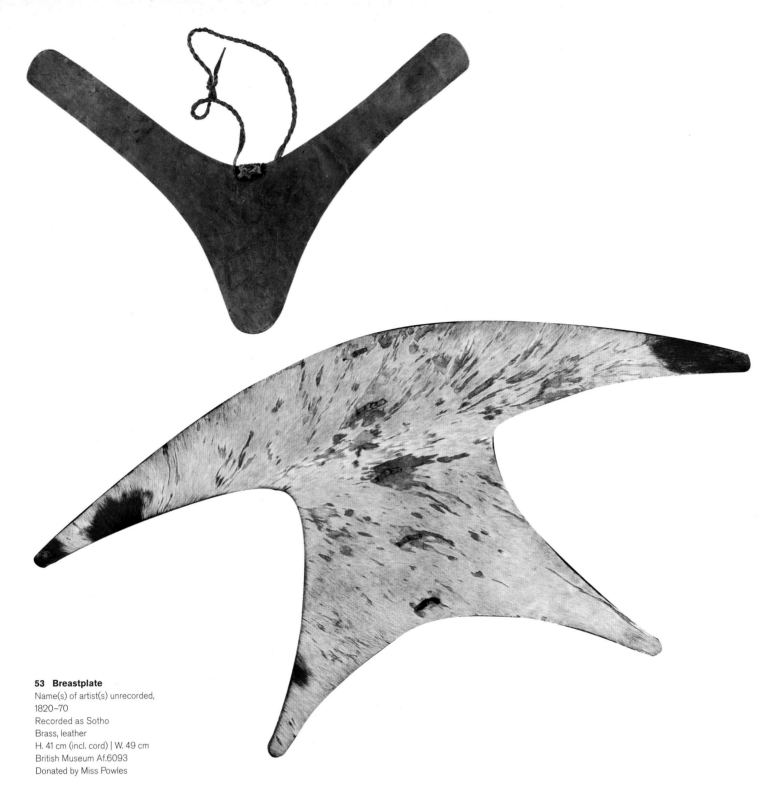

53 Breastplate
Name(s) of artist(s) unrecorded,
1820–70
Recorded as Sotho
Brass, leather
H. 41 cm (incl. cord) | W. 49 cm
British Museum Af.6093
Donated by Miss Powles

54 Shield
Name(s) of artist(s) unrecorded,
1820–70
Recorded as Sotho
Oxhide, iron, fibre
H. 51 cm | W. 98.7 cm
British Museum Af,6094
Donated by Miss Powles

55 Plume
Name(s) of artist(s) unrecorded,
1820–70
Recorded as Sotho
Ostrich plumes, iron, fibre
H. 139.2 cm | W. 14 cm
British Museum Af,6095
Donated by Miss Powles

**56 Basuto warrior
in full war dress**
Name(s) of artist(s) unrecorded,
1850–99
Recorded as Basuto
Etching
H. 19 cm | W. 14 cm
British Museum Af 2006,prt.176

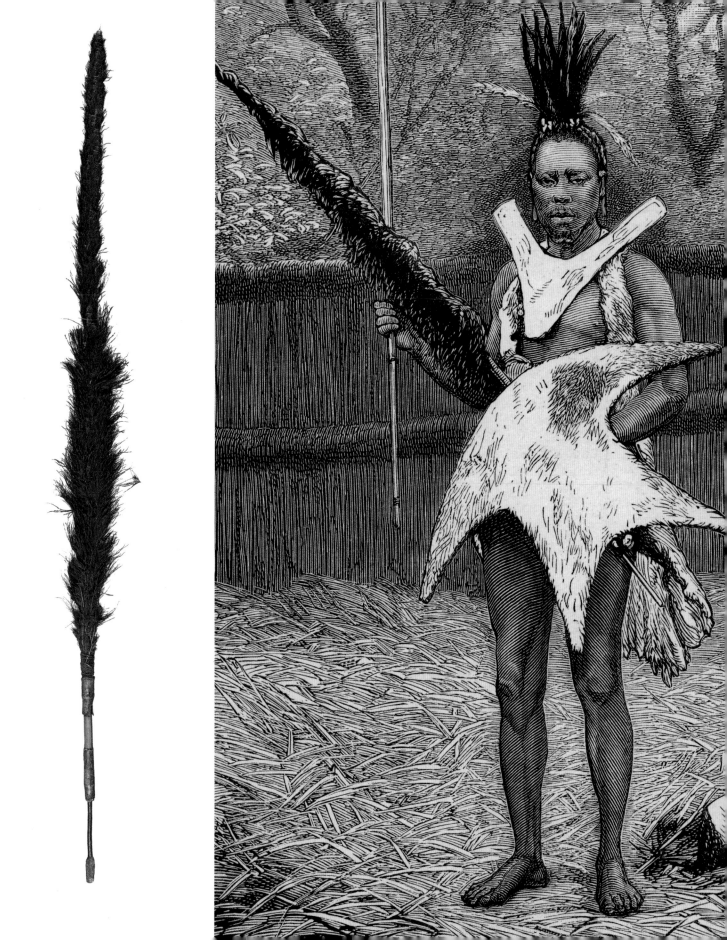

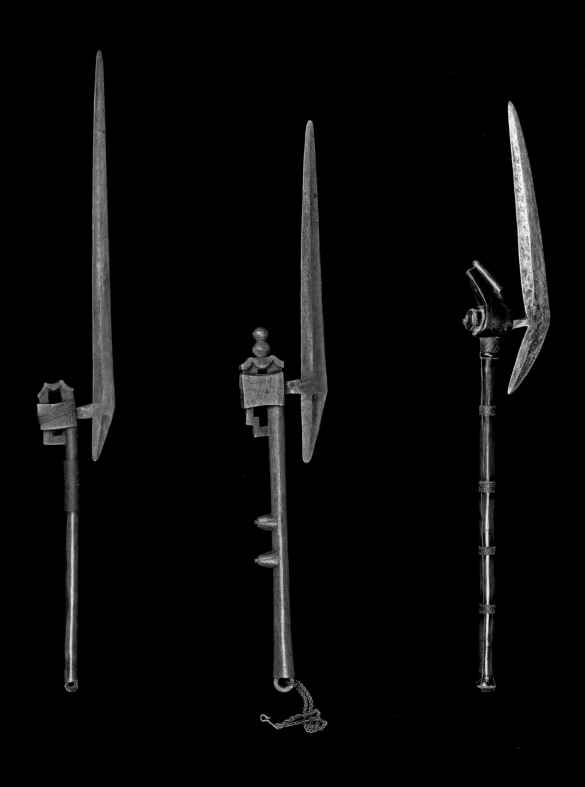

57 Axe
Name(s) of artist(s) unrecorded,
1800–99
Recorded as Tsonga or Venda
Wood, iron, H. 103 cm | W. 13.5 cm
British Museum Af1982,32.34

58 Axe
Name(s) of artist(s) unrecorded,
1800–99
Recorded as Venda
Wood, iron, H. 79 cm | W. 12 cm
British Museum Af1907,0725.1

59 Axe
Name(s) of artist(s) unrecorded,
1800–99
Recorded as Tsonga
Wood, iron, H. 91 cm | W. 11.5 cm
British Museum Af1954,+23.2813
Donated by the Wellcome
Historical Medical Museum

successfully appealed to Queen Victoria for protectorate status, which was duly granted in 1868. Lesotho did not become part of the Union of South Africa in 1910, and in 1966 was able to secure its independence from both Britain and – in principle if not always in practice – South Africa. The history of Swaziland follows a similar path: first recognized as an independent nation by the British in 1881, it became a protectorate of the Transvaal in 1894, a British protectorate following the end of the Second South African War in 1902, and independent again in 1968.

While the Sotho shield and breastplate discussed above were concerned with protecting the body, the Venda and Tsonga war axes illustrated here were concerned with attacking it (figs 57–9). Yet they too had a symbolic value beyond their more immediate function. Known as *mbado* by the Venda, the axes were composed of a long, slim blade attached to a short wooden haft, which often took the form of a stylized human body or an object of power and prestige, such as a rifle. In the nineteenth century firearms were a prized commodity among the Venda, who acquired them through trade with the Portuguese at Delagoa Bay (see page 65), and the shape of the blade on these axes may owe something to the bayonets used on the European military rifles of this period. Although varieties of these axes were used as weapons, it is likely that the three axes illustrated here were created and used for ceremonial purposes. Before setting off on a military expedition, the Venda would anoint an axe of this type with 'magical' substances in order to bring them success. This process transformed the axe into a sacred charm known as a *tshirovha*. The *tshirovha* had its own bearer, who, under the instruction of his chief, would swing the weapon in the direction of the enemy, as if to strike him down.[44]

Questioning colonial collections

The artworks presented in this chapter form an important part of South Africa's artistic heritage. However, their acquisition was inevitably influenced by a European, colonial world view, one that is reflected in the collections in which they now reside. Three artworks in particular (figs 60–62) highlight the problematic way in which these collections came together, including the acquisition of artworks as specimens of supposedly dying cultures, and the narrow collecting practices that, as a whole, presented the cultural identities and artistic concerns of San|Bushmen, Khoekhoen and black South Africans as intrinsically different from those of the West.

There are many reasons why people of European descent collected South African artworks in the nineteenth century. Just as some may have collected such items because of a deep reverence for their artistic qualities, others may have collected them as curios; others still may have collected them for academic interest and the study of newly encountered cultures. Nevertheless, a number of similarities may be observed in the outcome of these activities and the ideologies that underpinned them.

Collecting usually involved the removal of artworks from their original context, through purchase, gifting or theft, and the attribution of a cultural affiliation based on language, geographical location or object type – but without recording the name of the maker and/or owner. As a consequence, artworks were collected less as works of art created by individual artists, and more as specimens of a particular culture to be gazed on by the collector, their family and other international audiences.[45]

Looking at the ideologies that underpinned these activities, it was a widely held colonial belief that Africans and other non-Western peoples were in a perennial state of decline, doomed to extinction without the intervention of Western 'civilization'.[46] Little was it realized at the time, of course, that the crises seen to be affecting such peoples were in many cases the result of colonial activities, such as the introduction of new diseases or increased competition over access to productive lands. As it was, the belief that these groups were on the brink of destruction drove the collection of their artworks as remnants of dying peoples.

A headdress bequeathed to the British Museum in 1933 by William Leonard Stevenson Loat, an archaeologist and natural historian, is an excellent example of an object collected as if it were a specimen of a people (fig. 60). At the time of its acquisition, it was recorded as the 'Queen of Swaziland's bodyguard's head-dress made of feathers, fibre'. It was presented to the museum in a bell jar, a bell-shaped glass cover with wooden base commonly used in the nineteenth century for enclosing laboratory specimens, especially those from the realm of natural history. The heavy but movable glass case permitted easy display and access for teaching and comparative analyses, as well as facilitating the interest of more casual audiences. Through its placement in a bell jar, the headdress became, perhaps unwittingly, a scientific specimen of the Swazi royal family and culture. Although this is an extreme example – not all artworks from nineteenth-century South Africa were displayed in this manner – it underlines the way in which the collection

of such artworks acted as a means of 'collecting' and 'preserving' non-Western people for European audiences.

The impact of this colonial collection of people was far-reaching. Because collectors were interested in preserving and exhibiting the remains of supposedly exotic and dying cultures, only those objects considered suitably interesting and representative of specific cultures were collected. As a consequence, colonial collections served the colonial project by demonstrating to international audiences that non-Western peoples were exotic heathens at a different stage of social evolution, and that they were in need of Western-led Christian development for their own salvation.

Colonial collections thus not only reflect problematic colonial thinking but also present an incomplete and distorted view of artistic creativity and lives in the nineteenth century. By the late nineteenth century, for example, it is estimated that 80 per cent of black South Africans owned some Western clothing, yet very few museums, if any, have examples in their collections. Similarly, despite many black South Africans being a part of urban life in Cape Town, Johannesburg, Pretoria and Durban in the late nineteenth and early twentieth centuries, museum collections rarely preserve artworks related to these lives. Instead, collections typically represent a rural, traditional, ethnic ideal that reflects European notions of Africans. Indeed, such notions were famously given form in the early twentieth-century photographs of Alfred Martin Duggan-Cronin. For these photographs, Duggan-Cronin's subjects were made to take off their everyday clothes and to wear traditional outfits in poses that matched Western conceptions of black South African life (see figs 24, 33 and 44). Today, colonial collections of the kind discussed above present a powerful image of black South African life, but one that is biased and whose integrity must be challenged to prevent the content of these collections from being normalized as a representative history.

The questioning of Western conceptions of black South African life is at the heart of Santu Mofokeng's eloquent *The Black Photo Album / Look at Me: 1890–1950* (1997; fig. 61),

The Black Photo Album

Santu Mofokeng

60 Headdress in bell jar
Name(s) of artist(s) unrecorded,
1850–99
Recorded as Swazi
Feather, vegetable fibre and bell jar
(glass, wood), H. 21 cm | W. 29 cm
British Museum Af1933,0315.105
Bequeathed by William Leonard
Stevenson Loat

61 *The Black Photo Album/*
Look At Me: 1890–1950
(see also overleaf)
Santu Mofokeng, 1997
Black-and-white slide projection
MAKER, Johannesburg

Are these images evidence of mental colonisation or did they serve to challenge prevailing images of 'The African' in the western world?

Tokelo Nkole (seated), was an avid follower of **Marcus Garvey**. He left school at standard six. Before he died in 1940, he first worked as a factory clerk, then took a position as 'boss-boy' on the mines and finally became a warden at the Diepkloof Reformatory School with the renowned author, **Alan Paton**.

What was the occasion?

Who is gazing?

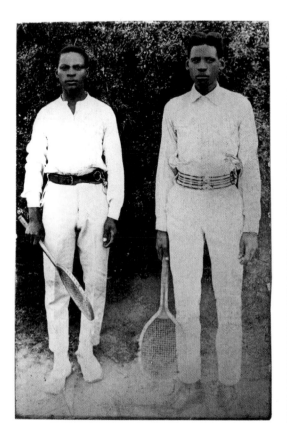

Moeti and **Lazarus Fume**

Silver bromide print.

Photographer: Unknown

a slide show that highlights black, working- and middle-class urban lives and, in so doing, contrasts them with the rural, ethnic, traditional ideals that anthropological collections often emphasize. Mofokeng began his monumental work in the late 1980s at the University of the Witwatersrand, Johannesburg, when he was a member of the Afrapix collective. Founded in 1982, Afrapix helped develop a politically engaged school of documentary photography during the apartheid era. Among its members were such photographers as Omar Badsha and Guy Tillim.

To create *The Black Photo Album/Look at Me: 1890–1950*, Mofokeng collected images of urban black South Africans from the early twentieth century. In its final form, the work consists of two elements. The first is a series of mounted, gelatin-silver reproductions of found archival prints. The second, more famous element is an eighty-slide projection of those prints interspersed with biographical information, quotations from the period, and questions posed by the artist, such as, 'Who are these people? What were their aspirations' (slide 66). The work in its entirety was first exhibited in 1997 at the second Johannesburg Biennale, curated by Okwui Enwezor, an event that the writer and academic Alexandra Dodd described as 'a watershed […] in the global uptake of South African contemporary art'.[47]

Here, Mofokeng describes the origins of the work:

I began collecting old photographs. If you went to libraries or museums you'd never find pictures of black people portrayed as a wholesome human family or communal beings. I remember when I went to [South African newspaper] *The Star* to look at the archives and I said, 'Why don't you have old images of black people?' They said, 'Black people could not afford to be photographed' … If you go to libraries, you'll find ethnographic images of black people like you do with flora and fauna. Sometimes [Alfred Martin] Duggan-Cronin made a photograph that looks like a science drawing: you have front elevation, side elevation and back elevation. Or else you'll find pictures of black people next to machinery on the mines or whatever. Either you are a worker or you are flora and fauna. I was doing this project [*The Black Photo Album/Look at Me*] not to deny other stories, other narratives, but I was trying to insert this work within the body of knowledge of the past.[48]

Duggan-Cronin's eleven-volume photographic work *The Bantu Tribes of South Africa* (1928–54) may be seen as a thinly disguised advertisement for the Native Administration Act of 1927, which supported the displacement of black South Africans into ethnically specific areas (see page 173). Setting out on a tour of South Africa, Duggan-Cronin persuaded his subjects to abandon European dress in favour of 'native' costume to create a South African 'ethnographic present'. One of Mofokeng's aims in creating *The Black Photo Album/Look at Me* was to subvert this rigid construction of identity, which had been imposed on South Africans by the apartheid system and earlier forms of segregation. Writing in 1999, Colin Richards, professor at the Michaelis School of Fine Art in Cape Town from 2010 until his death in 2012, summarized the situation in chilling detail:

The apartheid gaze has placed identity beyond context and history. Identity has been fixed by 'nature', backed by God. Every identity – worker, woman, African, Zulu, Afrikaner – is prefixed by a static ethno-nationalist category. This fixation has maimed and crippled our cultural life. That the identity may be dynamic has been foreclosed. That people might choose different identities in different situations has been denied. The cruel economies of the apartheid vision have dissected identity, inflating its alienated fragments into a grotesque wholeness.[49]

The Black Photo Album/Look at Me: 1890–1950 rediscovered a black South African history that apartheid had sought to erase. According to Mofokeng:

These are images that urban black working- and middle-class families commissioned, requested or tacitly sanctioned. Some were left behind by dead relatives. Some hang on obscure parlour walls in the townships. In some families they are coveted as treasures, displacing totems in discursive narratives about identity, lineage and personality. And because to some people photographs contain the 'shadow' of the subject, they are carefully guarded [...] Sometimes they are destroyed with other rubbish during spring-cleaning because of interruptions in continuity or disaffection with the encapsulated meanings and history the images convey. Most often they are rotting through neglect, lying hidden in chests, cupboards, cardboard boxes and plastic bags [...] When we look at them we believe them, for they tell us a little about how these people imagined themselves. How we see these images is determined by the subjects themselves, for they have made them their own [...] the images depicted here reflect their sensibilities, aspirations and sense of self.[50]

The knowledge of what happened next to the people in Mofokeng's images, to their sons and daughters, grandsons and granddaughters, imbues them with an almost unbearable poignancy. As the historian James T. Campbell has observed, 'they record a specific historical catastrophe. They depict the rise and fall of a class of educated, urban, Christian Africans in late nineteenth- and early twentieth-century South Africa.'[51] These were the people who in other African countries would 'transform colonial Victorianism into a discourse of their own liberation from imperialism' – people who, if Mofokeng had not intervened, might have disappeared from collective memory altogether.[52]

Yet Mofokeng has also stressed that the meanings of the photographs are subjective and change over time:

You could look at some of Duggan-Cronin's work and have a completely different reading if you don't know about Duggan-Cronin. You are just looking at a portrait, and some of them are really beautiful. Duggan-Cronin was an ordinary guy on the mines who had a fascination with all these men who were working around him. But it's only later that he begins to do what you call anthropology. To me, photographic meaning shifts.[53]

This point is well illustrated by Nelson Mandela's appreciation of Duggan-Cronin's photographs as 'a unique representation of the wealth and diversity of our many cultures'.[54] As Mandela's words remind us, despite the many problems associated with ethnographic collections, their value as an artistic record of life in the nineteenth and early twentieth centuries should be protected.

Anonymous and apolitical artworks

Because San | Bushmen, Khoekhoen and black South African artists of the nineteenth century were not asked to comment on their reasons for making a particular artwork – or, if they were, their reasons were not recorded – it is difficult for these artworks to speak about individuals and specific events in the same way as other artworks do. Take, for example, the carved wooden milk vessels discussed earlier. Although it is possible to access the cultural relevance of the *amasumpa* on such vessels and their symbolic relationship to scarification on female bodies, we cannot access the exact reasons why each artist made their marks differently. They may have been signatures, representations of particular female bodies, reactions to a specific event, and so on, but we will never know for sure. As a consequence, anthropological and artistic interpretations of such artworks are unavoidably directed towards non-individualistic, and therefore non-political, explanations. In turn, we are left with a distorted picture of San | Bushmen, Khoekhoen and black South African artists not making political art until the adoption of Western traditions in the late twentieth century. This

is not only inaccurate but also highly problematic, as it reinforces colonial ideas that San|Bushmen, Khoekhoen and black South African societies lacked agency, and were passive in the face of pressures that were leading to their inevitable decline and eventual demise.

Some San|Bushman and Khoekhoe rock art of the late nineteenth century clearly disputes such ideas. Illustrated here is a piece of rock art from the Swartruggens hills in the Western Cape that is believed to be a political and satirical depiction of European settlers rushing north in the 1860s to exploit the newly discovered diamond fields around Kimberley (fig. 62).[55] The painting depicts men driving horse-drawn wagons, or standing nearby with their hands on their hips, alongside women in crinoline dresses. As discussed earlier in this book, the Khoekhoe and San|Bushman rock art in which Europeans appear is typically termed 'contact art'. This example, however, was created many decades after the earliest contact between Europeans and the San|Bushmen and Khoekhoen in this area. It is therefore less about spiritually negotiating the arrival of newcomers and more a commentary on current events.

It is probable that the artist, or artists, who made this painting worked on white South African farms. As explained by Simon Hall and Aron Mazel, the archaeologists who analysed the painting, 'as the colonial frontier closed around them, [Khoekhoen and San|Bushmen] lost their economic independence and ideological identities, merged and became fully subordinated within the labour needs of the rural farm economy.'[56] Crucially, however, the painting was created in the mountains at a distance from the farms and the road, and were thus not meant for the eyes of colonial 'masters'. They were instead, suggest Hall and Mazel, a subversive 'social commentary that perhaps gave expression to the local and personal conditions of subordination within a rural economy and wider events'.[57]

The scenes portrayed in the painting, such as riders falling from horses, are depicted in such detail that it is likely that the artists who painted them witnessed the events for themselves and were visually recalling them in a humorous fashion for others who had not. Other parts of the painting show men in moving carriages banging their heads on the carriage's roof, being flipped upside down, or clinging on for dear life having been thrown out of the back. Another amusing detail is the contrasting way in which the different sexes are portrayed. While both men and women are shown with their hands on their hips – a typical Western pose – the men are depicted as spindly figures dominated by the women in their enormous crinoline dresses.[58]

In contrast to many of the other historic artworks featured in this chapter, this two-dimensional figurative scene allows us to access its political and satirical purpose, demonstrating that political intent was not necessarily absent from the work of San|Bushmen, Khoekhoen and black South African artists of the nineteenth century. Nevertheless, as Hall and Mazel note, even in this particular case, it is still not possible to get very close to the artists themselves or the specific, individual moments that inspired them.[59]

62 Rock art of European settlers
Name(s) of artist(s) unrecorded, c. 1860
Recorded as Khoekhoen
Digital image, David Coulson
H. 20 cm | W. 94 cm (four-horse wagon)
British Museum 2013,2034.19504
Donated by Trust for African Rock
Art (TARA)

Chapter 6

Experiencing and resisting segregation and apartheid

Racial segregation in South Africa began many decades before the National Party formally introduced apartheid legislation in 1948. As early as the nineteenth century, during the Xhosa Frontier Wars, for example, the British created separate areas for black and white South Africans. It was also the British who, as discussed in Chapter 4, introduced racially defined concentration camps during the Second South African War (see page 117).

The formalization of racial segregation did not begin, however, until after the Union of South Africa in 1910. Following the end of the Second South African War, there were concerns among white South Africans that colonial divisions might jeopardize the supply of the cheap black South African labour on which the diamond, gold and agricultural industries depended. In response, the former Afrikaner Boer republics and British colonies (see map on page 174) agreed to unify and create one government – an act that formalized the disenfranchisement of black South Africans, the vast majority of the population, from official political and economic life.

Beyond the Cape, where a 'colour blind' policy was supposedly maintained until 1936, the Union denied the vote to all black South Africans to prevent them from democratically challenging the extreme inequalities of white minority rule. Soon after the creation of the Union, in 1913, the government also introduced the Natives Land Act, a piece of legislation that restricted land ownership among black South Africans – approximately 80 per cent of the population – and attempted to force them on to 10 per cent of the land. Although in theory the culturally defined reserves that were created were owned and ruled by chiefs, they could not be bought and sold or treated in the same way as other assets might be.[1]

When the National Party came to power in 1948, it introduced the ideology of apartheid (Afrikaans for 'separateness'), which sought to expand racial segregation to all aspects of South African life. Subsequently, the Natives Land Act was amended to create ten Bantustans, or Homelands – ethnically defined communal areas into which all Bantu-speaking groups would be confined (see map). As discussed in Chapter 2, the creation of these reserves was premised on the colonial myth that European settlers arrived in the region at the same time as Bantu speakers, who occupied only a relatively small amount of land in the north-east of the country. The plan, therefore, was to 'return' these Bantu speakers to their 'original' lands, where they would develop separately not only from the white population but also from one another, eventually be granted independence, and ultimately be excluded from the South African state, which was to be a white nation. Although it was ultimately unsuccessful (approximately half of the black South African population remained in urban areas), the Bantustan/Homeland system resulted in the forced relocation of millions of people.[2]

The early period of racial segregation in South Africa can be illustrated by means of two groups of contrasting artworks: a collection of Ndebele clothing, and the paintings of the landscape artist Jacob Pierneef.

In the introduction to this book, we presented Esther Mahlangu's *BMW Art Car 525i Number 12* (page 10), a celebration of the end of apartheid featuring Ndebele house-painting designs that were created in the early to mid-twentieth century partly in response to ethnic segregation. These designs evolved out of a beadwork tradition that was itself developed as an implicit protest against racial segregation.[3] At the turn of the twentieth century, Ndebele garments included exquisite beadwork using large amounts of tiny white beads, but with small, discreet patterns in other colours, as can be seen in the beaded train and cape illustrated here (figs 1 and 2). As the century progressed, and the Ndebele's territory became more restricted, clothing began to be more heavily and colourfully beaded, as demonstrated by an example of a *mapoto*, a type of apron (fig. 3). Finally, by the mid-twentieth century, such garments as *orare* (wedding blankets) became almost completely, and elaborately, covered in beads (fig. 4). Although this progression must partly be understood in the context of the increasing

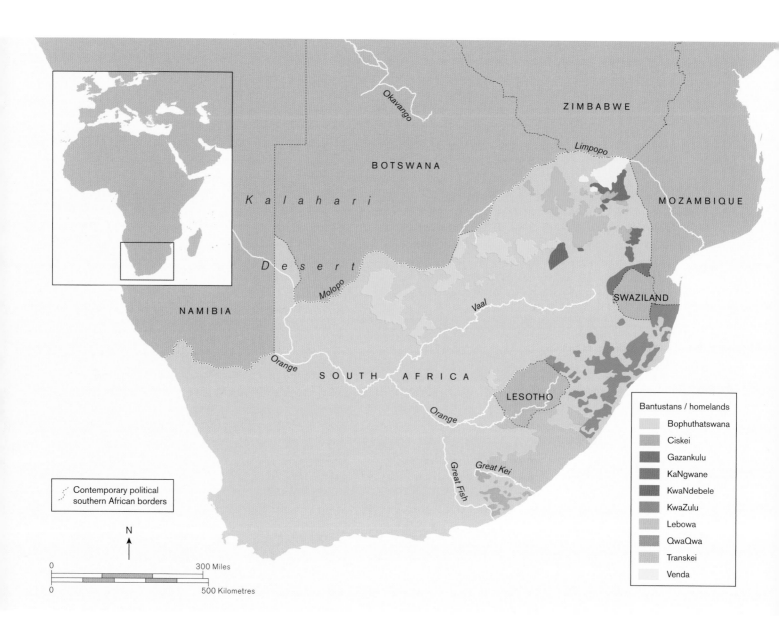

ZIMBABWE

MOZAMBIQUE

BOTSWANA

Okavango

Limpopo

K a l a h a r i

SWAZILAND

NAMIBIA

D e s e r t

Molopo

Vaal

Orange

SOUTH AFRICA

LESOTHO

Orange

Great Kei

Great Fish

Bantustans / homelands

- Bophuthatswana
- Ciskei
- Gazankulu
- KaNgwane
- KwaNdebele
- KwaZulu
- Lebowa
- QwaQwa
- Transkei
- Venda

Contemporary political
southern African borders

N

0 300 Miles

0 500 Kilometres

**Map of Bantustans/Homelands
in South Africa**

This map shows the locations of
the ten Bantustans, or Homelands,
created in 1948 following the
amendment of the Natives Land
Act by the National Party.

availability of beads and different colours, it can also be seen, when linked to the development of house painting, as a form of speaking out against oppressive segregation.

At the same time as these Ndebele artworks were protesting about cultural presence in an ever more restricted landscape, South Africa's most famous white landscape painter, Jacob Hendrik Pierneef (1886–1957), was producing artworks that were almost devoid of human life (figs 5 and 6). Pierneef's empty landscapes appear to support the very foundation of colonial and apartheid rule – the concept of *terra nullius* (literally, 'no one's land'), the myth of the empty land (see page 58) – and, as a result, were celebrated by the National Party. William Kentridge, one of South Africa's most famous contemporary artists, has described Pierneef's controversial landscapes as 'documents of disremembering', made possible only after 'puffs of gun-smoke' determined who owned the land.[4]

Pierneef's landscapes received heavy criticism both during and after apartheid. As early as 1983, the artist André van Zyl painted works that provided a direct critique of Pierneef's vision, with a pastiche of a Pierneef landscape in the top half, and a skeleton-filled earth in the bottom half.[5] The South African art historian Nick Coetzee described Pierneef's landscapes as 'clearly an outsider's view of the land, a view of the land that was de-historicized, de-humanized, drained of compassion',[6] while in 2000, the then high commissioner for South Africa in London, Cheryl Carolus, proposed that the 1935 Pierneef panels inside South Africa House in Trafalgar Square be covered over.[7]

The suggestion that Pierneef's landscapes were a deliberate attempt to support the ideology of segregation and apartheid is, however, open to debate. In his defence, Pierneef was a landscape painter in the European tradition who sought to make a living by continuing to work in his most popular style, which, reportedly, was also inspired by San | Bushmen and Khoekhoen rock art.[8] Furthermore, although Pierneef was a member of the Afrikaner National Party and of the Afrikaner Broederbond, a secret brotherhood that aimed to advance Afrikaner interests, his

1 Beaded wedding train
Name(s) of artist(s) unrecorded, 1890–1910
Recorded as Ndebele
Beadwork, vegetable fibre, metal crottals, H. 172 cm | W. 26 cm
Karel Nel, Johannesburg

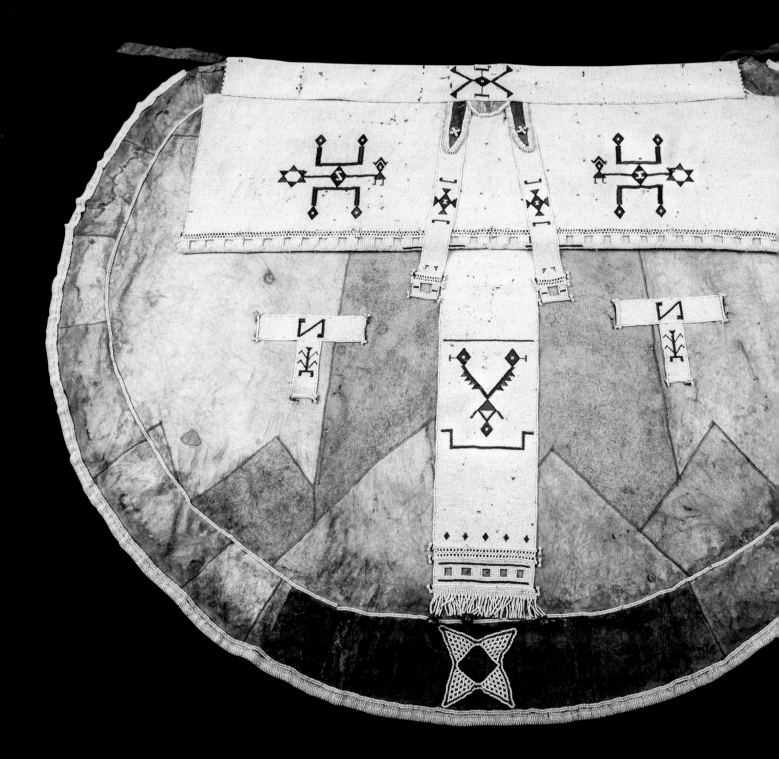

2 Beaded cape
Name(s) of artist(s) unrecorded,
1890–1910
Recorded as Ndebele
Beadwork, vegetable fibre, leather
H. 150 cm | W. 158 cm
Karel Nel, Johannesburg

3 *Mapoto*
Name(s) of artist(s) unrecorded,
1900–25
Recorded as Ndebele
Leather, beadwork
H. 54 cm | W. 46.3 cm
British Museum Af1986,09.4

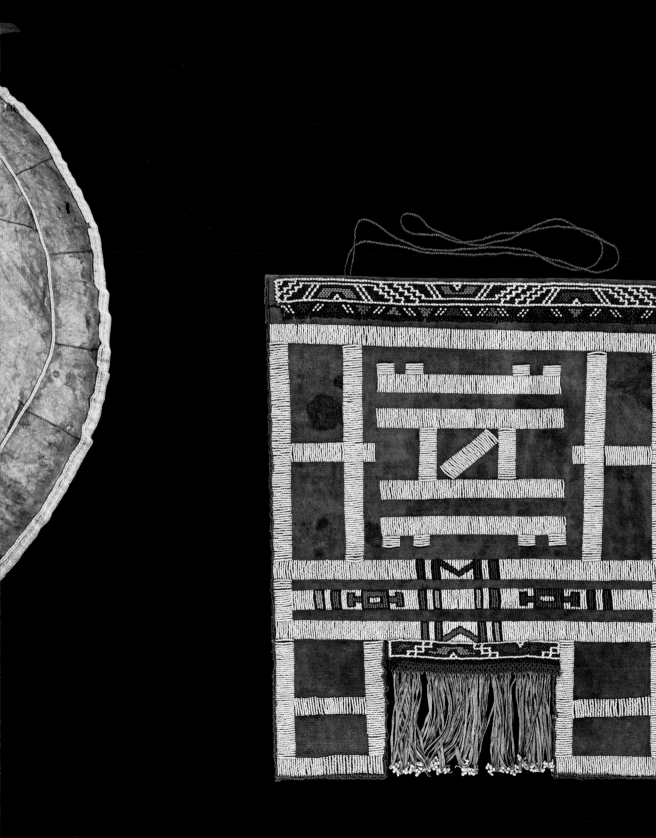

4 Beaded blanket
Name(s) of artist(s) unrecorded,
c. 1950
Recorded as Ndebele
Beadwork, synthetic fibre, cotton
H. 107 cm | W. 148 cm
British Museum 2015,2011.1

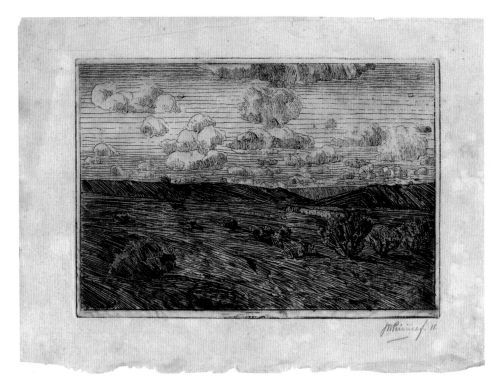

5 Landscape around Pretoria
Jacob Hendrik Pierneef, 1911
Etching, H. 9.4 cm | W. 13.7 cm
British Museum 1953,0717.3
Bequeathed by Miss S. C. Harding

work was adopted in earnest by the nationalist government only after his death.[9] Whatever one's opinions about his landscapes, Pierneef, working as he was within a particular political context, created a vision of South Africa that was used for political ends. In the view of one art critic:

> Pierneef's distinctive but consistent stylistic vocabulary and colour palette regularized the many different regional landscapes of South Africa and assimilated them into a single, overarching, representational imagined geography [...] Together, his paintings of South African terrain were tailored to meet the tastes of the growing urban middle class, and his more populist woodcuts that appealed to impoverished, newly urbanized Afrikaners became a screen on which the racist-environmentalist construction of Afrikaner history and identity could be projected during this period.[10]

Pierneef's landscapes, which are deafening in their silence on the people and oppression in the rural landscape, stand in stark contrast to Ndebele beadwork and house painting, which proclaimed 'we are here'.

Forced migrant labour

As black South Africans were being forced into racially and ethnically defined reserves, some also periodically

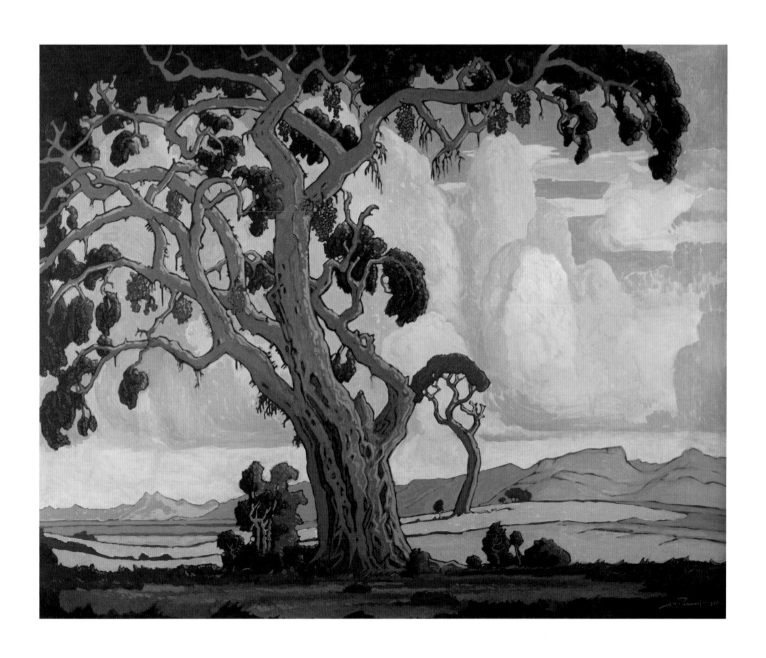

6 *Tree in the Bushveld*
Jacob Hendrik Pierneef, 1930
Oil on canvas, H. 90 cm | W. 119 cm
University of Pretoria, Pretoria 410793

production being a male activity. But as male migrant workers, particularly such nightwatchmen as Amos Ntuli, began to encounter the brightly coloured wire used in telephone junction boxes, both at work and on their way to and from work, this situation began to change. As well as making their own *imbenge*, the men started to take the wire home with them, where the female members of their household gradually re-incorporated it into *their* basketry repertoire. Today, women dominate the *imbenge* industry, which has grown so large that at least one factory now produces telephone wire specifically for the weavers.[12]

In making baskets from telephone wire, the migrant workers and their families not only adopted a new material but also challenged the authority of white minority rule, its machinery and its communication. At the time, officials reported considerable irritation at the theft of the wire. Yet this frustration, it has been speculated, may have been as much to do with the individual instances of petty theft as with a recognition on the part of the authorities that the resulting basketry was a form of black South African protest against white South African rule.[13]

Heavily beaded Western-style clothing was another form of implicit artistic protest against forced migrant labour (figs 11 and 12). In the nineteenth century, black South Africans who worked at colonial settlements were forced to comply with a strict dress code, which required them to cover their bodies from the shoulder to the knee, something that traditional forms of dress did not necessarily do. As a result, migrant workers had to either make or buy Western-style clothing, a practice that continued into the twentieth century. But as Anitra Nettleton has observed, the wearing of such clothes had a direct effect on the workers' ability to express their cultural affiliations:

> While traditionalists followed particular body practices that marked them physically and permanently as women, men or as members of a specific 'ethnic' group, once they were stripped of 'customary dress' and placed in ubiquitous Western-style clothing – in the case of

migrated to white South African industries in order to earn money to pay the taxes imposed on these reserves by the government – a policy that helped maintain a ready supply of cheap black South African labour.[11] The displacement of people into new labour environments led to significant changes in the gendered division of labour, including artistic production, with men unavailable to work at home for extended periods of time and women taking on male roles. Consider, for example, the production of *imbenge*, baskets made initially by men from telephone wire, but modelled on traditional beer-pot lids woven by women using grass fibre (figs 8–10). Wirework has been practised in South Africa for hundreds of years (see, for instance, the nineteenth-century wire-decorated snuffbox on page 130), and was historically associated with male artists – metal

7 Amos Ntuli making a basket
David Goldblatt, 1990
Photographic print
Collection of the artist

**8 Telephone wire basket on
metal lampshade mould**
Keshwa Ngubane, 1980–91
Recorded as Zulu
Wire, plastic
H. 6 cm | Diam. 24.7 cm
British Museum Af1991,09.25
Donated anonymously

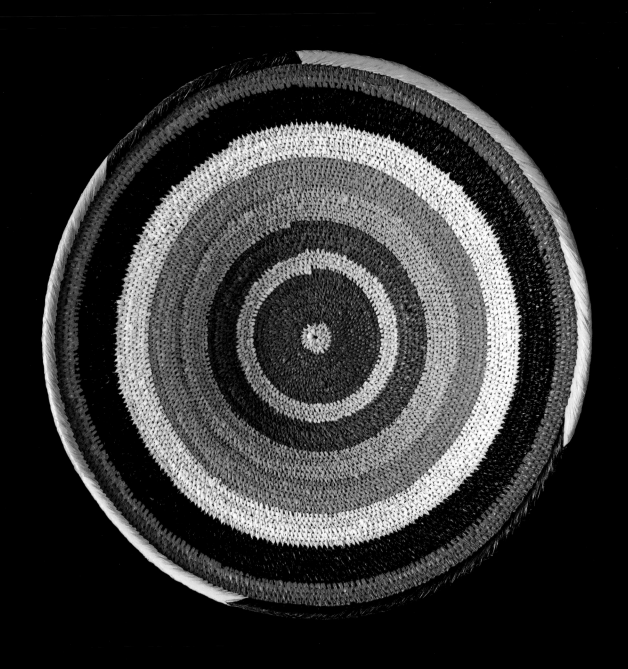

9 Plastic bag basket
Name(s) of artist(s) unrecorded,
1980–91
Recorded as Tsonga
Wire, plastic
H. 8.5 cm | Diam. 29.5 cm
British Museum Af1991,09.73
Donated anonymously

10 Telephone wire basket
Alex Mmola, 1980–91
Wire, plastic
H. 8.5 cm | Diam. 28.5 cm
British Museum Af1991,09.67
Donated anonymously

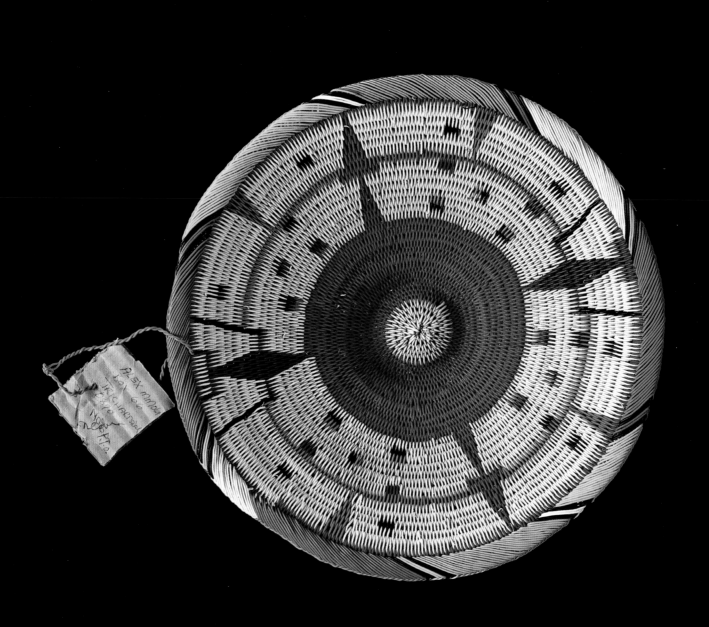

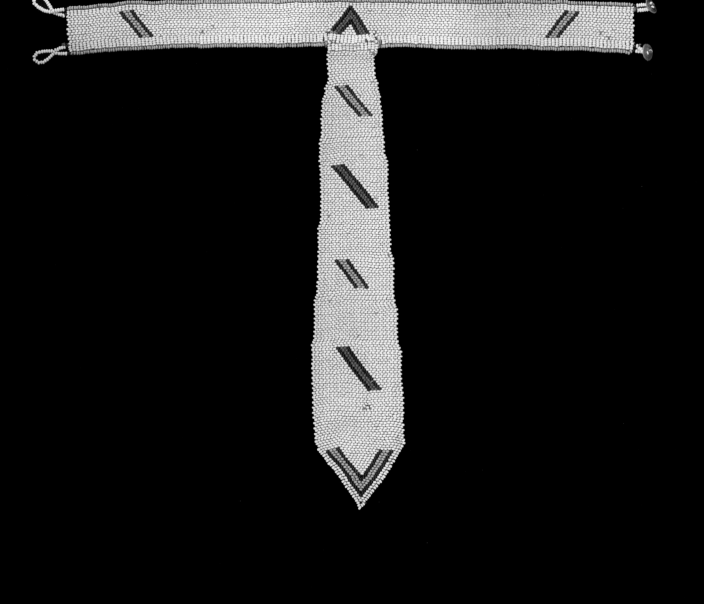

11 Beaded tie
Name(s) of artist(s) unrecorded,
1950–70
Recorded as Xhosa
Beadwork, vegetable fibre
H. 33 cm | W. 41.8 cm
British Museum Af1970,24.5

12 Beaded waistcoat
Name(s) of artist(s) unrecorded,
1950–87
Recorded as Zulu
Beadwork, wool
H. 65 cm | W. 46 cm
British Museum Af1987,16.1

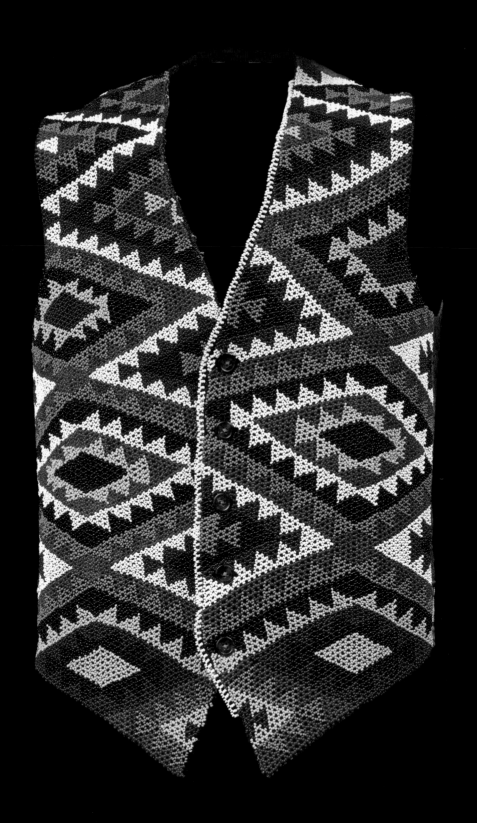

migrants this would be trousers and shirts, sometimes with shoes and socks, or indeed in plain blankets – they would lose their immediately striking, particular visual identity.[14]

In response, workers embellished their new, Western-style clothing with beadwork that referenced traditional designs. By doing so, explains Nettleton,

> Beaders [...] created new kinds of objects, among them items of wear for both men and women, which reflected particular kinds of interaction by individuals with changing circumstances, and the building of forms of resistance and cultural survival.[15]

As African versions of modern Western clothing, such items of wear would have marked the workers as participants 'in a process of speaking back to the centre of power'.[16]

Beaded Western-style clothing was not, however, limited to colonial contexts. It later became part of ceremonial dress in rural areas as a challenge to the idea of primitiveness,

a form of hybridity that recycled colonial oppression into black South African agency. As Nettleton explains:

> The beaded body had, by the 1890s, become a body of resistance, and it was to remain such for the next seventy years, proclaiming tradition and asserting modernity in the same breath, and making visible the labour of women by its presence.[17]

In the mid-twentieth century, the critique of forced migrant labour by black South African artists was not restricted to rural arts, but could also be found within the Western art market. One of the most powerful examples of such criticism in the context of Western art traditions is, perhaps, Gerard Sekoto's *Song of the Pick* (1946; fig. 14). Sekoto painted *Song of the Pick* in Eastwood, Pretoria, just before departing for Paris and a lifelong exile from the country of his birth. During the 1980s, postcard-sized reproductions of this iconic painting were widely distributed in South Africa, as both a badge of honour and a source of inspiration in the struggle against apartheid.[18]

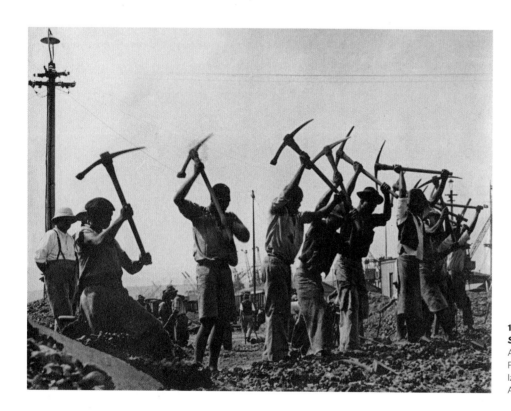

13 Source photo for
Song of the Pick
Andrew Goldie, *c.* 1930s
Photographic print
Iziko Museums of South
Africa Art Collections

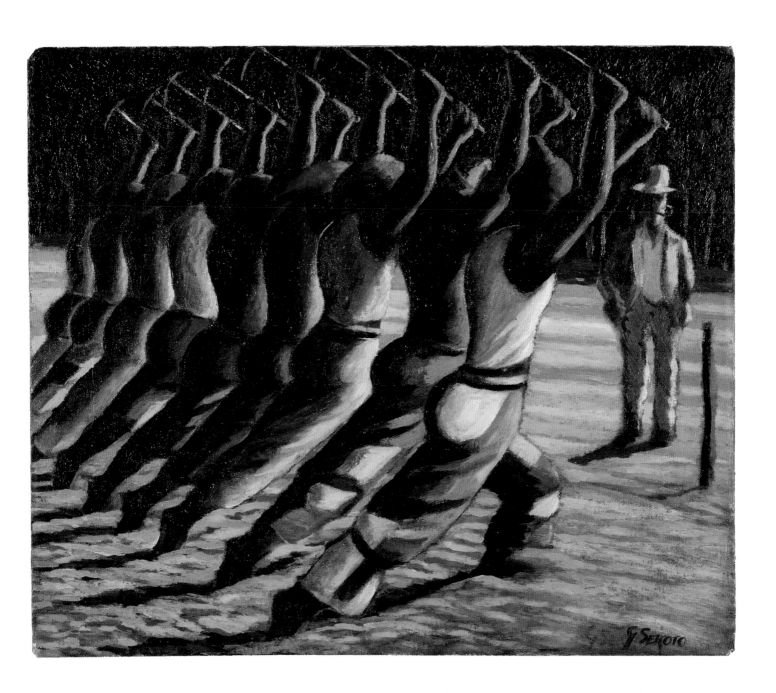

14 *Song of the Pick*
Gerard Sekoto, 1946
Oil on canvas
H. 50.5 cm | W. 60.5 cm
South32 Collection,
Johannesburg 573

15 *Yellow Houses –*
A Street in Sophiatown
Gerard Sekoto, 1939–40
Oil on canvas
H. 50.5 cm | W. 58 cm
Johannesburg Art Gallery,
Johannesburg

Together with an earlier version of the same scene created by Sekoto in 1939, *Song of the Pick* is based on Andrew Goldie's 1930s photograph of black South African workers labouring under the watchful eye of a white foreman (fig. 13).[19] In the version of *Song of the Pick* from 1946, however, the balance of power has shifted, with the pipe-smoking white overseer seemingly in danger of annihilation from the picks of the powerful workers striking in unison. In this sense, Sekoto's painting has something in common with John Muafangejo's *The Battle of Rorke's Drift* (1981), in which the defending British soldiers appear tiny in comparison to the attacking Zulu warriors (see pages 104–5).

Gerard Sekoto was born in Botshabelo, Mpumalanga province, in 1913, the year in which the Natives Land Act dispossessed many black South Africans of their ancestral lands. In 1938 Sekoto moved to Sophiatown, Johannesburg. He held his first solo exhibition the following year, and in 1940 the Johannesburg Art Gallery purchased *Yellow Houses – A Street in Sophiatown* (1939–40; fig. 15).[20] It was the first painting by a black South African artist to be acquired by a South African art institution, although Sekoto had to pose as a cleaner to see his own painting hanging in the gallery.[21] *Yellow Houses* is also notable in that it does not present the kind of subject normally expected of 'township art', such as groups of black people drinking or playing music, but is instead a townscape painting. The situation for black South Africans in Sophiatown became increasingly oppressive, however, and before leaving for Paris, Sekoto moved first to District Six in Cape Town (where he lived from 1942 to 1945) and then to Eastwood in Pretoria (1945–7).

In 1960, in response to the Sharpeville Massacre, which saw the killing of sixty-nine anti-apartheid protesters by the South African police, Sekoto painted a series of ten watercolours collectively titled *Recollection of Sharpeville*. Although he continued occasionally to show his work in South Africa, in 1966 the South African government revoked his passport, preventing his return. In the 1970s,

together with the work of other exiled South African artists, such as Gavin Jantjes (see below), Sekoto's paintings became more overtly political, particularly such works as *Homage to Steve Biko* (1978). In 2013 Wits Art Museum, Johannesburg, celebrated the centenary of Sekoto's birth with the exhibition *Song for Sekoto*.[22]

'Resistance art': five examples

The term 'resistance art' is typically used to describe artworks that were created in opposition to the apartheid state, from the Soweto Uprising of 1976 to the end of apartheid around 1989.[23] The former event was a mass protest in response to the South African government's proposal to make Afrikaans, historically a predominantly white language, the main mode of teaching in all schools. Some 20,000 students protested, and hundreds were killed by the police.

Although South African artists had been producing anti-apartheid work for many years before the Soweto Uprising, from the 1970s onwards a more concerted effort was made to use art as a form of protest against racial segregation. As Sue Williamson demonstrated in her book *Resistance Art in South Africa* (1989), a huge range of artworks may be described as 'resistance art'.[24] In this section we discuss a small number of mostly two-dimensional artworks that trace the evolution of resistance art from the 1970s to 1989, and which relate to both specific historical moments and more general apartheid themes.

Created in 1974, Gavin Jantjes's *A South African Colouring Book* is a commentary on the South African government's attempt to 'colour in' society through apartheid legislation (fig. 16). Jantjes first studied art as a young boy at the Children's Art Centre in District Six – officially, the Sixth Municipal District of Cape Town. When District Six was established in 1867, its population was extremely diverse, drawing on different elements of Cape Town's migrant demographic, and it remained that way into the middle of the next century. However, owing to its proximity

CLASSIFY
THIS
COLOURED

S.A. BURGER — S.A. CITIZEN

022 561735

KAAPSE KLEURLING — CAPE COLOURED
PERSOONSKAART
IDENTITY CARD

MANLIK — MALE

JANTJES G P

PRETORIA 1.2.63 Sekretaris van Binnelandse Sake
 Secretary for the Interior

CLASSIFIED

REPUBLIEK VAN SUID-AFRIKA · REPUBLIC OF SOUTH AFRICA

RE: The Population Registration Act (Act No. 30 of 1950)

The Population Registration Act defines three main racial groups - "WHITE" "COLOURED" and "NATIVE" (or "Bantu"). The "Coloured" group has seven sub-divisions viz "Cape Coloured" "Cape Malay" "Griqua" "Chinese" "Indian" "Other Coloured" and "Other Asiatics". The "Bantu" group is sub-divided into eight "national units" viz. Zulu Xhosa Swazi North-Sotho South-Sotho Tswana Shangaan and Venda.

The general practice is to distinguish between the people in four categories - "white" "coloured" "Bantu" and "Asiatic".

The racial label put on a non-white child at birth is not only a badge of race, it is a permanent brand of inferiority, the brand of class distinction. Throughout his life his race label will warn all concerned which doors are open to him, and which are closed. In addition to the political and social taboos attached to his race identity card, it will proclaim what sort of education he may receive and the limits on his choice of employment.

If he is classified as "Coloured" he will be excluded from certain occupations reserved for "whites"; his trade union and other rights will be inferior to those of his "white fellow workers; In many occupations his pay is likely to be lower.

If he is classified as a "Bantu" he is in every way made inferior both to "whites" and "Coloureds" - in education, employment, earnings, trade union rights and everything else concerned with making a living.

18/20

Gavin Jantjes

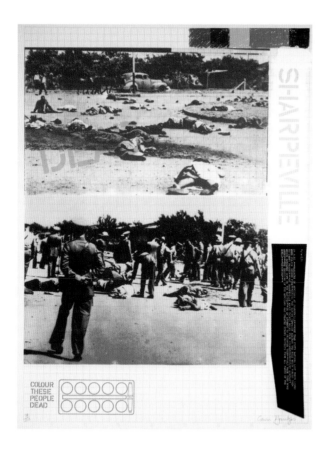

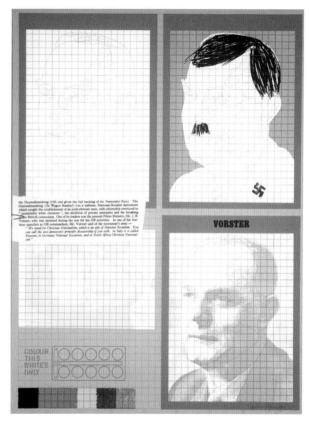

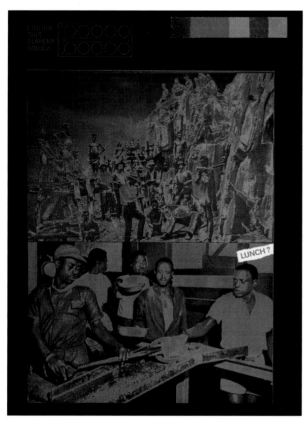

16 *A South African Colouring Book*
Gavin Jantjes, 1974
11 silk-screened panels with collage
Edition of 20
H. 60.2 cm | W. 45.2 cm
Tate, London P78646-56

to the centre of the city and the port, in 1966 the Group Areas Act of 1950 was used to declare it a 'white area'. This Act dictated where different racial groups could live in cities and towns across South Africa. As a result, more than 60,000 people were relocated to the Cape Flats on the outskirts of Cape Town, while their houses were demolished. In 1970, having completed his BA at the Michaelis School of Fine Art in Cape Town, Jantjes left South Africa to study in Germany, and did not return until the end of apartheid.[25]

Produced in Hamburg, *A South African Colouring Book* consists of eleven screen-printed pages, each one featuring image and text as they might appear in a child's colouring book. The title of each of the poster-style pages makes reference to 'colour' and to the vocabulary of racial discrimination under the apartheid regime. For the 'Classify this Coloured' page (see page 192), Jantjes reproduced his identity card, which describes him as 'Cape Coloured', alongside handwritten excerpts from the Population Registration Act of 1950, the legislation that divided South African society into three racial groups: 'white', 'coloured', and 'native' or 'Bantu' ('Indian' was added later as a separate group). Jantjes also lists the seven subdivisions of the 'coloured' group, as stipulated by the Act (Cape Coloured, Cape Malay, Griqua, Chinese, Indian, Other Coloured and Other Asiatics), and the eight 'national units' classified as Bantu (Zulu, Xhosa, Swazi, North Sotho, South Sotho, Tswana, Shangaan and Venda). Jantjes's handwritten text also describes the impact of these divisions on South African society:

> The racial label put on a non-white child at birth is not only a badge of race, it is a permanent brand of inferiority, the brand of class distinction. Throughout his life his race label will warn all concerned which doors are open to him and which are closed. In addition to the political and social taboos attached to his race identity card, it will proclaim what sort of education he may receive and the limits on his choice of employment.

A South African Colouring Book also makes extensive use of the work of the photojournalist Ernest Cole, including, on the 'Colour this Labour Dirt Cheap' page, his image of a black South African woman cleaning the floor in front of a 'Whites Only' sign. Cole, born Ernest Levi Tsoloane Kole in 1940, was South Africa's first black freelance photographer, producing work for such magazines as *Drum* and *Bantu World* (later *The Sowetan*). Cole changed his name so that he would be classified as 'coloured' by the Race Classification Board. This gave him additional privileges, including the option, as exercised by Jantjes, of leaving South Africa, which he did in 1966. Travelling to New York, Cole took with him the negatives that, a year later, would be published as *House of Bondage*, winner of the *New York Times* 'book of the year' award. The photos it contained, which Cole had taken at great personal risk in such places as tightly controlled mining compounds, opened the eyes of the world to the apartheid regime in South Africa.[26]

Elsewhere in *A South African Colouring Book*, Jantjes addresses such subjects as slavery (the 'Colour this Slavery Golden' page), the Sharpeville Massacre ('Colour these People Dead') and B. J. Vorster ('Colour this Whites Only'). In the last of these, Jantjes pointedly compares the face of the former prime minister of South Africa to that of Adolf Hitler (see page 193 for all three pages).

Together with Cole's *House of Bondage*, *A South African Colouring Book* was one of the first outspoken assaults on the apartheid regime by a South African artist. Notably, both works were censored in South Africa. Before the Soweto Uprising, Jantjes's and Cole's were two of only a handful of voices challenging the 'culture of silence', in which people who could have spoken out against the apartheid regime chose to say nothing. 'The *Colouring Book* project', wrote Jantjes in 1978, 'was my first step out of the culture of silence. It is therefore dedicated to all those struggling for humanity and equal rights.'[27]

In 1983 the South African photographer David Goldblatt was invited by the Second Carnegie Inquiry

17 9:00 PM Going Home:
Marabastad-Waterval bus:
For most of the people in
this bus the cycle will start
again tomorrow at between
2:00 and 3:00 a.m.
David Goldblatt, 1983
Photographic print
H. 29 cm | W. 43.5 cm
Goodman Gallery, Johannesburg

into Poverty and Development in Southern Africa to make a photographic essay on the subject of the transport of migrant labour. From October 1983 to February 1984, Goldblatt took a series of photographs on the buses travelling between the towns of Wolwekraal and Waterval in KwaNdebele and the bus depot at Marabastad, Pretoria – a journey of several hours, morning and night (fig. 17). For many of the thousands of people living in KwaNdebele, the only forms of employment open to them were low-paid factory work or jobs as domestic servants in Pretoria. In 1989 Goldblatt's photographs were published as *The Transported of KwaNdebele: A South African Odyssey*, with texts by Brenda Goldblatt and Philip van Niekerk. In his own written contribution to the book, Goldblatt observes:

Through more than two years in which many of the people of KwaNdebele […] suffered abuse, detention, torture, and even death for their resistance to imposed independence and incorporation, the daily ritual of the interminable bus rides continued unbroken […] Far from being irrelevant it seemed that there was in the bussing photographs a story that had to be told.[28]

Goldblatt has favoured the book as a means of presenting his work ever since his collaboration with the late South African writer and activist Nadine Gordimer, *On the Mines* (1973). Indeed, Goldblatt has cited writers, rather than other photographers or visual artists, as having had the greatest impact on his work: 'I was hardly influenced by South African photography over the years […] But I have been influenced in a very fundamental way by South African literature.'[29]

In his earlier books, including *On the Mines, Some Afrikaners Photographed* (1975), *Cape Dutch Homesteads* (1981), *In Boksburg* (1982) and *Lifetimes: Under Apartheid* (1986), Goldblatt portrayed the day-to-day activities of people – both black and white – living out their lives under apartheid. In so doing, he transformed the apparent banalities of daily life into acts that are by turn heroic and full of pathos. Goldblatt's photographs of men and women in *The Transported of KwaNdebele*, whether queuing for or travelling on buses, awake or asleep, are of people maintaining their pride and dignity under the most difficult of circumstances. Goldblatt's use of black-and-white photography helps conjure up this twilight world.

Reflecting on photography's role in resisting and exposing the system of apartheid, Goldblatt was unequivocal is his belief in the power of the medium:

I think photography achieved a great deal. The work of *Drum* magazine and the photographers working there, people like Jürgen Schadeberg, Peter Magubane, Ian Berry, Alf Kumalo and Bob Gosani. They did very important things: revealing what was happening in prisons, in farm labour, and gang culture in the townships […] And then the younger generation of photographers who became active in the 1980s – Omar Badsha […] Guy Tillim […] Santu Mofokeng […] and others. The work of these photographers in exposing apartheid was, in my opinion, critical.[30]

In 1989 Goldblatt founded the Market Photo Workshop in the inner-city suburb of Newtown, Johannesburg. At the time of its creation, Goldblatt envisioned the workshop as a place to provide further education in visual literacy and photographic practice to disadvantaged learners living under the apartheid regime.[31]

Although there were many protests against apartheid, including what became the Sharpeville Massacre in 1960, the mass-protest movement is typically identified as having begun with the Soweto Uprising of 1976. The movement continued into the following decade, and in 1986 was marked by *UDF 1987: Forward to Peoples Power*, a calendar for 1987 created by the cartoonist Zapiro on behalf of the United Democratic Front (UDF), a non-racial coalition established to fight apartheid (fig. 19).

Jonathan Shapiro, aka Zapiro, joined the UDF when it was established in 1983. Based on a UDF campaign slogan,

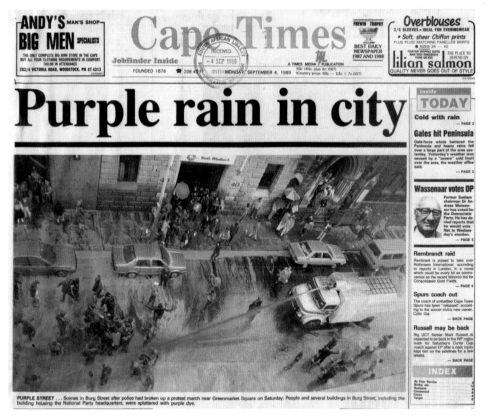

Cape Times

Jobfinder Inside

FOUNDED 1876 · 208 49 · ON TV. MONDAY, SEPTEMBER 4, 1989 · A TIMES MEDIA PUBLICATION

BEST DAILY NEWSPAPER 1987 AND 1988

Purple rain in city

inside
TODAY

Cold with rain — PAGE 2

Gales hit Peninsula
Gale-force winds battered the Peninsula and heavy rains fell over a large part of the area yesterday. Yesterday's weather was caused by a "severe" cold front over the area, the weather office said. — PAGE 2

Wassenaar votes DP
Former Sanlam chairman Dr Andreas Wassenaar has voted for the Democratic Party. He has denied reports that he would vote Nat in Wednesday's election. — PAGE 5

Rembrandt raid
Rembrandt is poised to take over Rothmans International, according to reports in London, in a move which could be every bit as controversial as the recent Minorco bid for Consolidated Gold Fields. — PAGE 8

Spurs coach out
The coach of embattled Cape Town Spurs has been "released" according to the soccer club's new owner, Colin Gie. — BACK PAGE

Russell may be back
Big UCT flanker Mark Russell is expected to be back in the WP rugby team for Saturday's Currie Cup match against EP after a neck injury kept him on the sidelines for a few weeks. — BACK PAGE

INDEX

PURPLE STREET . . . Scenes in Burg Street after police had broken up a protest march near Greenmarket Square on Saturday. People and several buildings in Burg Street, including the building housing the National Party headquarters, were splattered with purple dye.

18 *Purple rain in city*
Cape Times, 1989
Photographic print
Cape Times, Cape Town

the title of his calendar proved highly prescient: in a speech delivered on 8 January 1987 at the ANC's seventy-fifth anniversary meeting, Oliver Tambo, ANC president from 1967 to 1991, ruled out negotiations with the South African government, declaring that 1987 would be 'the Year of Advance to People's Power'.[32] Highlighting important dates in 'the struggle', the calendar includes a large cartoon showing UDF members clashing with riot police during a protest. At the centre of the cartoon, a policeman has mistakenly sprayed one of his fellow officers with purple dye, a method of marking out protesters for subsequent arrest that was routine procedure at the time (fig. 18).

Zapiro's depiction of the use of purple dye also proved prescient. On 2 September 1989, a group of anti-apartheid protesters marched on parliament in Cape Town and were assaulted by riot police using tear gas, batons, whips, attack dogs and water cannon filled with purple dye. During the

ensuing mayhem, one of the protesters climbed on to a Casspir armoured vehicle and turned a jet of purple dye on the riot police. The following day, on walls around Cape Town, graffiti artists sprayed the slogans 'Forward to Purple People's Power' and 'The Purple Shall Govern', the latter in reference to the ANC's 1955 Freedom Charter, which declares: 'The People Shall Govern!' Over the next few days, similar slogans appeared on the walls of other South African cities. These events, referred to today as the 'Purple Rain Protests', were key moments in the dying years of apartheid. The following week, Bishop Desmond Tutu led 30,000 people on an anti-apartheid march through Cape Town unopposed by the police; four months later, Nelson Mandela was released after twenty-seven years in prison on Robben Island.

Created just a couple of years after Zapiro's calendar, *Anguish* (1988; fig. 20) represents Helen Mmakgabo Sebidi's

JANUARY

SUN	MON	TUES	WED	THUR	FRI	SAT
				1	2	3
4	5	6	7	8	9	10
11	12	13	14	15	16	17
18	19	20	21	22	23	24
25	26	27	28	29	30	31

1st - NEW YEAR'S DAY

FEBRUARY

SUN	MON	TUES	WED	THUR	FRI	SAT
1	2	3	4	5	6	7
8	9	10	11	12	13	14
15	16	17	18	19	20	21
22	23	24	25	26	27	28

NEIL AGGETT'S DEATH (1982)

MARCH

SUN	MON	TUES	WED	THUR	FRI	SAT
1	2	3	4	5	6	7
8	9	10	11	12	13	14
15	16	17	18	19	20	21
22	23	24	25	26	27	28
29	30	31				

19th - NATIONAL DETAINEES DAY · 21st - SHARPEVILLE (1960), UITENHAGE (1985) MASSACRES

APRIL

SUN	MON	TUES	WED	THUR	FRI	SAT
			1	2	3	4
5	6	7	8	9	10	11
12	13	14	15	16	17	18
19	20	21	22	23	24	25
26	27	28	29	30		

17th - GOOD FRIDAY · 20th - FAMILY DAY

MAY

SUN	MON	TUES	WED	THUR	FRI	SAT
					1	2
3	4	5	6	7	8	9
10	11	12	13	14	15	16
17	18	19	20	21	22	23
24/31	25	26	27	28	29	30

1st - LABOUR DAY

JUNE

SUN	MON	TUES	WED	THUR	FRI	SAT
	1	2	3	4	5	6
7	8	9	10	11	12	13
14	15	16	17	18	19	20
21	22	23	24	25	26	27
28	29	30				

16th - SOWETO UPRISINGS (1976) · 26th - FREEDOM CHARTER LAUNCHED (1955)

JULY

SUN	MON	TUES	WED	THUR	FRI	SAT
			1	2	3	4
5	6	7	8	9	10	11
12	13	14	15	16	17	18
19	20	21	22	23	24	25
26	27	28	29	30	31	

AUGUST

SUN	MON	TUES	WED	THUR	FRI	SAT
						1
2	3	4	5	6	7	8
9	10	11	12	13	14	15
16	17	18	19	20	21	22
23/30	24/31	25	26	27	28	29

9th - NATIONAL WOMEN'S DAY · 20th - UDF NATIONAL LAUNCH (1983) · 26th - NAMIBIA SOLIDARITY DAY

SEPTEMBER

SUN	MON	TUES	WED	THUR	FRI	SAT
		1	2	3	4	5
6	7	8	9	10	11	12
13	14	15	16	17	18	19
20	21	22	23	24	25	26
27	28	29	30			

3rd - TROOPS INVADE SEBOKENG (1984) · 12th - STEVE BIKO'S DEATH (1977)

OCTOBER

SUN	MON	TUES	WED	THUR	FRI	SAT
				1	2	3
4	5	6	7	8	9	10
11	12	13	14	15	16	17
18	19	20	21	22	23	24
25	26	27	28	29	30	31

11th - INTERNATIONAL DAY OF SOLIDARITY WITH POLITICAL PRISONERS

NOVEMBER

SUN	MON	TUES	WED	THUR	FRI	SAT
1	2	3	4	5	6	7
8	9	10	11	12	13	14
15	16	17	18	19	20	21
22	23	24	25	26	27	28
29	30					

DECEMBER

SUN	MON	TUES	WED	THUR	FRI	SAT
		1	2	3	4	5
6	7	8	9	10	11	12
13	14	15	16	17	18	19
20	21	22	23	24	25	26
27	28	29	30	31		

16th - HEROES DAY · 25th - CHRISTMAS

19 *UDF 1987: Forward to Peoples Power*
Zapiro (Jonathan Shapiro), 1986
Ink, card
H. 78.5 cm | W. 59 cm
British Museum 2016,2006.1

first experiment with the technique of collage. Born in 1943, Sebidi grew up in the north-east of South Africa, in what is now the province of Mpumalanga. After the National Party came to power in 1948, her parents were forced to work for most of the year in Johannesburg. As a consequence, Sebidi was brought up by her grandmother, who taught her the Tswana traditional arts of house painting and ceramics. At the age of sixteen, Sebidi left her ancestral home to work in Johannesburg, taking her grandmother's lessons with her:

> I was born with, and was married to this culture. My life was tough but my grandmother's route was the right one. I had to keep pushing and my grandmother motivated me. I get dreams and visions from my ancestors who guide me with each painting I create – their spirit has always been with me.[33]

In Johannesburg, Sebidi was taught by John Koenakeefe Mohl, one of the first black South African artists to be involved in formal art education and training. Mohl was a landscape artist, bucking the trend for black South African artists to paint scenes of township life. Mohl's clients, however, strongly advised him to paint township scenes rather than landscapes, maintaining that the latter were the preserve of European artists and of such white South Africans as Pierneef, to which Mohl replied: 'But I am African, and when God made Africa, he also created beautiful landscapes for Africans to admire and paint.'[34] Influenced by Mohl, Sebidi's early paintings were also of landscapes. During further studies at the Katlehong Art Centre, the Johannesburg Art Foundation, the Funda Centre in Soweto and the Thupelo workshops (see below), Sebidi developed her own collage style.

Anguish is a reworking of Christ's final, agonizing journey to Golgotha wearing a crown of thorns. Sebidi's claustrophobic collage style is a comment on urban township life and, in particular, the breakdown of social values and the impact on women. As we have seen, the Group Areas Act of 1950 formalized the concentration of black and coloured South Africans into townships, thereby radically altering existing social relations. In *Anguish*, as in her other collages, Sebidi uses the technique of split representation, dividing her characters' faces into two. Each half is looking in a different direction, suggesting both the mental and the physical schism created in apartheid South Africa.

We conclude this section by looking at a work by William Kentridge. *Negotiations Minuet* (1989; fig. 21) was created as the apartheid regime was going through its death throes. It satirizes those who continued loudly and aggressively to debate and challenge the end of apartheid even though the movement towards democracy had already built up an unstoppable momentum.[35] All the figures in the composition have their faces hidden, whether beneath an umbrella, behind a megaphone or by a huge pair of blinkers. The last of these are sported by Soho Eckstein, the fictional property developer who appears in several of Kentridge's prints, drawings and animations.

The central grouping of four figures is based on an aquatint showing figures dancing in a circle from the series *Los Disparates* (also known as *Los Proverbios*, 1816–24) by the Spanish artist Francisco de Goya (fig. 22). A further reference to Goya can be found in the figure bound to a stake, which is drawn from the eighty prints that make up the Spanish artist's series *Disasters of War* (1810–13; fig. 23). Kentridge was influenced by the politically charged works of such European satirists as Goya, William Hogarth and Honoré Daumier, relating them to the society he saw in South Africa: 'I have never tried to make illustrations of apartheid, but the drawings and the films are certainly spawned by, and feed off, the brutalised society left in its wake.'[36]

Art(ists) under apartheid

Under apartheid, both the creation and the exhibition of art was restricted. Any art that was critical of the

20 *Anguish*
Helen Mmakgabo Sebidi, 1988
Ink on paper, collage
H. 207 cm | W. 147 cm
Private collection, London

21 *Negotiations Minuet*
William Kentridge, 1989
Charcoal on paper
H. 108 cm | W. 164 cm
Private collection, London

22 *Los Proverbios (Si Marina bayló, tome lo que hallo)*
Francisco de Goya, 1816–24
Ink, paper
H. 24.5 cm | W. 35.5 cm
British Museum 1975,1025.363
Donated by HM Treasury

23 *Disasters of War (Y no hai remedio)*
Francisco de Goya, 1810–13
Ink, paper
H. 14.2 cm | W. 16.9 cm
British Museum 1975,1025.214
Donated by HM Treasury

apartheid regime risked being banned, and there were few opportunities for black South African artists to exhibit their work, whether critical of apartheid or not. Within this context, Polly Street Art Centre, Rorke's Drift Art and Craft Centre, and the Thupelo workshops were vitally important to the development of new artists. Today, their legacy lives on in South Africa's contemporary art scene.[37]

Initiatives in the 1940s by the Johannesburg Local Committee for Non-European Adult Education, in consultation with the Johannesburg City Council, secured the use of a hall on Polly Street. The city council appointed a cultural recreation officer in 1949, but the facility was not fully utilized until the appointment of the London-born artist Cecil Skotnes in 1952. It was under his guidance that the Polly Street Recreational Centre became the Polly Street Art Centre and, eventually, a significant training ground for a whole generation of artists. The accessibility of the centre, and the subsequent exhibition of students' work at galleries in Johannesburg, enabled black and white South African artists to meet and work together, sharing technical knowledge and aesthetic debate. Polly Street was effectively shut down by the apartheid authorities in 1975.[38]

The Evangelical Lutheran Church Art and Craft Centre at Rorke's Drift in rural KwaZulu-Natal was established in 1962 by the Swedish artists Ulla and Peder Gowenius. Over the course of twenty years, its fine art school was attended by students from across southern Africa. After the closure of Polly Street, the importance of Rorke's Drift as an arts centre open to black South African artists increased enormously. John Muafangejo is perhaps most closely connected to the centre – both as a student and as a tutor – but other luminaries of black South African art have also taught or studied there, among them Azaria Mbatha, Lionel Davis (see page 220), Avhashoni Mainganye, Kagiso Patrick Mautloa and Sam Nhlengethwa (see below and page 213).[39]

The Thupelo workshops were styled on those of the Triangle Arts Trust, a British charity founded in 1982 by Robert Loder (see page 89) and the English sculptor Sir Anthony Caro. The workshops provided South African artists with the opportunity to work not only with one another but also with artists from the international community. Led by artists – *thupelo* is a Sotho word meaning 'to teach by example' – the workshops provided participants with a space in which to create their art and exchange ideas, experiences, techniques and disciplines. This interaction between artists from diverse cultural, national and social backgrounds imbued the workshops with a creative energy. The first Thupelo workshop took place in Johannesburg in 1985, and was held in the city every year until 1990, when it was relocated to Cape Town.[40]

Many of South Africa's most famous contemporary artists benefited from the Thupelo workshops and the studios that grew out of them, such as the Bag Factory, which was co-founded in Johannesburg in 1991 by Robert Loder and the South African artist David Koloane. The Bag Factory enabled artists to develop their individual practices through the exchange of ideas and innovative techniques, and has helped launch the careers of some of South Africa's most important artists, including Penny Siopis (see page 58), Wayne Barker, Ricky Burnett and Deborah Bell, all of whom have at some point taken up residencies at the factory.[41]

In 2010, in an interview with Polly Savage, Sam Nhlengethwa discussed his debt to the various workshops he had attended during the apartheid years, and how art had offered a means of resisting the inevitability of working in the Johannesburg mines:

When I started to do art at Rorke's Drift, that memory [of the gold miners] came back [...] For the first time, I was exposed to lino and etching, and they'd teach you how to draw, how to paint [...] They became my second family. We came there without anything and just grabbed that opportunity, as we did later with Thupelo. We didn't want to squander any chances [...] When

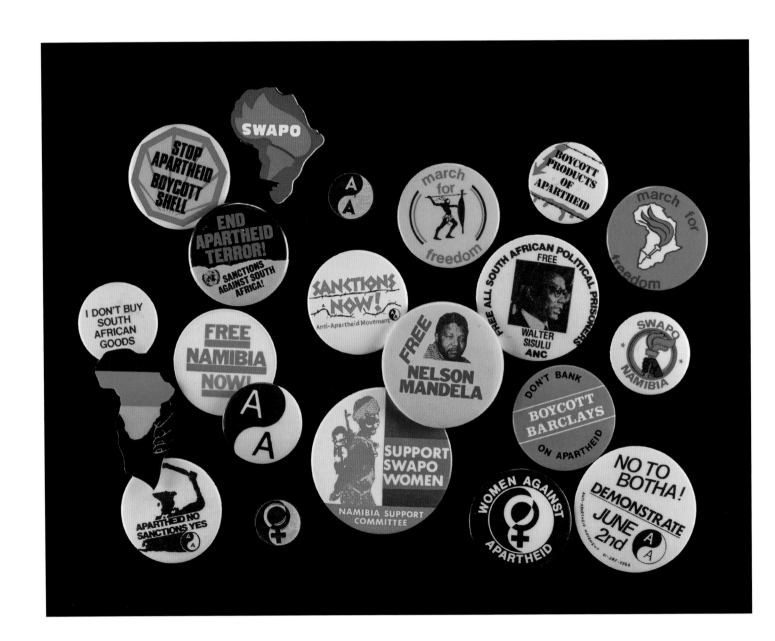

24 Anti-apartheid badges
Name(s) of artist(s) unrecorded,
1984–7
Recorded as British
Mixed media
Various dimensions
Donated by the
Anti-Apartheid Movement
For details of each badge,
see pages 247–8

Thupelo started in 1985, it was so exciting for us to work with other artists, especially international artists. There would be this energy, this free spirit, to paint without any restrictions.[42]

In 1999, following the success of the Bag Factory, the artist and teacher Jill Trappler, the radiologist Professor Isky Gordon, Robert Loder and Lionel Davis established Greatmore Studios, Cape Town. Greatmore continues to provide space and support for both established and emerging talents.

Art in exile

'Resistance art' was also produced outside South Africa, with politically active groups using such popular art forms as badges, T-shirts and posters to promote the fight against apartheid. Here, we draw on a collection of anti-apartheid badges donated to the British Museum in the 1980s by the Anti-Apartheid Movement (AAM; fig. 24).

The AAM began in 1959 as the Boycott Movement, a campaign group made up of South African exiles and British opponents to apartheid. Inspired by the ANC's boycott of companies that supported apartheid, the Boycott Movement called for an international boycott of all South African products. Following the Sharpeville Massacre in 1960, the Boycott Movement became AAM. In so doing, it maintained its stance on South African products while also calling for the complete political and economic isolation of South Africa.[43] Some of the badges in the collection relate to the boycott campaigns, such as those bearing the slogans 'Boycott Barclays: Don't Bank on Apartheid', 'Stop Apartheid, Boycott Shell', 'Boycott Products of Apartheid' and 'I Don't Buy South African Goods'. Others called for the imposition of sanctions against the South African government, which the then British prime minister, Margaret Thatcher, refused to support.

By wearing AAM badges and T-shirts, and by displaying its posters, people in the United Kingdom and elsewhere were able to show their support for political movements and political prisoners in other parts of Africa. Several of the badges refer to SWAPO (South West African Peoples Organization), an armed movement that was fighting for Namibian independence from South Africa. Following German defeat at the end of the First World War, South-West Africa – as Namibia was known during its time as a German colony – was given to South Africa by the League of Nations as a mandated territory, and was consequently subjected to a system of racial segregation and oppression as developed in South Africa. In 1989, in response to SWAPO's demands, democratic elections saw the organization achieve power. Namibia attained independence the following year, and SWAPO has been the governing party ever since.

Nelson Mandela is the most famous political prisoner depicted on the badges (see also page 208), but other important ANC figures, such as Walter Sisulu, are also represented. Sisulu joined the ANC in 1940, along with Mandela and Oliver Tambo. Jailed numerous times for political activism in the 1950s and 1960s, he was eventually sentenced to life imprisonment with Mandela and others at the Rivonia Trial. After serving twenty-five years on Robben Island, he was finally released in 1989. In 1991 he was elected deputy president of the ANC.

Through badges, T-shirts and posters made by the AAM and similar organizations, the world beyond South Africa came to know the faces of such political prisoners as Sisulu and Mandela, whose plight may not otherwise have been known by the international public. Following the first democratic elections in South Africa in 1994, the AAM became Action for South Africa, an organization that continues to campaign for human rights in South Africa.[44]

Chapter 7 **Transformations**

The period of 'Transformation', during which South Africa transformed from a racially segregated state to a democratic country free from the landscape of apartheid, might be defined as having begun in 1990 with the unbanning of political opponents and the freeing of political prisoners, and as having ended when the Truth and Reconciliation Commission published its final reports from 1998 to 2003. Between these two landmarks, South Africa dismantled apartheid legislation, staged its first democratic elections, was welcomed back into the international community and completed a complex reconciliation process. Yet despite these considerable transformations, artists continue to identify South Africa as being in a post-apartheid transitional state, with many political, economic and emotional transformations yet to be completed.

Democracy

The previous chapter concluded with a collection of badges produced by the Anti-Apartheid Movement, including one from 1984 that demanded 'FREE NELSON MANDELA'. Here, we pick up the narrative ten years later, with two further examples of popular political art. The first is a badge proclaiming, 'Mandela for President – The People's Choice' (fig. 1). The second is an unused laminated ballot paper from the 1994 elections on which nineteen political parties are represented, including the ANC (fig. 2). Both the badge and the ballot paper use the same image of Mandela as an elder statesman, in contrast to the bearded 'freedom fighter' shown on the badge from 1984. A decade on, and the man once regarded by the South African government as public enemy number one, whom it imprisoned for twenty-seven years, was now preparing to become his country's first democratically elected president as the leader of the ANC.

The long and complex history of the ANC's rise to power in 1994 as the winners of South Africa's first democratic elections begins in the early twentieth century.

In 1912 the South African Native National Congress (SANNC) was established to fight for black rights in response to their disenfranchisement following the Union of South Africa in 1910. The SANNC's early activities were largely unsuccessful, such as its failed challenge to the Natives Land Act of 1913, and in 1923 the organization was renamed the African National Congress. In this early period, the ANC operated alongside more influential opposition groups, such as the Industrial Commercial Workers Union and the Communist Party of South Africa.

In the 1940s the ANC established a youth wing whose membership included such famous figures of the ANC's future as Walter Sisulu, Oliver Tambo, Anton Lembede and Nelson Mandela. After the introduction of apartheid legislation by the National Party in 1948, the ANC called on the non-white majority to defy oppressive racial laws through a Programme of Action and the Defiance Campaign, which began in 1949 and 1952 respectively.

In 1955 the ANC, the Indian National Congress, the South African Coloured People's Organisation and the white South African Congress of Democrats, working together as the Congress Alliance, created the Freedom Charter. The charter set out a new democratic constitution for South Africa and directly challenged the apartheid state. In response, the National Party charged 156 of the charter's proponents with violent treason and communism. The ensuing 'Treason Trial' lasted for five years, ending in 1961 with the government's failure to demonstrate the accused's support for either violence or communism. Indeed, at the time, the ANC was committed to the principles of non-violent resistance, as established by Gandhi in South Africa and India (see pages 83–4), and as practised by such civil rights campaigners as Martin Luther King in the United States.

Decades of frustration at the continued oppression of black South Africans led some to question the policy of non-violence, and in 1959 a number of ANC members broke away from the main organization to form the Pan African Congress (PAC). The policy of non-violence was

**1 Nelson Mandela
for President badge**
Name(s) of artist(s) unrecorded,
1994
Recorded as British
Metal, paper, plastic
Diam. 5.5 cm
British Museum 1995,0820.1
Donated by Edward Baldwin

**2 1994 South African
ballot paper**
Name(s) of artist(s) unrecorded,
1994
Recorded as South African
Paper, laminate
H. 44 cm | W. 16.9 cm
Jane Samuels, London

tested again in 1960 during the Sharpeville Massacre (see page 191), an event used by the government as a pretext to ban both the ANC and the PAC. Faced with limited options, in 1961 the ANC formed an armed wing, Umkhonto we Sizwe (MK, 'Spear of the Nation'), to undertake acts of sabotage against government sites. Although the MK was initially successful in its aims, the police gradually caught up with both it and the ANC leadership. Mandela was arrested in 1962, and in 1963, having discovered the ANC's headquarters, the police arrested a number of its other leaders, including Walter Sisulu and Govan Mbeki. They were tried in Rivonia, Johannesburg, on charges of terrorism and communism, and in 1964 were found guilty and sentenced to life imprisonment.

Following the Rivonia Trial, the ANC leadership operated largely in exile, from where it trained new recruits to be sent back to South Africa to support underground operations. In the late 1970s ANC activity within South Africa began to increase with the emergence of mass resistance. The turning point in its campaign was the Soweto Uprising of 1976 (see page 191).

Riots and protests continued throughout the 1980s. In 1985 the South African government declared a state of emergency, leading to the eventual detention of tens of thousands of opposition supporters. The situation became untenable as the government's oppressive activities were increasingly placed under pressure by international sanctions and internal conflict. Secret talks between the government and the ANC began in 1985, and in 1989 Mandela, then deputy president of the ANC, met with two South African presidents: P. W. Botha and, following Botha's resignation, F. W. de Klerk. In 1990 the talks resulted in the unbanning of the ANC and other opposition groups, and the freeing of such prominent political prisoners as Mandela and Walter Sisulu. Finally, in 1991 the last pieces of apartheid legislation were dismantled, leading the way to the first democratic elections in 1994 and the ANC's victory led by Mandela.[1]

Transitions

The transformation of South Africa into a democratic nation was hard won. However, the unbanning of opposition groups, the release of political prisoners, the dismantling of apartheid legislation and the establishment of democracy did not make the landscape of apartheid magically disappear. The persistence of racism, inequality and violence in post-apartheid South Africa is an issue that has concerned the artist Willie Bester for more than twenty years. In an interview with Polly Savage, Bester reflected on the creation of one of the pieces in his *Transition* series (1994; fig. 3), made before the first democratic elections:

Transition was done at a time of negotiations about the new South Africa. The apartheid government claimed to have made a shift but the killings were continuing. It's from a series of about twelve, which documented whatever major atrocity had happened in the country. This one was about an incident in KwaZulu-Natal in 1994. The security police had information about some insurgents in a little house in KwaMashu, so they attacked in the middle of the night. They killed seven children who were sleeping in one bed, shooting more than 300 bullets into them [...] We thought we were on a good footing with negotiations, but they were trying to hijack what was happening [...] So this is where these doves of peace come in [...] The woman is mothering the black kid and is symbolic of the role of woman [*sic*] in our struggle [...] the shotgun shells are the evidence picked up in the morning after that incident, and the child is drinking water because living as an honest, basic person, when you find yourself in a war zone you can be killed going to fetch water [...] This is a passbook, the little book that black people were forced to carry from cradle to grave [...] These cups with different numbers are symbolic of the final phase of the crucifixion, when Jesus had to drink this bitter cup [...] The guitar is about a system which dictates to

3 *Transition*
Willie Bester, 1994
Mixed media
H. 92 cm | W. 152 cm
Private collection, London

the masses […] In the townships they say 'you dance according to the music' […] So the guitar symbolizes this system that you don't have any control over.[2]

At other times in his career, Bester felt that there was a danger of losing sight of what the struggle had achieved, and of slipping back into the horrors of the past:

People have built up a resistance to anything that addresses the psyche of mankind or people or themselves. I believe we must protest against that which is wrong. There is no form of escape; remaining apolitical is a luxury that South Africans simply cannot afford.[3]

Speaking in 1996, Bester was keenly aware of the need to uphold the struggle, despite the difficulties faced by those involved, himself included:

I'm tempted sometimes to call it a day, to go to the sea and paint beautiful things, but I don't want to be part of a peaceful community, I want to be part of the building of it. People want to forget […] but it is very important to keep track of the past. It must serve as a light into the future.[4]

In 2015 Bester was still making works in the *Transition* series, believing the transition to be incomplete.

During apartheid, Bester attended classes at the Community Arts Project (CAP) in District Six, Cape Town. A strongly political organization, the CAP was established after the Soweto Uprising with the aim of empowering black and other marginalized artists. There, Bester's talent blossomed as he realized that he could use his skills as an artist as a way of fighting back: 'I was angry […] so I used my work as a tool against apartheid. I didn't care if it matched your curtains or not. My art was a chance to be heard.'[5] To Bester, art provides a powerful tool in the fight against oppression:

I think art can conscientize people. Whereas some might fight a war with guns, artists just fight on another level. Nobody would give me a gun to go and kill people but I can do a work which reflects what's happening. I think artists played a major role in the struggle. Our approaches might have been different, but there was a common theme among our works.[6]

Many of Bester's works are mixed-media collages mounted on board, combining found objects with his own photographs and scenes painted in oils or enamel. In other contexts these found objects might be considered rubbish, but Bester elevates and dignifies them, together with the citizens of the townships they symbolize. While overtly resisting the system, Bester's art also champions the dignity, indomitable spirit and creativity of those who suffer at its hands. The portraits of well-known figures or 'ordinary' people that often appear in Bester's work represent beacons of hope for the future, although they sometimes look as though they are about to be swallowed up by the chaos that surrounds them.

The 'rainbow nation'

After the 1994 elections, Bishop Desmond Tutu used the term 'rainbow nation' to celebrate the wide spectrum of cultures in South Africa. In so doing, he attempted to reappropriate racial and ethnic difference, which the apartheid state had once defined, and turn it into a positive aspect of society. The label was quickly adopted by Nelson Mandela in his inagural speech as the newly elected president of South Africa: 'Each of us is as intimately attached to the soil of this beautiful country as are the famous jacaranda trees of Pretoria and the mimosa trees of the Bushveld – a rainbow nation at peace with itself and the world.'[7]

In contrast to other post-conflict countries, such as post-genocide Rwanda, which has sought to extinguish ethnic

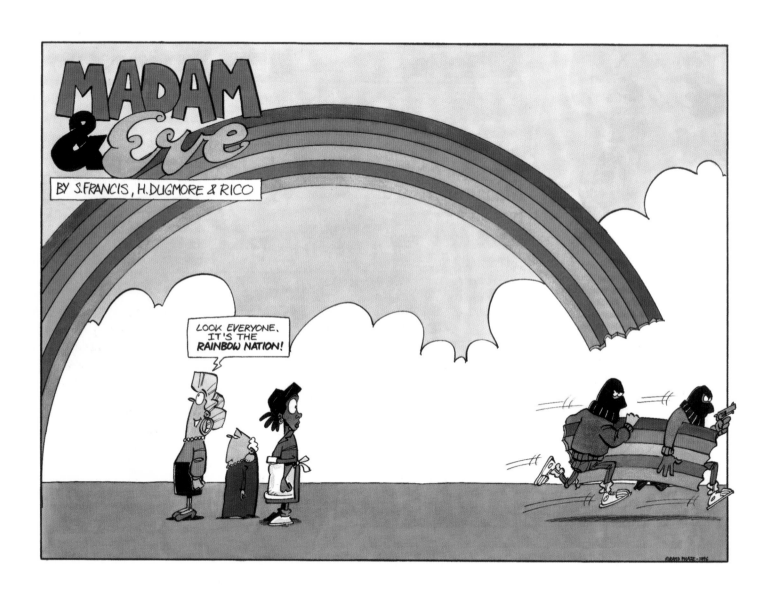

4 *Rainbow Nation*
Stephen Francis and
Rico Schacherl, 1996
Digital image
Madam & Eve,
Johannesburg

diversity and promote unity through a single national identity, the idea of the rainbow nation actively celebrated equality through cultural difference within South Africa. Not everyone, however, viewed the concept in such positive light. In its sense of unqualified optimism, 'rainbowism' was criticized for masking the social inequalities that still needed to be tackled. Although policies of racial oppression had been dismantled, extreme inequalities persisted along class lines that broadly followed earlier racial distinctions. Much of the wealth of South Africa remained in the hands of a predominantly white minority, while crime rates soared.

Such concerns are the subject of *Rainbow Nation* (1996; fig. 4), a single cartoon from the 'Madam & Eve' comic strip by Stephen Francis, Harry Dugmore and Rico Schacherl. In the cartoon, the tight-fisted Gwen 'Madam' Anderson and her reactionary, eighty-year-old mother, Mother Anderson, look up admiringly at the rainbow over their heads. Standing behind them is Eve Sisulu, Gwen's underpaid black 'domestic maintenance assistant'. Streetwise, and by far the brightest of the three, Eve looks over her shoulder to see two thieves – one black, one white – making off with a section of the rainbow. 'That drawing would be the same if I did it today,' remarked Rico, the artist behind the graphics for 'Madam & Eve', in an interview in 2012, 'except the thieves would be wearing suits. They would be politicians.'[8]

On its publication in 1996, *Rainbow Nation* highlighted a concern raised by other South African political commentators, warning against the potential side effects of 'rainbowism' in concealing many of the less-than-utopian aspects of the new South Africa. As expressed by the poet Jeremy Cronin:

Allowing ourselves to sink into a smug rainbowism will prove to be a terrible betrayal of the possibilities for real transformation, real reconciliation, and real national unity that are still at play in our contemporary South African reality.[9]

The Truth and Reconciliation Commission

Key to transformation is the resolution of past injustices. In 1996 the Truth and Reconciliation Commission (TRC) was established to 'enable South Africans to come to terms with their past on a morally accepted basis and to advance the cause of reconciliation'.[10] The TRC was made up of three committees: the Human Rights Violation Committee, for investigating testimony-based human-rights abuses between 1960 and 1994; the Reparation and Rehabilitation Committee, for supporting victims financially and emotionally; and the Amnesty Committee, for hearing applications from perpetrators who admitted a political crime in order to be granted amnesty from prosecution.[11]

In general, the TRC was considered a positive step towards reconciliation. However, given the time limits set on its jurisdiction and the complex nature and considerable age of many of the crimes investigated, it is also remembered for leaving the process incomplete and unresolved. Sam Nhlengethwa's *It left him cold – the death of Steve Biko* (1990; fig. 5) helps to deepen our understanding of truth and reconciliation in post-apartheid South Africa. Although this painting was created six years before the TRC was established, it tells the story of a famous figure of the struggle, Steve Biko, whose unresolved death was investigated by the TRC.

Famous for using the slogan 'Black is Beautiful', Biko was one of the founding members of the Black Consciousness Movement (BCM). After the ANC and PAC were banned, the BCM emerged in the mid-1960s to fight the psychological and physical effects of apartheid. In 1972 Biko, once an aspiring medical student, chose to dedicate himself to the study of law, politics and the struggle against apartheid for a more 'human' South Africa. Speaking in 1973, he said:

We have set out on the quest for true humanity, and somewhere on the distant horizon we can see the

glittering prize. Let us march forth with courage and determination, drawing strength from our common plight and our brotherhood. In time we shall be able to bestow upon South Africa the greatest gift possible – a more human face.[12]

Biko was an influential figure in the BCM, and his political activism attracted the attention of the South African government. In 1973 he was given a banning order preventing him from speaking publicly and from leaving King William's Town in the Eastern Cape. The BCM was heavily involved in the protests that led to the Soweto Uprising in 1976, and Biko was arrested during the uprising itself, serving 101 days in solitary confinement. The following year, he was arrested again having breached his banning order. He was taken to Walmer Police Station in Port Elizabeth, where he was chained naked for twenty days before being transferred to another building in the city. There, he was badly beaten by the police because he refused to stay standing. As a result of the beating, Biko suffered a brain haemorrhage. He was seen by two doctors but no action was taken. Unable to speak, frothing at the mouth and naked, he was driven in the back of a police van to a Pretoria prison some 700 km away. He was seen by a third doctor on arrival but died in his cell the following day.[13]

Biko's death prompted an immediate public outcry. The police, however, expressed ambivalence. The title of Nhlengethwa's painting refers to the statement made by the minister of justice, James Kruger, in response to Biko's murder: 'I am not glad and I am not sorry about Mr Biko. It leaves me cold. I can say nothing to you. Any person who dies, I should also be sorry if I die.'[14]

According to the police, Biko had been on hunger strike and effectively committed suicide, a story that was repeated in state media:

Should Mr Biko's death be the result of suicide it would fit into a pattern, which has become common among detainees in South Africa. However, numerous detainees, who have been detained following communist training and indoctrination, have testified that they receive specific instructions to commit suicide rather than divulge information to the police.[15]

Soon after Biko's death, photographs taken during his autopsy were leaked to the press. Nhlengethwa used a composite of six of these photos to portray Biko's face.[16] The autopsy confirmed that Biko had died of a brain haemorrhage. However, the resulting inquest undertaken two months after his death concluded that he had died of a 'prison accident'.[17] Biko's unresolved death was not forgotten, and in 1990, as apartheid was unravelling, Nhlengethwa returned to his story with *It left him cold* – a timely reminder of the many injustices that needed to be righted.

In early 1997, at the TRC, four former police officers admitted to killing Stephen Biko, and were told in 1999 that they would not be granted political amnesty because there was no obvious political motive. Referring to its own findings and those of the original inquest led by Magistrate Marthinus Prins, the TRC reported:

The Commission finds that the death in detention of Mr Stephen Bantu Biko on 12 September 1977 was a gross human rights violation. Magistrate Marthinus Prins found that the members of the SAP [South African Police] were not implicated in his death. The magistrate's finding contributed to the creation of a culture of impunity in the SAP. Despite the inquest finding no person responsible for his death, the Commission finds that, in view of the fact that Biko died in the custody of law enforcement officials, the probabilities are that he died as a result of injuries sustained during his detention.[18]

Four years later, in 2003, the TRC determined that, owing to insufficient evidence and the amount of time that had

**5 *It left him cold –
the death of Steve Biko***
Sam Nhlengethwa, 1990
Collage, pastel, paint and
pencil on paper
H. 90.5 cm | W. 115.2 cm
Wits Art Museum, University of
the Witwatersrand, Johannesburg
1994.10.02

6 Street cadets with harbinger:
wish, walk / Loop, Long
Jane Alexander, 1997–8
Reinforced plaster, oil paint, found
clothing and objects, sheep pelt,
rabbit pelt, wood, steel
H. 110 cm | W. 70 cm | D. 21 cm
Private collection, London

7 Butcher Boys
Jane Alexander, 1985–6
Reinforced plaster, animal bone,
horns, oil paint, wood bench
H. 128.5 cm | W. 213.5 cm | D. 88.5 cm
Collection Iziko South African National
Gallery, Cape Town SANG90/73

elapsed since Biko's death in 1977, the state would not prosecute the police.

Two famous quotes from Nelson Mandela capture Steve Biko's contribution to South Africa:

> One of the greatest legacies of the struggle which Biko waged – and for which he died – was the explosion of pride among the victims of apartheid. The value that black consciousness placed on culture reverberated across our land; in our prisons; and amongst the communities in exile. Our people, who were once enjoined to look to Europe and America for creative sustenance, turned their eyes to Africa.[19]

> Living, he was the spark that lit a veld fire across South Africa. His message to the youth and students was simple and clear: Black is Beautiful! Be proud of your Blackness! And with that he inspired our youth to shed themselves of the sense of inferiority they were born into as a result of more than three hundred years of white rule.[20]

Children

Problematic apartheid legacies were also carried into post-apartheid South Africa by children born under the regime. Based on two street children that lived around Loop Street and Long Street in Cape Town in the late 1990s, Jane Alexander's *Street cadets with harbinger: wish, walk / Loop, Long* (1997–8; fig. 6) is a poignant reminder of this fact.

For *Street cadets with harbinger*, Alexander employed the sculptural style she had used for her most famous work, *Butcher Boys* (1985–6; fig. 7), a group of three life-size, white, naked, horned, grotesque yet disturbingly human figures, their sternums and spines raw as if their organs have been removed. Produced as a response to the violence perpetrated by the apartheid regime, *Butcher Boys* made a powerful comment on the ugliness of apartheid.

The apartheid regime had been dismantled by the time Alexander produced *Street cadets with harbinger*, but, as she explained to Polly Savage in 2013, its legacy could still be seen in the street children of Cape Town:

> *Street cadets with harbinger* is one of a number of works that make reference to displaced children encountered and observed on the street in the city of Cape Town between 1990 and 2000. This was a period of transition in South Africa from apartheid to a democratically elected government, and throughout that period, groups of children lived on Long Street around my home […] *Street cadets* makes reference to two children known to me at the time – a baby kept in a supermarket trolley by his homeless parents, and the rare occurrence of a girl living on the street […] The title refers to text on the sculpted baby's jacket, and to Loop and Long streets in Cape Town, the two major parallel one-way streets in the centre, where the children spent their days and often slept.[21]

At once charming and achingly pathetic, the 'street cadets' in Alexander's work seem to embody the words of the South African writer J. M. Coetzee, who, on receiving the Jerusalem Prize for the Freedom of the Individual in Society in 1987, observed: 'The deformed and stunted relations between human beings that were created under colonialism and exacerbated under what is loosely called apartheid have their psychic representation in a deformed and stunted inner life.'[22] In *Street cadets*, the two protagonists on handcarts are still children underneath their masks, yet they are being pushed and pulled by the ape-like 'harbinger'.

Alexander's inspiration springs not only from first-hand experience of the repressive, dehumanizing effects of the apartheid regime and its legacy, but also from an imaginative recreation of Nazi Germany, from which her German Jewish grandfather was forced to flee in 1936.[23]

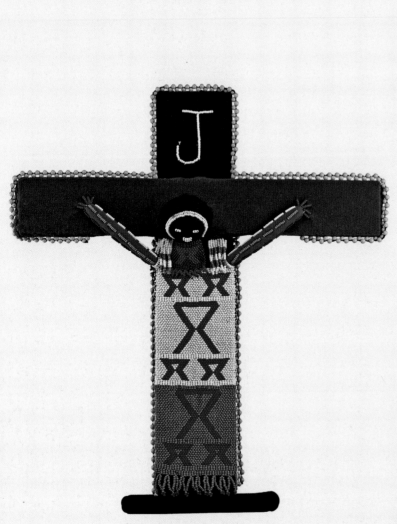

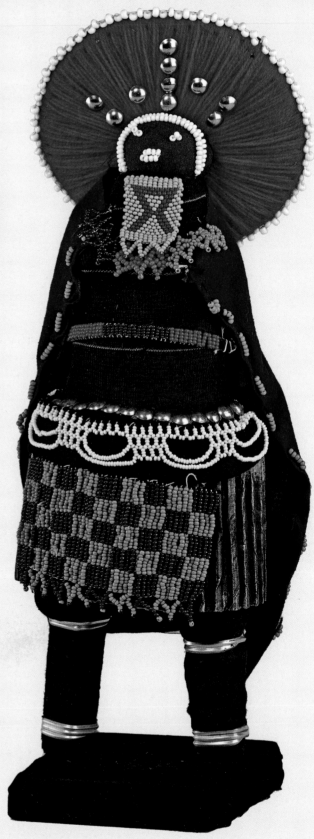

8 HIV/AIDS crucified figure
Name(s) of artist(s) unrecorded, 2002
Siyazama Project
Fabric, wood, wool, plastic, cotton
H. 50.2 cm | W. 46.5 cm
British Museum Af2002,07.4

9 Female figure
Name(s) of artist(s) unrecorded, 2002
Siyazama Project
Fabric, wood, wool, plastic, cotton
H. 37.5 cm | W. 10.5 cm
British Museum Af2002,07.6

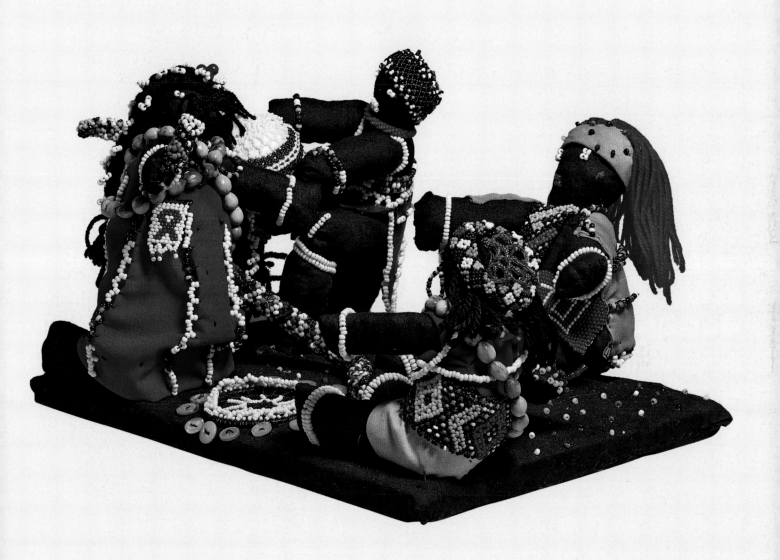

10 Sangoma tableau
Name(s) of artist(s) unrecorded, 2002
Siyazama Project
Textile, wood, wool, plastic, cotton
H. 14 cm | W. 31 cm
British Museum Af2002,07.1

Health

Another obstacle to transformation in South Africa is the continuing disparity in access to services that might improve the living standards of the majority of the population. First denied such services because of apartheid, these people continue to be denied them because of a lack of recognition and/or money. The HIV/AIDS pandemic is a tragic example.

South Africa has one of the highest levels of HIV infection in the world, with estimates of approximately 19 per cent of the population (6.3 million people) living with the virus in 2013.[24] Although the relationship between HIV and AIDS is now acknowledged, the government of President Thabo Mbeki famously denied this link.[25] One result of this denial was the failure to provide drugs to prevent mother-to-child transmission and anti-retrovirals to prevent needlessly premature deaths.[26] The government's policy was compounded by the cost of drugs imposed by international pharmaceutical companies, meaning that people could not afford to purchase their own even if they could access them. After a long fight, the South African government now imports and supplies much cheaper generic versions, and access to medication has improved.[27]

Illustrated here are beaded 'dolls' and a beaded tableau made by female artists in KwaZulu-Natal in 2002 at the height of the HIV/AIDS pandemic in South Africa. The artists were working for the Siyazama (isiZulu for 'we are trying') project, which was established to look at responses to HIV/AIDS. Although dolls of various types were traditionally made by Zulu girls and boys as toys, and by older girls of courtship age as love tokens (see Chapter 5), older women did not begin to make dolls for sale to tourists until the 1930s.[28] These trade dolls were initially made by women living in impoverished circumstances whose husbands had been forced into the system of migrant labour (see page 180). Eventually, however, such private organizations as the African Art Centre in Durban began to promote the dolls' production more widely.[29]

Originally, the dolls and tableaux were intended to appeal to a white clientele, with subjects including tennis, wild animals, helicopters and crucifixions of a white Jesus with long, straight hair. But the HIV/AIDS pandemic, coupled with the collapse of the apartheid regime, shifted the focus to social concerns within the women's communities. Crucifixion figures, for example, began to depict Jesus with a black cloth face (fig. 8), while dolls were created to memorialize women who had died from HIV/AIDS. The artists also created such powerful scenes as a *sangoma*, or traditional doctor, performing a virginity test on a young girl, despite such practices being taboo. Another tableau shows a *sangoma* holding a consultation with an older woman, who may have come to ask how to treat an HIV/AIDS victim within her family (fig. 10). The detailed scene includes a sacred pattern into which the *sangoma* would have thrown divination bones to seek an answer. Surrounding this pattern are buttons representing the silver coins paid by the woman for the services of the *sangoma*, whose power is represented by the snake that winds through the centre of the scene.

This mode of communication was both economically and socially empowering. The renewed sense of pride felt by the makers of these dolls and tableaux may be seen in the individual figures of Zulu women in traditional dress who are also boldly wearing the red ribbon of HIV/AIDS awareness in beaded panels around their necks (fig. 9).

Reclamation

Colonial rule and apartheid resulted in the physical and psychological appropriation of South African lives, including land, wealth and the freedom to think and act. Consequently, there is a need to reclaim what has been taken. This is the topic of *Reclamation* (2004; fig. 11), a self-portrait by the artist Lionel Davis.

Davis was born in District Six, a culturally diverse area of Cape Town that, as discussed in Chapter 6, was home

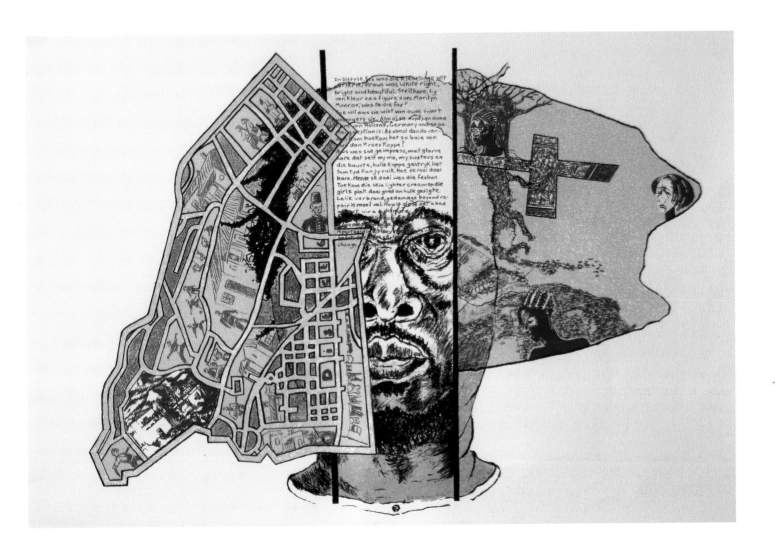

11 *Reclamation*
Lionel Davis, 2004
Screen-print on paper
H. 90.5 cm | W. 115.2 cm
Museum of Archaeology and
Anthropology, University of
Cambridge 2013.222

to many 'coloured' (mixed race) South Africans, as well as black and Indian families (see page 191). Davis was arrested for sabotage in 1964 and imprisoned on Robben Island. In 2010, Davis spoke about his career and the individual elements that make up *Reclamation*:

[It] was made at a workshop at the Caversham Press in KwaZulu-Natal of visual artists and writers. The artists had to write and the writers had to make art. The writing at the top of my head is in the Afrikaans patois [non-standard language] spoken by the local people of Cape Town. My writing is about women in the black community that in my youth and even today do all sorts of funny things to their hair to get rid of the kink or wooliness. It is a sickness which seems to permeate not only South Africa, but wherever black people are influenced by a European or an American culture. The street map is of the old District Six where the inhabitants were forcefully removed in 1969. The right side of my face is a segment of Robben Island and is open to interpretation.[30]

While Davis was in jail on Robben Island, his family was forcibly removed from District Six and resettled in a township reserved for those classified as 'coloured' by the regime. He was released in 1971 but placed under house arrest for the next five years: 'Being under house arrest is a very traumatic experience. You're your own jailer. At the time, I was looking for a channel, for something to heal myself, although I never thought of it in that way. I had an urge to become creative.'[31]

In 1978, in common with Willie Bester (see above), Davis began his formal art education at the Community Arts Project in Cape Town. After two years there, he moved to the Art and Craft Centre at Rorke's Drift, KwaZulu-Natal (see page 203), where he learned the art of screen printing. On his return to Cape Town he taught screen printing at CAP, enabling and empowering students to produce popular political art on posters and T-shirts.

As Davis explains, 'through the medium of art [...] you can begin to dignify a person'.[32] In 1986 he was invited to the second Thupelo workshop (see page 203), which he found to be a 'transformative' experience. Together with Jill Trappler, Garth Erasmus and Velile Soha, Davis helped to run the Thupelo workshops from 1993, and continues to do so today.

In 1997 Davis became an educator and tour guide on Robben Island:

After twenty-one years going back there was not easy, but every day was a catharsis; you just got rid of all your angst. Every day is an opportunity to learn something new about yourself, about people, about so much, so it's a joy to be living. All of these experiences were transformative for me, wonderful growth points, and so I'm tall now! Even today, when I look back, I just think, thank God that I went that way because it has helped me to grow tremendously.[33]

Featuring maps of both Robben Island and District Six, as well as Davis's own written comments on the Westernization of culture, *Reclamation* speaks of the highly personal and collective need to reclaim not only the self but also the many tangible things stolen by apartheid. In so doing, the work connects with the Black Consciousness Movement and the belief that the struggle against apartheid was as much a personal, psychological fight as a practical one – a fight that continues today.

Generations

Since the end of apartheid, a generational shift in South Africa has resulted in the rise of a black South African middle-class majority and a related sense of isolation among some white South Africans. This is the topic of Candice Breitz's *Extra!* (2011; fig. 12). Commissioned by the Standard Bank of South Africa, *Extra!* consists

of a single-channel video installation and a series of chromogenic prints, shot on the set of the soap opera *Generations* over a two-week period.

At the time *Extra!* was made, *Generations* was South Africa's most popular soap opera. First broadcast on SABC 1 in 1994, it was also the most-watched television programme on the African continent. Set against the backdrop of the advertising industry, the first episodes of *Generations* painted a picture of an emergent black South African middle class. As Breitz explains:

> It's easy to imagine how refreshing it must have been for black South Africans to turn on the telly and discover *Generations* when it was first launched in 1994, at a time when successful black entrepreneurs and affluent black socialites were relatively rare, given the economic logic of apartheid [...] Rather than depicting a given present, *Generations* imagined and fed into fantasies about an imminent future, almost in the manner of science fiction.[34]

Generations does not include any major white South African characters, partly because they do not fit into the aspirational landscape of the show, and partly because large portions of the script are in one of the Nguni languages, which are rarely spoken by white South Africans. In *Extra!*, Breitz (a white South African) places herself in a number of actual scenes from the soap, 'sometimes subtly, sometimes awkwardly and absurdly, always without judgment or easy explanation'.[35] The cast of *Generations* was asked to ignore Breitz's presence on the set to the greatest degree possible. Once each scene had been filmed, an additional take was made with the artist included, so that she becomes both invisible and the centre of attention. In the finished work, Breitz 'resonates as a conspicuously white presence amongst an otherwise black cast. The resulting images are simultaneously thought provoking and uncomfortably amusing, implicitly raising questions about what it might mean to be white in the context of the new South Africa.'[36]

According to Breitz herself:

Extra! was motivated by many questions, not least the question of what it means to be a white South African, to belong to a demographic that has inflicted so much trouble, and that continues to be largely unengaged by and un-integrated into the complex and vibrant reality of the transformed and transforming South Africa. At the time of conceptualizing *Extra!*, I was following the debate that had been unleashed by Samantha Vice's essay closely and voraciously – that debate felt very important to me. [The philosopher Samantha Vice had suggested that white South Africans should be ashamed of their history as oppressors and should adopt a position of humble and silent neutrality in political matters.]

For so long, the discussion around race in South Africa had let 'whiteness' off the hook. Whiteness had barely been perceived as a highly constructed social and political identity. Samantha Vice's lecture generated a variety of diverse and charged commentaries on whiteness and its expressions, opening into a heated discourse about the concrete effects and affects of whiteness, the modes according to which whiteness is voiced, articulated, imposed, asserted. *Extra!* was very much my contribution to that debate, though I never formally framed it as such. One of the anxieties for me, as I read the debate that grew out of Vice's essay, was that the conversation was being had in a relatively restricted circle, among journalists, intellectuals and academics. I wondered to myself whether it might not be possible to find the language, the form, with which to stage the debate in more accessible terms. What does whiteness do? How does it figure and engage? Is it productive or obstructive? When is it voyeuristic? When is it obnoxious? When does it withhold or exert its voice? I hoped that *Extra!* might be able to somehow capture and communicate the important questions raised by the Vice debate for a wider audience, an

12 *Extra!*
Top: #5
Bottom left: #12
Bottom right: #4
Candice Breitz, 2011
Chromogenic print
Each H. 56 cm | W. 84 cm
Goodman Gallery, Johannesburg

audience of television viewers who might lack the specialized language and jargon to participate in the academic version of the conversation, but who could certainly draw on their lived experience and the embodied smarts [physical pain] to engage the questions at stake.[37]

Breitz's original intention was to convince the SABC to broadcast her manipulated scenes to a network audience within scheduled daily episodes, and it was agreed with *Generations* creator Mfundi Vundla that they would 'hijack' one week of the soap. Despite Vundla's support, however, the network did not fulfil the request because it was concerned it would alienate the programme's audience. As Breitz explains:

Extra! rests on a somewhat utopian proposition, driven by my interest in questioning the extent to which it might be possible to hijack popular form to explore questions that point beyond entertainment, or at least to work from within existing mainstream formats to render visible the manner in which popular entertainment reflects, reproduces and perpetuates the very social structures and ideologies from which it claims to be able to offer 'escape'.[38]

Beyond the larger backdrop of life in post-apartheid South Africa, there is also an intensely personal element to *Extra!*, which relates to Breitz's absence from South Africa since 1994, when she left on an academic scholarship. The invitation to present a survey of her work in South Africa in 2011 therefore represented an extraordinary challenge:

The challenge as I saw it, was to play the role of an absent presence or a present absence, an extra who is at the same time a very visible and pale sore thumb, a glaringly white question mark […] On the one hand it was a wonderful opportunity to bring my work 'home'. And yet, when I set out to make a new work in South

Africa to mark the occasion, it was clear that it would be ridiculous for me to assume that I could simply pick up where I left off in 1994 and speak from the position of an insider. It occurred to me that any work that I made in the South African context would have to acknowledge the awkwardness of coming back after a long period of time, the awkwardness of being someone who at the same time feels very close to and very far away from the daily realities of South Africa. Inserting myself into the microcosm that is *Generations* seemed like a productive way to allegorically explore my insider–outsider status, a way to both express a desire for proximity and at the same time acknowledge the various historical, political and personal factors that make it impossible for me to seamlessly or simply incorporate myself into that imaginary world and, by extension, into the daily reality of South Africa at large, after such a long absence.[39]

Yet far from *Extra!* suggesting deep divisions in the new South Africa, there is something about the humorous acceptance of Breitz in the midst of *Generations* that is profoundly positive. While there is inevitably tension between Breitz and the professional actors around her, there is also a sense of balance:

There were certainly a couple of moments when I sensed that I'd better make myself scarce and disappear into the shadows, so as to avoid stretching everybody's patience too thin. But I remember far more moments of shared laughter, moments when one or another absurd pose that I struck within a scene would crack the consummate professionalism of the crew and cast, and reduce us all to giggles.[40]

The Purple Do Govern

We conclude this book with an examination of Mary Sibande's *A Reversed Retrogress: Scene 1* (2013; fig. 13). We

have chosen this artwork because it represents a powerful personal and collective commentary on the past, present and future of South Africa.

As a personal commentary, *A Reversed Retrogress* marks a key moment in the artistic, intellectual and spiritual development of Sibande as she pays homage to 'Sophie', her first internationally famous alter ego, dressed in iridescent blue and dazzling white. The work also welcomes the arrival of a new alter ego in the form of a female figure clad in 'royal' purple and swathed in a writhing mass of tendrils, which seem to spring up from the ground or descend from above. The black manikins that inhabit these costumes are casts of the artist's own body. Sophie, wearing a Victorian-style dress made from *shweshwe* (see page 159), represents three generations of Sibande's maternal relatives: her mother, grandmother and great-grandmother, all of whom were maids. In Sibande's hands, however, Sophie is a superheroine, elevated in her various incarnations to the status of religious, military and royal leader.

Sophie first appeared in Sibande's early solo exhibitions, *My Madam's Things* (2006) and *Four Tales* (2008), and is always portrayed with her eyes closed. 'If she opened her eyes', Sibande once explained, 'it would be back to work – cleaning this, dusting that. Her dress would become an ordinary maid's uniform.'[41]

In 2010 the Johannesburg Art City project created a series of nineteen giant photographic murals on the sides of buildings, each based on a different incarnation of Sophie.[42] For the 2011 Venice Biennale, Sibande began to change Sophie's dress and place new figures beside her: 'I've been telling people that Sophie will disappear [...]

13 *A Reversed Retrogress: Scene 1* (see also opposite and page 228)
Mary Sibande, 2013
Mixed media
Each figure H. 180 cm | W. 120 cm
Gallery MOMO, Johannesburg

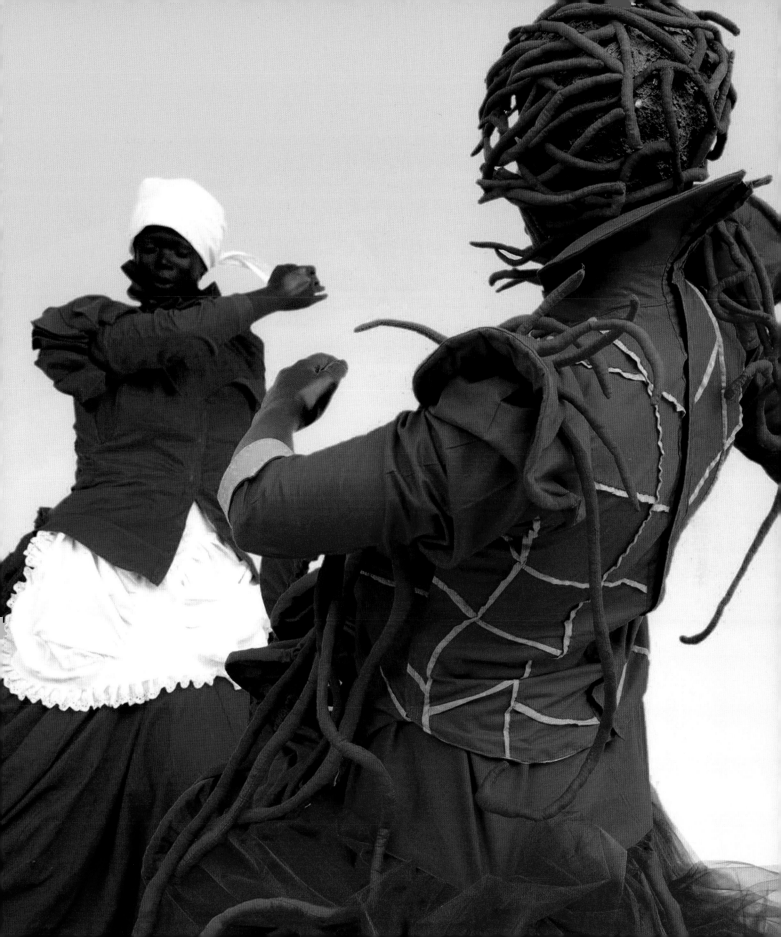

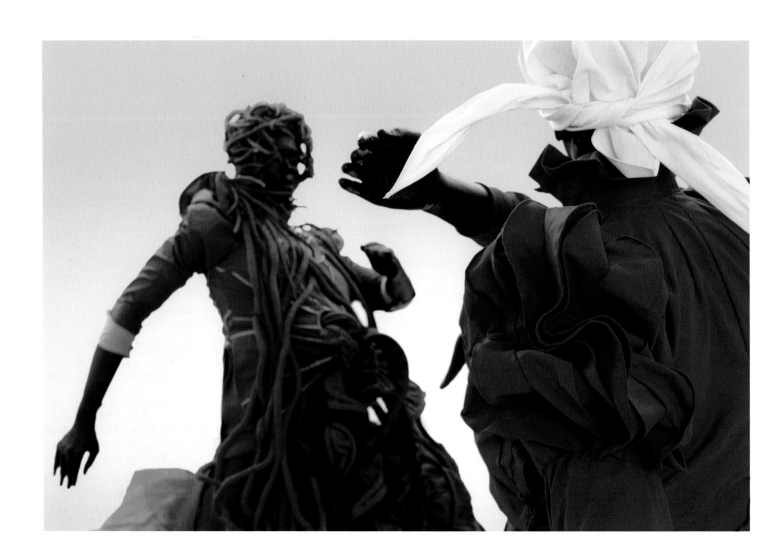

Though that figure is really important to me, I don't want it to go stale. There is only so much I can say on her or about her.'[43]

As Sibande points out, colour is a crucial element in her work, and it was partly through colour that she began to move away from Sophie:

> Colour is important in South Africa – we make it important. Colour places you, colour tells where you are within the geography of South Africa. And when I thought of colour, I realized that I cannot ignore the incident that happened in 1989 [the 'Purple Rain Protests'].[44]

As discussed in Chapter 6, the Purple Rain Protests saw protesters turn water cannon, which the police were using to spray the protesters with purple dye, back on the police themselves (see page 197). In addition to giving rise to the slogan 'The Purple Shall Govern', as sprayed on the walls of Cape Town by graffiti artists in reference to the ANC's declaration 'The People Shall Govern', the name of the protests became the title of Sibande's new series of works.

As well as employing the colour purple to distinguish her new alter ego in *A Reversed Retrogress*, Sibande re-establishes her complex connection to Sophie by means of the notion of 'rhizomes'. This idea was developed by the philosophers and cultural theorists Gilles Deleuze and Felix Guattari in *A Thousand Plateaus* (1980) as part of their model for a culture that is non-hierarchical and non-chronological. Rhizomes appear in Sibande's work in the form of the serpentine, tuberous purple excrescences that surround her new character. And although the work represents 'the next chapter, in which I speak of my own aspirations, desires, fears and anxieties of being a woman',[45] it also returns to the subject of colour: 'Colour remains a predominant factor in our social interactions and it continues to play a dominant role in our perceptions of one another as South Africans. In my view, it is like a monster that we are all too familiar with.'[46]

While acknowledging the freedom in South African society that previous generations did not enjoy, Sibande is at pains to point out that there is much work still to be done:

> Although there has been a political change in our country there are some conditions which are still prevalent that are direct results of apartheid [...] I intend to investigate the shadow of apartheid that still lingers in South African society. Although one can argue the freedom of our country under the new democratic dispensation, many members of South African society are not free in their minds, haunted as they are by lingering self-doubts. My work also looks at the ideals of beauty and femininity represented by examples of privileged members of society, and the aspiration of less fortunate women to be like them.[47]

Yet, while Sibande is realistic about the state of South Africa today, her new alter ego gives her a great sense of optimism for the future:

> Purple is a colour of royalty. The clergy and the royalty of England wear, or wore, purple if they were meeting an important person. Purple dye was expensive so only the rich were able to wear it. So I thought: 'I like the idea that the colour places you.' I thought, I am actually privileged and rich at the same time. I am not like my mother, I am not like my grandmother and I'm not like my great-grandmother. And I needed to elevate the figure that represented me.[48]

Notes

Introduction

1 F. R. de Jager and A. G. Loots, *Esther Mahlangu* (exhib. cat.), VGallery, Cape Town, 2003, p. 16.
2 M. Courtney-Clarke, *Ndebele*, London, 2002, pp. 17–18.
3 A. W. Oliphant *et al.*, *Democracy X: Marking the Present/Re-presenting the Past* (exhib. cat.), University of South Africa, Pretoria, 2004, p. 307.
4 See www.gcis.gov.za/sites/default/files/docs/resourcecentre/guidelines/corpid/3_2.pdf (accessed May 2016).
5 'Khoekhoe' refers to the language, 'Khoekhoen' to the cultural group.
6 For a summary of the debate surrounding San, Bushman and Khoekhoe nomenclature in southern Africa, see William F. Ellis, '*Ons is Boesmans*: commentary on the naming of Bushmen in the southern Kalahari', *Anthropology Southern Africa*, 38(1–2), 2015, pp. 120–33.
7 J. D. Lewis-Williams, 'Quanto?: the issue of "many meanings" in southern African San rock art research', *South African Archaeological Bulletin*, 53(168), December 1998, pp. 86–97.
8 A digitized version of the Bleek and Lloyd manuscripts can be found at http://lloydbleekcollection.cs.uct.ac.za.
9 See Lewis-Williams, 'Quanto?'; Patricia Vinnicombe, 'Myth, motive and selection in southern African rock art', *Africa*, 42, 1972, pp. 192–204; Patricia Vinnicombe, *People of the Eland: Rock Paintings of the Drakensberg Bushmen as a Reflection of Their Life and Thought*, Pietermaritzburg, 1976.
10 Benjamin Smith *et al.*, 'Archaeology and symbolism in the new South African coat of arms', *Antiquity*, 74(285), September 2000, pp. 467–8. Available online at www.msu.ac.zw/elearning/material/1213012225smith_etal_2000.pdf (accessed May 2016).
11 See Lewis-Williams, 'Quanto?'.
12 Sidney H. Haughton, 'Note on the Zaamenkomst Slab', *Transactions of the Royal Society of South Africa*, 14(3), 1927, p. 315.
13 Jeni Couzyn, email to author, August 2015.

Chapter 1

1 Jill Cook, *Ice Age Art: The Arrival of the Modern Mind* (exhib. cat.), British Museum, London, 2012.
2 Christopher S. Henshilwood, 'Stratigraphic integrity of the Middle Stone Age levels at Blombos Cave', in Francesco d'Errico and Lucinda Backwell (eds), *From Tools to Symbols: From Early Hominids to Modern Humans*, Johannesburg, 2005, pp. 441–58; Philip G. Chase and Harold L. Dibble, 'Middle Paleolithic symbolism: a review of current evidence and interpretations', *Journal of Anthropological Archaeology*, 6(3), 1987, pp. 263–96.
3 Here, 'symbolic culture' refers to the existence of a particular, distinct type of decoration found on a variety of objects across a region, in contrast to isolated examples of symbolic behaviour.
4 Christopher S. Henshilwood *et al.*, 'Engraved ochres from the Middle Stone Age levels at Blombos Cave, South Africa', *Journal of Human Evolution*, 57(1), 2009, pp 27–47, p. 28.
5 Robert G. Bednarik, 'Pleistocene palaeoart of Africa', *Arts*, 2(1), 2013, pp. 6–34, p. 9; see also P. B. Beaumont, 'Kathu Pan', in P. Beaumont and D. Morris (eds), *Guide to Archaeological Sites in the Northern Cape*, Kimberley, 1990, pp. 75–100; P. Beaumont, 'Kathu Pan and Kathu Townlands/Uitkoms', in D. Morris and P. Beaumont (eds), *Archaeology in the Northern Cape: Some Key Sites*, Kimberley, 2004, pp. 50–53; S. McBrearty and A. S. Brooks, 'The revolution that wasn't: a new interpretation of the origin of modern human behaviour', *Journal of Human Evolution*, 39, 2000, pp. 453–563.
6 Peter B. Beaumont and Robert G. Bednarik, 'Tracing the emergence of palaeoart in sub-Saharan Africa', *Rock Art Research*, 30(1), 2013, pp. 33–54, p. 44.
7 Robert Bednarik, 'The "australopithecine" cobble from Makapansgat, South Africa', *South African Archaeological Bulletin*, 53, 1998, pp. 4–8.
8 P. L. McFadden *et al.*, 'Palaeomagnetism and the age of the Makapansgat hominid site', *Earth and Planetary Science Letters*, 44(3), 1979, pp. 373–82; Beaumont and Bednarik, 'Tracing the emergence of palaeoart in sub-Saharan Africa'.
9 McFadden *et al.*, 'Palaeomagnetism and the age of the Makapansgat hominid site'; Bednarik, 'Pleistocene palaeoart of Africa', p. 9.
10 McFadden *et al.*, 'Palaeomagnetism and the age of the Makapansgat hominid site'; Raymond A. Dart, 'The first australopithecus cranium from the pink breccia at Makapansgat', *American Journal of Physical Anthropology*, 17(1), 1959, pp. 77–82; Raymond A. Dart, 'Waterworn australopithecine pebble of many faces from Makapansgat', *South African Journal of Science*, 70(6), 1974, pp. 167–9; Kenneth P. Oakley, 'Emergence of higher thought 3.0–0.2 Ma BP', *Philosophical Transactions of the Royal Society of London B: Biological Sciences*, 292(1057), 1981, pp. 205–11; James B. Harrod, 'Palaeoart at 2 million years ago? A review of the evidence', *Arts*, 3(1), 2014, pp. 135–55; Paul G. Bahn and Jean Vertut, *Journey through the Ice Age*, Berkeley, CA, 1997.
11 McFadden *et al.*, 'Palaeomagnetism and the age of the Makapansgat hominid site'.
12 *Ibid.*; Bednarik, 'The "australopithecine" cobble from Makapansgat, South Africa'.
13 Bednarik, 'Pleistocene palaeoart of Africa', p. 8.
14 Ben Watson, 'The eyes have it: human perception and anthropomorphic faces in world rock art', *Antiquity*, 85(327), 2011, pp. 87–98, p. 91.
15 Bednarik, 'Pleistocene palaeoart of Africa', p. 8.
16 Harrod, 'Palaeoart at 2 million years ago?', p. 136.
17 Eckart Voland and Karl Grammer (eds), *Evolutionary Aesthetics*, Berlin, 2013; Marek Kohn and Steven Mithen, 'Handaxes: products of sexual selection?', *Antiquity*, 73(281), 1999, pp. 518–26. The date of 1,000,000 BP is based on new, unpublished archaeological evidence from Kathu Pan, as communicated to the author in an email from David Morris, McGregor Museum, Kimberley.
18 Kohn and Mithen, 'Handaxes', p. 522.
19 Beaumont and Bednarik, 'Tracing the emergence of palaeoart in sub-Saharan Africa'.
20 Henshilwood, 'Stratigraphic integrity of the Middle Stone Age levels at Blombos Cave'; T. D. White *et al.*, 'Pleistocene Homo Sapiens from Middle Awash, Ethiopia', *Nature*, 423, 2003, pp. 742–7.
21 Christopher S. Henshilwood and Curtis W. Marean, 'The origin of modern human behavior', *Current Anthropology*, 44(5), 2003, pp. 627–51, p. 629.

22 Henshilwood *et al.*, 'Engraved ochres from the Middle Stone Age levels at Blombos Cave, South Africa'.

23 Lyn Wadley *et al.*, 'Ochre in hafting in Middle Stone Age southern Africa: a practical role', *Antiquity*, 78(301), 2004, pp. 661–75.

24 Henshilwood *et al.*, 'Engraved ochres from the Middle Stone Age levels at Blombos Cave, South Africa'.

25 Christopher S. Henshilwood *et al.*, 'A 100,000-year-old ochre-processing workshop at Blombos Cave, South Africa', *Science*, 334(6053), 2011, pp. 219–22.

26 Michael Chazan and Liora Kolska Horwitz, 'Milestones in the development of symbolic behaviour: a case study from Wonderwerk Cave, South Africa', *World Archaeology*, 41(4), 2009, pp. 521–39.

27 Francesco d'Errico *et al.*, 'An engraved bone fragment from c. 70,000-year-old Middle Stone Age levels at Blombos Cave, South Africa: implications for the origin of symbolism and language', *Antiquity*, 75(288), 2001, pp. 309–18, p. 315.

28 *Ibid.*, p. 309.

29 Jill Cook, *Ice Age Art*, p. 4.

30 Christopher Henshilwood *et al.*, 'Middle Stone Age shell beads from South Africa', *Science*, 304(5669), 2004, p. 404; Francesco d'Errico *et al.*, '*Nassarius kraussianus* shell beads from Blombos Cave: evidence for symbolic behaviour in the Middle Stone Age', *Journal of Human Evolution*, 48(1), 2005, pp. 3–24.

31 *Ibid.*

32 *Ibid.*, pp. 4–6.

33 Abdeljalil Bouzouggar *et al.*, '82,000-year-old shell beads from North Africa and implications for the origins of modern human behavior', *Proceedings of the National Academy of Sciences*, 104(24), 2007, pp. 9,964–9.

34 Guillaume Porraz *et al.*, 'Technological successions in the Middle Stone Age sequence of Diepkloof Rock Shelter, Western Cape, South Africa', *Journal of Archaeological Science*, 40(9), 2013, pp. 3,376–400.

35 Helen Anderson, 'Crossing the line: the early expression of pattern in Middle Stone Age Africa', *Journal of World Prehistory*, 25(3–4), 2012, pp. 183–204.

36 Kalyan Kumar Chakravarty and Robert G. Bednarik, *Indian Rock Art and Its Global Context*, Delhi, 1997.

37 Wolfgang Erich Wendt, '*Art mobilier* aus der Apollo 11 Grotte in Südwest-Afrika', *Acta praehistorica et archaeologica*, 5(6), 1974, p. 5.

38 Riaan F. Rifkin *et al.*, 'Pleistocene figurative *art mobilier* from Apollo 11 Cave, Karas region, southern Namibia', *South African Archaeological Bulletin*, 70(201), 2015, pp. 113–23.

39 Michael Lewis Wilson *et al.*, *An Investigation of the 'Coldstream Stone'*, Cape Town, 1990.

40 David G. Pearce, 'Iconography and interpretation of the Tierkloof painted stone', *Goodwin Series*, 2005, pp. 45–53.

41 Karel Nel, in Elizabeth Burroughs *et al.* (eds), *Life of Bone: Art meets Science*, Johannesburg, 2011.

42 Nelson Mandela, quoted in '"I am prepared to die": document recalls famous speech from the dock', *Nelson Mandela Foundation*, www.nelsonmandela.org/news/entry/i-am-prepared-to-die (accessed July 2016).

43 The photograph was taken by Dr Katesa Schlosser at Ceza Mountain, KwaZulu-Natal. For a related discussion of the symbolic significance of red and white colours with regards to the Schroda Figurines, see page 57.

Chapter 2

1 See Jayson Orton *et al.*, 'An early date for cattle from Namaqualand, South Africa: implications for the origins of herding in southern Africa', *Antiquity*, 87(335), 2013, pp. 108–20.

2 A. W. Oliphant *et al.*, *Democracy X: Marking the Present/Re-presenting the Past* (exhib. cat.), University of South Africa, Pretoria, 2004, p. 287; Peter Mitchell, *The Archaeology of Southern Africa*, Cambridge, 2002, p. 284.

3 *Ibid.*

4 Oliphant *et al.*, *Democracy X*, p. 287.

5 R. R. Inskeep and T. M. O'C. Maggs, 'Unique art objects in the Iron Age of the Transvaal, South Africa', *South African Archaeological Bulletin*, 30(119/120), 1975, pp. 114–38; Mitchell, *The Archaeology of Southern Africa*, p. 284.

6 *Ibid.*, pp. 268, 270.

7 *Ibid.*, p. 284; T. Phillips, *Africa, the Art of a Continent* (exhib. cat.), Royal Academy of Arts, London, 1995, p. 194.

8 Other examples of such masks in fragmentary form were found at Ndondonwane in KwaZulu-Natal. See Chapter 10 of Mitchell, *The Archaeology of Southern Africa*.

9 Inskeep and Maggs, 'Unique art objects in the Iron Age of the Transvaal, South Africa'; Phillips, *Africa, the Art of a Continent*.

10 T. M. Evers, 'Excavations at the Lydenberg Heads Site, eastern Transvaal, South Africa', *South African Archaeological Bulletin*, 37, 1982, pp. 16–33; E. Hanisch, 'Schroda, a Zhizo site in northern Transvaal', in E. Voigt (ed.), *Guide to Archaeological Sites in the Northern and Eastern Transvaal*, Pretoria, 1981, pp. 1–6; Mitchell, *The Archaeology of Southern Africa*, p. 285.

11 Oliphant *et al.*, *Democracy X*, p. 287; see also Phillips, *Africa, the Art of a Continent*.

12 *Ibid.*, p. 195.

13 Mitchell, *The Archaeology of Southern Africa*, p. 284.

14 *Ibid.*

15 J. A. Van Schalkwyk and E. O. M. Hanisch (eds), *Sculptured in Clay: Iron Age Figurines from Schroda, Limpopo Province, South Africa*, Pretoria, 2002.

16 Tom Huffman, 'Introduction', in *ibid.*, p. 9.

17 Schalkwyk and Hanisch, *Sculptured in Clay*, pp. 26, 32; Hanisch, 'Schroda, a Zhizo site in northern Transvaal'; Mitchell, *The Archaeology of Southern Africa*, p. 274.

18 *Ibid.*, p. 300.

19 Innocent Pikirayi, 'The Zimbabwe culture and its neighbours: origins, development, and consequences of social complexity in southern Africa', in Peter Mitchell and Paul Lane (eds), *The Oxford Handbook of African Archaeology*, Oxford, 2013, pp. 915–28, p. 917; E. A. Voigt, 'Tales from bones: reconstructing Iron Age economy, diet and cultural activities at Mapungubwe in the northern Transvaal', *Transvaal Museum Bulletin*, 17, 1979,

pp. 27–8; Marilee Wood, 'Making connections: relationships between international trade and glass beads from the Shashe-Limpopo area', *Goodwin Series*, 2000, pp. 78–90; Marilee Wood, 'A glass bead sequence for southern Africa from the 8th to the 16th century AD', *Journal of African Archaeology*, 9(1), 2011, pp. 67–84.

20 Schalkwyk and Hanisch, *Sculptured in Clay*, p. 21.

21 *Ibid.*, p. 51.

22 *Ibid.*, p. 24.

23 *Ibid.*, p. 26.

24 *Ibid.*, p. 44.

25 *Ibid.*, pp. 50, 51.

26 *Ibid.*, p. 53.

27 *Ibid.*, p. 35.

28 Schalkwyk and Hanisch, *Sculptured in Clay*.

29 *Ibid.*, p. 52.

30 *Ibid.*, p. 5.

31 Mitchell, *The Archaeology of Southern Africa*, p. 284, referring to J. H. N. Loubser, 'Ndondondwane: the significance of features and finds from a ninth-century site on the lower Thukela River, Natal', *Natal Museum Journal of Humanities*, 5, 1993, pp. 109–51.

32 Schalkwyk and Hanisch, *Sculptured in Clay*, p. 36.

33 *Ibid.*, p. 29.

34 *Ibid.*, pp. 72, 73.

35 *Ibid.*, p. 50.

36 *Ibid.*, p. 35.

37 *Ibid.*, p. 75.

38 Mitchell, *The Archaeology of Southern Africa*, p. 302; Andrie Meyer, 'K2 and Mapungubwe', *Goodwin Series*, 2000, pp. 4–13, p. 10.

39 The gold rhinoceros, bowl and sceptre were found in a near complete condition during the original excavations, while the wild cat and cow, or ox, were reconstructed from gold fragments in 2009.

40 Mitchell, *The Archaeology of Southern Africa*, p. 6.

41 Maryna Steyn, 'The Mapungubwe gold graves revisited', South African Archaeological Bulletin, 2007, pp. 140–46, p. 140.

42 Mitchell, *The Archaeology of Southern Africa*.

43 Andrew Oddy, 'Gold in the southern African Iron Age', *Gold Bulletin*, 17(2), 1984, pp. 70–78, p. 70.

44 Sian Tiley, *Mapungubwe: South Africa's Crown Jewels*, Cape Town, 2004.

45 Phillips, *Africa, the Art of a Continent*, p. 199.

46 Maria Wilhelm, quoted in *ibid.*, p. 199.

47 Shula Marks, 'South Africa – "The myth of the empty land"', *History Today*, 30(1), 1980, pp. 7–12.

48 *Ibid.*, p. 8.

49 Penny Siopis, quoted in Sue Williamson, *Resistance Art in South Africa*, Cape Town, 1989, p. 20.

50 Penny Siopis, quoted in Polly Savage (ed.), *Making Art in Africa: 1960–2010*, Farnham/Burlington, 2014, p. 211.

51 *Ibid.*

52 *Ibid.*, p. 213.

53 Savage, *Making Art in Africa*, p. 211.

54 Penny Siopis, quoted in *ibid.*, p. 105.

55 Colin Richards, quoted in Olu Oguibe and Okwui Enwezor (eds), *Reading the Contemporary: African Art from Theory to the Marketplace*, London, 1999, p. 369.

56 The province of Limpopo is also where the Schroda Figurines and Mapungubwe sculptures were found, while the Lydenburg Heads Site is located nearby. Thus, contemporary wood carvings from this region may be seen as belonging to a long tradition of sculpture in the area.

57 Owen Ndou, quoted in Savage, *Making Art in Africa*, p. 197.

58 *Ibid.*

Chapter 3

1 Pieter Schoonees, *Inscriptions on Padroes, Postal Stones, Tombstones, and Beacons*, Cape Town, 1991.

2 *Ibid.*, p. 67.

3 *Ibid.*

4 See https://en.wikisource.org/wiki/Page:Dictionary_of_National_Biography_volume_14.djvu/39 (accessed June 2016).

5 See www.oxforddictionaries.com/definition/english/hottentot and www.etymonline.com/index.php?allowed_in_frame=0&search=kaffir (accessed July 2016).

6 See https://en.wikisource.org/wiki/Gardiner,_Allen_Francis_(DNB00) (accessed June 2016).

7 'Life of Captain Allen Gardiner, the founder of the Patagonian Mission', *Mission Life*, vol. I (October and November 1866), pp. 348–54. Available online at http://anglicanhistory.org/sa/gardiner/mission_life1866.html (accessed June 2016).

8 George French Angas, *The Kafirs Illustrated in a Series of Drawings taken among the Amazulu, Amaponda, and Amakosa Tribes*, London, 1849.

9 Russel Viljoen, 'Sketching the Khoi: George French Angas and his depiction of the Genadendal Khoikhoi characters at the Cape of Good Hope, c. 1847', *South African Journal of Art History*, 22(2), 2007, p. 283.

10 Sidney Lee (ed.), *The Dictionary of National Biography: Second Supplement, January 1901–December 1911*, London, 1912, pp. 1367–8.

11 Justine Wintjes, 'Archaeology and visuality, imaging as recording: a pictorial genealogy of rock painting research in the Maloti-Drakensberg through two case studies', unpublished PhD thesis, University of the Witwatersrand, 2012. Available online at http://hdl.handle.net/10539/11865 (accessed June 2016).

12 *Ibid.*

13 Johannes Phokela, quoted in N. Dlamini, www.joburg.org.za/2006/july/jul28-phokela.stm (accessed January 2016).

14 Johannes Phokela, quoted in Polly Savage (ed.), *Making Art in Africa: 1960–2010*, Farnham/Burlington, 2014, p. 176.

15 Rob Williams, 'No Laughing Matter: Comic Relief Invested in Tobacco, Alcohol and Arms Firms', *The Independent*, 10 December 2013.

16 Johannes Phokela, quoted in Savage, *Making Art in Africa*, p. 176.

17 *Ibid.*, p. 175.

18 Iris Berger, *South Africa in World History*, Oxford, 2009, p. 44.

19 See www.sahistory.org.za/article/cape-malay#sthash.6tS6uK9k.dpuf (accessed June 2016). Although the term 'Cape Malay' is in common usage today, it has been contested both historically and more recently.

20 See 'The Young Lawyer', *Mahatma Gandhi in South Africa*, http://gandhi.southafrica.net (accessed July 2016).

21 Mohandas Karamchand Gandhi, quoted in 'The Campaigner', *Mahatma Gandhi in South Africa*.

22 Mohandas Karamchand Gandhi, quoted in Eknath Easwaran, *Gandhi the Man: How One Man Changed Himself to Change the World*, Tomales, CA, 2011, p. 196.

23 Jan Smuts, quoted in 'Mahatma Gandhi in South Africa', http://gandhi.southafrica.net (accessed July 2016).

24 See www.bbc.co.uk/news/world-africa-32287972 (accessed June 2016).

25 Melanie Yap, *Colour, Confusion and Concessions: The History of the Chinese in South Africa*, Hong Kong, 1996.

26 See 'Census 2001', *Statistics South Africa*, www.statssa.gov.za/?page_id=3892 (accessed July 2016).

27 Willem Boshoff, quoted in Savage, *Making Art in Africa*, p. 180.

28 Jackson Hlungwani, quoted in *ibid.*, p. 194.

29 *Ibid.*

30 Robert Loder, quoted in John Picton and Jennifer Law (eds), *Cross Currents: Contemporary Art Practice in South Africa – An Exhibition in Two Parts* (exhib. cat.), Atkinson Gallery, Street, 2000, p. 57.

31 Willem Boshoff, quoted in Savage, *Making Art in Africa*, p. 179.

32 *Ibid.*, pp. 179–80.

33 *Ibid.*, p. 180.

34 Willem Boshoff, 'Cosmic threads', in Christine Mullen Kreamer *et al.*, *African Cosmos: Stellar Arts* (exhib. cat.), National Museum of African Art, Smithsonian Institution, Washington, DC, 2012, p. 25.

35 Angas, *The Kafirs Illustrated*.

Chapter 4

1 A. Wanless, 'Headrests in the Africana Museum, Johannesburg', *Africana Notes and News*, 27(8), 1987, p. 320.

2 Henri A. Junod, *The Life of a South African Tribe*, 2 vols, New York, 1927, vol. 1, p. 129.

3 Peter Delius, *The Land Belongs to Us: The Pedi Polity, the Boers and the British in the Nineteenth-Century Transvaal*, London, 1984, p. 68.

4 Anitra Nettleton, *African Dream Machines: Style, Identity and Meaning of African Headrests*, Johannesburg, 2007, p. 360.

5 R. Becker, 'Headrests: Tsonga types and variations', in Becker *et al.*, *Art and Ambiguity: Perspectives on the Brenthurst Collection of Southern African Art* (exhib. cat.), Johannesburg Art Gallery, 1991, p. 74.

6 Junod, *Life of a South African Tribe*, vol. 2, p. 420.

7 Shula Marks, 'Khoisan resistance to the Dutch in the seventeenth and eighteenth centuries', *Journal of African History*, 13(1), 1972, pp. 55–80.

8 Jeffrey Brian Peires, 'A History of the Xhosa, *c.* 1700–1835', unpublished MA thesis, Rhodes University, 1976; Jeffrey B. Peires, 'Nxele, Ntsikana and the origins of the Xhosa religious reaction', *Journal of African History*, 20(1), 1979, pp. 51–61.

9 *Ibid.*

10 Cowper Rose, *Four Years in Southern Africa*, London, 1829, pp. 74–6.

11 *Ibid.*, p. 53.

12 Leslie Stephen (ed.), *The Dictionary of National Biography*, 63 vols, London, 1885–1900, vol. 13, p. 324. Available online at https://archive.org/stream/dictionaryofnati13stepuoft (accessed July 2016).

13 P. Davison, 'Some Nguni crafts, part 2: the uses of horn, bone and ivory', *Annals of the South African Museum*, 70(2), 1976, pp. 79–155, p. 144.

14 Ella Margaret Shaw and Nicolaas Jacobus van Warmelo, *Material Culture of the Cape Nguni*, Cape Town, 1972, p. 658.

15 Tim Maggs, 'The Zulu battle-axe', *Natal Museum Journal of Humanities*, 5, 1993, pp. 175–88, pp. 180–83.

16 L. Hooper, 'Some Nguni crafts, part 3: wood-carving', *Annals of the South African Museum*, 70(3), 1981, p. 248.

17 Edward Lucie-Smith, quoted in Sue Williamson, *Resistance Art in South Africa*, Cape Town, 1989, p. 17.

18 L. Hooper *et al.*, 'Some Nguni crafts, part 4: Nguni skin-working technology', *Annals of the South African Museum*, 70(4), 1989, p. 372.

19 F. Roodt, 'Zulu metalworking', in Marilee Wood (ed.), *Zulu Treasures: Of Kings and Commoners – A Celebration of the Material Culture of the Zulu People* (exhib. cat.), KwaZulu Cultural Museum, Ulundi, and Local History Museums, Durban, 1996, p. 96.

20 *Ibid.*, p. 98.

21 John Laband and Ian W. Knight, *The Anglo-Zulu War, 1879*, Stroud, 1996.

22 T. Maggs, 'A glimpse of colonial life through Zulu eyes: 19th century engraved cattle horns from Natal', *Natal Museum Journal of Humanities*, 2, November 1990, pp. 143–62.

23 Davison, 'Some Nguni crafts'.

24 P. S. Thompson, *Black Soldiers of the Queen: The Natal Native Contingent in the Anglo-Zulu War*, Tuscaloosa, 2006, p. vii.

25 D. D. Hall, 'Artillery in the Zulu War, 1879', *Military History Journal*, 4(4), 1979, pp. 152–61; Maggs, 'A glimpse of colonial life through Zulu eyes', p. 150.

26 Helena Hugo, quoted in *Museum Kuns Katalogus/Universal Suffering during the South African War 1899–1902*, Bloemfontein, 2013.

27 Iain R. Smith, *The Origins of the South African War: 1899–1902*, London, 1996.

28 'South African War', *Encyclopaedia Britannica*, www.britannica.com/event/South-African-War (accessed July 2016).

29 Emily Hobhouse, quoted in www.geni.com/people/Emily-Hobhouse (accessed July 2016).

30 A. W. Oliphant *et al.*, *Democracy X: Marking the Present/Re-presenting the Past* (exhib. cat.), University of South Africa, Pretoria, 2004, p. 301.

31 A. E. Duffey, *Anton van Wouw: The Smaller Works*, Pretoria, 2008, p. 51.

32 *Ibid.*, p. 52.

33 D. C. Boonzaier, diary, 1914, National Library of South Africa, Cape Town, quoted in Ron Roche, 'Anton van Wouw: father of South African sculpture and the progeny of the Johannesburg randlords', unpublished MA thesis, Sotheby's Institute of Art, London, 2013.

Chapter 5

1 Catherine Elliot *et al.*, 'Maker, material and method: reinstating an indigenously made chair from KwaZulu-Natal, South Africa', *British Museum Technical Research Bulletin*, vol. 7, 2013.

Available online at www.britishmuseum.org/pdf/
BMTRB_7_Elliott_Cartwright_and_Kevin.pdf
(accessed July 2016).

2 Hélène Joubert and Manuel Valentin (eds),
Ubuntu: arts et cultures d'Afrique du Sud (exhib. cat.),
Musée National des Arts d'Afrique et d'Océanie,
Paris, 2002, p. 148.

3 Axel-Ivar Berglund, *Zulu Thought-Patterns and
Symbolism*, London, 1976.

4 L. Hooper, 'Some Nguni crafts, part 3: wood-
carving', *Annals of the South African Museum*, 70(3),
1981, p. 214.

5 S. Klopper, '"Zulu" headrests and figurative
carvings', in Becker *et al.*, *Art and Ambiguity:
Perspectives on the Brenthurst Collection of Southern
African Art* (exhib. cat.), Johannesburg Art Gallery,
1991, p. 85; Hooper, 'Some Nguni crafts, part 3:
wood-carving', p. 217.

6 S. Klopper, in T. Phillips, *Africa: The Art of a
Continent* (exhib. cat.), Royal Academy of Arts,
London, 1995, p. 223.

7 A. Wanless, in *Art and Ambiguity*, p. 130.

8 George French Angas, 'Zulu blacksmiths at
work', in *The Kafirs Illustrated in a Series of Drawings
taken among the Amazulu, Amaponda, and Amakosa
Tribes*, London, 1849.

9 Karel Nel, in Joubert and Valentin, *Ubuntu*,
p. 154.

10 Colin Murray, 'Sex, smoking and the shades:
a Sotho symbolic idiom', in M. G. Whisson and
M. West (eds), *Religion and Social Change in Southern
Africa: Anthropological Essays in Honour of Monica
Wilson*, Cape Town, 1975, pp. 58–77.

11 Joubert and Valentin, *Ubuntu*, p. 288.

12 Henri A. Junod, *The Life of a South African Tribe*,
2 vols, New York, 1927, vol 2, p. 411.

13 Joubert and Valentin, *Ubuntu*, p. 170.

14 Ella Margaret Shaw, *Native Pipes and Smoking
in South Africa*, n.p., 1938, pp. 277–302.

15 Joubert and Valentin, *Ubuntu*, p. 284; see also
Sam Challis, 'Creolisation on the nineteenth-
century frontiers of southern Africa: a case
study of the AmaTola "Bushmen" in the Maloti-
Drakensberg', *Journal of Southern African Studies*,
38(2), 2012, pp. 265–80.

16 A. Wanless, in *Art and Ambiguity*, p. 140.

17 A. Nettleton, 'History and myth of Zulu
sculpture', *African Arts*, 21(3), 1987/8, p. 48.

18 *Ibid.*, p. 50.

19 William Distant, *A Naturalist in the Transvaal*,
London, 1892, p. 114.

20 Nettleton, 'History and myth of Zulu
sculpture', p. 38.

21 Malcolm McLeod and John Mack, *Ethnic
Sculpture*, London, 1985, p. 21.

22 Elizabeth Dell, in Karel Nel *et al.*, *Evocations of
the Child: Fertility Figures of the Southern African Region*
(exhib. cat.), Johannesburg Art Gallery, 1998, p. 11.

23 Marilee Wood, in Nel *et al.*, *Evocations of the
Child*, p. 37.

24 Frank Jolles, *African Dolls = Afrikanische Puppen:
The Dulger-Collection*, Stuttgart, 2010, p. 6.

25 M. Carey, *Beads and Beadwork of East and
South Africa*, London, 1986, p. 44; G. Van Wyk,
'Illuminated signs', *African Arts*, 36, autumn 2003,
p. 18; J. Pemberton, *African Beaded Art: Power and
Adornment*, Northampton, MA, 2008, p. 170.

26 Anitra Nettleton, 'Jubilee dandies: collecting
beadwork in Tsolo, Eastern Cape, 1897–1932',
African Arts, 46(1), spring 2013, pp. 36–49, p. 44.

27 M. Shaw and N. J. van Warmelo, 'The
material culture of the Cape Nguni, part 4:
personal and general', *Annals of the South African
Museum*, 58(4), 1988, pp. 447–949, p. 668.

28 Pemberton, *African Beaded Art*, p. 194.

29 *Ibid.*

30 A. W. Oliphant *et al.*, *Democracy X: Marking the
Present / Re-presenting the Past* (exhib. cat.), University
of South Africa, Pretoria, 2004, p. 297.

31 Hooper, 'Some Nguni crafts, part 3: wood-
carving', p. 182.

33 Anitra Nettleton, 'Of severed heads and snuff
boxes: "survivance" and beaded bodies in the
Eastern Cape, 1897–1934', *African Arts*, 48(4), 2015,
pp. 22–33.

33 *Ibid.*

34 Nettleton, 'Jubilee Dandies', p. 44.

35 Pemberton, *African Beaded Art*, p. 175.

36 Shaw and van Warmelo, 'The material culture
of the Cape Nguni', p. 538.

37 *Ibid.*

38 Angas, *The Kafirs Illustrated*.

39 Joubert and Valentin, *Ubuntu*, p. 308.

40 Carey, *Beads and Beadwork of East and South
Africa*, p. 50.

41 C. Spring, *Zulu Beadwork*, London, 1997, p. 7.

42 G. Tylden, 'Bantu shields', *South African
Archaeological Bulletin*, 1(2), 1946, p. 33.

43 P. Sanders, *Moshoeshoe, Chief of the Sotho*,
London, 1975.

44 H. A. Stayt, *The Bavenda*, Oxford, 1931, p. 72.

45 Nettleton, 'Jubilee dandies', *passim*.

46 See, for example, Nettleton, 'Of severed heads
and snuff boxes', p. 22.

47 Alexandra Dodd, '"Live transmission":
intimate ancestors in Santu Mofokeng's *Black Photo
Album / Look at Me: 1890–1950*', *African Arts*, 48(2),
summer 2015, p. 57.

48 Santu Mofokeng, quoted in Tamar Garb,
*Figures and Fictions: Contemporary South African
Photography* (exhib. cat.), Victoria and Albert
Museum, London, 2011, p. 283.

49 Colin Richards, in Olu Oguibe and Okwui
Enwezor, *Reading the Contemporary: African Art from
Theory to the Marketplace*, London, 1999, p. 369.

50 Santu Mofokeng, in *Grand Street*, spring 1998,
pp. 157–8.

51 James T. Campbell, 'African studies', in Santu
Mofokeng, *The Black Photo Album / Look at Me:
1890–1950*, Göttingen and New York, 2013, n.p.

52 Simon Gikandi, 'The embarrassment of
Victorianism: colonial subjects and the lure of
Englishness', in John Kucich and Dianne F. Sadoff
(eds), *Victorian Afterlife*, Minneapolis and London,
2000, p. 168.

53 Santu Mofokeng, quoted in Garb, *Figures and
Fictions*, p. 283.

54 Nelson Mandela, quoted in M. Godby,
'Alfred Martin Duggan-Cronin's photographs for
The Bantu Tribes of South Africa (1928–1954): the
construction of an ambiguous idyll', *Kronos*, 36(1),
2010, p. 28.

55 Simon Hall and Aron Mazel, 'The private
performance of events: colonial period rock art
from the Swartruggens', *Kronos*, 31, 2005,
pp. 124–51.

56 *Ibid.*, p. 124.

57 *Ibid.*, p. 151.

58 *Ibid.*, p. 144.
59 Hall and Mazel, 'The private performance of events'.

Chapter 6

1 For a discussion of the Natives Land Act, see Harvey M. Feinberg, 'The 1913 Natives Land Act in South Africa: politics, race, and segregation in the early 20th century', *International Journal of African Historical Studies*, 26(1), 1993, pp. 65–109.
2 For a discussion of the 'homelands' policy, see Heather Deegan, *Politics South Africa*, Harlow and New York, 2011, pp. 34–7.
3 A. W. Oliphant *et al.*, *Democracy X: Marking the Present/Re-presenting the Past* (exhib. cat.), University of South Africa, Pretoria, 2004.
4 William Kentridge, quoted in Sean O'Toole, 'Pierneef's Art', *Times Live*, www.timeslive.co.za/lifestyle/2010/12/12/pierneef-s-art (accessed July 2016).
5 S. Blaine, 'J. H. Pierneef: time to revise the revisionism', *Rand Daily Mail*, 14 July 2015. Available online at www.rdm.co.za/lifestyle/2015/07/14/jh-pierneef-time-to-revise-the-revisionism (accessed July 2016).
6 N. J. Coetzee, quoted in O'Toole, 'Pierneef's Art'.
7 O'Toole, 'Pierneef's Art'.
8 Blaine, 'J. H. Pierneef'.
9 Wilhelm van Rensburg, 'Considering Pierneef', *Creative Feel*, 3 July 2015, http://creativefeel.co.za/2015/07/consideringpierneef (accessed July 2016).
10 Jeremy Foster, *Washed with the Sun: Landscape and the Making of White South Africa*, Pittsburgh, PA, 2008, pp. 198–9.
11 'The creation of native reserves and migratory labour system to South African mines', *South African History Online*, www.sahistory.org.za/article/creation-native-reserves-and-migratory-labour-system-south-african-mines (accessed July 2016).
12 Anitra Nettleton, 'Life in a Zulu village: craft and the art of modernity in South Africa', *Journal of Modern Craft*, 3(1), March 2010, pp. 55–78, p. 66.

13 A. F. Roberts, '"Break the silence": art and HIV/AIDS in KwaZulu-Natal', *African Arts*, 34(1), 2001, pp. 36–49.
14 Anitra Nettleton, 'Women, bead work and bodies: the making and marking of migrant liminality in South Africa, 1850–1950', *African Studies*, 73(3), 2014, pp. 341–64, p. 350.
15 *Ibid.*, p. 351.
16 *Ibid.*, p. 352.
17 *Ibid.*, p. 357.
18 M. Krouse, 'Song for Sekoto: duet of politics and money', *Mail & Guardian*, 3 May 2013, http://mg.co.za/article/2013-05-03-00-song-for-sekoto-duet-of-politics-and-money (accessed July 2016).
19 *Ibid.*
20 Chloë Reid, 'Sekoto's life', *Gerard Sekoto Foundation*, www.gerardsekotofoundation.com/artist-overview.htm (accessed July 2016).
21 L. Davie, 'Gerard Sekoto's "illustrious album"', *SouthAfrica.info*, www.southafrica.info/about/arts/sekoto-album.htm (accessed July 2016).
22 M. J. Darroll, *Song for Sekoto* (exhib. cat.), Wits Art Museum, Johannesburg, 2013.
23 Sue Williamson, *Resistance Art in South Africa*, Cape Town, 1989.
24 *Ibid.*
25 See http://africa.si.edu/exhibits/gavinjantjes.html (accessed July 2016).
26 'Ernest Cole', *South African History Online*, www.sahistory.org.za/people/ernest-cole (accessed July 2016).
27 See www.tate.org.uk/art/artworks/jantjes-colour-this-whites-only-p78647/text-summary (accessed July 2016).
28 David Goldblatt, in Goldblatt *et al.*, *The Transported of KwaNdebele: A South African Odyssey*, rev. edn, Göttingen, 2013, p. 9.
29 David Goldblatt, quoted in Tamar Garb, *Figures and Fictions: Contemporary South African Photography* (exhib. cat.), Victoria and Albert Museum, London, 2011, p. 268.
30 *Ibid.*
31 See under 'Biography', www.goodman-gallery.com/artists/davidgoldblatt (accessed July 2016).
32 See www.sahistory.org.za/archive/january-8th-statements-statement-national-executive-

committee-occasion-75th-anniversary-anc (accessed July 2016).
33 Helen Sebidi, quoted in Mamodima Monnakgotla, 'Artist Sebidi guided by ancestors', *Sowetan Live*, 26 April 2013, www.sowetanlive.co.za/goodlife/2013/04/26/artist-sebidi-guided-by-ancestors (accessed July 2016).
34 John Koenakeefe Mohl, quoted in 'John Koenakeefe Mohl', *South African History Online*, www.sahistory.org.za/people/john-koenakeefe-mohl (accessed July 2016).
35 Polly Savage (ed.), *Making Art in Africa: 1960–2010*, Farnham/Burlington, 2014, p. 185.
36 William Kentridge, quoted in Michael Godby, 'William Kentridge: Retrospective', *Art Journal*, 58(3), 1999, pp. 74–85, p. 83.
37 Savage, *Making Art in Africa*, pp. 17–18.
38 'The Polly Street Era', *South African History Online*, www.sahistory.org.za/archive/polly-street-era (accessed July 2016).
39 See www.iziko.org.za/news/entry/print-in-the-spotlight-impressions-of-rorkes-drift (accessed July 2016).
40 See www.thupelo.com/about (accessed July 2016).
41 G. Ozynski, 'The Bag Factory: nurturing South African art since 1991', *Media Club South Africa*, 25 July 2014, www.mediaclubsouthafrica.com/culture/3950-the-bag-factory (accessed July 2016).
42 Sam Nhlengethwa, quoted in Savage, *Making Art in Africa*, p. 167.
43 See www.aamarchives.org (accessed July 2016).
44 *Ibid.*

Chapter 7

1 For more on the history of the ANC, see 'African National Congress (ANC)', *South African History Online*, www.sahistory.org.za/organisations/african-national-congress-anc (accessed July 2016).
2 Willie Bester, quoted in Polly Savage (ed.), *Making Art in Africa: 1960–2010*, Farnham/Burlington, 2014, pp. 236–7.
3 Willie Bester, quoted in A. Magnin *et al.*, *African Art Now: Masterpieces from the Jean Pigozzi Collection*, London and New York, 2005, p. 66.

4 S. Williamson and A. Jamal, *Art in South Africa: The Future Present*, Cape Town, 1996, p. 136.

5 Willie Bester, quoted in Chris Spring, *Angaza Afrika: African Art Now*, London, 2008, p. 62.

6 Willie Bester, quoted in Savage, *Making Art in Africa*, p. 237.

7 Nelson Mandela, quoted in Karel Anthonie Bakker and Liana Müller, 'Intangible heritage and community identity in post-apartheid South Africa', *Museum International*, 62(1–2), 2010, pp. 48–54; see also www.mandela.gov.za/mandela_speeches/1994/940510_inauguration.htm (accessed July 2016).

8 Rico Schacherl, quoted in Alex Duval Smith, 'Madam & Eve cartoon charts highs and lows of changing South Africa', *The Guardian*, 10 December 2012, www.theguardian.com/world/2012/dec/10/madam-eve-cartoon-south-africa (accessed July 2016).

9 J. Cronin, 'A luta dis-continua? The TRC final report and the nation building project', paper presented at TRC: Commissioning the Past, conference organized by the Centre for the Study of Violence and Reconciliation, University of Witswatersrand, Johannesburg, South Africa, June 1999, cited in Nahla Valji, 'Creating the nation: the rise of violent xenophobia in the new South Africa', unpublished MA thesis, York University, July 2003.

10 Quoted in www.justice.gov.za/trc (accessed July 2016).

11 See www.justice.gov.za/trc/trccom.html (accessed July 2016).

12 Steve Biko, quoted in Pieter Hendrik Coetzee and Abraham Pieter Jacob Roux (eds), *The African Philosophy Reader*, 2nd edn, New York, 2003, p. 101.

13 Lindy Wilson, *Steve Biko*, Athens, OH, 2012; see also 'Stephen Bantu Biko', *South African History Online*, www.sahistory.org.za/people/stephen-bantu-biko (accessed July 2016).

14 James Kruger, quoted in 'IV – The death of Steve Biko', *South African History Online*, http://www.sahistory.org.za/archive/iv-death-steve-biko (accessed July 2016).

15 Quoted in *ibid.*

16 S. Hill, 'Iconic autopsy', *African Arts*, 38(3), 2005, p. 20.

17 Philip Tobias, the eminent palaeoanthropologist, launched a legal case that in 1985 forced the South African Medical and Dental Council to reverse its earlier decision and acknowledge that the doctors concerned had collaborated with the police and thus violated the Hippocratic oath.

18 Truth and Reconciliation Commission, *Truth and Reconciliation Commission Report*, 5 vols, London, 1999.

19 Nelson Mandela, quoted in 'We remember Steve Bantu Biko', *Nelson Mandela Foundation*, www.nelsonmandela.org/news/entry/we-remember-steve-bantu-biko (accessed July 2016).

20 Nelson Mandela, quoted in 'Stephen Bantu Biko', *South African History Online*, www.sahistory.org.za/people/stephen-bantu-biko (accessed July 2016).

21 Jane Alexander, quoted in Savage, *Making Art in Africa*, p. 239.

22 J. M. Coetzee, quoted in G. Adelman, 'Stalking Stavrogin : J. M. Coetzee's *The Master of Petersburg* and the writing of *The Possessed*', *Journal of Modern Literature*, 23(2), 1999, p. 351.

23 C. Spring, *Angaza Afrika: African Art Now*, London, 2008, p. 26.

24 'HIV and AIDS in South Africa', *Avert*, www.avert.org/professionals/hiv-around-world/sub-saharan-africa/south-africa (accessed July 2016).

25 Nelson Mandela also did little to address the HIV/AIDS epidemic while president – something he later acknowledged and regretted.

26 Michael Carter, 'Mbeki's opposition to ARVs cost 330,000 lives, shows study', *NAM aidsmap*, 27 November 2008, www.aidsmap.com/Mbekis-opposition-to-ARVs-cost-330000-lives-shows-study/page/1432574 (accessed July 2016).

27 See, for example, *Fire in the Blood* (Sparkwater India, 2013), dir. Dylan Mohan Gray.

28 F. Jolles, 'Contemporary Zulu dolls', *African Arts*, 27(2), 1994, p. 54.

29 E. Preston-Whyte, 'Zulu bead sculptors', *African Arts*, 24(1), 1991, p. 65.

30 Lionel Davis, quoted in Savage, *Making Art in Africa*, p. 229.

31 *Ibid.*, p. 227.

32 Lionel Davis, quoted in www.capetown.at/heritage/personalities/lionel%20davis.htm (accessed July 2016).

33 Lionel Davis, quoted in Savage, *Making Art in Africa*, p. 227.

34 Candice Breitz, quoted in N. Watermeyer, 'Invading the vitrine', *Classic Feel Magazine*, 2012, p. 27.

35 Taken from wall text at the exhibition *Extra!*, Standard Bank of South Africa, Johannesburg, 2011.

36 *Ibid.*

37 Candice Breitz, personal email correspondence with Chris Spring, 30 October 2015. For more on the Vice debate, see http://mg.co.za/tag/samantha-vice (accessed July 2016) and Samantha Vice, 'How do I live in this strange place', *Journal of Social Philosophy*, 41(3), 2010, pp. 323–42.

38 Candice Breitz, personal email correspondence with Chris Spring, 6 November 2015.

39 Candice Breitz, quoted in Watermeyer, 'Invading the vitrine', pp. 30–31.

40 *Ibid.*, p. 31.

41 Mary Sibande, quoted in A. Stielau, 'Mary Sibande', *Art Throb*, www.artthrob.co.za/Artbio/Mary_Sibande_by_Anna_Stielau.aspx (accessed July 2016).

42 See www.designboom.com/art/mary-sibande (accessed July 2016).

43 Mary Sibande, quoted in Stielau, 'Mary Sibande'.

44 Mary Sibande, quoted in M. Krouse, 'Mary Sibande: the purple shall reign at Grahamstown's arts fest', *Mail & Guardian*, 21 June 2013, http://mg.co.za/article/2013-06-21-mary-sibande-the-purple-shall-reign-at-the-fest (accessed July 2016).

45 Mary Sibande, quoted in L. Meekison, 'The many incarnations of Mary Sibande', *Scope*, 21 December 2014, www.scope-mag.com/2014/12/incarnations-mary-sibande (accessed July 2016).

46 *Ibid.*

47 Mary Sibande, quoted in Stielau, 'Mary Sibande'.

48 Mary Sibande, quoted in Krouse, 'Mary Sibande.

Further reading

L. Barham and P. Mitchell, *The First Africans: African Archaeology from the Earliest Toolmakers to Most Recent Foragers*, New York and Cambridge, 2008

R. Becker *et al.*, *Art and Ambiguity: Perspectives on the Brenthurst Collection of Southern African Art*, Johannesburg Art Gallery, 1991

E. Bedford (ed.), *Ezakwantu: Beadwork from the Eastern Cape* (exhib. cat.), South African National Gallery, Cape Town, 1993

—, *Contemporary South African Art 1985–1995 from the South African National Gallery Permanent Collection*, Cape Town, 1997

J. Brenner *et al.* (eds), *Life of Bone: Art Meets Science*, Johannesburg, 2011

P. Davison *et al.*, 'Some Nguni crafts', *Annals of the South African Museum*, 70(1–4), 1976

C. Deliss (ed.), *Seven Stories about Modern Art in Africa* (exhib. cat.), Whitechapel Art Gallery, London, then touring, 1995–6

P. Delius *et al.* (eds), *A Long Way Home: Migrant Worker Worlds, 1800–2014*, Johannesburg, 2014

A. Dodd, '"Live transmission": intimate ancestors in Santu Mofokeng's *Black Photo Album/Look at Me: 1890–1950*', *African Arts*, 48(2), 2015, pp. 52–63

A. Duffey, *Anton van Wouw: The Smaller Works*, Pretoria, 2008

A. Duffey *et al.*, *The Art and Heritage Collections of the University of Pretoria*, Pretoria, 2008

D. Elliott *et al.*, *Art from South Africa* (exhib. cat.), Museum of Modern Art, Oxford, then touring, 1990–91

O. Enwezor, 'Reframing the black subject: ideology and fantasy in contemporary South African representation', in O. Oguibe and O. Enwezor (eds), *Reading the Contemporary: African Art from Theory to the Marketplace*, London, 1999

O. Enwezor and C. Okeke-Agulu, *Contemporary African Art since 1980*, Bologna, 2009

J. Foster, *Washed with the Sun: Landscape and the Making of White South Africa*, Pittsburgh, PA, 2008

T. Garb, *Figures and Fictions: Contemporary South African Photography* (exhib. cat.), Victoria and Albert Museum, London, 2011

K. Geers (ed.), *Contemporary South African Art: The Gencor Collection*, Johannesburg, 1997

D. Goldblatt, *The Transported of KwaNdebele: A South African Odyssey*, New York, 1989

D. Goldblatt and N. Gordimer, *On the Mines*, Cape Town, 1973

T. Goniwe (ed.), *Mary Sibande: The Purple Shall Govern* (exhib. cat.), Gallery MOMO, Johannesburg, 2013

C. Hamilton (ed.), *The Mfecane Aftermath: Reconstructive Debates in Southern African History*, Johannesburg, 1995

F. Herreman (ed.), *Liberated Voices: Contemporary Art from South Africa* (exhib. cat.), Museum of African Art, New York, 1999

E. Itzkin, *Gandhi's Johannesburg: Birthplace of Satyagraha*, Johannesburg and London, 2001

F. Jolles, *African Dolls = Afrikanische Puppen: The Dulger-Collection*, Stuttgart, 2010

H. Joubert and M. Valentin (eds), *Ubuntu: arts et cultures d'Afrique du Sud* (exhib. cat.), Musée National des Arts d'Afrique et d'Océanie, Paris, 2002

T. Katzenellenbogen, 'Imbenge', *Journal of Museum Ethnography*, 4, December 1993, pp. 49–72

D. Koloane, 'The identity question: focus on black South African expression', in O. Oguibe and O. Enwezor (eds), *Reading the Contemporary: African Art from Theory to the Marketplace*, London, 1999

N. Leibhammer (ed.), *Dungamanzi = Stirring Waters: Tsonga and Shangaan Art from Southern Africa* (exhib. cat.), Johannesburg Art Gallery, 2007

J. D. Lewis-Williams and S. Challis, *Deciphering Ancient Minds: The Mystery of San Bushman Rock Art*, London, 2011

J. McAleer, *Representing Africa: Landscape, Exploration and Empire in Southern Africa, 1780–1870*, Manchester and New York, 2010

T. Maggs, 'A glimpse of colonial life through Zulu eyes: 19th century engraved cattle horns from Natal', *Natal Museum Journal of Humanities*, 2, November 1990, pp. 143–62

S. Marks, 'Class, culture, and consciousness in South Africa, 1880–1899', in R. Ross *et al.*, *The Cambridge History of South Africa, Volume 2: 1885–1994*, Cambridge, 2011, pp. 102–56

E. Miles, *Polly Street: The Story of an Art Centre*, Johannesburg, 2004

P. Mitchell, *The Archaeology of Southern Africa*, Cambridge, 2002

Musuva (June Bam-Hutchison), *Peeping Through the Reeds: A Story about Living in Apartheid South Africa*, London, 2010

K. Nel *et al.*, *Evocations of the Child: Fertility Figures of the Southern African Region* (exhib. cat.), Johannesburg Art Gallery, 1998

A. Nettleton, *African Dream Machines: Style, Identity and Meaning of African Headrests*, Johannesburg, 2007

—, 'Of severed heads and snuff boxes: "survivance" and beaded bodies in the Eastern Cape, 1897–1934', *African Arts*, 48(4), 2015, pp. 22–33

S. Njami (ed.), *Africa Remix: Contemporary Art of a Continent* (exhib. cat.), Johannesburg Art Gallery, 2007

A. W. Oliphant *et al.*, *Democracy X: Marking the Present/Re-presenting the Past* (exhib. cat.), University of South Africa, Pretoria, 2004

G. Olivier (ed.), *Penny Siopis: Time and Again*, Johannesburg, 2014

S. O'Toole, *Candice Breitz: Extra!* (exhib. cat.), Goodman Gallery, Johannesburg, then touring, 2012

J. B. Peires, *The House of Phalo: A History of the Xhosa People in the Days of Their Independence*, Johannesburg, 1981

J. Pemberton, *African Beaded Art: Power and Adornment*, Northampton, MA, 2008

T. Phillips, *Africa, the Art of a Continent* (exhib. cat.), Royal Academy of Arts, London, 1995

C. Richards, 'About face: aspects of art history and identity in South African visual culture', in O. Oguibe and O. Enwezor (eds), *Reading the Contemporary: African Art from Theory to the Marketplace*, London, 1999

A. F. Roberts, '"Break the silence": art and HIV/AIDS in KwaZulu-Natal', *African Arts*, 34(1), 2001, pp. 36–49

R. Ross *et al.*, *The Cambridge History of South Africa, Volume 2: 1885–1994*, Cambridge, 2011

P. Savage (ed.), *Making Art in Africa: 1960–2010*, Farnham/Burlington, 2014

J. A. van Schalkwyk and E. O. M. Hanisch (eds), *Sculptured in Clay: Iron Age Figurines from Schroda, Limpopo Province, South Africa*, Pretoria, 2002

E. M. Shaw and N. J. van Warmelo, 'The material culture of the Cape Nguni', *Annals of the South African Museum*, 58, 1988

C. Spring, *African Arms and Armour*, London, 1993

—, *Angaza Afrika: African Art Now*, London, 2008

—, *African Textiles Today*, London, 2012

S. Tiley, *Mapungubwe: South Africa's Crown Jewels*, Cape Town, 2004

S. Tiley-Nel (ed.), *Mapungubwe Remembered: Contributions to Mapungubwe by the University of Pretoria*, Johannesburg, 2011

S. Williamson, *Resistance Art in South Africa*, Cape Town, 1989

—, *South African Art Now*, New York, 2009

S. Williamson and A. Jamal, *Art in South Africa: The Future Present*, Cape Town, 1996

M. Wood (ed.), *Zulu Treasures: Of Kings and Commoners – A Celebration of the Material Culture of the Zulu People* (exhib. cat.), KwaZulu Cultural Museum, Ulundi, and Local History Museums, Durban, 1996

G. Younge, *Art of the South African Townships*, London, 1988

Zapiro (J. Shapiro) and M. Wills, *Democrazy: SA's Twenty-Year Trip*, Johannesburg, 2014

List of lenders

The British Museum would like to thank all the lenders to the exhibition *South Africa: the art of a nation* for their generosity.

Ditsong National Cultural History Museum, Pretoria
Gallery MOMO, Johannesburg
Goodman Gallery, Johannesburg
Iziko Museums of South Africa
Jane Samuels, London
Karel Nel, Johannesburg
McGregor Museum, Kimberley
MAKER, Johannesburg
Museum Africa, Johannesburg
Private collections, London
South32 Collection, Johannesburg
Studio Breitz, Berlin
Tate, London
BMW Museum, Munich
Museum of Archaeology and Anthropology, University of Cambridge
University of Pretoria, Pretoria
University of the Witwatersrand, Johannesburg
Wits Art Museum, Johannesburg

List of exhibits

The following objects in this book feature in the exhibition *South Africa: the art of a nation*. Details correct at the time of going to press.

Further information about objects in the collection of the British Museum can be found on the Museum's website at britishmuseum.org.

Page references for where illustrations appear in this publication are given at the end of each entry.

Introduction: South African art

BMW Art Car 525i Number 12
Esther Mahlangu, 1991
Metal, paint and plastic, H. 141 cm | L. 472 cm
The BMW Museum, Munich 869759
Illustrated pp. 10 and 11

Zaamenkomst Panel
Name(s) of artist(s) unrecorded, pre-1900
Recorded as San|Bushman
Stone, ochre, H. 93 cm | W. 247 cm
Iziko Museums of South Africa,
Cape Town SAM-AA1617
Illustrated pp. 16 and 17

Creation of the Sun
First People Artists, Bethesda Arts Centre, 2015
Textile, H. 146 cm | W. 211 cm
British Museum 2016,2023.1
Illustrated p. 22

1. Origins and early art

Makapansgat Pebble of Many Faces
Originally collected *c.* 3,000,000 BP
Recorded as australopithecine
Jasperite stone, H. 8.3 cm | W. 6.9 cm
Evolutionary Studies Institute, University of the Witwatersrand, Johannesburg
Illustrated p. 29

Kathu Pan hand-axe
Made *c.* 1,000,000 BP
Recorded as *Homo ergaster*
Banded ironstone, H. 23.2 cm | W. 11.4 cm
McGregor Museum,
Kimberley MMK6538
Illustrated p. 30

Blombos Cave beads
Name(s) of artist(s) unrecorded,
c. 78,000–75,000 BP
Recorded as *Homo sapiens*
Nassarius kraussianus shells
Average H. 0.8 cm | W. 0.6 cm
Iziko Museums of South Africa,
Cape Town SAM-AA 8987/001-012
Illustrated p. 34

Coldstream Stone
Name(s) of artist(s) unrecorded, *c.* 9,000 BP
Recorded as San|Bushman
Stone, ochre, H. 8 cm | W. 30 cm
Iziko Museums of South Africa,
Cape Town SAM-AA6008
Illustrated p. 36

Quagga petroglyph
Name(s) of artist(s) unrecorded,
c. 1,000–2,000 BP
Recorded as San|Bushman
Andesite rock, H. 38 cm | W. 48 cm
British Museum Af1886,1123.1
Donated by F. Schute
Illustrated p. 37

Taung
Karel Nel, 1985
Digital print, H. 148 cm | W. 112 cm
Collection of the artist, Johannesburg
Illustrated p. 38

Potent Fields
Karel Nel, 2002
Ochre, linen, H. 122 cm | W. 242 cm
British Museum 2016,2005.1
Illustrated p. 41

2. Sculpture and initiation

Lydenburg Head
Name(s) of artist(s) unrecorded, AD 500–900
Recorded as Bantu language speaker
Terracotta, white pigment and specularite
H. 38 cm | W. 26 cm
University of Cape Town Collection
at the Iziko Museums of South Africa,
Cape Town UCT701/1
Illustrated p. 47

Schroda female fertility figurine
Name(s) of artist(s) unrecorded, AD 900–1020
Recorded as Zhizo
Clay, H. 22 cm | W. 5.8 cm
Ditsong National Cultural History Museum, Pretoria
Illustrated p. 49

Schroda human figurines
Name(s) of artist(s) unrecorded, AD 900–1020
Recorded as Zhizo
Clay
Male H. 21.2 cm | W. 9.6 cm
Female H. 18.4 cm | W. 8.8 cm
Ditsong National Cultural History Museum, Pretoria
Illustrated p. 50

Schroda Figurines
Name(s) of artist(s) unrecorded, AD 900–1020
Recorded as Zhizo
Clay
Bird figurine H. 19.8 cm | W. 5.5 cm
Goat figurine H. 8.8 cm | W. 11.3 cm
Mouse figurine H. 5.5 cm | W. 3.8 cm
Mythological Beast figurine H. 8.2 cm | W. 17 cm
Expressive Human figurine H. 6.7 cm | W. 4 cm
Hippopotamus figurine H. 15.5 cm | W. 22.6 cm
Elephant figurine H. 13.5 cm | W. 15 cm
Ditsong National Cultural History Museum, Pretoria
Illustrated p. 51

Schroda Figurines
Name(s) of artist(s) unrecorded, AD 900–1020
Recorded as Zhizo
Clay

Schroda Sheep figurine H. 17.8 cm | W. 6.3 cm
Schroda Cattle figurine H. 3.2 cm | W. 2.8 cm
Ditsong National Cultural History Museum, Pretoria
Not illustrated

Mapungubwe feline
Name(s) of artist(s) unrecorded, AD 1250–90
Recorded as Zhizo
Gold, H. 5.1 cm | L. 17 cm
University of Pretoria MAP/G/2015/003
Illustrated p. 54

Mapungubwe bovine
Name(s) of artist(s) unrecorded, AD 1250–90
Recorded as Zhizo
Gold, H. 5.6 cm | L. 12.2 cm
University of Pretoria MAP/G/2015/002
Illustrated p. 54

Mapungubwe sceptre
Name(s) of artist(s) unrecorded, AD 1250–90
Recorded as Zhizo
Gold, L. 20.6 cm | DIAM. 5.7 cm
University of Pretoria MAP/G/2015/004
Illustrated p. 54

Mapungubwe bowl
Name(s) of artist(s) unrecorded, AD 1250–90
Recorded as Zhizo
Gold, H. 6.1 cm | DIAM. 14 cm
University of Pretoria MAP/G/2015/005
Illustrated p. 54

Mapungubwe rhinoceros
Name(s) of artist(s) unrecorded, AD 1250–90
Recorded as Zhizo
Gold, H. 6.2 cm | L. 14.5 cm
University of Pretoria MAP/G/2015/001
Illustrated p. 55

Kenilworth Head
Name(s) of artist(s) unrecorded, c. 1650
Recorded as San | Bushman or Khoekhoen
Schist stone, H. 15 cm | W. 9 cm
McGregor Museum, Kimberley MMK 85
Illustrated p. 57

Cape of Good Hope: 'A History Painting'
Penny Siopis, 1989
Collage, oil on canvas
H. 155 cm | W. 141 cm
Private collection, London
Illustrated p. 61

Oxford Man
Owen Ndou, 1992
Wood, paint, H. 135 cm
Private collection, London
Illustrated p. 62

3. European and Asian arrivals

Twenty miniature bottles
Name(s) of artist(s) unrecorded, c. 1648
Recorded as Chinese
Glazed porcelain
Average H. 4.8 cm | W. 2.4 cm
British Museum 1853,1220.30-50
Donated by Henry Adams
Illustrated p. 68

Dutch galleon rock art photo
Name(s) of artist(s) unrecorded, c. 1650
Recorded as Khoekhoen
Digital image, David Coulson
H. 29 cm | W. 38 cm (galleon)
British Museum 2013,2034.19495
Donated by Trust for African
Rock Art (TARA)
Illustrated p. 68

Seekoei River Beacon
Name(s) of artist(s) unrecorded, c. 1788
Recorded as Dutch
Stone, H. 45 cm | W. 43 cm
Iziko Museums of South Africa,
Cape Town ACC.225
Illustrated p. 69

Trekboer Making a Camp
Samuel Daniell, 1804–5
Aquatint, paper, H. 45.5 cm | W. 59.6 cm

British Museum 1913,0129.1.19
Transferred from the British Library
Illustrated p. 71

*A Hotentot, A Hotentot Woman, a Kaffre,
a Kaffre Woman*
Samuel Daniell, 1804–5
Aquatint, paper, H. 45.5 cm | w. 59.6 cm
British Museum 1913,0129.1.15
Transferred from the British Library
Illustrated p. 72

Illustration from *Narrative of a Journey to the
Zoolu Country in South Africa*
Allen Francis Gardiner, 1836
Ink on paper (leather-bound book)
H. 23.5 cm | w. 15 cm
British Museum, Anthropology Library
& Research Centre
Illustrated p. 74

Portrait of Uyedwana, a Zulu, in Visiting Dress
George French Angas, 1847
Watercolour and bodycolour on paper
H. 32.7 cm | w. 23.7 cm
British Museum 1876,0510.502
Illustrated p. 76

Pantomime Act Trilogy
Johannes Phokela, 1999
Oil on canvas, H. 183 cm | w. 168 cm
Private collection, London
Illustrated p. 81

Conical *toedang* hat
Name(s) of artist(s) unrecorded, 1700–1900
Recorded as Cape Malay
Vegetable fibre, textile
H. 27 cm | w. 51 cm
British Museum Af1960,20.113
Donated by Royal Botanical Gardens at Kew
Illustrated p. 82

Maquette for the Gandhi Memorial Statue
Anton Momberg, 1990
Fibre cast resin, H. 63.9 cm

Iziko South African National Gallery,
Cape Town SANG93/21
Illustrated p. 83

Gandhi's sandals
Mohandas Karamchand Gandhi, pre-1915
Leather, brass, wool, L. 27.6 cm | w. 10.5 cm
Ditsong National Cultural History Museum,
Pretoria HG. 51388/1–2
Illustrated p. 84

Christ with Football
Jackson Hlungwani, 1992
Wood, H. 210 cm | w. 57 cm
Private collection, London
Illustrated p. 88

Bad Faith Chronicles
Willem Boshoff, 1995
Paper, metal, plastic, H. 125 cm | w. 63 cm
Private collection, London
Illustrated p. 90

'Cape Malay Priest and his wife Nazea',
from *The Kafirs Illustrated*
George French Angas, 1849
Ink on paper (leather-bound book)
H. 14.5 cm | w. 67.5 cm
British Museum, Anthropology
Library & Research Centre
Illustrated p. 92

4. Colonial conflicts

Knobkerrie headrest
Name(s) of artist(s) unrecorded, *c.* 1850–99
Recorded as Tsonga
Wood, H. 15.2 cm | w. 61.9 cm
British Museum Af1954,+23.1825
Donated by the Wellcome Historical
Medical Museum
Illustrated p. 98

Martini-Henry shaped rifle headrest
Name(s) of artist(s) unrecorded, *c.* 1850–99

Recorded as Tsonga
Wood, H. 13.5 cm | w. 74 cm
British Museum Af1954,+23.1824
Donated by the Wellcome Historical
Medical Museum
Illustrated p. 98

Lee-Speed shaped rifle headrest
Name(s) of artist(s) unrecorded, *c.* 1850–99
Recorded as Tsonga
Wood, H. 16 cm | w. 66 cm
British Museum Af1979,01.4935
Illustrated p. 98

Chieftain's armlet
Name(s) of artist(s) unrecorded, *c.* 1800–79
Recorded as Xhosa
Ivory, H. 3.5 cm | w. 11.5 cm
British Museum Af1936,1218.20
Donated by Lady Cunninghame
Illustrated p. 101

Chieftain's armlet
Name(s) of artist(s) unrecorded, 1800–99
Recorded as Xhosa
Ivory, H. 3 cm | w. 12.2 cm
British Museum Af1936,1218.19
Donated by Lady Cunninghame
Illustrated p. 101

Human figure axe
Name(s) of artist(s) unrecorded, 1800–99
Cultural identity unknown
Iron, ivory, fibre
H. 68.3 cm | w. 20.5 cm
British Museum Af1949,46.612
Purchased with contribution from the Art Fund
Illustrated p. 101

Decorated axe
Name(s) of artist(s) unrecorded, 1800–99
Cultural identity unknown
Wood, iron, lead and fibre
H. 84.7 cm | w. 19.5 cm
British Museum Af1878,1101.536
Illustrated p. 101

War standard
Name(s) of artist(s) unrecorded, 1800–99
Recorded as Zulu
Wood, iron, H. 160 cm
Karel Nel, Johannesburg
Illustrated on pp. 102 and 103

Throwing spear
Name(s) of artist(s) unrecorded, 1800–79
Recorded as Zulu
Wood, iron, brass, H. 85.5 cm
British Museum Af1954,03.3
Donated by T. C. R. Ansty in 1954
Illustrated on p. 102

Thrusting spear
Name(s) of artist(s) unrecorded, 1800–79
Recorded as Zulu
Wood, iron, brass, H. 85.5 cm
British Museum Af1954,03.2
Donated by T. C. R. Ansty in 1954
Illustrated p. 102

The Battle of Rorke's Drift
John Muafangejo, 1981
Linocut print on paper
H. 44.5 | W. 69.5 cm
Wits Art Museum, University
of the Witwatersrand, Johannesburg
Johannesburg 1986.20.19
Illustrated pp. 104–5

Oxhide shield
Name(s) of artist(s) unrecorded, 1800–79
Recorded as Zulu
Oxhide, H. 149 cm | W. 115 cm
British Museum Af1954,03.1
Illustrated p. 106

Ceremonial armlet
Name(s) of artist(s) unrecorded, 1800–99
Recorded as Zulu
Brass, H. 18 cm | W. 10 cm
British Museum Af1926,0612.1
Donated by G. R. Clarkson
Illustrated p. 107

Ceremonial armlet
Name(s) of artist(s) unrecorded, 1800–99
Recorded as Zulu
Brass, H. 18.3 cm | W. 7.7 cm
British Museum Af1923,1010.1
Donated by Lady Mary Bruce
Illustrated p. 107

Ceremonial armlet
Name(s) of artist(s) unrecorded, 1800–99
Recorded as Zulu
Brass, H. 16.2 cm | W. 9.2 cm
British Museum Af1934,0712.8
Donated by Major General Sir Reginald Thynne
Illustrated p. 107

Carved cattle horns and cranium
Name(s) of artist(s) unrecorded, 1879–99
Recorded as Zulu
Animal bone, horn, H. 38 cm | W. 68 cm
British Museum Af1960,08.1a,b&c
Illustrated pp. 108 and 109

Boer commandos sketch
Charles Wellington Furse, *c.* 1895
Graphite on paper, H. 22 cm | W. 43.9 cm
British Museum 1907,1018.5
Illustrated p. 114

Boer commando horse sketches
Charles Wellington Furse, *c.* 1895
Graphite on paper, H. 22 cm | W. 43.9 cm
British Museum 1907,1018.30-31
Illustrated p. 115

Concentration camp plate
Miss Hamelberg, *c.* 1900
Unglazed earthenware, paper, adhesive
DIAM. 36.1 cm
Museum Africa, Johannesburg MA1972/606
Illustrated p. 116

British military tunic
Name(s) of artist(s) unrecorded, *c.* 1902
Recorded as British
Fabric and ink, H. 75 cm | W. 51 cm

Museum Africa, Johannesburg MA1967/709
Illustrated p. 116

The Watchers
Francki Burger, 2014
Photographic print, H. 40 cm | W. 70 cm
British Museum 2016,2011.1
Illustrated p. 118

Kruger in Exile
Anton van Wouw, 1907
Bronze, H. 24.5 cm | W. 34 cm
Private collection, London
Illustrated p. 119

5. Rural art in the 1800s

Milk pot
Name(s) of artist(s) unrecorded, 1800–80
Recorded as Zulu
Wood, H. 46.3 cm | W. 17.5 cm
British Museum Af1917,1103.8
Donated by Dowager Viscountess Louisa Wolseley
Illustrated p. 124

Ornamental vessel
Name(s) of artist(s) unrecorded, 1800–69
Recorded as Zulu
Wood, H. 33 cm | W. 34 cm
British Museum Af.1561.a-c
Donated by Henry Christy
Illustrated p. 125

Horn snuff box (for headdress)
Name(s) of artist(s) unrecorded, 1800–80
Recorded as Zulu
Horn, H. 24.9 cm | W. 6 cm
British Museum Af,+.1436.a-b
Donated by Sir A. W. Franks
Illustrated p. 126

Ox snuff box
Name(s) of artist(s) unrecorded, 1850–99
Recorded as Xhosa

Sinew, blood, hair, H. 9.8 cm | W. 7.5 cm
British Museum Af1910,1005.63
Donated by Sir Bartle Frere
Illustrated p. 128

Human figurine snuff box
Name(s) of artist(s) unrecorded, 1800–99
Recorded as South Sotho
Horn, wood, H. 12 cm | W. 4.3 cm
British Museum Af1949,46.600
Purchased with contribution from the Art Fund
Illustrated p. 129

Cattle figurine snuff box
Name(s) of artist(s) unrecorded, 1800–99
Recorded as South Sotho
Horn, wood, H. 11.2 cm | W. 4.5 cm
British Museum Af1949,46.599
Purchased with contribution from the Art Fund
Illustrated p. 129

Ivory snuff box
Name(s) of artist(s) unrecorded, 1800–99
Recorded as Tswana
Ivory, wood, leather, H. 20 cm | W. 3.5 cm
British Museum Af1910,-.384.a
Illustrated p. 130

Gourd snuff box
Name(s) of artist(s) unrecorded, 1800–99
Recorded as Zulu
Gourd, brass, H. 6.1 cm | W. 7.5 cm
British Museum Af,Br.133
Illustrated p. 130

Ornamental knobkerrie snuff box
Name(s) of artist(s) unrecorded, 1800–99
Recorded as Zulu
Wood, glass, cotton, resin, H. 16 cm | W. 60 cm
British Museum Af1954,+23.62
Donated by the Wellcome Historical Medical
Museum
Illustrated p. 132

Headrest snuff boxes
Name(s) of artist(s) unrecorded, 1850–99

Recorded as Tsonga
Wood, metal, H. 17.5 cm | W. 85.5 cm
British Museum Af1939,03,01
Illustrated p. 132

Beaded snuff box
Name(s) of artist(s) unrecorded, 1800–80
Recorded as Xhosa
Gourd, glass, fibre
H. 64.5 cm | W. 7.5 cm (incl. cord)
British Museum Af1883,0608.1
Donated by Thomas Pike
Illustrated p. 133

Horn snuff box
Name(s) of artist(s) unrecorded, 1800–99
Recorded as Zulu
Horn, metal
H. 14 cm | W. 5 cm
British Museum Af1954,+23.591
Donated by Wellcome Institute for
the History of Medicine
Illustrated p. 133

Snuff-spoon comb
Name(s) of artist(s) unrecorded, 1800–95
Recorded as Zulu
Bone, H. 22 cm | W. 5 cm
British Museum Af1895,0806.10
Donated by A. Byrne
Illustrated p. 134

Snuff-spoon comb
Name(s) of artist(s) unrecorded, 1800–82
Recorded as Zulu
Bone, H. 14.6 cm | W. 3 cm
British Museum Af,Cf.2
Illustrated p. 134

Pipe
Name(s) of artist(s) unrecorded, 1800–99
Recorded as San | Bushman
Steatite, H. 11 cm | DIAM. 0.9 cm
British Museum Af.9034
Donated by Dr W. H. I. Bleek
Illustrated p. 135

Horse-shaped pipe
Name(s) of artist(s) unrecorded, 1860–93
Recorded as Sotho
Wood, H. 7.5 cm | W. 3 cm
British Museum Af1905,-.64
Donated by Jeffrey Whitehead
Illustrated p. 135

Pipe
Name(s) of artist(s) unrecorded, 1850–79
Recorded as Xhosa
Wood, metal, H. 7.5 cm | W. 3 cm
British Museum Af1936,1218.17
Donated by Lady Cunninghame
Illustrated p. 135

Pipe
Name(s) of artist(s) unrecorded, 1860–93
Recorded as Xhosa
Wood, H. 13.2 cm | W. 2.8 cm | L. 47.5 cm
British Museum Af1905,-.71
Donated by Jeffrey Whitehead
Illustrated p. 136

Beaded pipe
Name(s) of artist(s) unrecorded, 1800–99
Recorded as Xhosa
Wood, iron, glass, fibre
H. 16 cm | W. 2.4 cm | L. 26.7 cm
British Museum Af1933,0609.34
Donated by Frank Corner through the Art Fund
Illustrated p. 138

Human figure pipe
Name(s) of artist(s) unrecorded, 1860–93
Recorded as Xhosa (Gcaleka)
Wood, beads, H. 10.5 cm | W. 4.2 cm
British Museum Af1905,-.63.a-b
Donated by Jeffrey Whitehead
Illustrated p. 139

Pair of human figurines
Name(s) of artist(s) unrecorded, 1800–92
Recorded as Tsonga
Wood, textile
Female H. 55 cm | W. 16 cm

Male H. 56.5 cm | w. 13.5 cm
British Museum Af,+.6190-1
Donated as part of the Christy Collection
Illustrated p. 141

Sculpture of a human figure
Name(s) of artist(s) unrecorded, 1850–99
Recorded as Tsonga
Wood, H. 62.5 cm | w. 22 cm
British Museum Af1954,+23.3567
Donated by the Wellcome Historical
Medical Museum
Illustrated p. 143

Doll
Name(s) of artist(s) unrecorded, 1900–33
Recorded as Xhosa
Corn, ochre, fibre, glass, cotton
H. 22.5 cm | w. 10 cm
British Museum Af1933,0609.134.a-b
Donated by Frank Corner through the Art Fund
Illustrated p. 144

Pair of gun cartridge dolls
Name(s) of artist(s) unrecorded, 1900–33
Recorded as Sotho
Glass, brass, seed, leather, fibre
H. 7.4–7.5 cm | w. 2–4 cm
British Museum Af1933,0609.137.a-b
Donated by Frank Corner through the Art Fund
Illustrated p. 145

Headdress
Name(s) of artist(s) unrecorded, 1825–74
Recorded as Xhosa
Glass, fibre, skin, hair
H. 144 cm (incl. straps) | w. 35 cm
British Museum Af.3244
Donated by Henry Christy
Illustrated p. 147

Necklace
Name(s) of artist(s) unrecorded, 1800–99
Recorded as Xhosa
Leather, fibre, teeth, glass
H. 18 cm | w. 15 cm

British Museum Af,SA.35.a
Illustrated p. 148

Necklace
Name(s) of artist(s) unrecorded, 1800–99
Recorded as Zulu
Leopard claws and fibre, H. 11 cm | w. 12 cm
British Museum Af.3186
Donated as part of the Christy Collection
Illustrated p. 149

Iziqu necklace
Name(s) of artist(s) unrecorded, pre-1945
Recorded as Tsonga
Wood, antelope horn, cotton, H. 25 cm | w. 15 cm
British Museum Af1945,04.24
From Mrs F. J. Newman
Illustrated p. 150

Wood necklace
Name(s) of artist(s) unrecorded, pre-1933
Recorded as Xhosa
Wood, glass, sinew, H. 20 cm | w. 20 cm
British Museum Af1933,0609.114
Donated by Frank Corner through the Art Fund
Illustrated p. 151

Snuff-box necklace
Name(s) of artist(s) unrecorded, pre-1933
Recorded as Xhosa
Tin, fibre, glass, H. 48 cm | w. 20 cm
British Museum Af1933,0609.28
Donated by Frank Corner through the Art Fund
Illustrated p. 152

Ingqosha beaded necklace
Name(s) of artist(s) unrecorded, 1850–99
Recorded as Xhosa
Brass, fibre, glass, H. 9.5 cm | w. 27 cm
British Museum Af1933,0609.44
Donated by Frank Corner, through the Art Fund
Illustrated p. 155

Woman's cloak
Name(s) of artist(s) unrecorded, 1800–67
Recorded as Xhosa

Animal hide, hair, ochre, brass, iron, metal,
tortoise shell, H. 157.5 cm | w. 70 cm
British Museum Af.4591
Donated by John Currey
Illustrated p. 156

Cosmetics container
Name(s) of artist(s) unrecorded, 1800–67
Recorded as Xhosa
Psammobates tentorius carapace, copper, leather
H. 36 cm | w. 6.8 cm (incl. strap)
British Museum Af.4591.a
Donated by John Currey
Illustrated p. 156

Inkciyo apron
Name(s) of artist(s) unrecorded, 1800–67
Recorded as Xhosa (Gcaleka)
Leather, glass beads, brass, H. 33.5 cm | w. 16.5 cm
British Museum Af4582
Donated by John Currey
Illustrated p. 158

Girl's belt and apron
Name(s) of artist(s) unrecorded, 1800–99
Recorded as Zulu
Glass beads, vegetable fibre
H. 31 cm | w. 32 cm
British Museum Af1902,0717.2
Donated by Mr and Mrs R. Samuelson
Illustrated p. 158

Beaded apron
Name(s) of artist(s) unrecorded, pre-1910
Recorded as Khoekhoen
Glass beads, fibre, H. 14 cm | w. 27.5 cm
British Museum Af1910,-.401
Not illustrated

Breastplate
Name(s) of artist(s) unrecorded, 1820–70
Recorded as Sotho
Brass, leather, H. 41 cm (incl. cord) | w. 49 cm
British Museum Af.6093
Donated by Miss Powles
Illustrated p. 160

Shield
Name(s) of artist(s) unrecorded, 1820–70
Recorded as Sotho
Oxhide, iron, fibre
H. 51 cm | W. 98.7 cm
British Museum Af,6094
Donated by Miss Powles
Illustrated p. 160

Plume
Name(s) of artist(s) unrecorded, 1820–70
Recorded as Sotho
Ostrich plumes, iron, fibre
H. 139.2 cm | W. 14 cm
British Museum Af,6095
Donated by Miss Powles
Illustrated p. 161

Axe
Name(s) of artist(s) unrecorded, 1800–99
Recorded as Venda
Wood, iron, H. 79 cm | W. 12 cm
British Museum Af1907,0725.1
Illustrated p. 162

Axe
Name(s) of artist(s) unrecorded, 1800–99
Recorded as Tsonga
Wood, iron, H. 91 cm | W. 11.5 cm
British Museum Af1954,+23.2813
Donated by the Wellcome Historical
Medical Museum
Illustrated p. 162

Headdress in bell jar
Name(s) of artist(s) unrecorded, 1850–99
Recorded as Swazi
Feather, vegetable fibre and bell jar (glass, wood)
H. 21 cm | W. 29 cm
British Museum Af1933,0315.105
Bequeathed by William Leonard Stevenson Loat
Illustrated p. 164

The Black Photo Album / Look At Me: 1890–1950
Santu Mofokeng, 1997
Black-and-white slide projection

MAKER, Johannesburg
Illustrated pp. 165 and 166–7

Rock art of European settlers
Name(s) of artist(s) unrecorded, *c.* 1860
Recorded as Khoekhoen
Digital image, David Coulson
H. 20 cm | W. 94 cm (four-horse wagon)
British Museum 2013,2034.19504
Donated by Trust for African
Rock Art (TARA)
Illustrated p. 170

6. Experiencing and resisting segregation and apartheid

Beaded wedding train
Name(s) of artist(s) unrecorded, 1890–1910
Recorded as Ndebele
Beadwork, vegetable fibre, metal crottals
H. 172 cm | W. 26 cm
Karel Nel, Johannesburg
Illustrated p. 175

Beaded cape
Name(s) of artist(s) unrecorded, 1890–1910
Recorded as Ndebele
Beadwork, vegetable fibre, leather
H. 150 cm | W. 158 cm
Karel Nel, Johannesburg
Illustrated p. 176

Mapoto
Name(s) of artist(s) unrecorded, 1900–25
Recorded as Ndebele
Leather, beadwork
H. 54 cm | W. 46.3 cm
British Museum Af1986,09.4
Illustrated p. 177

Beaded blanket
Name(s) of artist(s) unrecorded, *c.* 1950
Recorded as Ndebele
Beadwork, synthetic fibre, cotton
H. 107 cm | W. 148 cm

British Museum 2015,2011.1
Illustrated pp. 178–9

Tree in the Bushveld
Jacob Hendrik Pierneef, 1930
Oil on canvas, H. 90 cm | W. 119 cm
University of Pretoria, Pretoria 410793
Illustrated p. 181

Telephone wire basket
Alex Mmola 1980–91
Wire, plastic
H. 8.5 cm | DIAM. 28.5 cm
British Museum Af1991,09.67
Donated anonymously
Illustrated p. 185

Beaded tie
Name(s) of artist(s) unrecorded, 1950–70
Recorded as Xhosa
Beadwork, vegetable fibre
H. 33 cm | W. 41.8 cm
British Museum Af1970,24.5
Illustrated p. 186

Beaded waistcoat
Name(s) of artist(s) unrecorded, 1950–87
Recorded as Zulu
Beadwork, wool
H. 65 cm | W. 46 cm
British Museum Af1987,16.1
Illustrated p. 187

Song of the Pick
Gerard Sekoto, 1946
Oil on canvas, H. 50.5 cm | W. 60.5 cm
South32 Collection, Johannesburg 573
Illustrated p. 189

A South African Colouring Book
Gavin Jantjes, 1974
11 screen-printed panels, ink on card
Edition of 20
H. 60.2 cm | W. 45.2 cm
Tate, London P78646-56
Illustrated pp. 192–3

9:00 PM Going Home: Marabastad-Waterval bus:
For most of the people in this bus the cycle will start
again tomorrow at between 2:00 and 3:00 a.m.
David Goldblatt, 1983
Photographic print, H. 29 cm | W. 43.5 cm
Goodman Gallery, Johannesburg
Illustrated p. 195

UDF 1987: Forward to Peoples Power
Zapiro (Jonathan Shapiro), 1986
Ink, card, H. 78.5 cm | W. 59 cm
British Museum 2016,2006.1
Illustrated pp. 198 and 199

Anguish
Helen Mmakgabo Sebidi, 1988
Ink on paper, collage, H. 207 cm | W. 147 cm
Private collection, London
Illustrated p. 201

Negotiations Minuet
William Kentridge, 1989
Charcoal on paper, H. 108 cm | W. 164 cm
Private collection, London
Illustrated p. 202

AA badge
Name(s) of artist(s) unrecorded, 1984
Recorded as British
Metal, paper, plastic, DIAM. 2.5 cm
British Museum 1984,0642.1
Donated by the Anti-Apartheid Movement
Illustrated p. 204

No to Botha badge
Name(s) of artist(s) unrecorded, 1984
Recorded as British
Metal, paper, plastic, DIAM. 2.5 cm
British Museum 1984,0642.2
Donated by the Anti-Apartheid Movement
Illustrated p. 204

End Sanctions badge
Name(s) of artist(s) unrecorded, 1984
Recorded as British
Metal, paper, plastic, DIAM. 23.2 cm

British Museum 1984,0642.3
Donated by the Anti-Apartheid Movement
Illustrated p. 204

Walter Sisulu badge
Name(s) of artist(s) unrecorded, 1984
Recorded as British
Metal, paper, plastic, DIAM. 3.8 cm
British Museum 1984,0642.4
Donated by the Anti-Apartheid Movement
Illustrated p. 204

Free Nelson Mandela badge
Name(s) of artist(s) unrecorded, 1984
Recorded as British
Metal, paper, plastic, DIAM. 3.8 cm
British Museum 1984,0642.5
Donated by the Anti-Apartheid Movement
Illustrated p. 204

SWAPO badge
Name(s) of artist(s) unrecorded, 1984
Recorded as British
Metal, paper, plastic, DIAM. 2.5 cm
British Museum 1984,0642.6
Donated by the Anti-Apartheid Movement
Illustrated p. 204

Support SWAPO badge
Name(s) of artist(s) unrecorded, 1984
Recorded as British
Metal, paper, plastic, DIAM. 4.4 cm
British Museum 1984,0642.7
Donated by the Anti-Apartheid Movement
Illustrated p. 204

Boycott Barclays badge
Name(s) of artist(s) unrecorded, 1987
Recorded as British
Metal, paper, plastic, DIAM. 3.2 cm
British Museum 1987,1214.1
Donated by the Anti-Apartheid Movement
Illustrated p. 204

Green March for Freedom badge
Name(s) of artist(s) unrecorded, 1985–6

Recorded as British
Metal, paper, plastic, DIAM. 3.2 cm
British Museum 1987,1214.3
Donated by the Anti-Apartheid Movement
Illustrated p. 204

Yellow March for Freedom badge
Name(s) of artist(s) unrecorded, 1985–6
Recorded as British
Metal, paper, plastic, DIAM. 3.2 cm
British Museum 1987,1214.4
Donated by the Anti-Apartheid Movement
Illustrated p. 204

Free Namibia Now badge
Name(s) of artist(s) unrecorded, 1985–6
Recorded as British
Metal, paper, plastic, DIAM. 3.2 cm
British Museum 1987,1214.5
Donated by the Anti-Apartheid Movement
Illustrated p. 204

Sanctions Now! badge
Name(s) of artist(s) unrecorded, 1985–6
Recorded as British
Metal, paper, plastic, DIAM. 3.2 cm
British Museum 1987,1214.6
Donated by the Anti-Apartheid Movement
Illustrated p. 204

Apartheid No Sanctions Yes badge
Name(s) of artist(s) unrecorded, 1985–6
Recorded as British
Metal, paper, plastic, DIAM. 3.2 cm
British Museum 1987,1214.7
Donated by the Anti-Apartheid Movement
Illustrated p. 204

Women Against Apartheid badge
Name(s) of artist(s) unrecorded, 1985–6
Recorded as British
Metal, paper, plastic, DIAM. 3.2 cm
British Museum 1987,1214.8
Donated by the Anti-Apartheid Movement
Illustrated p. 204

Stop Apartheid Boycott Shell badge
Name(s) of artist(s) unrecorded, 1985–6
Recorded as British
Metal, paper, plastic, DIAM. 3.2 cm
British Museum 1987,1214.10
Donated by the Anti-Apartheid Movement
Illustrated p. 204

Boycott Products of Apartheid badge
Name(s) of artist(s) unrecorded, 1985–6
Recorded as British
Metal, paper, plastic, DIAM. 2.5 cm
British Museum 1987,1214.11
Donated by the Anti-Apartheid Movement
Illustrated p. 204

I Don't Buy South African Goods badge
Name(s) of artist(s) unrecorded, 1985–6
Recorded as British
Metal, paper, plastic, DIAM. 2.5 cm
British Museum 1987,1214.12
Donated by the Anti-Apartheid Movement
Illustrated p. 204

Yin and Yang AA badge
Name(s) of artist(s) unrecorded, 1985–6
Recorded as British
Metal, paper, plastic, DIAM. 1.5 cm
British Museum 1987,1214.14
Donated by the Anti-Apartheid Movement
Illustrated p. 204

Female Yin and Yang badge
Name(s) of artist(s) unrecorded, 1985–6
Recorded as British
Metal, paper, plastic, DIAM. 1.5 cm
British Museum 1987,1214.15
Donated by the Anti-Apartheid Movement
Illustrated p. 204

Hand Holding Africa badge
Name(s) of artist(s) unrecorded, 1985–6
Recorded as British
Metal, paper, plastic
H. 4.4 cm | w. 2.4 cm
British Museum 1987,1214.16

Donated by the Anti-Apartheid Movement
Illustrated p. 204

Africa SWAPO badge
Name(s) of artist(s) unrecorded, 1985–6
Recorded as British
Metal, paper, plastic
H. 3.5 cm | w. 3 cm
British Museum 1987,1214.17
Donated by the Anti-Apartheid Movement
Illustrated p. 204

7. Transformations

Nelson Mandela for President badge
Name(s) of artist(s) unrecorded, 1994
Recorded as British
Metal, paper, plastic, DIAM. 5.5 cm
British Museum 1995,0820.1
Donated by Edward Baldwin
Illustrated p. 208

1994 South African ballot paper
Name(s) of artist(s) unrecorded, 1994
Recorded as South African
Paper, laminate, H. 44 cm | w. 16.9 cm
Jane Samuels, London
Illustrated p. 208

Transition
Willie Bester, 1994
Mixed media, H. 92 cm | w. 152 cm
Private collection, London
Illustrated p. 210

It left him cold – the death of Steve Biko
Sam Nhlengethwa, 1990
Collage, pastel, paint and pencil on paper
H. 90.5 cm | w. 115.2 cm
Wits Art Museum, University of
the Witwatersrand, Johannesburg 1994.10.02
Illustrated p. 215

HIV/AIDS crucified figure
Name(s) of artist(s) unrecorded, 2002

Siyazama Project
Fabric, wood, wool, plastic, cotton
H. 50.2 cm | w. 46.5 cm
British Museum Af2002,07.4
Illustrated p. 218

Female figure
Name(s) of artist(s) unrecorded, 2002
Siyazama Project
Fabric, wood, wool, plastic, cotton
H. 37.5 cm | w. 10.5 cm
British Museum Af2002,07.6
Illustrated p. 218

Sangoma tableau
Name(s) of artist(s) unrecorded, 2002
Siyazama Project
Textile, wood, wool, plastic, cotton
H. 14 cm | w. 31 cm
British Museum Af2002,07.1
Illustrated p. 219

Reclamation
Lionel Davis, 2004
Screen-print on paper
H. 90.5 cm | w. 115.2 cm
Museum of Archaeology and Anthropology,
University of Cambridge 2013.222
Illustrated p. 221

Extra!
Top: #5
Bottom left: #12
Bottom right: #4
Candice Breitz, 2011
Chromogenic print
Each H. 56 cm | w. 84 cm
Goodman Gallery, Johannesburg
Illustrated p. 224

A Reversed Retrogress: Scene 1
Mary Sibande, 2013
Mixed media
Each figure H. 180 cm | w. 120 cm
Gallery MOMO, Johannesburg
Illustrated pp. 226, 227 and 228

Acknowledgements

This book was written to accompany an exhibition made possible by our generous sponsors, Betsy and Jack Ryan, and our logistics partner, IAG Cargo. Support for exhibition research was made possible by a Jonathan Ruffer Curatorial Grant from the Art Fund. Both the book and the exhibition celebrate works by South African artists from the deep past to the present day. It is to these artists that we owe our deepest debt of gratitude, in particular: Jane Alexander, Willie Bester, Willem Boshoff, Candice Breitz, Francki Burger, Lionel Davis, David Goldblatt, Helena Hugo, Gavin Jantjes, William Kentridge, Esther Mahlangu, Santu Mofokeng, Anton Momberg, Owen Ndou, Karel Nel, Sam Nhlengethwa, Johannes Phokela, Rico Schacherl, Helen Sebidi, Jonathan Shapiro, Mary Sibande, Penny Siopis and the Bethesda artists.

A huge debt of gratitude is also owed to Professor Peter Mitchell, University of Oxford, for providing expert advice on the text in both the book and the exhibition. For their indispensable assistance with the book, we thank our editors at the British Museum, Emma Poulter and Claudia Bloch; our publishing partners, Thames & Hudson; and the British Museum photographic team, Mike Row, John Williams and Ivor Kerslake.

We are grateful to the South African Heritage Resources Agency, which provided export permits for loan objects for the exhibition, and to the South African Department of Arts and Culture, which assisted us with invaluable advice and contacts. We also thank the many South African museums, art galleries and individuals who generously loaned works to the exhibition: Iziko Museums of South Africa, Ditsong National Cultural Heritage Museum, McGregor Museum, University of the Witwatersrand, University of Pretoria, University of Cape Town, Museum Africa, Wits Art Museum, Goodman Gallery, Gallery MOMO, MAKER, Karel Nel and South32. Equal thanks are due to our lenders in Europe – Jane Samuel, Tate Modern, Museum of Archaeology and Anthropology, Cambridge, BMW Museum, Studio Breitz – and private collections, London.

We thank the South African High Commissioner to the United Kingdom, HE Obed Mlaba, and his team, Sisanda Lisa, Golden Neswswi and Sinenhlanhla Sithole, for their assistance and support. We also thank the following individuals for their advice and encouragement: Ceri Ashley, June Bam-Hutchison, Lunetta Bartz, John Battersby, Evelyn Bester, Wendy Black, Clare Cooper, Jeni Couzyn, Richard Dowden, Damon Garstang, Thomas Girst, Kerryn Greenberg, Sara Hallatt, Matt Incledon, Regina Isaacs, Natalie Knight, Dudu Madonsela, Lara Mallen, Barend van der Merwe, David Morris, Karel Nel, Bona Nyawose, Rooksana Omar, David Pearce, Fiona Rankin-Smith, Ciraj Rasool, Cheryl de la Rey, Janet Roche, Roydon Roche, Polly Savage, Johnny van Scalkwyk, Sian Tiley-Nel, Jill Trappler, Zoe Whitley, Theodore van Wyk and Bernhard Zipfel.

Our thanks to the Director of the British Museum, Hartwig Fischer, for his foreword, and to our many colleagues involved in the project: Rachel Berridge, Julia Brown, Rachel Brown, Selene Burn, Sarah Choy, Jill Cook, Darrel Day, Tony Doubleday, Gary Eagleton, Claire Edwards, Catherine Elliott, Nicola Elvin, Sian Flynn, Beatrice Hendry, Elaine Hunter, Caroline Ingham, Ella Lewis-Collins, Ann Lumley, Jill Maggs, Carolyn Marsden-Smith, Freddie Matthews, Alexander Myers, Jennifer Nicholls, Rob Owen, Caitlin Pearson, Julianne Phippard, Monique Pullan, Susan Raikes, Chris Stewart, Jennifer Suggitt, Sarah Terkaoui, Patricia Wheatley and Helen Wolfe. We are ever thankful for the support we have received from our colleagues in the Department of Africa, Oceania and the Americas, with especial thanks to Helen Anderson, Kate Bagnall, Lissant Bolton, Julie Hudson, David Noden and Stewart Watson. Our final thanks must go to our truly outstanding project curator, Laura Snowling, who held the whole operation together.

250

Illustration credits

The publishers would like to thank the copyright holders for granting permission to reproduce the images illustrated. Every attempt has been made to trace accurate ownership of copyrighted images in this book. Any errors or omissions will be corrected in subsequent editions provided notification is sent to the publishers. All works illustrated in this book are from the collection of the British Museum unless otherwise stated. Further information about the Museum and its collection can be found at britishmuseum.org.

All works are © The Trustees of the British Museum unless otherwise stated below
All maps are © The Trustees of the British Museum, with thanks to Paul Goodhead

Introduction Fig. 1: © Esther Mahlangu Photo © The BMW Group Archives. Used courtesy of BMW Group Archives and with permission of the artist; Fig. 2: © Esther Mahlangu Photo © The BMW Group Archives. Used courtesy of BMW Group Archives and with permission of the artist; Fig. 3 (and detail): Iziko Museums of South Africa, Social History Collections, and SARADA; Fig. 4: South African High Commission, United Kingdom, London; Fig. 5: Reproduced by permission of the artist © The Trustees of the British Museum; Fig. 6: Reproduced by permission of the artist © The Trustees of the British Museum; Fig. 7 (and detail): © Iziko Museums of South Africa, Social History Collections, and SARADA. Photograph by Neil Rusch; Fig. 8: © The Bestheda Foundation Limited, 2015

Chapter 1 Fig. 1: University of the Witwatersrand. Photo by Brett Eloff; Fig. 2: McGregor Museum, Kimberley; Fig. 3: © Iziko Museums of South Africa, Social History Collections; Fig. 4: Image courtesy of Christopher Henshilwood and Francesco d'Errico; Fig. 5: © Iziko Museums of South Africa, Social History Collections; Fig. 6:

© Iziko Museums of South Africa, Social History Collections; Fig. 9: © Karel Nel; Fig. 10: © Karel Nel; Fig. 11: © Karel Nel

Chapter 2 Fig. 1: © Iziko Museums of South Africa, Social History Collections; Fig. 2: Ditsong National Museum of Cultural History, Pretoria; Fig. 3: Ditsong National Museum of Cultural History, Pretoria; Fig. 4: Ditsong National Museum of Cultural History, Pretoria; Fig. 5: Department of Arts, University of Pretoria; Fig. 6: Department of Arts, University of Pretoria; Fig. 7: Department of Arts, University of Pretoria; Fig. 8: Department of Arts, University of Pretoria; Fig. 9: Department of Arts, University of Pretoria; Fig. 10: McGregor Museum, Kimberley; Fig. 11: © Penny Siopis; Fig. 12: © Penny Siopis; Fig. 13: © Owen Ndou; Fig. 14: © Steve Hilton-Barber/AfriPics

Chapter 3 Fig. 1: William Cullen Library, University of the Witwatersrand, Johannesburg, South Africa; Fig. 3: Reproduced by permission of the artist © The Trustees of the British Museum; Fig. 4: © Iziko Museums of South Africa, Social History Collections; Fig. 15: Courtesy of Mr R. Loder and J. Phokela; Fig. 17: Anton Momberg. Image © Iziko South Africa National Gallery; Fig. 18: Ditsong National Museum of Cultural History, Pretoria; Fig. 19: © Dennis Cox/ Alamy Stock Photo; Fig. 20: Warren Siebrits Collection, Johannesburg, South Africa; Fig. 21: William Cullen Library, University of the Witwatersrand, Johannesburg, South Africa; Fig. 22: © the estate of the artist; Fig. 23 (and detail): © the artist; Fig. 24: © the artist

Chapter 4 Fig. 4: © Anne S. K. Brown Military Collection, Brown University Library; Fig. 9 (and detail): Karel Nel; Fig. 12: © The Estate of John Muafangejo (The John Muafangejo Trust). All rights reserved. DACS 2016; Fig. 16: The War Museum, Bloemfontein, South Africa; Fig. 17: © War Museum of the Boer Republics, Bloemfontein, South Africa; Fig. 18: © War Museum of the Boer Republics, Bloemfontein,

South Africa; Fig. 21: Museum Africa Collections Archives, City of Johannesburg. Photo: Kenneth Hlungwani; Fig. 22: Museum Africa Collections Archives, City of Johannesburg. Photo: Kenneth Hlungwani; Fig. 23: Francki Burger; Fig. 24: © UP Art Collection University of Pretoria

Chapter 5 Fig. 24: McGregor Museum, Kimberley; Fig. 28: R. H. Porter, London; Fig. 33: McGregor Museum, Kimberley; Fig. 36: Iziko Museums of South Africa Art Collections. Photograph by Carina Beyer; Fig. 44: McGregor Museum, Kimberley; Fig. 45: © PVDE/Bridgeman Images; Fig. 52: © Noxolo Dyobiso; Fig. 61: © Santu Mofokeng/Image courtesy Luetta Bartz, MAKER, Johannesburg; Fig. 62: Reproduced by permission of the artist © The Trustees of the British Museum

Chapter 6 Fig. 1: Karel Nel; Fig. 2: Karel Nel; Fig. 6: UP Art Collection, University of Pretoria; Fig. 7: Courtesy of David Goldblatt; Fig. 13: © Iziko Museums of South Africa Art Collections. Photograph by Carina Beyer; Fig. 14: © Gerard Sekoto Foundation. Image: South32, SA Limited; Fig. 15: © Gerard Sekoto Foundation. Image: Johannesburg Art Gallery, Johannesburg; Fig. 16: © Gavin Jantjes. Image: © Tate, London 2016; Fig. 17: Courtesy of David Goldblatt; Fig. 18: *Cape Times*, Cape Town; Fig. 19 (and detail): Reproduced by permission of the artist © The Trustees of the British Museum; Fig. 20: Helen Mmakgabo Sebidi; Fig. 21: Courtesy of the artist

Chapter 7 Fig. 2: Courtesy of Jane Samuels, London; Fig. 3: © Willie Bester; Fig. 4: Stephen Francis & Rico Schacherl; Fig. 5: © the artist and Goodman Gallery. Photo: Courtesy of Sam Nhlengethwa and Wits Art Museum, Johannesburg; Fig. 6: © Jane Alexander, DALRO; Fig. 7: © Jane Alexander, DALRO; Fig. 11: © the artist; Fig. 12: Courtesy Goodman Gallery; Fig. 13 (and details): Courtesy of the artist and Gallery MOMO

Index

Italic page numbers refer to illustrations.